The Cultural Impact of
RuPaul's Drag Race

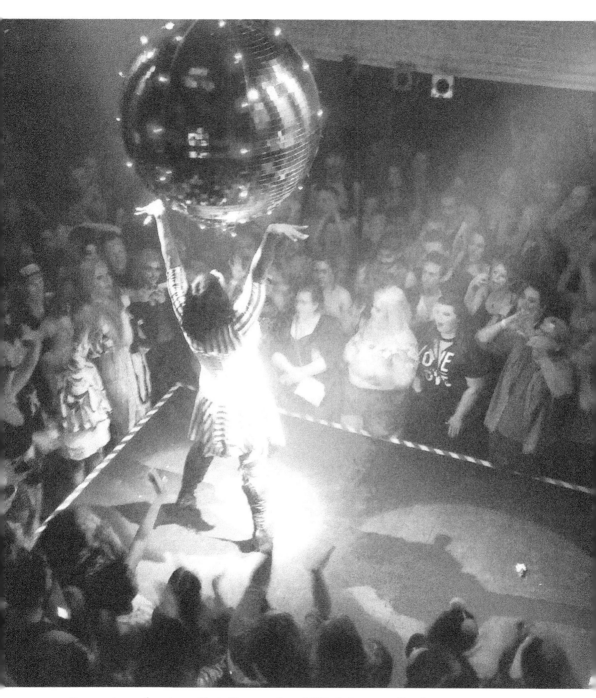

Peppermint performing at Fly in Toronto, June 2017. © Cameron Crookston.

The Cultural Impact of *RuPaul's Drag Race*

Why Are We All Gagging?

Edited by
Cameron Crookston

Bristol, UK / Chicago, USA

First published in the UK in 2021 by
Intellect, The Mill, Parnall Road, Fishponds, Bristol, BS16 3JG, UK

First published in the USA in 2021 by
Intellect, The University of Chicago Press, 1427 E. 60th Street,
Chicago, IL 60637, USA

Copyright © 2021 Intellect Ltd

All rights reserved. No part of this publication may be reproduced, stored in a retrieval system, or transmitted, in any form or by any means, electronic, mechanical, photocopying, recording, or otherwise, without written permission.

A catalogue record for this book is available from the British Library.

Copy editor: Newgen KnowlegdeWorks
Cover designer: Holly Rose
Production manager: Aimée Bates
Typesetting: Newgen KnowledgeWorks

Paperback ISBN 978-1-78938-566-3
Hardback ISBN 978-1-78938-256-3
ePDF ISBN 978-1-78938-257-0
ePub ISBN 978-1-78938-258-7

Printed and bound by TJ Books Limited

To find out about all our publications, please visit
www.intellectbooks.com
There you can subscribe to our e-newsletter, browse or download our current catalogue, and buy any titles that are in print.

This is a peer-reviewed publication.

Contents

Acknowledgments	vii
Introduction: Why Are We All Gagging? Unpacking the Cultural Impact of *RuPaul's Drag Race* *Cameron Crookston*	1
1. Twerk It & Werk It: The Impact of *RuPaul's Drag Race* on Local Underground Drag Scenes *Joshua W. Rivers*	11
2. "Change the motherfucking world!": The Possibilities and Limitations of Activism in *RuPaul's Drag Race* *Ash Kinney d'Harcourt*	27
3. Queering Africa: Bebe Zahara Benet's "African" Aesthetics and Performance *Lwando Scott*	45
4. "Heather has transitioned": Transgender and Non-binary Contestants on *RuPaul's Drag Race* *K. Woodzick*	63
5. How *Drag Race* Created a Monster: The Future of Drag and the Backward Temporality of *The Boulet Brothers' Dragula* *Aaron J. Stone*	81
6. *RuPaul's Drag Race*: Between Cultural Branding and Consumer Culture *Mario Campana and Katherine Duffy*	108
7. RuPaul's Franchise: Moving Toward a Political Economy of Drag Queening *Ray LeBlanc*	131
8. Legend, Icon, Star: Cultural Production and Commodification in *RuPaul's Drag Race* *Laura Friesen*	156

9. Repetition, Recitation, and Vanessa Vanjie Mateo: Miss Vanjie and the Culture-Producing Power of Performative Speech in *RuPaul's Drag Race* — 175
 Allan S. Taylor
10. It's Too Late to RuPaulogize: The Lackluster Defense of an Occasional Unlistener — 194
 Timothy Oleksiak
11. "This is a movement!": How RuPaul Markets Drag through DragCon Keynote Addresses — 212
 Carl Schottmiller

Contributors — 233

Acknowledgments

I wish to extend my gratitude to the team at Intellect for supporting this book and encouraging me through its development. In particular I wish to thank James Campbell, Katie Evans, Naomi Curston, and Aimée Bates for their support and guidance. I would also like to thank Professors Jacob Gallagher-Ross and VK Preston at the University of Toronto for their good counsel and sound advice on editing. To the group of scholars who contributed to this book, I offer my most sincere thanks for your hard work. Finally, I wish to thank the artists, both those named in this book and those unnamed, whose work contributes to the vibrant and expansive world of drag.

Introduction

Why Are We All Gagging? Unpacking the Cultural Impact of *RuPaul's Drag Race*

Cameron Crookston

Since its premier in 2009, *RuPaul's Drag Race* has captured the attention and imagination of fans. *Drag Race* has spawned conventions and international spin-off programs and transformed not only the careers of its over one hundred contestants but also the very landscape of drag performance itself. In addition to the enthusiasm and critical acclaim the show has gained from fans and critics, *Drag Race* has become the subject of scholarship and academic analysis around the world. Over the past decade *Drag Race* has been the subject of articles and essays in publications such as *Studies in Popular Culture* (Edgar 2012), *Journal of Research in Gender Studies* (Moore 2013), *Feminist Media Studies* (Strings and Bui 2014), *GLQ: A Journal of Lesbian and Gay Studies* (Goldmark 2015), and *Transgender Studies Quarterly* (Collins 2017), among many others. It has been the subject of book chapters, academic conference presentations, and doctoral and master's theses. In 2014 Jim Daems edited *The Makeup of* Rupaul's Drag Race: *Essays on the Queen of Reality Shows*, the first published anthology of critical works to examine the then cult reality hit. Just three years later Niall Brennan and David Gudelunas released the second collection of academic works, RuPaul's Drag Race *and the Shifting Visibility of Drag Culture* (2017). *The Cultural Impact of* RuPaul's Drag Race: *Why Are We All Gagging?* joins a conversation that has evolved over ten years in response to a show that has itself grown and changed as the very subject it documents, the art and world of drag, has been transformed radically.

 The seed of this project was born when I participated in a roundtable discussion on contemporary drag performance at *Q2Q: A Symposium on Queer*

Theatre and Performance in Canada, held at Simon Fraser University, in 2016. Seated between drag performers Isolde N. Barron and Rose Butch the conversation turned to recent changes and influences in local drag communities across Canada. Barron discussed her experience of "marathon drag" in Toronto, a fairly recent phenomena in which rather than preparing two or three numbers to perform in a contained single show, queens were expected to perform over a dozen numbers, for hours, with "shows" running virtually nonstop from opening to closing. Increases in straight audience members and higher numbers of aspiring performers were also noted as major changes to drag in the second decade of the twentieth century, all of which could be traced to the popularity and proliferation of *RuPaul's Drag Race*. Audiences who might have never wandered into a bar to discover drag were having it piped into their living rooms. Queer youth who would have had to wait another decade or move to a larger city could access drag earlier and more easily. Even for those who did not actively seek out the program, *Drag Race* spawned memes, viral catch phrases, hashtags, *Saturday Night Live* sketches, and spin-off series. As such, drag audiences changed. They grew in size and in demographic diversity. They experienced drag via television first and brought those expectations to local live shows. And through this all, *Drag Race* continued to grow.

Initially, I conceived of this collection as a volume in Intellect's *Fan Phenomena* series. I was interested in exploring *Drag Race*'s transition from cult program to mainstream hit and bringing scholarly attention to events such as DragCon, the trend of "viewing parties" at local bars around the world, and the unique way that *Drag Race* performers related to their fans via social media. However, as I worked with Intellect, we quickly decided that while fan culture was a part of this discussion, there was much more going on and that it warranted a broader scope than merely an analysis of fan studies. So we put out a call for the collection as it stands, a project that asked scholars to reflect on the impact *Drag Race* has had on the world around us. I asked, with a wink and a nod that seemed appropriate within the context of drag studies: why are we all gagging?[1] What is the cultural impact of *RuPaul's Drag Race*?

I received submissions from scholars in theater and performance studies, English literature, and cultural anthropology. From media studies, linguistics, sociology, and marketing. These chapters provided a rich and diverse engagement with the question of how *Drag Race* has affected local live cultures, fan cultures, queer representation, and the very fabric of drag as an art form in popular consciousness. The result is this collaborative project informed by the research and experience of scholars and fans, who have each contributed unique cultural, academic, and often personal perspectives on my question about the cultural impact of *RuPaul's Drag Race*.

INTRODUCTION

The Cultural Context of RuPaul's Drag Race

The turn of the twenty-first century witnessed an explosion of reality programing[2] development and a popularity that continues even today. Shows such as *Big Brother* (1999), *Survivor* (2000), and *American Idol* (2002) ushered in the modern era of reality television and solidified contemporary formatting and structural audience expectations for reality TV formulas. Thus, when *RuPaul's Drag Race* premiered in February of 2009, reality television had been a staple of Western mainstream entertainment for a decade. In her contribution to Daemon's collection, Mary Marcel submits that "whatever naïve early notions the public may have had about the 'realness' of reality television, many years in, we know that reality TV programs are cast, edited, and often scripted" (2014). Because of drag's very foundation of cultural parody and self-referential construction of "realness," *Drag Race* offered what many critics and scholars saw as the perfect platform to parody the popular form at a moment in the zeitgeist when audiences had had enough time to become critically aware of the constructed nature, and thus the ironic lack of reality, of reality television. Marcel, among others, observes the degree to which RuPaul's vision for the show, at least in the early seasons, presented a parody of reality TV conventions.

However, despite the subversive potential that *Drag Race*'s parody of reality television might have offered, critics and scholars almost immediately spotted the danger of adapting a queer art form for mass cultural consumption. Articles that cautioned against the pitfalls of *Drag Race*'s attempt to thrust drag into the mainstream were among some of the first academic works on the program. Ten years later, the question of *Drag Race*'s relationship to the mainstream has grown increasingly urgent. In an effort to sell a commercially viable and politically simplified version of drag, *Drag Race* has attempted to draw clean, often exclusive lines around what constitutes drag, and in doing so perpetuated transphobic and trans-exclusive elements of drag. These issues have been taken up by scholars and critics in both Daemon's and Brennan and Gudelunas's edited volumes, as well as dozens of journal articles and conference presentations over the past decade, and yet even today the subject is far from resolved.

I offer this summation of earlier work on *Drag Race* because these controversies, tensions, and conversations continue today. The contributing authors of *The Cultural Impact of* RuPaul's Drag Race: *Why Are We All Gagging?* offer new insights into many questions that have permeated *Drag Race* discourse since the show's premier. However, this collection has the benefit of much hindsight, of watching *Drag Race*'s evolution and cultural impact over the past decade. For example, the very goal of the show, its desire to find a worthy queen to wear "the crown," has been subtly transformed by the show's success.

Drag Race was at its inception, and still is, presented as the search for the "next Drag Superstar." However, what this title means, both more abstractly and in terms of its effect on a queen's professional trajectory, has changed considerably since the phrase was first uttered in 2009. Scholars such as Mary Marcel note that the elusive rubric for the show's winner, in the early seasons, seemed to focus on finding or creating a queen who could emulate RuPaul's success as a spokesperson and brand ambassador, as well as a commercially accessible pop fashion icon. The assumption of course was that the *next* Drag Superstar would follow in the footsteps of the *last* Drag Superstar. Additionally, the grand prize for the first two seasons included a contract to appear in a print advertising campaign for LaEyeworks, a position RuPaul had held in the 1990s. Many note the degree to which early winners Bebe Zahara Benet, Tyra Sanchez, and Raja emulated RuPaul's regal high glam aesthetic and successfully performed as poised and accessible spokesqueens in various challenges, in comparison to some of their campier, racier, and/or more provocatively queer peers.

However, in more recent seasons, the model for and professional trajectory of the show's winners has changed considerably. This shift is directly tied to the success of *Drag Race* itself. While early winners headlined modest national tours to a niche audience, today *Drag Race* has spawned multiple international tours that play to sold-out theaters, such as *Battle of the Seasons* (2015), *Shady Queens* (2016), *Werk the World* (2017), not to mention individual tours in theaters and stadiums by break-out stars such as Bianca Del Rio, Adore Delano, and Trixie Mattel. The year 2015 saw the launch of DragCon, a wildly successful convention for fans of *Drag Race* to meet past contestants, attend panel discussions on drag, and buy *Drag Race* merchandise. Today DragCon is held in both Los Angeles and New York, with reported attendance of over 50,000 per convention. *Drag Race* contestants are mainstays of global Pride celebrations, sell their own merchandise, and command legions of social media followers in the millions. They have appeared in feature films, in popular television programs, and on the cover of major commercial magazines. The very landscape of professional drag has been altered by the show's alumni, and thus the career path for the next Drag Superstar has radically transformed.

The impact of *Drag Race* extends well beyond the careers of contestants. The show's depiction of drag as both a celebrated form of entertainment and a potentially lucrative career path has created an explosion of aspiring queens in unprecedented numbers, a phenomenon that season eight winner Bob the Drag Queen refers to as "the *Drag Race* Baby Boom" (Murray 2016). Audiences have also grown and changed since the show's early days. What was once a cult show marketed primarily to gay men, *Drag Race* has drawn both praise and criticism for its ability to market itself to broader, straighter, and increasingly younger fans.

INTRODUCTION

Particularly since its move from Logo to VH1, as well as its availability on Netflix, *Drag Race* has taken the world of drag from the age-restrictive and queerly specific world of bars and nightclubs into living rooms and laptops around the world, changing access and exposure and thus cultivating larger and demographically broader audiences. As *Drag Race* takes up more and more space in mainstream culture, conversations around representation and optics, which have existed for as long as the show has been in production, have taken on increased urgency and focus.

What I have curated in this collection is a conversation around these elements, on *Drag Race*'s evolution and its impact on the wider culture. In doing so I have attempted to shift the focus from an analysis of the show itself—a worthy project that has and continues to be taken up elsewhere—to an analysis of the influence that *RuPaul's Drag Race* has had on fans, artists, and members of queer communities around the world.

Chapters

In the early days of *Drag Race* there was considerable academic attention on the effect that translating drag from the subcultural spaces of queer gay bars to the mainstream media of television might have for *Drag Race* as a product. However, what few critics predicted was the effect that the mediatization of drag might have on its fans' participation in live drag. In "Twerk It & Werk It: The Impact of *RuPaul's Drag Race* on Local Underground Drag Scenes," Joshua Rivers documents the development of a drag party that was held in Utrecht in the Netherlands by a group of Dutch, German, and American students in response to local interest in drag generated by *Drag Race*. Rivers, who attended several iterations of the event and interviewed organizers, assesses *Drag Race*'s influence on the creation of the event and the expectations of attendees and the degree to which the American reality show's politics and aesthetics combined and clashed with the city's local drag culture.

The porous relationship between *Drag Race* and the world around also applies to the show's many contestants. While the program itself has been criticized for its depiction of neoliberal politics, many contestants have backgrounds in more grassroots political activism. Ash Kinney d'Harcourt's chapter, " 'Change the motherfucking world!': The Possibilities and Limitations of Activism in *RuPaul's Drag Race*," presents a study of *Drag Race* contestants whose artistic practice and personal lives intersect with activist work. In doing so they examine how the show has framed the relationship between drag and activism through the lens of these personal "backstories." Analyzing how *Drag Race* contestants have

continued their activism after appearing on the show, d'Harcourt compares the show's onscreen representation of politics with the larger history of activism in drag as a form of queer cultural expression.

While *Drag Race* has evolved considerably since its early seasons, questions of representation and optics remain at the forefront of many conversations among critics, scholars, and viewers. As such, an academic collection on the show's cultural impact would be incomplete without a detailed consideration of the politics of representation. The first chapter to continue this work is Lwando Scott's "Queering Africa: Bebe Zahara Benet's 'African' Aesthetics and Performance." This chapter scrutinizes how the winner of the first season of *Drag Race* has negotiated the optics of African queerness. Scott, himself a queer man of color living in South Africa, considers how Zahara Benet's unique presence as a queer African man of color in popular culture complicates questions about the visibility of African queerness, camp, and the possibility of subverting racial stereotypes.

Similarly, "'Heather has transitioned': Transgender and Non-binary Contestants on *RuPaul's Drag Race*" by K. Woodzick considers *Drag Race*'s complex history of trans visibility. Through a critical chronology of some of the show's trans and non-binary contestants, Woodzick reflects on their own experience as a trans audience member to track the evolution of the transgender optics and visibility in the first ten seasons of *Drag Race*. They put these events in conversation with the wider popular culture and consider the ethics of disclosure and agency in coming-out narratives and self-representation for trans artists in the media.

While *Drag Race* offers a complex vision for the reparative power of representation, it often does so at the expense of antinormative queer factions of both the drag community and its potential queer fan base. Many scholars have noted that RuPaul and his contestants have toted the subversive and radical nature of drag's potential, while offering up a sanitized, defanged version of the supposedly radical art form—a criticism that has become more pointed as the show has evolved. In "How *Drag Race* Created a Monster: The Future of Drag and the Backward Temporality of *The Boulet Brothers' Dragula*," Aaron J. Stone considers how *RuPaul's Drag Race* created a desire in audiences for subversive queer forms of expression that the show itself was unable to supply as it became increasingly popular and mainstream. Examining press, marketing, and statements by early contestants, Stone argues that *Drag Race*'s promise of promoting radical queer futurity actually primed audiences to engage with the more subversive, less mainstream *Dragula*, itself an almost dark parodic reimagining of *Drag Race*, which draws on horror, fetish, and radical queer performance aesthetics.

Criticisms of *Drag Race*'s commercialization may be common; however, the nature of that engagement is anything but simple. Indeed, the way *Drag Race* has altered the economics of drag as an art form is among one of the most

significant impacts that the show has had on the world around it. "*RuPaul's Drag Race*: Between Cultural Branding and Consumer Culture" by Mario Campana and Katherine Duffy engages in consumer culture research and the very idea of cultural branding to examine exactly how *Drag Race* has adapted existing language, symbols, and myths within queer culture and LGBTQ+ history. The authors consider larger discourses and trends in popular representation of queers in contemporary media and politics, while also examining the unique relationship that the program has to digitized and live media, to analyze *Drag Race*'s rare branding strategies and outcomes.

Similarly, Ray LeBlanc's "RuPaul's Franchise: Moving toward a Political Economy of Drag Queening" considers the show's output of additional products and programming to examine the impact *Drag Race* has had in creating a cottage industry of official *Drag Race* drag culture. By examining DragCon, spin-off programs, and the long-term careers of past contestants, LeBlanc considers how the *Drag Race* franchise has not only influenced but also transformed the industry and economy of drag.

While Campana and Duffy examine the commercialization of queer culture itself, and LeBlanc considers the impact of *Drag Race*'s political economy on the contestants and performers, Laura Friesen's "Legend, Icon, Star: Cultural Production and Commodification in *RuPaul's Drag Race*" examines *Drag Race*'s relationship to its straight fans and mainstream popularity. In particular, the author considers how the content of *Drag Race*, as well as touring works by *All Stars* season four winner, Trixie Mattel, has evolved since the show's inception and begun coveting the appeal of younger and straighter fans. In doing so, Friesen considers how *Drag Race* has repositioned its claims to queer representation and the promotion of LGBTQ+ cultural histories.

Drag Race's ability to engage with ever-broadening legions of fans has been significantly bolstered by the degree to which its fans have engaged with the show via social media. In "Repetition, Recitation, and Vanessa Vanjie Mateo: Miss Vanjie and the Culture-Producing Power of Performative Speech in *RuPaul's Drag Race*," Allan S. Taylor examines Miss Vanjie's infamous elimination at the beginning of season ten and the subsequent viral internet storm in order to discuss the way *Drag Race* produces unique linguistic constructions that extend beyond the program itself and connect with online fan culture. He uses the exemplar of the Miss Vanjie phenomenon to study how drag's historic precedent of citational visual and linguistic practices are extended and evolved through *Drag Race*'s unique relationship with its fans via social media and broadcasting.

While *Drag Race* more often than not utilizes social media to its benefit, RuPaul's own internet presence has drawn controversy on more than one occasion. In his chapter "It's Too Late to RuPaulogize: The Lackluster Defense of an

Occasional Unlistener," Timothy Oleksiak examines the debate between RuPaul, his producers, and members of the trans community with regard to the show's use of transphobic slang and history of problematic treatment of trans representation on the show. In particular, the author employs an analysis of RuPaul's rhetoric in his online responses, specifically his more recent "apologies" under mounting pressure from the wider LGBTQ+ community.

As the figurehead of *Drag Race*, much of the show's evolution and shifting relationship to popular culture can be tracked through RuPaul's own public discourse. In his chapter "'This is a movement!': How RuPaul Markets Drag through DragCon Keynote Addresses," Carl Schottmiller analyzes RuPaul's keynote addresses from the first three Los Angeles DragCons, as well as audience demographics and reactions to these speeches. In this final chapter Schottmiller tracks the evolution of RuPaul's "guRu" persona, itself arguably the product of the drag mogul's own success within the world of reality television. In doing so, the author tracks how RuPaul's keynote addresses have drifted from passionate discussions of LGBTQ+ history and camp humor to more "accessible" and neoliberal pronouncements on self-help and spirituality. He also retraces the history of *Drag Race*, DragCon, and RuPaul's own evolution as a cultural icon and influencer.

Conclusion

With the popularity of *RuPaul's Drag Race*, and the far-reaching and numerous effects it has had on the world around it, it is tempting to say that the contemporary moment of drag's popularity is unprecedented. However, a glance into the history books of drag, such as Laurence Senelick's *The Changing Room: Sex, Drag and Theatre* (2002), reveals that the art form has seen moments of immense popularity and heightened visibility in the past. Female impersonators and pantomime Dame Comedians were among the most popular entertainers of the nineteenth century. The Pansy Craze of the interwar period saw a flood of mainstream interest in underground queer subculture. Indeed, from the illustrious career of music hall female impersonator Julian Eltinge (1881–1941), to Mae West's controversial play *The Drag* (1927), and mainstream drag headliner Danny LaRue (1927–2009), drag has had numerous moments of widespread popularity and mainstream interest.

However, while the current interest in drag may not be without precedent, the circumstances that surround *Drag Race* are unique and, as such, its range and effect on the world is indeed rare. Eltinge did not have the advantage of social media to foster increased connections to his fans. LaRue's popularity did not lead to a Baby Boom of aspiring queens around the world. There were no fan conventions, spin-off programs, or Reddit threads to work as conduits to expand the reach and

influence of earlier performers. As such, while the history of drag reveals earlier moments of popularity and mainstream interest, the success of *RuPaul's Drag Race* has produced unique effects.

It is also important to note that while *Drag Race* is often viewed as an overnight success story, a sudden wildfire that has expanded the popularity of drag on the sheer force of will of RuPaul and his army of queens, *Drag Race* itself stands on the shoulders of decades of slowly building interest in drag among mainstream audiences. Queer film scholar B. Ruby Rich notes that the early 1990s marked the birth of New Queer Cinema, a movement of queer-themed independent film that was embraced by straight audiences. Beginning with films such as Jennie Livingston's *Paris Is Burning* (1990), the movement soon gave way to a mainstream trend of "gay-themed" film and television titles such as *The Adventures of Priscilla, Queen of the Desert* (1994), *To Wong Foo, Thanks for Everything, Julie Newmar* (1995), and *The Bird Cage* (1996). RuPaul's success with the dance hit "Supermodel (You Better Work)" in 1992 is itself a benefactor of this moment of mainstream interest in drag.

This is not to say that *RuPaul's Drag Race* is merely one in a long line of popular drag products. While I do wish to point out the larger narrative of drag's popular appeal and the preceding cultural context that allowed for the show's emergence, to say that anything like *Drag Race* existed in these earlier decades would be untrue. *Drag Race* has taken the torch it was passed and lit the world on fire. Nowhere is this more evident than in the marked effect *Drag Race* has had on the world around it. No other drag show has inspired legions of fans in the millions, built cottage industries of tours and products, and inspired a generation of new performers with the same magnitude. No other example has had such a drastic effect on drag around the world. And it is this impact, far reaching, complex, and ongoing, that the scholars in this collection examine.

NOTES

1. The subtitle of this anthology—"Why Are We All Gagging?"—serves as a tongue-in-cheek follow-up question to a line from *Paris Is Burning* in which a ball's M.C., referring to a queen's history of flawless performance, calls to the audience: "I don't know why you all gagging, she bring it to you every ball." The term "gagging" is used to mean overwhelmingly impressed to the point of shock or surprise. Like many iconic lines from *Paris Is Burning*, "I don't know why you all gagging" has been referenced repeatedly by *Drag Race*, most notably by season eight winner Bob the Drag Queen.
2. As with any genre, tracing the definite origins of reality television is complex, and an argument can be made for its origins in numerous docuseries of the mid-twentieth century such as *Queen for a Day* (1945–64), *An American Family* (1973), and *Real People* (1979).

REFERENCES

Brennan, Niall, and David Gudelunas. 2017. RuPaul's Drag Race *and the Shifting Visibility of Drag Culture*. Cham, Switzerland: Palgrave Macmillan.

Collins, Cory G. 2017. "Drag Race to the Bottom? Updated Notes on the Aesthetic and Political Economy of *RuPaul's Drag Race*." *Transgender Studies Quarterly* 4 (1): 128–34.

Daems, Jim. 2014. *The Makeup of* RuPaul's Drag Race: *Essays on the Queen of Reality Shows*. Jefferson, NC: McFarland.

Edgar, Eri-Anne. 2012. "'Xtravaganza!': Drag Representation in *RuPaul's Drag Race*." *Studies in Popular Culture* 34 (1): 133–46.

Elliott, Stephan, dir. *The Adventures of Priscilla, Queen of the Desert*. 1994; Universal City, CA: Gramercy Pictures.

Goldmark, Matthew. 2015. "National Drag: The Language of Inclusion in *RuPaul's Drag Race*." *GLQ: A Journal of Lesbian and Gay Studies* 21 (4): 501–20.

Kidron, Beeban, dir. *To Wong Foo, Thanks for Everything, Julie Newmar*. 1995; Universal City, CA: Amblin Entertainment, 2005. DVD.

Livingston, Jennie, dir. *Paris Is Burning*. 1990; Fargo, ND: Off White Productions.

Marcel, Mary. 2014 "Representing Gender, Race and Realness: The Television World of America's Next Drag Superstars." In *The Makeup of* RuPaul's Drag Race, edited by Jim Daems. Jefferson, NC: McFarland. Kindle edition.

Moore, Rammy. 2013. "Everything Else Is Drag: Linguistic Drag and Gender Parody on *RuPaul's Drag Race*." *Journal of Research in Gender Studies* 3 (2): 15–26.

Murray, Nick. 2016. *RuPaul's Drag Race*. Season 8, episode 1, "Keeping it at 100." Aired March 7, 2016, on Logo TV.

Nichols, Mike, dir. *The Bird Cage*. 1996; Beverly Hills, CA: United Artists.

Rich, Ruby B. 2013. *New Queer Cinema: The Director's Cut*. Durham, NC: Duke University Press.

Senelick, Laurence. 2000. *The Changing Room: Sex, Drag and Theatre*. New York: Routledge.

Strings, Sabrina, and Long T. Bui. 2014. "'She is not acting, she is': The Conflict between Gender and Racial Realness on *RuPaul's Drag Race*." *Feminist Media Studies* 14 (5): 822–36.

"Supermodel (You Better Work)." RuPaul. *Supermodel of the World*. 1992. New York: Tommy Boy.

1

Twerk It & Werk It: The Impact of *RuPaul's Drag Race* on Local Underground Drag Scenes

Joshua W. Rivers

"What's a drag race, though?"

It is January in Washington, D.C., in the year 2013. Outside the sky is gray, the cherry blossoms are nowhere in sight, and I am sitting on a forgotten-in-the-attic, brown, grungy-yet-comfortable armchair in a university-owned townhouse doing all I can to ignore the fact that a chapter of my senior thesis is due in three days. Sitting next to me on a similarly worn couch are four of my six housemates and friends, two of whom have convinced the rest of us to join them in watching the premiere of something they keep referring to as a "drag race." Knowing only that drag races are usually related to cars in some form or fashion and not entirely sure why my two radically queer roommates are so committed to proselytizing such a thing, I nevertheless accept that this TV show seems the best option for advancing my carefully planned procrastination scheme. Confused as to why my roommates have tuned into the LGBTQ+ content focused network Logo TV on our university's cable network, Rae, sporting purple hair and a colorful set of leggings, giggles a bit while telling the rest of us how excited she is for what we're about to experience. I take a sip of tea that the townhouse's other *Drag Race* apostle has made for the group, unsure as to why the energy-drink-loving auburn-haired Lily chose to center tea as the beverage of choice for the evening, and in a flash of neon pink and light blue, *RuPaul's Drag Race* (*RPDR*) season five begins. An hour after the episode ends, I am hurriedly typing to my Dutch friend Tom, who is just waking up to begin his day in Utrecht, about this show he must see. "What's a drag race,

though? Sorry, it's early," is his first response. Two weeks and a bit of explaining later we are both avid *RPDR* fans.

Growing up in a religious household in the American South during the 1990s, I was never exposed to RuPaul or his career before starting season five, but I found myself enthralled by his persona and those of his queens after each week's episode. While I had heard of drag queens before and regularly participated in my university's annual *Rocky Horror Picture Show*, its own form of queer performance art, it was not until seeing drag queens compete on *RPDR* that I began to understand better what it meant to perform drag. Alongside investigating local drag shows, which I found fascinating in their ability to entrance a crowd, I also took it upon myself to binge-watch the entirety of season four during any spare time I found between episodes of season five airing, and in February of 2013, it became my personal mission in life to join Lily and Rae in spreading the word about this show, its appeal, and the queer affirmation to be found with drag performance gone mass media.

Six thousand miles away, with an ocean separating us, Tom was one of the first to hear me praise the show, as well as one of the first in my circle of Dutch and German friends to become as avid a fan as I was. Having originally met through a couch-surfing-host-turned-friend from Amsterdam, whose childhood best friend happened to live with Tom, we had grown close during my time studying abroad in Berlin in 2012 as I made frequent visits to Utrecht. Given this friendship and my desire to return to Europe as soon as possible, Tom and I had been planning to see each other during my spring break in March. During one of our many Skype calls about the trip in February, Tom mentioned, "So I've been thinking and you know how it was my birthday, that I never celebrate, right? It's also Danny's birthday and we've been thinking of throwing a party, a *drag* party. Would you be ok with that while you're here?" to which I answered, "Absolutely. I'm so excited. Let's do it." A month later in an aristocratically inspired white wig from a Carnival[1] shop, heels from a discount shoe store, and a glittery skirt I borrowed from Tom's friend Marloes, I stepped into Danny's loft for the first iteration of what would become an annual Utrecht tradition: Twerk It & Werk It.[2]

Inspired in no small part by Tom and Danny's recent exposure to *RPDR*, Twerk It & Werk It grew from a small house party of roughly twenty guests dipping their toes into the drag queen and drag king waters to a larger underground party of nearly one hundred people from all over the country. Hosted in townhomes and empty apartments throughout Utrecht, each iteration of Twerk It & Werk It involved drag performers with make-up "beat for the gods," costumery to rival a Las Vegas show, as well as catwalk and lip-sync competitions befitting an *All Stars* episode of *RPDR*. Throughout this chapter, I trace the history of this particular underground drag party and its associated drag scene as they come into being by

virtue of their founders' exposure to *RPDR*. I then note particular shifts away from *RPDR*'s norms of acceptable and permissible drag as they came to light in more recent iterations. Finally, I discuss how the organizers' decision to place the party on hiatus and thereby place its surrounding drag scene in hibernation is a definitive break from the show's underlying support of mainstreaming queer performance art such as drag and profiting from it. In doing so, I explore the indeterminate manner in which one constellation of underground drag performers both draw on and reject *RPDR*'s norms as said norms codify "proper" drag styles, drag bodies, and drag culture. This, in turn, highlights how nuanced analyses of *RPDR*'s impact better serve us in understanding the complex ways in which the show and its apparatus have irrevocably altered contemporary drag scenes both within the United States and abroad.

The goal of this chapter is not to paint *RPDR* as a purely neocolonial capitalist enterprise or to laud it for having made queerness mainstream. Instead, by rooting my analyses in four years of ethnographic research, as well as supplementary interview data, I hope to highlight the complexities of how one particular network of actors, those who attend Twerk It & Werk It, engage with, reinterpret, embrace, and eschew *RPDR* and its message of what drag is or can be.

On Where This Happened and How

In part because of our primary methodological tool, participant observation, we anthropologists are often found deeply embedded in the lives of our interlocutors, as well as in the goings-on in our field sites. This is certainly true of my location within this project. Being close friends with Tom and several of the original Twerk It & Werk It partygoers, I found myself invited to every iteration of the party, which began in 2013 and is currently on hiatus following the 2016 edition, for reasons I will address later. In contrast to traditional drag shows in bars or other Dutch queer parties such as PANN, this party was invite-only and often hosted at a home within Utrecht capable of fitting upward of fifty to one hundred guests. There was also a strict policy of requiring guests to attend in drag. Partygoers not in drag were asked to don drag-wear from the "box of misfit bras," a box near the entrance that contained various types of clothing and women's wigs, or immediately leave the party. Indeed, this policy of what counts as drag constitutes part of my analysis given various party organizers and attendees often had varying ideas of what doing drag entailed.

My interlocutors were the organizers of the party, Tom, Danny, and eventually Nina, as well as the attendees of the Twerk It & Werk It parties I attended. Save for myself and two guests I brought with me from Germany and Amsterdam in

2016, all partygoers were Dutch and lived somewhere in the Netherlands. Many lived in Utrecht directly, though several traveled from as far as Groningen in the northern part of the country.[3]

Being friends with Tom and Danny, I was lucky enough to gain access to the party, as well as permission to write on what I observed in academic venues. Accordingly, this chapter is based on ethnographic research conducted at two of the four Twerk It & Werk It parties, the 2013 and 2016 iterations. Most of my data is drawn directly from conversations had and observations made at these parties, though several interviews were conducted via Skype either preceding or following the parties. Where my field notes are sparse, I supplement data with narrative interviews from partygoers and organizers. For the parties in 2014 and 2015, I relied on retellings of the night and interviews with the organizers to inform my understanding of those years' events. Nevertheless, I will not speak to those installments with any sort of ethnographic authority and will instead rely on the field notes and observations I have in order to present my analysis.

Using the data I have, I aim to make a nuanced argument centered on three ethnographic vignettes. Each of these tales speaks to the complicated manner in which Twerk It & Werk It attendees and organizers draw on and reject *RPDR* when crafting their drag personas and shaping this particular drag scene. Despite the rather broad title of this chapter, my intent is not to speak authoritatively to all instances of underground drag parties or to generalize beyond the context of Twerk It & Werk It. Instead, by speaking to this specific instance of *RPDR*'s multiplicitous impact on a particular drag party and its connected scene, I highlight how popular discourse surrounding *RPDR* as either malevolently homonormative or righteously queer and transgressive through its "mainstreaming" of drag founders on an unnecessary binary. As is often the case, and as Sally Falk-Moore (1978) reminds us, reality is a fair deal messier than we would like it to be; the same can be said for this network of drag performers and friends.

On Globalizing Forces and Aesthetic Formations

To understand the impact of an American reality TV show on the drag party of a group of queer Dutch people, it is important to first speak to my underlying understanding of globalization. Combining a nuanced view of what identity-making processes are with an equally nuanced depiction of what said processes do in a globalizing world, Geschiere and Meyer's (1998) insights on globalization and identity guide my own understanding of how the Twerk It & Werk It scene works to draw on *RPDR* while simultaneously stabilizing their own group identity. Geschiere and Meyer are quick to point out that

globalization is not only about flows but also entails constant efforts towards closure and fixing at all levels [...] it raises important questions about [...] how attempts are made to maintain the illusion that the world does indeed consist of "nameable groups," bound to certain territories from time immemorial. (614)

Their depiction of globalization as a flow that influences attempts to bound off groups within the world and maintain a reality that such bounded groups are tied to particular territories and geographies is significant for this work because of the repeated disavowal of *RPDR* as inspiration on the part of Twerk It & Werk It partygoers and organizers, despite the party's roots in its organizers' exposure to the show. Tom and Danny came to the idea of hosting a drag party only after watching season five of *RPDR*, and yet they felt the need to distinguish their event from *RPDR*'s depiction of drag, most notably in the inclusion of drag kings. Accordingly, attempts to fix the group's identity to a form of Utrechtian drag and close said scene off from outside influences such as *RPDR* were and are present in the language and actions of Twerk It & Werk It's organizers as relates to the party.

Utrecht's queer nightlife scene is smaller than one might expect, yet simultaneously well-renowned. The city's first gay bar, De Roze Wolk, opened in 1982 (Dercksen 2018). As opposed to gay bars in New York City or Berlin, which often implement "men only" entrance policies, De Roze Wolk was open and welcoming of both men and women (Dercksen 2018). In 1969, concurrent with the Stonewall riots in New York City and well before the now-shuttered De Roze Wolk's opening, PANN was founded as an LGBTQ+ student collective in Utrecht. Five of the collective's students took to hosting a sort of "protest party," itself named PANN, which grew to become one of the largest queer parties in the Netherlands with iterations now hosted across the country. Similar to De Roze Wolk, PANN was deliberately open to being a space welcoming of gay men and lesbian women. Indeed, with one notable exception,[4] every gay bar and queer party in Utrecht I have participated in or heard of has had a relatively even distribution of men and women, while also welcoming those outside of the gender binary. Given the history of Utrecht's queer nightlife scene as one relatively open to people of all genders, it is not surprising that my interlocutors pointed in part to Twerk It & Werk It's Utrechtian context to explain why the thought never crossed their mind to exclude drag kings.

It is also worth noting that Utrecht lacks a formal drag scene akin to Amsterdam's relatively young yet profligate scene with its annual drag queen only "Superball," where the city's drag houses compete against one another for trophies, crowns, and fame (cf. Daniels 2008). In fact, though Utrechtian drag performers attend nearly every queer party or LGBTQ+ bar and there are a number

of well-known drag queens, such as Salem Reed, there are no formal drag houses or regularly scheduled drag performances.

Against the backdrop of Utrecht's LGBTQ+ nightlife, Twerk It & Werk It appears indeed to be a uniquely Utrechtian form of a drag scene given its beginnings as a party organized by a small collective of friends open to both drag queens and kings. That said, it is not only due to its location in Utrecht that the scene has come to exist as such. Instead of further attempting to fix and close a particular scene's identity to its geographic location, I understand the scene's engagement with *RPDR* and other drag influences through the lens of what Birgit Meyer terms "aesthetic formations," a holistic expansion of Anderson's notion of "imagined communities" that is rooted in "the role played by things, media, and the body in actual processes of community making" (2010, 6). Moving beyond nationality and strictly delineated group identities, this concept allows us to see communities as existing in their enactment. That is to say, Twerk It & Werk It comes to exist in part by the act of the party occurring and partygoers engaging in said party. While Tom and Danny's work in organizing the party was central to it happening, what constitutes this particular scene and its relationship with outside media forces such as *RPDR* lies also in the particular actions of all partygoers in attendance, as well as those connected to the scene who choose not to attend.

In utilizing an analytical lens based on an understanding of globalization as an attempt to fix messy realities into bounded identities along with Meyer's holistic notion of community-making, I am better able to speak to the multifaceted manner in which *RPDR* impacts Twerk It & Werk It as a drag scene and thereby as community.

On RuPaul's Drag Race *as Homonormative or Radically Queer*

While questions surrounding drag queens as emblematic of performative identity and as heralds of queer culture have been addressed by earlier authors (cf. Butler 1990; Newton 1979), it is only recently that *RPDR* has captured academic attention. From intersectional analyses of *RPDR* such as Jenkins's (2013) or Brennan and Gudelunas's (2017) edited volume on *RPDR* as shifting the visibility of drag culture, several authors have pointed to *RPDR* as being at the core of shifting ideals related to drag performances and cultures.

Early authors writing on *RPDR* include Edgar (2011), Goldmark (2013), and Jenkins (2013), who each analyze earlier seasons of *RPDR* and find it problematically hegemonic in its singular idea of drag as feminine, white, and wealthy. Jenkins in particular notes that *RPDR* polices drag styles outside of these specifically feminine norms and describes how such drag is often derided on the show.

More recently, Collins (2017) has noted that such policing appears to be softening and more recent seasons such as season ten and *All Stars* season four certainly appear to be more accepting of drag outside of the bounds. Nevertheless, in direct contrast to *Dragula*, another drag reality TV show focused on the nebulously undefined "monstrous drag," a recent episode of *RPDR*'s season eleven challenged show participants to participate in a "Monster Ball" where the winner of the episode was notably lacking horror or monstrosity in her costumery, but instead embodied traditional beauty ideals of whiteness and femininity. It seems, then, that far from embracing a broad array of acceptable drag, the show remains rooted in a narrow vision of what kinds of bodies should participate in drag and what said drag should look like. Even ignoring the lack of drag kings on the series, norms related to drag queen performativities remain, in contrast to Collins's (2017) aspirational argument, rather narrow. It is in this narrow definition of drag that my analysis of Twerk It & Werk It begins.

On Defining Drag: "Boys will be girls, girls will be boys"

It is March of 2013, and I have just landed at Amsterdam Schiphol airport, jetlagged but exhilarated to be seeing Tom again while also a bit nervous as to what doing drag alongside a small number of friends and fifteen strangers will be like. Wearing a brightly colored T-shirt that makes me stand out in the sea of muted color tones that were popular in the Netherlands of the time, I ask my blue-skinny-jean-wearing friend the following, "So, Tom, I know the invite states that drag is mandatory but what exactly are you planning to wear?" As the bright blue and yellow painted train from Schiphol slowly carries us through gray and rainy weather on our way back to Tom's apartment in Utrecht, he answers, "Ah, you know, obviously heels are necessary. I think we'll go classic drag and require boobs, makeup, wigs, heels. Pantyhose will also be a requirement if you're not shaving your legs. Shaved armpits are a must, though, even for Burly Legal[5] who's already a bit trashy." As I begin to doze off, the jetlag and swaying of the train hitting me hard, I ruminate on these standards of drag, not thinking much of them save that I would likely be making use of pantyhose for the sake of time and comfort on the plane ride home in under a week.

A few days later, in a sea of "shake-n-go" wigs, make-up done by a professional make-up artist testing out his drag make-up skills for the first time, and the mandatory accoutrements Tom had described earlier, several drag queens are assembled in a relatively empty apartment on the outskirts of Utrecht, dancing to Rita Ora's "How We Do" alongside several notable exceptions to *RPDR*'s limited range of acceptable drag performance types: drag kings. Sporting facial hair, bulges, leather

pants, suit jackets, and a creative assortment of "menswear," the kings attending the party highlight an important break from *RPDR* norms on the part of Twerk It & Werk It: including drag kings at all. At first accepting their presence at face value, it was only later during an interview when asking Tom about how the party differs from other drag scenes that he pointed out this important distinction, noting, "Well in contrast to Amsterdam and other gay cities, Utrecht is a pretty evenly divided scene. We've got 50 percent lesbians and 50 percent gays and we're all present in each other's spaces. We're all friends so of course drag kings were also going to be present at Twerk It & Werk It. That was never a question."

Though open to drag kings attending, there still remains a strong gender binary in Twerk It & Werk It's underlying architecture, as hinted at by Tom's mention of "lesbians and gays." This imagined audience was reflected in the 2015 and 2016 installments' invitations, which noted, "Boys will be girls. Girls will be boys. Heels (♂) or bulges (♀) are mandatory as well as your very own drag-name." The conundrum of how what Butler (1990) describes as a blatant demonstration of gender as performance remains rigidly tied to a gender binary in this party is not lost on me and was a site of resistance at the 2016 party.

It is September of 2016; it is also my birthday and I am excited about the night ahead: another iteration of Twerk It & Werk It, this time at its new location in the heart of old-city Utrecht. Having recently moved to Amsterdam, I, as Prinzessin Augustina,[6] am gathered with the three drag guests I'll be bringing to this year's party: Lorenzo, Mizz Thang, and Stevie. While Lorenzo has donned perfectly shaded facial hair and a three-piece suit in honor of his Italian heritage, Mizz Thang is still adjusting her blonde wig and applying neon pink lipstick while Stevie continues to question their place at the party.

"Augustina, are you sure this outfit is allowed?" Stevie asks as they motion awkwardly with sweeping hands up and down their body while seated. Wearing skin-tight black jeans and a flowy black blouse alongside fiercely tall black-suede heels, Stevie is in the middle of having a smoky eye added to their face by Lorenzo as they once again broach the subject of their interpretation of drag for the evening. "You have heels, you're fine," I answer as I continue to contour my face. "Don't worry Stevie, we'll back you up if they say anything, which they won't because Augustina is technically an organizer, too, and it's her birthday," Mizz Thang shouts from the bathroom. This brief dismissal of any questioning about whether Stevie's more genderqueer drag stylings have a place at the party is quickly forgotten as we begin discussing train schedules and timing to get to Utrecht instead. With long acrylic nails, layer upon layer of makeup and their hair done in a style each of the rest of us from Amsterdam is sure we have seen on a Paris fashion week runway, Stevie arrives with the rest of us at the 2016 Twerk It & Werk It. Burly and Kitty are guarding the entrance to the party in a slightly tipsy state of

joviality and, notably, say nothing about Stevie's choice of drag save to welcome "our guests from America to our humble drag gathering."

It is only upon entering the party that Stevie, and the rest of our group, notice the large amount of drag attendees located nowhere neatly along the gender binary. The only challenge to Stevie's drag comes from a rather drunk longtime attendee and drag king, Noah, who ultimately apologizes to Stevie of his own volition saying, "I'm so sorry I critiqued you. I didn't see your makeup, just your jeans and it's dark, so sorry. You look fierce." Indeed, Stevie was not alone in eschewing "high-feminine" drag. In part because of the location and the lack of air-conditioning in Dutch homes, several attendees opted for cooler drag outfits consisting of T-shirts and open pants. By the end of the night, only two partygoers had kept their wigs on and the winner of the annual lip-sync extravaganza had removed her wig during her performance. Acceptable forms of drag for entering and staying at the party had changed since 2013, and it seems that policing of acceptable drag, though threatened in the invitation, was unlikely to occur.

This shift in acceptable forms of drag at Twerk It & Werk It, from rigidly "feminine" clothing and wigs for drag queens, as well as facial hair and bulges for drag kings being mandatory to a more open interpretation of drag as gender bending performances, came at a time in *RPDR*'s timeline when feminine drag was still the ultimate ideal. Indeed, though Collins (2017) notes that *RPDR* began in 2016 to address issues of class openly, discussions of drag king contestants, as well as non-binary or trans contestants participating, were noticeably missing. Stevie's more genderqueer aesthetic had only just arrived to the show through Milk on season seven and would not be celebrated by the judges until season nine in 2017.

While deceptively open to interpretation on several points, most notably outfit, Tom's initial description of drag spoke to the limited definition of drag that *RPDR* supported at the time of the party's beginnings as evidenced by season five's critique of contestant Alaska's "boy drag" in a challenge and season four's rejection of Milan's more genderqueer stylings (cf. Jenkins 2013). Having founded the party as equal parts birthday celebration and exploratory drag scene, Tom and Danny, the other co-organizer until Nina (aka Noah) joined the team in 2016, began with a relatively narrow view of what drag might entail, even mentioning that their inspiration was drawn in part from queens on the show. While Tom would later recount that "part of why we began Twerk It was because we wanted to see what each other might look like in drag," what drag initially meant has changed through the years. What remained, however, was the safety of a space in which partygoers were invited to experiment with drag in its various forms.

"Key to making the party successful is the mandate that everyone *must* come in drag," a pixelated image of Tom relays to me during a Skype interview following the 2015 installment of Twerk It & Werk It. "It is a bit uncomfortable at first, you

know? You're becoming someone else, well, a shimmer of someone else to start. But because everyone is in drag, that's what makes it special and so much fun." This rule, that all partygoers are to be in drag, is at the core of Twerk It & Werk It's identity as an underground drag party. It is also why so many of its attendees participate in the party, with several telling me that they were only "courageous enough" to try drag because they knew everyone else at the party would also be in drag.

Though being in drag is mandatory to attend Twerk It & Werk It, what has changed is what the term "drag" means to this scene. Originally a neatly bounded, high-feminine or high-masculine form of gender performance art, the relaxing of definitions of drag as reducible to the (still problematically binary) division of "heels (♂) or bulges (♀)" allowed partygoers at the 2016 edition of the party to experiment with gender performance in manners other than the traditionally drag-queen exclusive, "high feminine" form of drag performance that *RPDR* depicts. The large number of drag king attendees alone speaks to the ways in which this Dutch scene, rooted in a city known for tearing down boundaries between queer groupings such as gays and lesbians, chose to simply ignore particular norms as broadcast by *RPDR*. Drag kings were welcome at Twerk It & Werk It. So, too, were genderqueer drag performers such as Stevie, people that refuse to be neatly boxed into the drag queen or drag king categories that *RPDR* seems to mandate.

On Ceasing to Exist: *"We were being mainstreamed, no one wanted that"*

The 2016 party is coming to a close; it is nearly three in the morning. Exhausted and partially wigless, my companions and I from Amsterdam are among the fifteen remaining guests. Mizz Thang has lost most of her clothing since arriving at the party, though her platinum blonde wig remains securely fastened to her head. Lorenzo looks as if he's about to fall asleep standing up, having proven he is quite the fierce drag king dancer. Stevie is cheery, heels still on, outfit still perfectly composed. They annoy most of the rest of the guests with their composure at such a late hour. All throughout the square-shaped room with windows overlooking the canal, wigs are strewn about as the crowd has thinned. Faintly playing in the background is a mash-up of Carly Rae Jepsen's "Call Me Maybe" and RuPaul's "Sissy That Walk." As I stand in front of the window to cool down, I realize why a few moments prior Noah, whose town home the party is in, hurriedly shushed those of us remaining while instructing the DJ to quiet the music. It seems we have new guests, four of them in fact—strikingly beautiful with chiseled jawlines and sleek, tight-fitting black outfits. Lorenzo, Mizz Thang, and I gawk a bit at the guests arriving so late until one turns around and we notice the bright

neon "Politie" emblazoned on the back of her vest. It seems these are not late arrivals, but in fact the local police force here to investigate "music loud enough to be heard throughout the entire city." A bit of *polderen*[7] follows as Noah, Burly Legal, and Kitty Krystal[8] quietly discuss consequences with the officers, who are barely maintaining their own composure as they grin at the bedraggled crowd of remaining drag performers. Once discussion concludes, the police depart and the trio of organizers announces to those of us remaining, "Party is over. It was a lovely gala, we shall see you next year!" Already looking forward to the 2017 Twerk It & Werk It, my guests and I depart for the late-night train back to Amsterdam.

Much to our dismay, the 2017 Twerk It & Werk It party never happened. No invitation was sent out. The year 2017 came and went without word from the organizers or any mention of the party among the group of friends and acquaintances across various social media platforms or in in-person conversations for which I was present. A bit distracted by finishing my master's program, it was only once 2018 rolled around and I began to look back on my data from Twerk It & Werk It that I realized it had gone on an unannounced hiatus. In a follow-up interview with Tom later that year, I asked about why the party had taken a break and if there were any plans for it to return.

ME: So, could you speak to the end of Twerk It & Werk It? I wasn't around for any of the conversations about that, or rather I didn't hear anything. It just never happened again.

T: Really? I could have sworn we included you in those discussions. It was mostly just Danny and me talking, along with Nina. It turns out the change in location from 2015 to 2016 really impacted the feel of the party and while 2016 was great, you saw how it ended. At Louwenrecht, we didn't have to worry as much about noise, there was more space. Nina's, that was Noah's, place is spacious but it was in the heart of the city and that caused noise complaints. She was warned not to ever throw such an event again or she might be evicted.

ME: Oh wow, that definitely wasn't clear that night.

T: No, it wasn't clear to her either. But that's only one dimension. So the first time the party was really experimental, remember? But then with the 3rd and 4th times we began moving beyond experimental and opening the party up. We had professional hairdressers, makeup artists, people came from Groningen and it was the Groningen crowd that started to invite their own friends, people we didn't know at all. It got really big and so we talked and it became a matter of either give in to the pressure to commercialize, you know make it a real official party, or reduce to a smaller, more intimate crowd again.

ME: So preserving the underground of this underground drag party?

T: Exactly. It's very important that everyone come in drag. That is key to making the event safe and welcoming. If we were to commercialize, how do you force paying club-goers to be in drag? It seems difficult and having run a party, I don't want to necessarily run this one.

ME: You don't think that would work? Mainstreaming?

T: Well this is a safe space for experimentation with gender and drag, trying it out for the first time or again. Some people are incredibly averse to that, like Kyle (a mutual friend of ours). He never comes because he doesn't want to do drag. There was just this pressure to go big or reduce and instead of choosing either option, it's on a break. Maybe it will come back, we'll see.

This interview with Tom reveals another manner in which Twerk It & Werk It, initially inspired by *RPDR*, opted to eschew *RPDR* norms by foregoing "mainstreaming" of a drag event when the moment that was possible arrived.

Having grown from a small event with a limited definition of acceptable drag into a large enough event to draw police attention with a wide variety of drag styles, including genderqueer performers such as Stevie, the decision to place the party on hiatus, and in a sense freeze its drag scene, was recounted by the other organizers involved as a difficult one. While the party was fun, they noted that it was just as important they keep it *gezellig*[9] and a "safe space."

Equally as important to their vision of this underground drag party scene was the mandate that attendees perform drag in some form or fashion. While acceptable forms of drag changed throughout the years in ways notably different from *RPDR*'s standards and norms, drag was still central to this party and to the scene that came to exist around it. Unlike *RPDR*, which is often viewed and consumed by spectators out of drag, the organizers felt strongly that no one was to critique drag without first participating in drag.

According to Tom, to mainstream the party would mean one of two things: either the commercialized party would face critical failure because "few people would want to pay to participate in a party where drag is mandatory" or the organizers would have to relax their rules on drag and allow people to come out of drag. Noting one of RuPaul's many catchphrases, Stevie later reflected on this decision in noting, "Well it makes sense in a way. We're all born naked and the rest is drag, sure. But also drag is more than coming in boy-drag. Even my form of drag is more than that."

As it stands, Twerk It & Werk It is dormant. A success for its four years of running, the organizers are adamant that they do not want to go commercial nor do they want to selectively invite guests from among those who have already attended. In this way, what was originally an experimental form of engagement sparked by RuPaul's own

experiment to launch a reality TV show featuring drag queens at its core diverged from *RPDR*'s norms as they regard making money. The organizers were not interested in any attempt to commercialize. This is partially due to fears surrounding success, but another significant factor was their apprehension regarding the way in which commercializing this underground party would alter the nature of the party itself.

The organizers of Twerk It & Werk It did not purposefully choose to shutter the party's doors and reject offers to mainstream their annual drag gala so as to react in concert with critiques recently lobbied against *RPDR* as having sold-out or gone too mainstream by switching to the larger TV network VH1. Nevertheless, the timing of this shift is significant in that it reflects the indeterminacy behind such a drag party or any similar social gathering. Though annual and advertised as such, there is always the potential for the next event in a series simply not to occur. The organizers could have chosen to follow the norms as prescribed by *RPDR*, to mainstream and profit from drag. Instead, they chose not to so as to maintain the party's core identity as a site of experimental, *gezellig*, drag performances.

On Potentialities and Indeterminacy: "We were *never* RuPaul's Drag Race"

Tracing various aspects of Twerk It & Werk It from its nascence in 2013 to its closure in 2016, I have attempted to shed light on the nuanced way in which one group of friends began an underground drag party inspired by *RPDR* but ultimately diverged from *RPDR*'s relatively strict norms and standards for what is permissible within drag spaces through the aesthetic formation of their drag party.

The party began with strict norms of drag queen permissible outfits and required accouterments but immediately eschewed *RPDR*'s norm of excluding drag king contestants in a drag performance reality TV show. While never explicitly citing *RPDR* as the source of their initial definition of drag, Tom, Danny, and other partygoers noted how particular *RPDR* queens inspired their looks. Ultimately, though, Twerk It & Werk It also came to celebrate non-binary-based forms of drag such as Stevie's at a much earlier point in time than *RPDR*, which still remains focused on what have come to be "traditional" forms of drag performances akin to those seen in *Paris Is Burning*. Whereas the performers showcased in *Paris Is Burning* were primarily young gay and queer people of color from East Harlem and the Bronx, whose only means to access mainstream white society was through drag and drag balls, their style of drag as mainstreamed through *RPDR* has come to reify the superiority of white mainstream culture through its glorification of traditionally white and feminine forms of drag performances. Accordingly, while the ball scene of the 1990s was undeniably queer, its mainstreaming

in the present century is only questionably so. In breaking with these norms in their party, Tom and Danny disavowed what increasingly appears to be a globally intertwined "third culture" of drag performance, that is, a transnational "conduit [...] of diverse cultural flows which cannot be merely understood as the product of bilateral exchanges between nation-states" (Featherstone 1990, 1). Simultaneously, they established and fixed their own notion of what Utrechtian drag ought to be. The organizers also diverged from *RPDR* in another significant manner when, by opting not to go mainstream and attempt to profit from their party, they distanced themselves from *RPDR*'s goal of profiting from drag.

Throughout the lifespan of Twerk It & Werk It, partygoers and organizers participated in a process of community-making that was sparked to life by *RPDR* and the "*Drag Race* Baby Boom" but not determined by it. While discussing media, it is easy to paint with a broad brush how said media forms impact particular societal groups, such as the community behind Twerk It & Werk It. Though *RPDR* is partly, if not primarily, responsible for Twerk It & Werk It's existence, each of the actors involved in enacting the "aesthetic formation" of Twerk It & Werk It brought their own understanding of drag with them. Shaped by *RPDR*, it would be easy to conclude that Twerk It & Werk It is just another explorative drag scene rooted in *RPDR*. By instead focusing on fissures between this party and *RPDR*'s norms, I have pointed to the indeterminacy underlying social life and organization more broadly, as well as how the "*Drag Race* Baby Boom" can give rise to drag scenes that move beyond the show's limited definition of acceptable and praiseworthy drag performance. *RPDR* does not dictate what drag is by virtue of its existence and popularity. It does, however, influence and shape trends within globalizing notions of drag performance through its success and widespread recognition. In exposing both me and my interlocutors to the idea of drag, *RPDR* not only pushed me to experience drag, but also sparked a fledgling drag scene in Utrecht in the form of Twerk It & Werk It. Inspired by *RPDR*, but not determined by it, Twerk It & Werk It demonstrates that analyzing the impact of this media phenomenon through a nuanced lens better allows us to understand reality as the indeterminate and contingent mess that it often is.

NOTES

1. Carnival is a holiday celebrated in advance of Lent. In the Netherlands, it often involves raucous partying, public drinking, and costumery. It is not celebrated in Amsterdam or Utrecht, but rather in the southern parts of the country, including Breda and Eindhoven. Nevertheless, Carnival Costume shops abound across the entire country.
2. There is much that could be said about the party's name and its origins. Perhaps surprisingly, the organizers never expounded on the name in any of our interviews and often appeared

3. It is worth noting that to travel from Groningen to Utrecht is, by Dutch standards, a grand adventure. Despite this and in part because these attendees were also close friends of Tom's, they were one of the most committed groups of participants and were present for every installment of Twerk It & Werk It.
4. Following the closing of De Roze Wolk in 2006, a leather bar named Bodytalk opened. This bar enforced a strict "men only" policy that has since been revoked in light of the bar's attempts to draw in more LGBTQ+ students.
5. Burly Legal is Tom's drag self. She is a "mix of Ke$ha, Brooke Candy, that trashy girl who loves to party, you know?"
6. Augustina is my drag self, a member of an insignificant aristocratic family of former German royalty.
7. A time-honored Dutch tradition, *polderen* occurs at many unofficial and unpermitted house parties or open-air parties. When police show up, the organizers of the event present themselves to the officers and a round of discussion about how to close down the party in as socially amenable (*gezellig*) a manner as possible takes place. An agreement is reached and both parties abide by the agreement. If the offending party does not, they are fined. I have never witnessed a party being shut down where *polderen* did not occur, nor have I ever witnessed the offending party (often due to noise) not abide by their part of the agreement.
8. Kitty is Danny's drag self, a catsuit-wearing, bedazzled party girl.
9. The Dutch concept of *gezellig* is one that does not translate well. It is the feeling of community, a sort of Durkheimian "collective effervescence" in smaller, more casual form (cf. 1912/1995). For a more in-depth discussion of the concept, see Lindemann (2009).

REFERENCES

Brennan, Niall, and David Gudelunas. 2017. *RuPaul's Drag Race and the Shifting Visibility of Drag Culture*. Cham, Switzerland: Palgrave Macmillan.

Butler, Judith. 1990. *Gender Trouble*. London: Routledge.

Collins, Cory. 2017. "Drag Race to the Bottom? Updated Notes on the Aesthetic and Political Economy of *RuPaul's Drag Race*." *TSQ: Transgender Studies Quarterly* 4 (1): 128–34.

Daniels, Christopher. 2008. *Girls Just Wanna Have Fun! An Examination of the Drag Queen Culture in Amsterdam*. Amsterdam: School for International Training.

Dercksen, Adrianne. 2018. *Roze Wolkennachten: Homodisco De Roze Wolk en homocafé De Wolkenkrabber in Utrecht 1982–2006*. Utrecht: Jan Scheepstra.

Durkheim, Emile. 1912/1995. *Elementary Forms of Religious Life*. Translated by Karen Fields. New York: Free Press.

Edgar, Eir-Anne. 2011. "*Xtravaganza!* Drag Representation and Articulation in *RuPaul's Drag Race*." *Studies in Popular Culture* 34 (1): 133–46.

Falk-Moore, Sally. 1978. *Law as Process*. Boston: Routledge and Kegan Paul.

Featherstone, Mike. 1990. "Global Culture: An Introduction." *Theory, Culture & Society* 7: 1–14.

Geschiere, Peter, and Birgit Meyer. 1998. "Globalization and Identity: Dialectics of Flow and Closure." *Development and Change* 29: 601–15.

Goldmark, Matthew. 2013. "National Drag: The Language of Inclusion in *RuPaul's Drag Race*." *GLQ* 21 (4): 501–20.

Jenkins, Sarah. 2013. "Hegemonic 'Realness'? An Intersectional Feminist Analysis of *RuPaul's Drag Race*." MA diss., Florida Atlantic University.

Lindemann, Hilde. 2009. "Autonomy, Beneficence, and *Gezelligheid*: Lessons in Moral Theory from the Dutch." *Hastings Center Report* 39 (5): 39–45.

Meyer, Birgit. 2010. *Aesthetic Formations: Media, Religion, and the Senses*. Houndmills, Basingstoke: Palgrave.

Newton, Esther. 1979. *Mother Camp: Female Impersonators in America*. Chicago: University of Chicago Press.

2

"Change the motherfucking world!": The Possibilities and Limitations of Activism in *RuPaul's Drag Race*

Ash Kinney d'Harcourt

In the 1993 Music Television Video Music Awards (MTV VMAs), a 32-year-old RuPaul copresented the Viewer's Choice Award alongside senior radio and television personality Milton Berle. The tension between the two on stage was palpable as RuPaul responded to Berle's scripted, homophobic dialogue with his own improvised barbs. When Berle feigned confusion about RuPaul's gender before complimenting his dress, RuPaul did not miss a beat: "You used to wear gowns and that's funny, now you wear diapers" (*MTV Video Music Awards*, MTV, September 2, 1993).

At the time, RuPaul had garnered enough popularity to appear on the media award show, but he was far from the venerated icon he is today, and his response to Berle received significant backlash in the entertainment press. In his autobiography, *Lettin It All Hang Out*, RuPaul (1995, 185) wrote about the damage his tiff with Berle inflicted on his carefully curated image as the Queen of Everybody Say "Love!" Elizabeth Schwew (2009, 675) notes that the mild, albeit pointed, insult by the drag celebrity continues to live on in popular culture websites as an "outrageous" moment, and more recently it continues to receive similar treatment as one of the top "shadiest" moments (Schillac 2016) and "craziest beefs" (Rosenthal 2015) in the history of the MTV VMAs. At the time the emasculation of America's beloved Uncle Miltie by a gay black man in a dress did not sit well with the predominantly white middle-class viewership, critics, and the network's executive leadership. When discussing the incident in a recent interview, RuPaul

expresses regret for his remarks; he explains that Berle's assaultive behavior backstage had upset him; "I took it out on the stage," and he further admonishes himself, "which is not a good thing" ("Erika Jayne and RuPaul" 2018). Schwew rightly points out how RuPaul glosses over the underlying structures of racism and heteronormativity that informed Berle's behavior and the subsequent public response in his framing of these events in specific personal terms. For example, he calls attention to the fact that Berle most likely would not have treated white and heterosexual supermodel Cindy Crawford in the same manner as he did RuPaul backstage.

RuPaul's public framing of the event as an individual encounter in lieu of explicitly naming Berle's racism and homophobia is analogous to what Ralina Joseph (2018, 21) calls strategic ambiguity, a performance enacted by women celebrities of color in order to avoid appearing aggressive or angry. Joseph describes this black feminist strategy as an attempt to resist racist and sexist ideologies by harnessing the rhetoric of a post-racial culture. Though not a woman, the damage to RuPaul's public image at the time corresponds with that inflicted by the stereotype of the "angry black woman" as described by bell hooks (1989, 12–13) in which black women are imagined as incapable of rational discourse and as attacking white people when identifying instances of inequity. Similarly, imagined queer violence is sometimes perceived as a threat, "the fantasy of unsanctioned eruptions of aggression from 'the wrong people, of the wrong skin, the wrong sexuality, the wrong gender,'" despite the fact that violence is usually carried out by straight, white men against minoritized people both in reality and in conventional media (Halberstam 1993, 199).

The enduring backlash to RuPaul's MTV VMA appearance illustrates the repercussions of "talking back" (hooks 1989, 9) to heterosexual, white America. RuPaul appears to have heeded the warning given in his early mainstream career, implementing its lessons in the co-crafting of World of Wonder's *RuPaul's Drag Race* (2009–present) as a palatable, relatively apolitical reality television series. While the show is notable for raising LGBTQ+ issues related to hate-violence and other forms of discrimination faced by the contestants in their day-to-day lives, it often fails to expand on them. Some individual drag stars from the show, however, have promoted awareness of queer issues through their activism off-screen, which they share in interviews, on social media, and at RuPaul's DragCon, an annual fan convention of drag culture launched by World of Wonder as an outgrowth of the successful series. Thus, despite the show's superficial approach to pressing social issues, it has nonetheless served as a catalyst in expanding queer (and specifically drag-themed) programming and broadening public discourse, its influence transcending the relative niche status of its cultural predecessors. This chapter explores the role of *RuPaul's Drag Race* in introducing this new discourse

and shifting norms both within drag communities and broader popular culture. Further, it offers a glimpse into the ways in which performers on the series conceive of drag as a political tool to imagine and create new modes of queer expression. In an effort to better understand how activism emerges in *RuPaul's Drag Race*, I first examine some of the key cultural and television industry contexts in which it was produced.

Historical Instances of Drag Activism

Judith Butler (1993, 125) has noted the potential for drag to be subversive "to the extent that it reflects on the imitative structure by which hegemonic gender is itself produced and disputes heterosexuality's claim on naturalness and originality." With its playful take on gendered stereotypes, drag challenges traditional constructs of gender, exposing unseen relationships between gender and power (Gamson and Grindstaff 2010, 253–54, 258). Moreover, to many of its participants, drag is more than simply a mode of performance; it is a grassroots social movement, making this art form a natural platform for political protest. As a drag performer, producer, and host of the reality competition series *RuPaul's Drag Race*, RuPaul (2011) articulates this connection in this ubiquitous expression: "Every time I bat my false eyelashes, it's a political statement." Although RuPaul implies his allegiance to the radical cultural history of drag in this quotation, the text of *RuPaul's Drag Race* is not as explicit—a fact that certainly helps account for its breakthrough mainstream success. This is not to say that the drag presented on the show is devoid of political meaning. Rather, the show adapts a fringe cultural practice for a broad audience, enacting a complex negotiation between a growing queer cultural visibility and the preservation of identities forged by historical marginalization. By harnessing the celebrity of its contestants and related peripheral media texts that have become an inseparable part of the contemporary reality television landscape, *RuPaul's Drag Race* becomes more than the sum of its tame, sometimes regressive, on-screen content.

A general history of drag's relationship to queer politics sheds light on the subversive potential of the art form, the performance of which has been described by scholars in terms of "boundary-disruptive tactics" and "protest episodes" (in Taylor, Rupp, and Gamson 2005, 111–13). Beyond its obvious push against the boundaries of societal gender norms, drag has contributed to shifting social discourse related to many queer issues. Beginning in the first half of the past century, drag balls in the United States created space for the formation of queer subcultures with "the role of the 'queen' as the symbolic embodiment of gay culture" (Chauncey 1994, 244, 291–99; Vogel 2009, 16–18). Drag balls and shows

continued to be a part of gay cultural events into the 1960s and became the impetus for several early protests of police harassment, including Compton's Cafeteria Riot in San Francisco in 1966 (Hillman 2011, 161). Though venerated by recent generations of queer activists seeking to build historical legacies and find role models, drag and transgender activists were shunned by early gay activist groups that sought acceptance from heteronormative society. Nonetheless, both played prominent roles in the gay rights protests throughout the 1960s in San Francisco, Los Angeles, and New York that culminated in the oft-commemorated Stonewall Riots of 1969 (Armstrong and Crage 2006, 744). Self-identified drag queens and transgender rights activists Marsha P. Johnson and Sylvia Rivera also organized the activist group Street Transvestite Action Revolutionaries in 1970 to support homeless queer youth in New York (Stryker 2008, 86–87).

Though drag has not consistently been used as a political tool in support of social causes, notable examples of drag activism by individuals and organizations manifest across a range of historical moments. For example, transfeminine performer and activist Sir Lady Java campaigned against workplace antiblack and homophobic discrimination in 1960s Los Angeles through drag performance and protests aimed at the Police Commission's criminalization of cross-dressing (Ellison 2017, 10). Around the same time, political activist and drag queen José Sarria, the Nightingale of Montgomery Street and later Empress José I, protested homophobic harassment in San Francisco through drag parody operas at the Black Cat Bar. Sarria additionally counseled gay bar patrons on how to avoid arrest during police raids and ran for city supervisor as the first openly gay candidate for public office in the United States (Miller 1995, 347), galvanizing a gay voting bloc in San Francisco. The International Imperial Court System, a charitable LGBTQ+ organization, and the annual pilgrimage that Sarria began as the Widow Norton persona are among the activist's legacies that continue to support and pay tribute to queer communities.

In the 1980s the "terrorist drag" of Vaginal Creme Davis helped to carve out a space for queer, punk communities of color in Los Angeles that felt they were "too gay for this new punk scene, but were too punk for the gay world" (This Is Not a Dream, June 3, 2017). In "The White to Be Angry," José E. Muñoz (1997, 91) explains how through humor and parody, Davis performs the "nation's internal terrors around race, gender, and sexuality," unsettling dominant heteronormativity and whiteness. Additionally, the Sisters of Perpetual Indulgence have staged political protest in San Francisco since the 1980s against the bigotry of the religious right through the use of Catholic imagery in drag. The organization is well known for its irreverent AIDS Coalition to Unleash Power (ACT-UP) protests staged in the 1990s to raise awareness about HIV/AIDS. Terrence Smith also brought the AIDS crisis and queer discrimination to the national forefront while running for

political office as drag queen Joan Jett Blakk in the presidential elections of 1992 (with the slogan "Lick Bush in '92!") and 1996 (Goodman 2018). While drag protest by the Sisters called attention to the hypocrisy of the Catholic Church, Smith's satirical political campaigns served to highlight the shortcomings and unfairness inherent in the US election process. Drag began to gain mainstream popularity at this time and again during the relatively more LGBT-friendly Obama administration. Alongside the growing popularity of *RuPaul's Drag Race* in the past decade, drag performance is more widely viewed in film, television, and new media with the potential to reach a wider audience than ever before.

Consequences of Commodification and Visibility

RuPaul's Drag Race provides a unique opportunity for drag performers and some members of the LGBTQ+ community to control their own representation for a popular audience, counteracting more prevalent depictions by cisgender straight men throughout cinema and television history seen in, for example, *To Wong Foo, Thanks for Everything, Julie Newmar* (1995) and NBC's *Will and Grace* (1998–2006; 2017–). However, this representation remains complicated by the commercial imperative of the television industry, whose interests are often in direct opposition to cultural risk-taking. When "gayness" became relatively trendier in the 1990s, this new media visibility simultaneously reproduced old stereotypes (seen in Sean Hayes's over-the top portrayal of the shallow and narcissistic Jack on *Will and Grace*) and created lasting restrictions on queer citizenship (Walters 2001, 12–13). Isabel Molina-Guzmán (2012, 138) observes that "citizenship in contemporary neoliberal society is intricately linked with the politics of cultural representation or the 'right to be represented.'" RuPaul has helped to define drag citizenship for mainstream audiences according to his current aesthetic; by 1990 the iconic drag queen had transitioned from the androgynous "gender fuck" style of performance (Kohlsdorf 2014, 71) to a more safely consumable "drag queen realness" with "tits—the lot" that conforms to gender binary discourses (RuPaul 1995, 107).

Eve Ng (2013, 258–59) observes how Logo TV's strategy of gaystreaming—marketing to queer as well as larger general audiences (e.g., heterosexual women who are commonly perceived to have shared affinities with gay men)—increases representation for some in the queer community, while marginalizing others. The limits in representation of queerness for straight consumption can be seen in *RuPaul's Drag Race*. Muñoz (1997, 85), for example, distinguishes between the drag performed in queer spaces of consumption such as Vaginal Davis's cross-sex, cross-race terrorist drag and the "commercial drag" meant to be enjoyable

as entertainment for mass audiences. The extent to which the commercialization of drag in *RuPaul's Drag Race* has homogenized drag culture has been noted by both critics and scholars. It is visible in, for example, the privileging of "glamour fish" queens with polished runway performances that emphasize high fashion, as noted by Lauri Norris (2014, 33–34), as well as the restrictions on body size noted by Amy Darnell and Ahoo Tabatabai (2017, 95–99). Contestants either adapt to these expectations of mainstream femininity or are eventually eliminated from the competition. Eir-Anne Edgar (2011, 133–34) further points out how the series normalizes drag performance and competition by requiring its contestants to "deploy stereotypical notions of femininity through performances of gendered norms."

In addition to the problematic portrayal of femininity on the series, the packaging of drag queens for consumption has contributed to the stereotyping of race (Jenkins 2017, 79–80; Morrison 2014, 139) and ethnicity (Anthony 2014, 50–51; McIntyre and Riggs 2017, 64), as well as to manifestations of transphobia (Norris 2014, 39–44; O'Halloran 2017, 222–24) and misogyny (Morrison 2014, 138–39). In earlier seasons, transgender contestants often waited until the season had ended to come out. The offensive "She-Male" segment on the series was eventually dropped after protest from the transgender community, though RuPaul continues to defend his use of the anti-transgender slur "tranny" and has voiced a preference to exclude trans women from the series (Reynolds 2018). The denigration of women's bodies in the language use and the exclusion of drag kings further reflects a troubling misogyny. This is likely reinforced by RuPaul's influential role on the series; he explains his personal view on the cultural work of men in drag, which he believes "has power, because we're not only mocking [the] synthetic version of a female, we're also mocking this revered idea of what masculinity is, because we're men." He further elaborates that "if a female were to do drag, it loses the irony" (Cider 2016). The suggestion that drag queens are more subversive than drag kings is puzzling since kinging—despite sometimes operating within different systems of humor and performance than in queening—nonetheless acts as "an assault on male privilege" (Halberstam 1997, 116–17); for a specific example, see the impersonation of President Trump by drag king Kristine Bellaluna aka Landon Cider.

Thus, cultural visibility on *RuPaul's Drag Race* is contradictory. On one hand, the series has made drag performance accessible to a more general audience; on the other, this representation of drag privileges stereotypical performances with which middle-class, white, and heterosexual audiences are more familiar and comfortable. What opportunities exist in this context for activism within the text? While remaining mindful of the limitations of the series described here, this chapter examines some of the ways in which *RuPaul's Drag Race* calls much needed attention

to the social and political issues relevant to queer communities by bringing the grassroots performance and activism of drag balls and bars in contact with the glossy, commercial production of the television series.

Clocking the Possibilities

Given the capitalist economy and culture in which drag performance is depicted on *RuPaul's Drag Race*, it is unlikely to be explicitly deployed as a political tool on the series. However, the show provides a space for contestation of the stereotypes, transphobia, and misogyny witnessed at times on the series. Indeed, there are moments of rupture in the highly cultivated production of the series. One way in which the series engages with political issues is through the selection of contestants, and in particular its season winners. By placing emphasis on the celebrity of the performers in the show and promotional materials, the producers invoke the star texts of the contestants. Richard Dyer (1998, 60–83, 106–17) describes a star's persona as the construction of a range of materials, including filmography and roles, unique qualities such as a particular look, voice, or certain skill, as well as the social and political context in which a star image is constructed. This is facilitated through the paratexts that accompany and create meaning in film and television texts, including trailers, merchandising, and most relevant to the current project, entertainment news, reviews, and other online discourse such as that generated on social media (Gray 2010, 4–11). Social media platforms in particular—inasmuch as we can glean from the performative disclosures on these platforms—allow for unprecedented access to celebrities' views and activities.

In addition, celebrities can act as symbols of important discursive structures in popular culture. For example, the work of drag queens reveals ways in which society negotiates changing gender, sexuality, and racial norms. The drag queens selected as season winners on the show are more heavily scrutinized than other contestants within this discourse both because they are in more episodes and because they are thought to represent the series during the season of their crowning. Each week, a contestant is eliminated through the subjective evaluation of a panel of judges, with RuPaul ostensibly having the final say. Since there is no objective performance measure or mechanism for audience input, the message communicated to viewers is that the winner of the season is of RuPaul's choosing. Thus, while *RuPaul's Drag Race* does not always articulate a progressive politics, the series can be seen to tacitly endorse the personal politics and political activism of its season winners.

The series indirectly highlights LGBTQ+ and broader political causes by engendering discourse by the series contestants off-screen as well. This was

particularly the case during the two seasons produced in the historical moment of the election of Donald Trump and Mike Pence as president and vice president, which set a decidedly pessimistic tone about the status of LGBTQ+ communities in the United States. As with many oppressed communities, the election of Trump reminded queer communities of the importance of defending civil liberties, which was reflected in recent DragCon panels, including "The Art of Resistance" and "What Is Drag in Trump's America?" (St. James 2017a). Drag performers have spoken out against the Trump presidency through social media and other means as well. Prior to the election, season five contestant Alaska Thunderfuck shared a video of herself beating a Trump piñata amid declarations of "Barack Obama *was* born in the United States!" and "Global. Warming. Is. *Real*!" (St. James 2016). Similarly, while progressive talking heads condemned Kathy Griffin's performance art with a bloody Trump mask after the election, *RuPaul's Drag Race* season four winner, Sharon Needles, reenacted the event on stage at a bar in Pittsburgh to the Yeah Yeah Yeah's song "Heads Will Roll" (St. James 2017b).

Bob the Drag Queen and Sasha Velour, the season winners leading up to and immediately after the last presidential election, were portrayed as activists through the series' unscripted dialogue, confessional reveals, and other performances on the show. Their political voices were further developed through entertainment press, specifically in interviews, as well as via social media, which is explored in the next sections. The series is then intertextually linked to discourse that addresses issues inside the community, such as hate-violence, health, and eating disorders, as well as those in the broader national context, namely, the outcome of the 2016 presidential election. That said, the winner of the subsequent season, Aquaria, represented a return to glamour and high fashion on the series, while another contestant, The Vixen, contributed much of the contestation of the series' status quo during season ten. The following analysis traces the role of the series in expanding political discourse during three recent seasons (eight through ten) by examining the scripted and unscripted dialogue of the series and its contestants' star texts.

Season Eight

RuPaul's Drag Race conforms to the reality television genre that attempts to provide its viewership an "unmediated, voyeuristic, and yet often playful look into what might be called the 'entertaining real'" (Ouellette and Murray 2008, 5). Similar in structure to other reality talent contest shows, contestants on the series face increasingly elaborate challenges in each episode starting with a mini-challenge, a main challenge, a runway show challenge, and finally a lip-sync battle that ends with the elimination of a contestant. Mini-challenges have included events such as Bitchfest, in which the contestants mock each other's puppet

likeness, and Slap Out of It, in which contestants humorously "insult" RuPaul and receive a mock "slap" across the face. The main challenges demand a more significant performance by the contestants; for example, the Snatch Game—a parody of the 1960s show *Match Game*—and drag parodies of television series and celebrities such as *Real Housewives* and the Kardashians test the contestants' skills at celebrity impressions and improvisational comedy. These performances embody a camp sensibility described by Susan Sontag (1964, 53) as "the love of the unnatural: of artifice and exaggeration." As Richard Dyer (2002, 49) points out, camp has historically been associated with the culture of gay men. This sensibility factors strongly into the aesthetic of drag in which artists perform exaggerated stereotypes that trouble the naturalness of heteronormativity, though critics have begun to argue that camp's contemporary mainstreaming in media is eroding this political charge (reviewed in Glyn Davis 2004, 56).

Before the 2012 presidential election, the episode "Frock the Vote" in the fourth season featured the contestants' campy performances in a mock presidential debate that focused primarily on drag's place in America. Four years later, during the 2016 presidential election campaign, the show's eighth season expanded on this theme. In the seventh episode of the season, the main challenge faced by contestants was to create a mock ad campaign for drag president of the United States. This created the opportunity for several jabs directed at Trump's conservative base, including season winner Bob the Drag Queen's satirical plan for the country—"the gay agenda"—though such discourse is limited to mocking one-liners that are not further developed into political arguments or calls-to-action on the show.

This dialogue is, however, expanded through the star image of season eight winner, Bob the Drag Queen (known out of drag as Christopher Caldwell). The selection of Bob as winner, with her public image as activist, is a significant contrast with most of the previous seasons, in which the focus is typically on the performer's glamour, comedy, and camp performance. Bob shares her off-screen social activism through cutaway confessionals in the series, most notably in the seventh episode in which the drag queen recounts protesting for marriage equality in Times Square. Accompanying photos of Bob stopping traffic near Bryant Park in drag during these scenes legitimize this activism.

Details of the season winner's off-screen involvement in protest is further made available to viewers through intertextual connections to entertainment news and interviews of the star. Jonathan Gray (2010, 41) describes this interactivity between media texts: "Between the outward overflow and inward convergence of paratextuality, we see the beating heart of the text." Throughout its many seasons, fans and the wider audience of *RuPaul's Drag Race* engage with its stars off-screen through a number of channels: podcasts, fantasy leagues, entertainment and queer magazines, the stars' personal social media, DragCon, and the series'

lucrative spin-offs. Following these sources, fans can learn that Bob cites Sisters of the Perpetual Indulgence as inspiration for her activism (Raushenbush 2017) and has participated in drag performances with activist groups such as Drag Queen Wedding for Equality and Queer Rising (Allen 2016). In interviews, the performer describes her brand of drag comedy as social commentary and specifically names her opposition to homophobia and the contemporary resurgence of white supremacy (Fitzmaurice 2016), the latter made more significant by the fact that racism is infrequently addressed on the series itself. Bob also spoke in a panel on Trump's America at DragCon in 2017 where she asserted that drag and art more broadly become stronger forces in politically treacherous times and extended the conversation beyond LGBTQ+ specific concerns to broader partisan issues such as environmental protection (O'Keeffe 2017).

Season Nine

Season nine was released four months after the 2016 election, and some of the dialogue was more explicitly directed at the Trump administration. For example, informal banter was aimed at the administration when RuPaul himself derisively names the president in some improvised dialogue while interviewing the contestants, "What do you think is gonna be your trump card? Oh, did I say fuckin' Trump?" In the season finale, the host references the president's rotating roster of special prosecutors by saying, "Now take that to your special prosecutor and investigate it!" and later insults the president's intelligence with the jest, "Speak slow, because Donald Trump is watching and he wants to know [the answer]." These call-outs, however, are infrequent during the season and not overtly controversial given the series' fan demographic, namely, gay men and increasingly young women (Miz Cracker 2017). They also imply the series has a progressive politics, which is at odds with some of the less inclusive aspects of the series reviewed earlier, such as gender and racial stereotypes and the exclusion of both trans and assigned female at birth (AFAB) women.

Season nine's winner, Sasha Velour (Alexander Hedges Steinberg), is unusual in the series and not only in her more conceptual costume choices. Sasha participated in several conversations in the series backstage on topics such as childhood bullying, eating disorders, and the illegality of drag outside of the United States. The discourse on eating disorders in this season contrasts with just two seasons prior in which the crowned winner Violet Chachki's fully cinched 18-inch waist caused no controversy on-screen among the series' other contestants and the judges. As with Bob the Drag Queen, Sasha's personal politics are further explored off-screen. In interviews, Sasha is critical of conservatism, describing the current political moment as "anti-intellectual, anti-information, and anti-historical" (Nolfi

2017). She cofounded House of Velour, which produces a drag cabaret called *Nightgowns in Brooklyn*. The performer studied political art as a Fulbright Scholar in Moscow and speaks about drag explicitly as a form of queer activism: "writing new stories that put queer people at the forefront" in which "audiences are revolutionaries" who disseminate the ideas they witness in drag performance. In a video shared on YouTube by House of Velour (2017), Sasha elaborates on the political potential of drag as an art form:

> What drag does is it takes normative narratives—the songs that we hear around us every day, the imagery, the characters that we surround ourselves with—and it squeezes our fabulous little queer bodies into it. And that shifts the meaning of that culture, of those normative stories, of stories of love, of beauty […] Next Friday we are going to welcome a cabinet of white supremacists to control this country, taking what many queer and brown people have known for a long time […] that progress in this country has not been linear and that we are not done with the fight yet for it. And drag is a place where we can transform that fight into something beautiful and present. And the fight for beautiful and awakened, the future of drag we talk about all the time […] needs to be more than just a wink and a nudge that culture here is wrong. It needs to be actually radically imagining new types of beauty, radically reevaluating the world around us, and writing new stories—fresh stories—that put queer people right at the forefront.
> (House of Velour, January 21, 2017)

Sasha's privileged academic background and her relatively empowered position as a white performer in the drag scene contribute to her being given the opportunity to articulate these ideas, which echo those of feminist and queer studies scholar Suzanna Danuta Walters. Rather than simple inclusion, Walters (2001, 24) advocates a conscious integration of queer communities into society that is altered by "new (gay-inspired) ideas and constructs about fundamental social structures." The spectacle in season nine finale of Sasha revealing her trademark bald head under a vibrant auburn wig among a cascade of rose petals was a fitting nod to her understanding of drag as making the claim that beauty is everywhere, especially in the queer community. Sasha was crowned the season nine winner, and the show closed with her declaring that drag can "change the motherfucking world!" The triumphant spectacle was nevertheless fraught. Sasha's wigless, bald head calls to mind the show's exclusion of women—both trans and AFAB—on the show, reminding viewers of the series that although beauty can be found everywhere, *RuPaul's Drag Race* is still only interested in the beauty of gay men. After RuPaul's statement that the series would "probably not" accept transgender contestants in the future (Aitkenhead 2018), however, Sasha responded

in a drag performance by the House of Velour, which was recorded and shared on social media:

> Call me old-fashioned, but I refuse to celebrate drag without women. Somehow there continues to be a very oxymoronic debate about what qualifies as "real drag," so here is our official response: trans women, trans men, AFAB [...] and non binary performers, but especially trans women of color, have been doing drag for literal centuries and deserve to be equally represented and celebrated alongside cis men.
>
> (referenced in Weaver 2018)

While this point of view is not represented on-screen in *RuPaul's Drag Race*, Sasha's commentary on the misogyny and transphobia in drag communities in response to the series' exclusion of trans women is nonetheless intertextually linked to the series through her star text and related media.

Season Ten

The series returned to less politically partisan dialogue in season ten. In episode five, the mini-challenge required contestants to transform themselves into what RuPaul calls "an army of fierce drag queens." He alludes to the historical work of drag in support of gay rights; however, in making the challenge about military-inspired fashion, the show's rhetoric simply reaffirms the values of patriotism and consumerism much like Morrison (2014) describes in earlier seasons. In the Snatch Game, season ten winner Aquaria (Giovanni Palandrani) impersonates Melania Trump, another opportunity to bring political critique into the series. The performance, though humorous, mainly plays with the first lady's mannerisms such as her squinting and blinking eyes. One of the youngest queens to win during the series, Aquaria is referred to on the show by RuPaul as an "Instagram queen" and is known for her modeling and presence in the New York City club scene. Excited about the mainstreaming of drag through *RuPaul's Drag Race*, she envisions her drag legacy to be in fashion and design (Montero 2018) which makes for a star text that is strikingly dissimilar to both winners of the two previous seasons, Bob the Drag Queen and Sasha Velour.

In contrast, season ten contestant The Vixen (Anthony Taylor) was outspoken throughout the season about the racialization of drag and the inequities in the drag community that have grown around it. In the fourth episode, "The Last Ball on Earth" (2018), she refers to herself as a "firestarter" in the Chicago drag scene during a backstage discussion with RuPaul, and later in a confessional reveal in the same episode states: "My drag can definitely get political." In the seventh episode of the season before she was eliminated from the competition, The Vixen

asserts that "a lot of people say drag should only be an escape from reality, but drag can also help us face reality and deal with it" ("Snatch Game" 2018). She further identifies her struggles as both black and gay in the drag scene and more generally in the United States. Throughout the season The Vixen faced antagonism from the other season contestants and even RuPaul for being outspoken. Fellow contestant Asia O'Hara was more sympathetic to The Vixen's frustration with the privileging of white queens, though even she claimed in the season's eighth episode, "The Unauthorized Rusical" (2018), that The Vixen was "handling it the wrong way" and urged her to consider being less vocal on the series. In the tenth season's reunion episode The Vixen walked off set, refusing to engage with the rest of the season ten cast in the role of the "angry black woman" trope. In exiting the set, she rejected the cultural stereotype and reality television trope that she had anticipated in an earlier episode would be assigned to her—the same one that was ascribed to RuPaul after the 1993 MTV VMAs. Two and a half decades later, RuPaul condemns The Vixen's premature exit on the drag competition series as "bad behavior," explaining that he is able to comport himself respectfully and expects the same of The Vixen. The Vixen was not present for the rest of the episode to respond, but later retweeted a *Buzzfeed* article: "RuPaul Perpetuates the Myth That Black Progress Is Tied to White Acceptance." In the article, Connor Garel (2018) astutely observes the racial optics of that moment and the unwillingness of the show to address racism and racial stereotypes in drag culture. As in previous seasons, this example illustrates how discussions about social issues in drag culture that are started on the series can continue off-screen through online discourse in entertainment media and the contestants' social media.

Conclusion

Progressive and inclusive drag politics will always be precarious in the context of the contemporary television industry. The limitations of the series' potential for resistance becomes obvious in comparison with its stars' images and the discourse that continues off-screen. Still, there are moments of contestation in *RuPaul's Drag Race* in which individual drag performers explicitly name drag as a political act, share their progressive queer values, as well as expose the racial biases, misogyny, and transphobia in the series. References to the use of drag in political protest by Bob the Drag Queen in season eight and the discourse on eating disorders and the homogenization of beauty standards in the drag community in season nine are two examples; The Vixen's dissent and rejection of racial stereotyping in the season ten reunion episode is another. In these ways, the show provides a space where antinormative identities and voices—though limited by the

process of commodification—push back against patriarchal and racist elements of the current culture of reality television. As O'Halloran (2017, 218) suggests of the show's mainstream status and capitalist context, the series' "political potentiality is not *despite* these elements, but rather made possible *through* them [emphases in original]." In this space, the contestants are not permitted to perform an outright disruption of hegemonic norms, but some successfully create a dialogue between different drag values, even resisting RuPaul's embrace of more hegemonic norms through their own drag and personal identities.

In addition, the series' power and reach is greater than what is depicted on-screen through the voices and activities of its drag stars that are circulated in related media paratexts. The stardom and fandom that drag celebrities gain from their participation in the series provides an unprecedented opportunity for them to amplify the messages of more progressive queer politics and activism. Rupaul's DragCon is one platform for such discourse off-screen, for example, where fans not only learn performance and makeup tips, but listen to their favorite performers discuss the state of drag in the Trump era. Drag performers on the series also expand on their drag politics through online discourse, in particular through interviews and social media as demonstrated in the examples of Bob the Drag Queen, Sasha Velour, and The Vixen reviewed in this chapter. These drag performers have expressed their aspirations to see drag continue to develop as a political art form in support of LGBTQ+ and other political causes, as well as reimagine alternative modes of being beyond restrictive labels of gender, race, and sexuality in the series.

REFERENCES

Aitkenhead, Decca. 2018. "RuPaul: 'Drag is a Big F-You to Male-Dominated Culture.'" *Guardian*, March 3, 2018. https://www.theguardian.com/tv-and-radio/2018/mar/03/rupaul-drag-race-big-f-you-to-male-dominated-culture.

Allen, Timothy. 2016. "Bob the Drag Queen Recollects the Time She Was Thrown in Jail in Full Drag." *Queerty*, April 18, 2016. https://www.queerty.com/bob-the-drag-queen-recollects-the-time-she-was-thrown-in-jail-in-full-drag-20160418.

Anthony, Libby. 2014. "Dragging with an Accent: Linguistic Stereotypes, Language Barriers and Translingualism." In *The Makeup of RuPaul's Drag Race: Essays on the Queen of Reality Shows*, edited by Jim Daems, 49–66. Jefferson, NC: McFarland.

Armstrong, Elizabeth, and Suzanna Crage. 2006. "Movements and Memory: The Making of the Stonewall Myth." *American Sociological Review* 71 (5): 724–51.

Butler, Judith. 1993. *Bodies That Matter*. New York: Routledge.

Chauncey, George. 1994. *Gay in New York: Gender, Urban Culture, and the Making of the Gay Male World, 1890–1940*. New York: Basic Books.

Cider, Landon. 2016. "Dear Drag Race: It's Time to Let the Kings Compete." *Advocate*, September 1, 2016. https://www.advocate.com/television/2016/9/01/dear-drag-race-its-time-let-kings-compete.

Darnell, Amy L., and Ahoo Tabatabai. 2017. "The Werk That Remains: Drag and the Mining of the Idealized Female Form." In RuPaul's Drag Race *and the Shifting Visibility of Drag Culture: The Boundaries of Reality TV*, edited by Niall Brennan and David Gudelunas, 91–102. Cham, Switzerland: Palgrave Macmillan.

Davis, Glyn. 2004. "Camp and Queer and the New Queer Director: Case Study—Gregg Araki." In *New Queer Cinema: A Critical Reader*, edited by Michele Aaron, 53–67. New Brunswick, NJ: Rutgers University Press.

Dyer, Richard. 1998. *Stars*. London: British Film Institute.

———. 2002. *The Culture of Queers*. London: Routledge.

Edgar, Eir-Anne. 2011. "*Xtravaganza!*: Drag Representation and Articulation in *RuPaul's Drag Race*." *Studies in Popular Culture* 34 (1): 133–46.

Ellison, Treva. 2017. "The Labor of Werquing It: The Performance and Protest Strategies of Sir Lady Java." In *Trap Door: Cultural Production and the Politics of Visibility*, edited by Reina Gosset, Eric A. Stanley, and Johanna Burton, 1–22. Cambridge, MA: MIT Press.

Fitzmaurice, Larry. 2016. "Bob the Drag Queen Tells Us How to Fight Trump." *Vice*, November 16, 2016. https://www.vice.com/en_us/article/bn37g8/bob-the-drag-queen-tells-us-how-to-fight-trump.

Gamson, Joshua, and Laura Grindstaff. 2010. "Cheerleaders, Drag Kings, and the Rest of Us." In *Handbook of Cultural Sociology*, edited by John R. Hall, Laura Grindstaff, and Ming-chen Lo, 252–62. London: Routledge.

Garel, Connor. 2018. "RuPaul Perpetuates the Myth That Black Progress Is Tied to White Acceptance." *Buzzfeed*, July 5, 2018. https://www.buzzfeednews.com/article/connorgarel/rupauls-drag-race-the-vixen-eureka-respectability-politics.

Goodman, Elyssa. 2018. "Drag Herstory: The Drag Queen Who Ran for President in 1992." *them*, April 20, 2018. https://www.them.us/story/joan-jett-blakk-drag-queen-president.

Gray, Jonathan. 2010. *Show Sold Separately: Promos, Spoilers, and Other Media Paratexts*. New York: New York University Press.

Halberstam, Jack. 1993. "Imagined Violence/Queer Violence: Representation, Rage, and Resistance." *Social Text* no. 37 (Winter): 187–201. http://www.jstor.org/stable/466268.

———. 1997. "Mackdaddy, Superfly, Rapper: Gender, Race, and Masculinity in the Drag King Scene." *Social Text* no. 52/53 (Autumn–Winter): 104–31. https://www.jstor.org/stable/466736.

Hillman, Betty L. 2011. "'The most profoundly revolutionary act a homosexual can engage in': Drag and the Politics of Gender Presentation in the San Francisco Gay Liberation Movement, 1964–1972." *Journal of the History of Sexuality* 20 (1): 153–81. https://www.jstor.org/stable/40986358.

hooks, bell. 1989. *Talking Back: Thinking Feminist, Thinking Black*. Boston: South End.

House of Velour. "Sasha Velour on 'What Drag Does' | NIGHTGOWNS." YouTube video, 0:32. January 21, 2017. https://www.youtube.com/watch?v=TBARiMKa6ok.

Jenkins, Sarah Tucker. 2017. "Spicy. Exotic. Creature. Representations of Racial and Ethnic Minorities on *RuPaul's Drag Race*." In RuPaul's Drag Race *and the Shifting Visibility of Drag Culture: The Boundaries of Reality TV*, edited by Niall Brennan and David Gudelunas, 77–90. Cham, Switzerland: Palgrave Macmillan.

Joseph, Ralina L. 2018. *Postracial Resistance: Black Women, Media, and the Uses of Strategic Ambiguity*. New York: New York University Press.

Kohlsdorf, Kai. 2014. "Policing the Proper Queen Subject: *RuPaul's Drag Race* in the Neoliberal 'Post' Moment." In *The Makeup of* RuPaul's Drag Race: *Essays on the Queen of Reality Shows*, edited by Jim Daems, 67–87. Jefferson, NC: McFarland.

McIntyre, Joanna, and Damien W. Riggs. 2017. "North American Universalism in *RuPaul's Drag Race*: Stereotypes, Linguicism, and the Construction of 'Puerto Rican Queens.'" In RuPaul's Drag Race *and the Shifting Visibility of Drag Culture: The Boundaries of Reality TV*, edited by Niall Brennan and David Gudelunas, 61–76. Cham, Switzerland: Palgrave Macmillan.

Miller, Neil. 1995. *Out of the Past: Gay and Lesbian History from 1869 to the Present*. New York: Vintage Books.

Miz Cracker. 2017. "The Girls Who Love Queens: Drag's Biggest Audience May Soon be Young Women." *Slate*, January 9, 2017. https://slate.com/human-interest/2017/01/why-drag-queens-biggest-fans-are-increasingly-young-women.html.

Molina-Guzmán, Isabel. 2012. "Salma Hayek's Celebrity Activism: Constructing Race, Ethnicity, and Gender as Mainstream Global Commodities." In *Commodity Activism: Cultural Resistance in Neoliberal Times*, edited by Roopali Mukherjee and Sarah Banet-Weiser, 134–53. New York: New York University Press.

Montero, Roytel. 2018. "Meet Aquaria: The New York City Clubkid Turned America's Next Drag Superstar." *Forbes*, June 29, 2018. https://www.forbes.com/sites/roytelmontero/2018/06/29/meet-aquaria-the-new-york-city-clubkid-turned-americas-next-drag-superstar/#72eb123e20e8.

Morrison, Josh. 2014. "'Draguating' to Normal: Camp and Homonormative Politics." In *The Makeup of* RuPaul's Drag Race: *Essays on the Queen of Reality Shows*, edited by Jim Daems, 124–47. Jefferson, NC: McFarland.

Muñoz, José E. 1997. "'The White to Be Angry': Vaginal Davis's Terrorist Drag." *Social Text* no. 52/53 (Autumn–Winter): 80–103. https://www.jstor.org/stable/466735.

Murray, Nick, dir. 2018. *RuPaul's Drag Race*. Season 10, episode 7, "Snatch Game." Aired 3 May 2018, on Logo TV.

Ng, Eve. 2013. "A 'Post-Gay' Era? Media Gaystreaming, Homonormativity, and the Politics of LGBT Integration." *Communication, Culture & Critique* 6 (2): 258–83.

Nolfi, Joey. 2017. "Drag Race Winner Defies Conservative Rule: 'Drag Is a Form of Activism.'" *Entertainment Weekly*, June 23, 2017. http://ew.com/tv/2017/06/23/rupauls-drag-race-season-9-winner-interview/.

Norris, Laurie. 2104. "Of Fish and Feminists: Homonormative Misogyny and the Trans*Queen." In *The Makeup of* RuPaul's Drag Race: *Essays on the Queen of Reality Shows*, edited by Jim Daems, 31–48. Jefferson, NC: McFarland.

O'Halloran, Kate. 2017. "*RuPaul's Drag Race* and the Reconceptualisation of Queer Communities and Publics." In RuPaul's Drag Race *and the Shifting Visibility of Drag Culture: The Boundaries of Reality TV*, edited by Niall Brennan and David Gudelunas, 213–30. Cham, Switzerland: Palgrave Macmillan.

O'Keeffe, Kevin. 2017. "Bob the Drag Queen, Alaska and More Talk Drag in Trump's America at RuPaul's DragCon." *Mic*, April 29, 2017. https://mic.com/articles/175617/bob-the-drag-queen-alaska-and-more-talk-drag-in-trump-s-america-at-ru-paul-s-drag-con#.xgiB26MG2.

Ouellette, Laurie, and Susan Murray. 2008. "Introduction." In *Reality TV: Remaking Television Culture*, edited by Susan Murray and Laurie Ouellette, 1–22. New York: New York University Press.

Raushenbush, Paul B. 2017. "Bob the Drag Queen: Where Activism Meets Fierce." *HuffPost*, September 10, 2017. http://www.huffingtonpost.com/paul-raushenbush/bob-the-drag-queen-where-_b_11930952.html.

Reynolds, Daniel. 2018. "The Meaning of RuPaul's Apology: What Changed from 2014 to 2018?" *Advocate*, March 10, 2018. https://www.advocate.com/transgender/2018/3/10/meaning-rupauls-apology-what-changed-2014-2018.

Rosenthal, Jeff. 2015. "10 Craziest Beefs in MTV VMA History." *Rolling Stone*, September 1, 2015. https://www.rollingstone.com/music/music-lists/10-craziest-beefs-in-mtv-vma-history-61480/kurt-cobain-vs-axl-rose-1992–176676/.

RuPaul. 1995. *Lettin It All Hang Out: An Autobiography*. New York: Hyperion Books.

———. 2011. "RuPaul Plays Not My Job." *Wait Wait ... Don't Tell Me!*, NPR, June 10, 2011. https://www.npr.org/2011/06/11/137096399/rupaul-plays-not-my-job.

Schillaci, Sophie. 2016. "12 Times the MTV VMAs Was the Shadiest Awards Show Ever—And We Love It!" *Entertainment Tonight*, August 26, 2016. https://www.etonline.com/news/196497_11_times_the_mtv_vmas_was_the_shadiest_awards_show_ever_and_we_love_it.

Schwew, Elizabeth. 2009. "Serious Play: Drag, Transgender, and the Relationship between Performance and Identity in the Life Writing of RuPaul and Kate Bornstein." *Biography* 32 (4): 670–95.

Sontag, Susan. 1964. "Notes on Camp." Reprinted in *Camp: Queer Aesthetics and the Performing Subject: A Reader*, edited by Fabio Cleto, 53–65. Ann Arbor: University of Michigan Press.

St. James, James. 2016. "Flashback One Year Ago This Week: *RuPaul's Drag Race* Queen Alaska Bashes Trump." *World of Wonder*, September 22, 2016. https://worldofwonder.net/donald-trump-is-a-drag-alaska-vs-trump/.

———. 2017a. "DragCon Gets Political: The Panels You Need to See This Weekend to Make It through Trump's America!" *World of Wonder*, April 26, 2017. https://worldofwonder.net/dragcon-gets-political-panels-need-see-make-trumps-america/.

———. 2017b. "Yes, Sharon Needles Went There: Performs 'Heads Will Roll' Dressed as Kathy Griffin." *World of Wonder*, June 6, 2017. https://worldofwonder.net/yes-sharon-needles-went-performs-heads-will-roll-dressed-kathy-griffin/.

Stryker, Susan. 2008. *Transgender History*. Berkeley: Seal.

Taylor, Verta, Leila J. Rupp, and Joshua Gamson. 2005. "Performing Protest: Drag Shows as Tactical Repertoire of the Gay and Lesbian Movement." *Research in Social Movements, Conflicts and Change* 25: 105–37. https://www.researchgate.net/publication/235305388.

This is Not a Dream. "THIS IS NOT A DREAM—Vaginal Davis." YouTube video, 0:38. June 3, 2017. https://www.youtube.com/watch?v=A03i57f53E4.

Vogel, Shane. 2009. *The Scene of Harlem Cabaret: Race, Sexuality, Performance*. Chicago: University of Chicago Press.

Walters, Suzanna Danuta. 2001. *All the Rage: The Story of Gay Visibility in America*. Chicago: University of Chicago Press.

Watch What Happens Live with Andy Cohen. 2018. "Erika Jayne and RuPaul." Bravo, March 20, 2018.

Weaver, Hilary. 2018. "*Drag Race* Winner Sasha Velour Is Not Done Addressing Those RuPaul Comments." *Vanity Fair*, March 15, 2018. https://www.vanityfair.com/style/2018/03/drag-race-winner-sasha-velour-addresses-rupaul-comments-at-nightgowns-show.

3

Queering Africa: Bebe Zahara Benet's "African" Aesthetics and Performance

Lwando Scott

Introduction

Watching *RuPaul's Drag Race* for the first time was like watching the first ever queer cultural Olympics. Like many people who watch the show, I am captivated by many of the drag queens. From the first season, I was and still am fascinated by Bebe Zahara Benet, and have quietly followed the development of her career since she was crowned the first winner of *RuPaul's Drag Race*. Bebe (henceforth, I will refer to Bebe Zahara Benet as just Bebe, as she is affectionately known) returned to *Drag Race* as an All-Star competitor in *RuPaul's Drag Race All Stars*, season three. While Bebe had a successful drag career before *Drag Race* in Minnesota, United States, being part of *Drag Race* and winning the first season catapulted her career to greater heights. Since *Drag Race* Bebe has had the opportunity to perform across the country in the United States and has expanded her creativity into music. Bebe is originally from Cameroon. She not only spoke about her African roots on the show, but she embodied and performed them through her drag art by embracing what I loosely call "African aesthetics."

A big part of my fascination with Bebe was precisely because she was from Cameroon doing drag on the world stage. As a queer kid growing up in South Africa there was little to no queer culture represented in popular media, so watching Bebe was a multilayered affirming experience. Living in a world that positioned, and continues to position, queerness as the antithesis of African identity, watching Bebe was a fantastic dispelling of the myth of queerness and African identity being

mutually exclusive. I was enthralled by Bebe because I wondered about the trajectory of an immigrant boy from Cameroon, a country that punishes sexual and gender nonconformity and criminalizes homosexual practices. Watching Bebe on *Drag Race*, I was increasingly fascinated by her artistic choices through the challenges, particularly how she used "African" aesthetics. At first, I read her as someone embodying queerness and "Africanness" all while being from a country that criminalizes nonheterosexual sexuality. I also appreciated her use of African iconography, to signal her African roots and to stamp a queer slant on African culture. Bebe's embrace of the "African" aesthetic includes different kinds of references to the African animal kingdom, particularly leopard print materials. She uses "tribal" make-up on her face and sometimes wears wigs that reference a lion's mane. While on the one hand, Bebe's use of "African" iconography in her performances can be seen as an embrace of "African" aesthetics in drag culture, on the other hand, they can also be problematic because they essentialize "African" aesthetics, and use well-worn colonial tropes to "represent" "Africa." This is not insignificant considering that both the *Drag Race* audience and Bebe's own fan base are primarily comprised of North Americans.

Bebe's existence as a drag queen in North America, her participation in *Drag Race*, and her artistic choices as an African immigrant from Cameroon living in the United States necessitate all kinds of questions. In this chapter I explore the multilayered character that is Bebe. I am interested in the political implications of Bebe's aesthetic and performance style. How do we understand Bebe's performance as a drag queen that goes against what majority Cameroonian society deems to be "normal" behavior? How do we understand her as a force of African queerness? What is the disruptive potential of Bebe's drag act, considering her African roots and the North American audience she commands? What are the implications of the use of "African" aesthetics in her drag performances, given her audience and queer politics in her native country? In other words, what are the queer political implications of being a drag queen from Cameroon, particularly considering that in the place she is from homosexuality and its accompanying culture is illegal? Also, what does Bebe's presence as an African drag queen do to drag culture in North America?

Moreover, as someone who watched and continues to watch *Drag Race* while situated in South Africa, how do I read Bebe and her drag art? What happens in the process of watching Bebe as an African queer kid and seeing her use of "African" aesthetics in her performance? Understanding Bebe's history as a Cameroon-born gay man and her ascendency to be a drag star in the United States is critical to appreciating her use of "African" aesthetics. I am intrigued by her particular uses of "African" iconography, and I am interested in the African femininity on display through her performance. What can be deciphered from Bebe's performance?

On a personal note, what are the relational affinities created by Bebe through her performance for me as a black queer person living in South Africa?

Thinking with Camp

It does not require going out on a limb to say that *Drag Race* is a camp show that uses camp language and makes camp pop cultural references. As acutely demonstrated by Carl Schottmiller (2017, 66) *Drag Race* is a show built on camp queer cultural references that "frequently operates as a type of social memory within queer social groups." In fact, Schottmiller argues that understanding the "camp references requires that the audience possess a queer cultural capital (knowledge of the source material)" (59). Here, Schottmiller uses Pierre Bodurdieu's ideas of cultural capital to explain that in order to master the camp references in *Drag Race*, you need to have been part of or at least be knowledgeable of the larger queer North American culture. To some degree *Drag Race* takes for granted that the viewer is queer (which does not necessarily mean homosexual) and will have a kind of knowledge about the references being made in the show. Simultaneously, through the use of camp references, the show also functions as a school of camp in that those watching can learn camp references. This learning is not only for the audience; indeed, *Drag Race* is also a camp school for the contestants themselves, particularly young contestants who have not been exposed to queer camp culture. While some queer scholars such as Moe Meyer (1994) have accused Susan Sontag (1987) of appropriating camp for heterosexual culture in her 1964 essay "Notes on Camp," I find her description apt and particularly useful in describing camp. Sontag describes camp as follows: "It is not a natural mode of sensibility, if there be any such. Indeed, the essence of camp is its love of the unnatural: of artifice and exaggeration" (275). Further, Sontag argues that "camp is a vision of the world in terms of style—but a particular kind of style. It is the love of the exaggerated, the 'off,' of things-being-what-they-are-not" (279). Sontag's take on camp is similar to the way that Richard Dyer (1986, 178) understood camp as "a characteristically gay way of handling the values, images, and products of the dominant culture through irony, exaggeration, trivialization, theatricalisation, and an ambivalent making fun of and out of the serious and respectable." Sontag's description of camp speaks to *Drag Race* and its sensibility in general, and to Bebe in particular, with reference to her dramatization of "African" aesthetics.

Interestingly, Schottmiller (2018, 6) argues that "*Drag Race* scholars largely ignore the significant role that camp plays in this franchise." This silence on camp seems counterintuitive since camp is obviously an integral part of *Drag Race*.

Indeed, Schottmiller argues that "this limited engagement with camp scholarship troubles me because camp is one of the integral operating logics of *RuPaul's Drag Race*. Indeed, camp infuses every aspect of this show and permeates the growing live economy" (7). This chapter takes up the challenge issued by Schottmiller to take seriously camp as a way to theorize *Drag Race* and its impact on queer culture. So, in thinking with camp as a lens, how do I make sense of Bebe's performance and articulations in the show and in her career at large? Through camp, how does one understand the intersection of Bebe's queerness and Bebe's "African" aesthetics and performance?

"If she wears leopard print one more time"—Bebe's "African" Aesthetics

From the first season, it was clear that Bebe was partial to what can be described as stereotypical depiction of "African" aesthetics. These aesthetics were not only situated in Bebe's way of dress, but also in the way she was characterized in the show by others. For example, when Bebe appeared on the main stage, RuPaul would affectionately shout "Cameroooooon," dragging the "o" in Cameroon as if singing in a melisma-kind-of-way. This, in turn, became a popular way of addressing Bebe for fans. When RuPaul shouted "Cameroooooon," she signaled a tribal call, an ancestral call, a call that went beyond Bebe herself, but spoke to ideas about Africans and their cultures. This call was striking in that like Bebe's personality, drag identity, and performance, it had a regal sound to it, a royal inflection. The tone of expression and the endearment with which it was delivered spoke to an appreciation of African cultures and peoples.

The "African" theme in Bebe's aesthetic continued after she won the first season of *Drag Race*, signaling that the theme was part of her drag "brand." It is because of this continued use of "African" aesthetics and performance that I can't help but be ambivalent about Bebe's representations of "Africa." For instance, in the music videos for "Jungle Kitty" (2018) and "Cameroon" (2010) Bebe uses stereotypical "African" tropes. For starters, the name of the song "Jungle Kitty" is a revelation itself. It is a multilayered name for this song and demands some attention. First, the name of the song conjures up images of wild cats found in African jungles, such as the lion, the cheetah, and the leopard. When the music video came out, Bebe had been consistent with her stereotypical reference to Africa, which now included the animal kingdom. Bebe also tapped into an already existing drag queen language of referring to themselves and each other as feline femme fatales. Of course, this language is read as offensive by others as it references terms such as "pussy," which is a staple term in drag queen language.

The name "Jungle Kitty" is thus the marriage of Bebe's two worlds, the world she comes from, Cameroon, and the world she currently lives in, North America.

In addition, "Jungle Kitty" contains lyrics that signal both queer feline tropes and African signification. Bebe sings about her pussy being on fire, and part of the lyrics are "made-up" words/sounds like when she says "ra-ka-tiki-ta-ta." In the song, there is an overheard voice that asks, "What is she saying?" This is a layered question in the song, a question that obviously anticipates these kinds of questions from the audience about the words/sounds she is making in the song. Furthermore, "what is she saying" is a reference to the immigrant experience, immigrants whose language is often treated with hostility in North America (Mayora 2014; 2016). In another part of the song, a white female North American voice is overheard saying, "If she wears leopard print one more time ..." Immediately after the line, Bebe is shown defiantly wearing a leopard print catsuit that even covers part of her face. This line references people who have complained about Bebe's partiality toward leopard print. While seemingly innocent, the statement is encumbered by a confluence of race, class, and gender. The overheard voice is distinctly that of a white female, and this underscores the "fashion authority" assumed by white people in positions of power, who supposedly dictate what is fashionable. In this instance, Bebe's leopard print can be read as representing working-class black female aesthetics, and therefore outside of "high fashion," a style that is often the aim of *Drag Race* aesthetics. The irony, of course, is that "street style" (often code for black or people-of-color "style") plays a major role in influencing "high fashion" styles (Dant 1999, 91–92). In fact, in the contemporary moment, "street style" and "high fashion" have a symbiotic relationship, where there is a crisscross of styles (92). The inclusion of "if she wears leopard print one more time" in the music and then wearing leopard print is clever and ultimately defiant.

The video for "Cameroon" contains more obvious stereotypes about Africa than "Jungle Kitty." In the music video, where she sings about Cameroon, Bebe is winking back to RuPaul's 2009 season one tribal call of "Cameroooooon" during the show. The video is filled with outfits made of feathers. Bebe is wearing a feather headgear and her face is covered in tribal paint. The other characters in the video who are dancing are covered in tribal face paint and they are also wearing feathers, albeit less glamorous than Bebe.

Intersectional Politics of Bebe—Race

Bebe's "African" aesthetics and performance reveal the complicated ways in which her identities intersect. Bebe comes from Cameroon, a country that outlaws homosexuality. Bebe is black and lives in the United States, a country with

a deep history of slavery and ongoing structural oppression of black people. Bebe is African. Bebe has a career as a drag artist, an art form that has historically not been highly regarded in mainstream society. Intersectionality is a way of describing the multiplicity of oppressions through the crisscross of multiple identities. It was first developed by Kimberlé Crenshaw (1991) to demonstrate the ways that black women experience oppression both as gendered *and* racialized beings, and to show that an analysis of their experiences can't separate these struggles into primary and secondary struggles. Furthermore, Patricia Hill Collins (1990, 225) sees intersectionality as "interlocking systems of oppression" that provide a way to view Bebe and how her multiple identities shape her and influence her aesthetics and performance. So, first and foremost, Bebe's articulations should be read with her intersectional identities and how they impact her life and drag art.

Taking into account Bebe's race as a black person, and her African roots, in reading her "African" aesthetics and performance, Bebe consciously self-constructs her persona. Bebe is a "recent" black immigrant, and her experience and life history is particular to North America. Here I am reminded of Minelle Mahtani's (2001, 300) articulations that "the complex ways that racialisation is socially constructed within particular places" foreground the need to seriously engage with people's positionality. In the "Jungle Kitty" music video, it is not a coincidence then that the overheard voice that asks "what is she saying" and the one that says "if she wears leopard print one more time" are distinctly that of a white female North American. Referencing the fan base of *Drag Race*, this suggests the ignorance in the United States of other cultures but also speaks to anti-immigrant sentiments that are currently part of the discourse in North America represented by the election of, and the statements made by, President Donald Trump. As established by Tod Hamilton, Janeria Easley, and Angela Dixon (2018), the complexities of being a black immigrant in North America is demonstrated by forced occupational niches that people of color occupy in their communities. These authors also show how US-born black Americans and black African immigrants fare similarly in earnings, demonstrating that race affects the income potential of immigrants. In a similar vein, Patrick Mason (2016) argues that there exist labor market inequalities in North America, and Xue Lan Rong and Frank Brown (2002) articulate the difficulties that black immigrant children face in being incorporated into America society. These race-related struggles of black immigrants are linked to the long history of black struggle in America in general, as demonstrated by the works of Eli Reed (1997), Cornel West (1993), and W. E. B. Du Bois (1903). The continued black racial struggle in North America is acutely felt in the twenty-first century as the world continues to witness the murder of black young people at the hands of the state police in greater North America (Alexander 2012; Anderson 2016;

Coates 2015; Hill 2016; Lowery 2016; Taylor 2016). The atmosphere of white supremacy and continued destruction of black lives in America is the context in which all black people are functioning in the United Sates and it affects how black people do art.

Drag Race does not exist in a vacuum but is heavily shaped by wider discourses of race politics in North America. This is an argument that was brought forward by Mayora (2014; 2016), who discusses the racial and cultural relations between mainstream gay culture (read white) and queer Latinx community. Mayora (2016, 190) observes that the complicated relationship between *Drag Race* and Latinx queens, and how these queens are received, "mirrors the actual dynamics between dominant subjects and queer Latinx," a relationship that is mired in stereotypes and unequal power relations because of the history of white supremacy in North America. The race relations articulated by Mayora (2018; 2016), albeit in different ways, can be linked to the racist attacks that Bebe and other black contestants have received on *RuPaul's Drag Race* targeting them for "eliminating" a "fan favourite," contestant who is often white (Instinct Staff 2018). Taking all of this into account, Bebe's "African" aesthetics and performance become more complicated because they can be read as reactions to the power of whiteness that other black and Latinx contestants have also felt.

Intersectional Politics of Bebe—Africa

For over ten seasons of *Drag Race*, Bebe was the only African immigrant to have been on the show. This changed in season eleven with the introduction of Mercedes Iman Diamond, an African Muslim immigrant, who is also from Minnesota, United States. Being an African immigrant carries its own set of politics and complications. It is important to note the nuances of the intersection of Bebe's African immigrant identity with her other already peripheral identities of being black and gay. Bebe's position brings to the fore Jeffrey Weeks's (2011, 96) articulations about how intersectionality is concerned with "overlapping, interweaving and multidimensional forms of power" that operate simultaneously to affect the lived experience of an individual. This tells us that blackness, gayness, and Africanness do not function individually in Bebe's life; rather, they eventually come through her aesthetics and performance and are "mutually constitutive" (Yuval-Davis 2006). An interesting moment related to Bebe's African aesthetics and performance was in the *Drag Race All Stars* season three variety show in the first episode ("All-Star Variety Show" 2018), when Trixie Mattel, a white presenting queen, remarked "Bebe *is The Lion King*." This was a crucial moment on multiple levels: it was

telling of the kind of imagery that was being used by Bebe; it gave us an idea of how the other drag contestants viewed her; it also gave us an idea of how she is possibly viewed by wider North America.

In that first episode of *Drag Race All Stars* season three Bebe performs a lip sync and dances to her own song "dirty drums/Cameroon." She enters to take part in this variety show on a dark stage appearing through smoke. When she emerges from the smoke, she is wearing a patchwork African print dress with big curly hair and a large beaded neckpiece. Her face is painted with white dots going through the middle of her face and around her eyes, and her lips are painted black. It is as if she is wearing a face mask. She comes out and walks about the stage singing, and after a short while being on stage, she takes off the African print dress and reveals a dress made of feathers, lots of feathers. She then erupts into a choreographed dance. Generally, the dance immediately reminded me of the thousands of music videos from South Africa and Nigeria. Particularly, her dance moves made me think of Kwaito star Lebo Mathosa's (2006) video for "Au Dede." Furthermore, Bebe's dance moves were similar to how young people dance in South Africa. Here, we see Bebe drawing from certain aspects of African popular culture, and drawing from popular culture is part of drag culture and performance. So, the question remains, what are the implications of this?

In order to understand the significance of "Bebe *is The Lion King*," one has to understand what *The Lion King* as a popular Disney movie means to North American white audiences. Many young North American children grow up watching *The Lion King*, and this partially forms their ideas about "Africa." So, when Trixie Mattel, who likely grew up watching *The Lion King*, says that Bebe *is The Lion King*, she is drawing from a reservoir of North American knowledge about Africa. Interestingly, it can be argued that Bebe herself is drawing from this North American reservoir of knowledge for her own gains. The recognition of Bebe as *The Lion King* tells us that Bebe is successful at Africanizing herself in *Drag Race*. The success of Bebe's African branding is revealed in the popularity of her song "Jungle Kitty." When "Jungle Kitty" came out, it was so popular that people responded to the #JungleKittyChallenge by creating their own videos mimicking Bebe and lip-syncing to the lyrics. The success of the song, and the video, can be attributed to the catchiness of the song, but also the "African" branding that Bebe has become associated with. *The Lion King* reference made by Trixie Mattel can be extended to the music videos for the songs "Cameroon" and "Jungle Kitty." Bebe makes references to "tribal Africa" in these videos with feathers, the theme of the jungle, and warrior-esque depictions. In her portrayals Bebe clearly sends up *Lion King*-esque African stereotypes. What is of interest to me is how do we read the articulations or commentary that is made by Bebe about Africanness and "African" culture? How do we read Bebe considering the context of North

America and her identities? How do I read Bebe's articulations as a queer person watching from South Africa?

Intersectional Politics of Bebe—Sexuality

The space where sexual diversity and African identities intersect is contested ground. The contested ground of African queerness is the shaky foundation on which Bebe is formulated and becomes a Drag Superstar. An analysis of Bebe has to take seriously what it means to be queer and African. The popular sentiment that homosexuality is "un-African" (which often includes all kinds of sexual and gender dissidents) and that it is an "import from the West" (Morgan and Wieringa 2005, 11) has become a mainstay in different parts of the African continent, used by laypeople, the state, government officials, African traditionalist, and religious entities (Awondo 2010; Nyanzi 2013; Reddy 2009). This narrative of homosexuality being "un-African" is powerful because it uses anti-imperialism logic to build a case against sexual and gender diversity. It is a narrative that understands the power of anti-colonial sentiments in postcolonial Africa. The discourse of homosexuality being "un-African" takes place in different parts of the African continent, with differing consequences for people with non-normative genders and sexualities. Indeed, as demonstrated by Ryan Richard Thoreson (2014) there are stark differences in the homophobias contained in the Anti-Homosexuality Bill of Uganda, the arrest of Tiwonge Chimbalanga and Steven Monjeza in Malawi after being involved in a commitment ceremony, and the anti-homosexuality persecution in Senegal. Thoreson (2014) argues for a particularity in describing and discussing what others have called a "wave of homophobia" in Africa. He is reminding us that Africa is a big continent consisting of multiple countries with different histories and trajectories. The appreciation of the complexity of the African continent does not mean we do not address homophobia in certain parts of the continent, but that we are vigilant of history and be particular in how we talk about homophobia as we would other social issues.

The claim that homosexuality is "un-African" has no basis in reality, because as demonstrated by historical, sociological, and anthropological accounts (Amadiume 1987; Ekine and Abbas 2013; Matebeni 2011; Moodie 1988; Morgan and Wieringa 2005; Murray and Roscoe 2001; Reid 2013; and Tamale 2011) homosexuality has existed in different parts of the continent throughout history. Furthermore, the work of Amadiume (1987) and Oyèrónkẹ́ Oyěwùmí (1997) demonstrates a complex configuration and nuanced understanding of gender and sexuality in some precolonial African communities. These gender and sexuality configurations were different from the simplistic European binaries, and they were

disrupted by the advent of colonization and forever changed. This is a history that is often missing in discussions of homosexuality as "un-African" because it is inconvenient to the politics of the day. What becomes clear is the power of this narrative for political gains by those who are in power or seeking power for different political gains in different contexts.

The intersection of sexual diversity and African identity is made more complicated by the transportation of US culture wars to African countries. The influence of the US Christian Right on homophobic policies in some African countries was made most obvious by the Christian Right's involvement in the Anti-Homosexuality Bill in Uganda (Downie 2014; Kaoma 2012; Thoreson 2014). The introduction of this bill in Uganda caused backlash toward Uganda from different corners of the world, including at the time US President Barack Obama, who issued a statement condemning the bill. The influence of US-based Christian Right organizations is felt as they push for "family values" in what Kaoma (2012, 2) calls "colonising African values" through a process of "Africanising American conservative teachings." This process of colonizing African values is done through a process of demonizing sexual and gender diversity and the fight for equal rights (McEwen 2016). The amnesia about the colonial history of Christian missionaries who were instrumental in the colonization of Africa is palpable. The influence of the Christian Right in gender and sexuality politics in some African communities has proven detrimental to the lives of queer people.

It is in the context of contestations over sexual diversity in African countries that Bebe's aesthetics and performance make a vital intervention into queer representation in popular culture. In a context where both Christian Right fundamentalists and some African states are pushing for the persecution on queer people, Bebe's emphasis on African aesthetics and performance can be read as political. It is asserting a queerness in Africanness and Africanness in queerness. She defies both the Christian Right and the African traditionalists. In this I do not see Bebe as a representative of Africa or even Cameroonians; I read her as a comment on the power and possibilities of drag. Bebe's performance exceeds a mere "representative" of the African continent to speak to the potentials created through drag that unsettle narratives such as queerness being "un-African."

Lost in Translation: Can Africa Be Camp?

In trying to understand Bebe's "African" aesthetic choices and performance, I wonder about the translation of camp. In other words, can Africa be camp? My instinct is to say yes, Africa can be camp. However, with the colonial history and the power imbalances in cultural understanding of Africa, there is a chance that

something is lost in translation. In pursuing my line of thinking about camp, I keep an open mind and remember Schottmiller's (2017) arguments that camp should be seen as an ever-evolving practice and not as unchanging or even singular. Thus, it should be possible for Africa to be read and/or performed as camp. Like in the history of the art of drag, Bebe sends up stereotypes about African aesthetics in her performances. The question then becomes, does Bebe challenge dominant ideas about Africa, or does Bebe reinforce damaging stereotypes about the continent. As demonstrated in the previous sections of this chapter, Bebe mines the "African" aesthetic and uses it as part of her brand. What does this do, and what are the implications of this work?

It would seem that Bebe simultaneously challenges and reinforces stereotypes. On the one hand, she is poking fun at herself and her "African" roots. On the other hand, she is feeding into an already existing narrative of associating Africa with feathers, wild animals, and face paint. In other words, she feeds into *The Lion King* narrative of Africa, which is the preferred North American understanding of the continent. In many ways Bebe's performance is the ultimate camp performance. Sontag's description of camp is embodied by Bebe in her drag aesthetic referencing Africa in the popular imagination. In performing "Africa" Bebe satirizes these tribal ideas that are synonymous with ideas about Africa. Bebe's drag performance as the "African Queen" complete with feather headgear and face paint is a knowing wink or even a middle finger to North America. In Bebe's case the simultaneity seems unavoidable in that in poking fun at the stereotypes by sending them up in camp style, she inadvertently reinforces stereotypes.

While camp is the mainstay of the show, there are moments where camp gives way for "real" reflection. For instance, in the variety show performance of *All Stars* season three ("All-Star Variety Show" 2018) Bebe sings, "I found my way back home, Cameroon. She is Cameroon. They call me Cameroon." She then goes on to sing-rap "the rhythm, the beat, pulsing, the heat." In between she is also making rhythmic sounds that do not really mean anything in the English language but go with the sound of the beat and the facial expressions she is making. In this performance Bebe seems proud of her heritage and her background as a Cameroonian. She claims where she is from and inserts her country of origin identity on stage. Bebe singing about "finding my way back home, Cameroon" takes on a deep meaning considering that she is living in North America and same-sex intimacy is criminalized in Cameroon. Bebe can be read as someone yearning to go home because the lyrics of finding her way home are accompanied by dress and body movements that beckon home. The performance represents a pride of where she is from, but in the process reveals the heaviness of knowing that Bebe can't live the gay life and have a drag career in Cameroon like she can in the United States. Again, here there is a simultaneous effect, a doubleness of

sort, of yearning for home but at the same time knowing that home is illusive, unreachable in many ways.

Reality Television, Affect, and Relationality

Pierpaolo Donati (2011, xvi) argues that

> we are what we care about, and if we do not relate to significant others, we are nothing, we become nothing. We are our "relational concerns," as individuals as well as social agents/actors, since we necessarily live in many different contexts that are social circles (like a family, a network of friends, maybe a civil association, up to a nation) which imply a collective identity.

I want to extend Donati's relational concerns to my relationship with Bebe in that in a queer sense I see our relationship as familial, connected through a queer African ancestry. The relationship with Bebe is one made through knowing without knowing, in that I have never met her, but I feel like I have and if we were to meet, we would already know each other. This is the power of reality television. As articulated by Graeme Turner in *Understanding Celebrity* (2004) the celebrity culture of "ordinary" people being "stars" is the "demonic turn" that has blurred the lines between stars and ordinary people. Elsewhere Turner (2006, 154) argues that "much of the participation in reality TV is aimed at a certain kind of recognition of the self." I think Turner is on to something here, particularly for us who consume reality TV in that we see ourselves in the TV shows we watch. The question then becomes, what do we do with the stories we see, the stories we watch? What becomes of the narratives we recognize or identify with?

Gamson (2011, 1062) argues that

> consumers of celebrity culture then do all sorts of things with these stories, often giving them new meanings. Some make use of celebrity stories to fantasize a different life, to construct their identities, or to model themselves on people they admire or envy; others use them as fodder for connecting socially with one another.

This is evidenced in my introduction, where I talk about my affection for Bebe, and in the earlier section, where I talk about her aesthetic, that we give meanings to the stories we see and apply them to our own realities. In my relational relationship with Bebe it is obvious that I see her queerness that is intimately linked with her Africanness as a source of admiration and something I identify with. This is

pertinent because the idea of queerness as "un-African" remains a forceful narrative in the ways that queerness is articulated in many African contexts.

It seems obvious to admit that my relational concerns with Bebe are entangled in the politics of affect. While obvious, I think it important to dissect what affect means and how it is deployed in this particular case. Taking my cue from Heather Love (2007) arguing for a considered uptake of the relationship between affect and politics, I am invested in the politics of affect that ensnarl my relationship with Bebe. As is often demonstrated in social science, human beings are more than just helpless actors controlled by structure. People have agency and use it to resist structural oppressions. Furthermore, people are emotive, they have experiences, they feel love, loss, and all kinds of emotions that are sometimes impossible to quantify or even verbalize. This is affect, and it influences our personal lives, our communities, and our politics. Affect is captured succinctly by Eric Shouse (2005, 6) in the assertion that "affect is what makes feelings feel." Moreover, Shouse (2005, 12) argues that "affect plays an important role in determining the relationship between our bodies, our environment, and others, and the subjective experience that we feel/think as affect dissolves into experience." The assertions made by Shouse about the important role played by affect implicating our bodies, our environment, and other people speak to the affective relationship I have with Bebe.

My relationship to Bebe goes beyond just "identifying" and engages with the politics in her art through drag. In *Politics of Affect*, Brian Massumi (2015, vii) argues that affect is the primary politics and that it involves "dimensions of life which carries a political valence." Our experiences are often measured with the experiences of others, and through this process affect is experienced. My experience of Bebe and how I am affected by Bebe is not an easy emotion/experience/feeling to translate into something tangible. This is something that Shouse (2005, 6) has warned us about—that affect is rooted in feelings and feelings rooted in our bodies through experiences; therefore, it is not easily translated into language because in its abstract nature "the body has a grammar of its own."

In many ways affect has to do with the nonverbal. It has to do with the communication of the body without words. It is feelings that are transferred through experience. Since the focus on affect, what some have called the "affective turn," there has been much speculation about why such a turn occurred. Lisa Blackman and Couze Venn (2010, 8) argue that

> one consequence of the heightened interest in the non-verbal, non-conscious dimensions of experience is a re- engagement with sensation, memory, perception, attention and listening. If much of what passes as experience occurs in this realm, how then can we model the psychic and sensory apparatuses that afford specific kinds of embodied knowing?

What Blackman and Venn are gesturing to is really a bringing of the whole human experience into the academic realm. They are asserting that human beings are more than just "rational" thoughts, or that only rational thoughts should be seen as the primary focus in academic inquiry but that people have other ways of being in the world. That feelings, emotions, and experiences matter, that "sensory apparatuses that afford specific kinds of embodied knowing" matter. My sometimes hard to articulate feelings and experiences of Bebe occur in a psychic and sensory realm, in that I connect with her as this queer African goddess, to use drag lingo, who through her art of drag speaks to me, speaks about me, and asserts a queer African pride that is connected to those queer pioneers who came before me and her on the continent.

Affect theory has not been without critiques. While Ruth Leys (2011) takes issue with many scholars who write about affect, she reserves the harshest critique for Massumi whom she regards as a leading scholar of affect theory. While Leys seems to agree that there is a need for research concerning emotions, and that leading scientists agree on this need, there is disagreement on how the science of emotions is to be carried out and how it is to be read. Leys primarily objects to what she calls the "false opposition between the mind and the body" that she sees as characterizing the majority of work of affect theorists (458)—a split between the mind and the body that has been heavily critiqued in post-structuralist thought. Here, I am in agreement with Leys about the suspicion of separating the body and mind or deciphering what comes first. For instance, in my fascination with Bebe and in my analysis of Bebe, there is no clear separation of "rational" thought and "emotions." My analysis of Bebe is influenced by both mind and body as I try to make sense of what she means to me as an African queer person. I am writing an academic piece about someone whose identities are entangled with mine, whose aesthetics and performance cause me to reflect on the ideas of representation. What I see as important in debates about affect that Leys is engaged with is the taking seriously of emotions in the ways that people make decisions in their lives. Furthermore, I see it as important that academic research takes seriously how we think with our emotions.

Conclusion: Reimagining African Identities

To me, Bebe's allure lies in her being an African queen, successfully doing drag, and therefore creating a different narrative of what it means to be a man, to be gay, to have effeminate qualities, and to be of African descent. Growing up in South Africa, I suspect when Bebe was also growing up in Cameroon, there was a lack of alternative ways of reading "African," let alone alternative sexualities. Bebe opens up a whole new world for many young South Africans, indeed Africans, which shows that there are many ways they can imagine themselves. Considering that many

LGBTQ+ people on the African continent continue to struggle to be visible and often adopt the inferiority complex projected on them by society, Bebe becomes a figure of different possibilities for queer Africans. She is a demonstration that there is a life beyond feelings of shame and self-hate regarding both sexuality and African identity. Through her drag art, Bebe embodies the essence of self-invention, which is the essence of the African Renaissance in the postcolonial era. The spirit of the African Renaissance was popularized by former South African president Thabo Mbeki (1998) placing emphasis on a creative, intellectually stimulating, and self-directing Africa. Speaking about Africans, Mbeki claims that "they are determined to define for themselves who they are and who they should be." The ideals that are prescribed in the imagined African Renaissance include freedom of sexual identity, and I see figures like Bebe as contributors to the reimagining of queers in African societies.

I find linkages between Bebe's drag and the ethos of Binyavanga Wainaina's (2014) articulations through a series of videos titled *We Must Free Our Imagination*. In these videos Wainaina talks about the need to step out of the boundaries of what we know and into the creative world of imagining. He asserts we should let go of the blueprints of how African queer life should be, left behind by the colonial and apartheid administration, and imagine queer African life for ourselves. Our imagination regarding African identities, including sexual identities, in twenty-first-century Africa needs to exist without the boundaries, often set by colonial administrators through penal codes and now Christian Right evangelists. The human potential is infinite, and if we are to prosper as countries and as a continent we cannot limit the possibilities of innovative self-identities, like how Bebe has done and continues to do through her drag.

Among the many things that colonialism took away from Africans is people's ability to create themselves. To fashion a self that is not regulated by colonial ideas of what it means to be African. The colonial administration's strong hold was also exercised on the ways that Africans could craft themselves through sexuality. This restriction from creating oneself was expressed through segregation such as apartheid in South Africa and penal codes that were a reflection of European anxieties about African sexuality. These anxieties created in colonial times are still with us in the postcolonial context now being expressed by Africans over other Africans through narratives such "homosexuality is un-African." While it is a false statement, it has garnered popularity and is used to oppress Africans with same-sex desires. It is in this context that the visibility of Bebe becomes a defiant statement of Africans creating themselves in spite of the obstacles. By using African iconography, and playing with African stereotypes, Bebe uses the art of drag to make commentary about Africa. Granted, her use of African aesthetics is double edged in that it reinforces certain stereotypes, but by using her drag art and using African symbolism, she is also giving a nod to those in the know that she hasn't forgotten her roots. Using camp and sending up stereotypes of Africa, she is engaged in a conversation both with those in her new home in North America and

also those she left behind in Cameroon. Bebe is an example of a freed queer African imagination, existing in a place where she can reimagine and reinvent herself over and over again. I am fascinated by Bebe because through her drag art, she represents what is possible with just a little bit more imagination.

REFERENCES

Alexander, M. 2012. *The New Jim Crow: Mass Incarceration in the Age of Colorblindness*. New York: New Press.

Amadiume, I. 1987. *Male Daughters, Female Husbands: Gender and Sex in an African Society*. London: Zed Books.

Anderson, C. 2016. *White Rage: The Unspoken Truth of Our Racial Divide*. London: Bloomsbury Books.

Awondo, P. 2010. "The Politicization of Sexuality and the Rise of Homosexual Movements in Post-colonial Cameroon." *Review of African Political Economy* 37 (125): 315–28.

Benet, B. 2010. "Cameroon." YouTube video, https://www.youtube.com/watch?v=syKM11ht3k0.

———. 2018. "Jungle Kitty." YouTube video, https://www.youtube.com/watch?v=EW0U2-bSjIw.

Blackman, L., and C. Venn . 2010. "Affect." *Body and Society* 16 (1): 7–28. https://doi-org.ezproxy.uct.ac.za/10.1177%2F1357034X09354769.

Coates, T. 2015. *Between the World and Me*. New York: Random House US.

Collins, P. H. 1990. *Black Feminist Thought: Knowledge, Consciousness, and the Politics of Empowerment*. London: HarperCollins Academic.

Crenshaw, K. 1991. "Mapping the Margins: Intersectionality, Identity Politics, and Violence against Women of Color." *Stanford Law Review* 43 (6): 1241.

Dant, T. 1999. *Material Culture in the Social World*. London, United Kingdom: McGraw-Hill Education.

Donati, P. 2011. *Relational Sociology: A New Paradigm for the Social Sciences*. London: Routledge.

Downie, R. 2014. "Revitalising the Fight against Homophobia in Africa." Center for Strategic and International Studies, Global Health Policy Center, Washington, DC.

Du Bois, W. 1903. *The Should of Black People*. Chicago: A.C. McClurg.

Dyer, R. 1986. "Judy Garland and Gay Men." In *Heavenly Bodies: Film Stars and Society*, edited by Richard Dyer, 141–94. New York: St. Martin's.

Ekine, S., and H. Abbas . 2013. *Queer African Reader*. Dakar, Senegal: Pambazuka.

Gamson, J. 2011. "The Unwatched Life Is Not Worth Living: The Elevation of the Ordinary in Celebrity Culture." *PMLA* 126 (4): 1061–69. http://repository.usfca.edu/cgi/viewcontent.cgi?article=1006&context=soc.

Hamilton, T., J. Easley, and A. Dixon. 2018. "Black Immigration, Occupational Niches, and Earnings Disparities between U.S.-Born and Foreign-Born Blacks in the United States." *RSF: The Russell Sage Foundation Journal of the Social Sciences* 4 (1): 60.

Hill, M. 2016. *Nobody: Casualties of Americas War on the Vulnerable, from Ferguson to Flint and Beyond*. New York: Atria Books.

Instinct Staff. 2018. "Bebe Zahara Benet Receives Major Racist Attacks Post Drag Race Elimination." *Instinct Magazine*. https://instinctmagazine.com/bebe-zahara-benet-receives-major-racist-attacks-post-drag-race-elimination/.

Kaoma, K. 2012. *Colonizing African Values: How the U.S. Christian Right Is Transforming Sexual Politics in Africa*. Boston, MA: Political Research Associates.

Leys, R. 2011. "The Turn to Affect: A Critique." *Critical Inquiry* 37 (3): 434–72. https://doi.org/10.1086/659353.

Love, H. 2007. *Feeling Backward: Loss and the Politics of Queer History*. Cambridge, MA: Harvard University Press.

Lowery, W. 2016. *They Can't Kill Us All: Ferguson, Baltimore, and a New Era in America's Racial Justice Movement*. New York City: Little, Brown and Company.

Mahtani, M. 2001. "Racial ReMappings: The Potential of Paradoxical Space." *Gender, Place and Culture: A Journal of Feminist Geography* 8 (3): 299–305. https://doi.org/10.1080/09663690120067366.

Mason, P. 2016. "Immigrant Assimilation and Male Labor Market Inequality." *IZA Journal of Migration* 5 (17): 2-32.

Massumi, B. 2015. *The Politics of Affect*. Cambridge: Polity.

Matebeni, Z. 2011. "Exploring Black Lesbian Sexualities and Identities in Johannesburg." PhD diss., University of the Witwatersrand.

Mathosa, L. 2006. *Au Dede*. YouTube video. https://www.youtube.com/watch?v=h0ny_4augoo.

Mayora, R. G. 2014. "Cover, Girl: Branding Puerto Rican Drag in 21st-Century US Popular Culture." In *The Makeup of RuPaul's Drag Race: Essays on the Queen of Reality Shows*, edited by Jim Daems, 106–23. Jefferson, NC: McFarland.

———. 2016. "Where's My Thanks: Citizenship and the Regulation of Queer Latinos in Contemporary Popular Culture." PhD thesis University of Florida. https://ufdc.ufl.edu/UFE0049582/00001.

Mbeki, T. 1998. *The African Renaissance, South Africa and the World*. United Nations University. http://archive.unu.edu/unupress/mbeki.html.

McEwen, H. 2016. "Transatlantic Knowledge Politics of Sexuality." *Critical Philosophy of Race* 4 (2): 239–62. https://doi.org/10.1080/09663690120067366.

Meyer, M. 1994. "Reclaiming the Discourse of Camp." In *The Politics and Poetics of Camp*, edited by Moe Meyer, 1–22. New York: Routledge.

Moodie, T. D. 1988. "Migrancy and Male Sexuality on the Southern African Gold Mines." *Journal of Southern African Studies* 14 (2): 228–56.

Morgan, R., and S. Wieringa. 2005. *Tommy Boys, Lesbian Men, and Ancestral Wives: Female Same-Sex Practices in Africa*. South Africa: Jacana Media.

Murray, Nick, dir. 2018. *RuPaul's Drag Race All Star*. Season 3, episode 1, "All Star Variety Show." Aired 25 January 2018, on Logo TV.

Murray, S., and W. Roscoe. 2001. *Boy-Wives and Female Husbands: Studies of African Homosexualities*. New York: Palgrave Macmillan.

Nyanzi, S. 2013. "Homosexuality in Uganda: The Paradox of Foreign Influence." MSIR Working Paper, 18. Makerere Institute of Social Research, Makerere University. http://misr.mak.ac.ug/sites/default/files/publications/14Homosexuality%20in%20Uganda.pdf.

Oyěwùmí, O. 1997. *The Invention of Women: Making an African Sense of Western Gender Discourses*. Minneapolis: University of Minnesota Press.

Reddy, V. 2009. "Perverts and Sodomites: Homophobia as Hate Speech in Africa." *Southern African Linguistics and Applied Language Studies* 20 (3): 163–75.

Reed, E. 1997. *Black in America*. New York: Norton.

Reid, G. 2013. *How to Be a Real Gay: Gay Identities in Small-Town South Africa*. South Africa: University of KwaZulu-Natal Press.

Rong, X., and F. Brown. 2002. "Socialization, Culture, and Identities of Black Immigrant Children." *Education and Urban Society* 34 (2): 247–73.

Schottmiller, C. 2017. "Reading *RuPaul's Drag Race*: Queer Memory, Camp Capitalism, and RuPaul's Drag Empire." UCLA. ProQuest ID: Schottmiller_ucla_0031D_16244. Merritt ID: ark:/13030/m58m25wj. https://escholarship.org/uc/item/0245q9h9.

———. 2018. "A Drag Primer: Situating *RuPaul's Drag Race* within Academic Drag Studies." Presented at PCA Conference, Indiana.

Shouse, E. 2005. "Feeling, Emotion, Affect." *M/C Journal* 8 (6). http://journal.media-culture.org.au/0512/03-shouse.php.

Sontag, S. 1987. "Notes on Camp." In *Against Interpretation*, edited by Susan Sontag, 275–92. London: Andre Deutsch.

Tamale, S. 2011. *African Sexualities: A Reader*. Cape Town: Pambazuka.

Taylor, K. 2016. *From #blacklivesmatter to Black Liberation*. Chicago: Haymarket Books.

Thoreson, R. R. 2014. "Troubling the Waters of 'Wave of Homophobia': Political Economies of Anti-queer Animus in Sub-Saharan Africa." *Sexualities* 17 (1/2): 23–42. https://doi.org/10.1177/1363460713511098.

Turner, G. 2004. *Understanding Celebrity*. London: SAGE.

———. 2006. "The Mass Production of Celebrity." *International Journal of Cultural Studies* 9 (2): 153–65.

Wainaina, B. 2014. *We Must Free Our Imagination*. YouTube video, https://www.youtube.com/watch?v=8uMwppw5AgU.

Weeks, J. 2011. *The Languages of Sexuality*. New York: Routledge.

West, C. 1993. *Race Matters*. Boston, MA: Beacon.

Yuval-Davis, N. 2006. "Intersectionality and Feminist Politics." *European Journal of Women's Studies* 13 (3): 193–209.

4

"Heather has transitioned": Transgender and Non-binary Contestants on *RuPaul's Drag Race*

K. Woodzick

Drag is what I do; trans is who I am.
—Monica Beverly Hillz, *RuPaul's Drag Race: Reunited*,
Season Five, 2013

In his book *Reality TV and Queer Identities: Sexuality, Authenticity, Celebrity*, Michael Lovelock makes the observation that "reality television has been one of the most prolific spaces of queer representation in Anglo-American popular media since the beginning of the twenty-first century" (2019, 3). This chapter asserts that within the canon of reality television, transgender and non-binary contestants from *RuPaul's Drag Race* have made a profound impact in accelerating representation for the smaller subset of transgender and non-binary identities contained under the LGBTQIA+ umbrella in a range of cultural spheres. Moreover, I argue that *Drag Race* has shifted the narrative of transgender and non-binary individuals in popular culture from one exclusively focused on suffering and trauma to one that includes celebration and agency.

The present chapter supports this assertion by examining the tenure of selected trans and non-binary contestants chronologically, in terms of when they first appeared on the show, making note of when and how they publicly came out and the arc of their impact as cultural ambassadors for the trans and non-binary community. The case study of each contestant will close with an appraisal of their Twitter and Instagram followings and bios as an equalizing measure of their reach

and agency in self-definition. Focus in this chapter is primarily on Kylie Sonique Love, Carmen Carrera, Jiggly Caliente, Jinkx Monsoon, Monica Beverly Hillz, Gia Gunn, Peppermint, and Shea Couleé.

Season Two: Kylie Sonique Love

Kylie Sonique Love competed on *RuPaul's Drag Race* as Sonique in season two, which aired in 2010. Though she was eliminated in the fourth episode, she left a memorable impression during her lip-sync performance against Morgan McMichaels, executing flawless gymnastic choreography. Particularly haunting, in retrospect, was the request from the judges' table for her to remove her cat mask because she appeared to be hiding. Watching transgender and non-binary contestants throughout the seasons, this is a theme that reoccurs: the judges commenting on not knowing who these contestants really are. This trend speaks to an expectation in reality television that Lovelock calls "compulsory authenticity." He defines this term as "the notion that each individual has an innate and essential 'true' self which is their duty to discover, manifest and be faithful to, and that failing to 'be yourself' constitutes nothing short of an existential crisis" (2019, 4).

Sonique is set up for her moment of compulsory authenticity during the season two episode, "Reunion" when RuPaul congratulates her on the lip sync between her and Morgan and asks about her overall experience on the show. Sonique replies that her time on the show felt dreamlike and she did not feel completely focused on the competition itself. At this point in the episode, the audience is reminded that this is indeed a reality show, as RuPaul woodenly asks the question that prompts the beginning of her disclosure of compulsory authenticity:

> RUPAUL: Like where else? What are you talking about?
> SONIQUE: I don't really feel that people got a chance to know who Sonique is.
> RUPAUL: And I've heard there's something you want to share with us, concerning that.
>
> (Reunion 2010)

At this point, Sonique starts to trip over her words, and it is difficult to tell how much is acting nervous for the camera and how much is her truly grappling with the decision to make this deeply personal part of herself public.

Morgan, who was last presented to the audience in relation to Sonique as a competitor, quickly follows to comfort her, and RuPaul waits a few beats before following as well. We hear faint audio of Sonique as she tells Morgan, "That's why I've been so unhappy for so long." When RuPaul presses her for

an answer, this time adopting a motherly tone with his inquiry, Sonique eloquently responds:

> I haven't been happy for a really long time in my life, and I've never understood why. I just had to be honest with myself, and I've ... I'm ... a woman. I'm not a boy who dresses up. The—I feel like the only thing I've ever done right was go to a doctor and start transitioning. I've never been happier in my entire life.
> (Reunion 2010)

Morgan's face beams with joy and acceptance for her friend. RuPaul offers a perfunctory "Good" and encourages them to go back to the group to "talk about it a little." Morgan continues to hold her hand and says, "I'm proud of you." Sonique returns to the set and reiterates what she said to the whole group.

RuPaul interjects with "Well, I know a lot of people get confused—what a transsexual is and what—"

Sonique interrupts to say (and correct the vocabulary used), "There's a line between drag and transgender. Most transgender girls do not drag. You know, they want to live their life solely as a woman. Where drag queens want to get out of drag and be a man. When I go home, I ne—I dread taking off my makeup" (2010).

RuPaul applauds her courage and thanks her for explaining and clarifying the difference between doing drag and being trans.

It is worthwhile to look at this interaction in detail, as it is the first time on the show that the word "transgender" is used. Both "tranny" and "transsexual" had been used before this episode aired. During the "Extra Special Edition" episode of season one, aired in 2009, Ongina says, "May the best tranny win." In the "Starbootylicious" episode of season two, the two competing burlesque teams danced to RuPaul's song "Tranny Chaser." Sonique has the distinction and legacy of introducing the word "transgender" into the lexicon of *Drag Race*. She uses her agency to start the conversation about the trans community being a culturally valued part of the LGTBQIA+ community, instead of an often-misunderstood identifier.

The shadow side of Sonique's visibility and impact as a trans woman competing on the program is the knowledge that she had already had the intention of physically transitioning before starting to film season two. She has since revealed that the producers told her that she would not be allowed to undergo hormone replacement therapy (or HRT) during the course of filming. They made the choice to prioritize what they perceived to be the visual appeal of the distinct difference between the contestants in and out of drag—the compulsory authenticity of showing both aspects of the gender binary.

In an interview since season two was released, Sonique looks back on that moment proudly and reflects on the impact that her words have had:

> It was so freeing coming out to the world as a girl on national television. Since the show aired, I've gotten emails from people all over the world who tell me things like "you saved my life." I've heard horror stories of friends' suicides and been told that my coming out gave so many people the courage to live their lives as who they are.
>
> (Fletcher 2014)

By making the decision to come out as trans on the reunion show, Sonique provided a template and gave permission to other transgender women who wanted to perform as drag artists to audition for the show. Though trans and non-binary contestants typically choose to wait until their season is over to have more control over their narratives, Sonique's presence and testimony on season two, especially the reunion episode, has cemented her place as the cornerstone of trans and non-binary representation on/from *Drag Race*.

Sonique is not as outspoken as some of her trans and non-binary peers. She continues to perform regularly and is honest about the hypervigilance that often accompanies those in the transgender community:

> I was out with a friend recently, and I was uncomfortable because I felt people were staring at me. My friend asked me what was wrong, and I told her. She said, "Relax, Kylie, people are looking at you because you're beautiful. You're not a freak; there's nothing wrong with you. People stare at you because you're beautiful."
>
> (Fletcher 2014)

Sonique returned to *Drag Race* in 2018 for the *RuPaul's Drag Race Holi-slay Spectacular*. While visiting Alaska and Willam's podcast *Race Chaser*, Sonique shared that World of Wonder (the production company that produces *RuPaul's Drag Race*) had reached out to her earlier to produce content with them, but she did not have the time. The *Holi-slay Spectacular* seemed like the ideal opportunity in terms of timing. Sonique wanted to show that a transgender person belonged on the special, but she wanted to control her narrative and not focus on her gender:

> I purposefully didn't talk about me being transgender on the show because I just feel like every time you see a trans person on tv, they're always talking about their story—but I already did that, and I just want people to see me as a fierce competitor.
>
> (Belli and Thunderfuck 2018)

Willam interjected that though the episode ended up not being a competition, the audience reaction was such that if it had been, Sonique would have won, as her outfits and performances really stood out. Sonique responded: "It's been incredible—the support from the friends—no one has questioned anything.

I get to be the girl character of *RuPaul's Drag Race*, you know" (Belli and Thunderfuck 2018).

Kylie Sonique Love has 184,000 followers on her Instagram and 54,000 on her Twitter. Her Twitter bio reads: "showgirl, recording artist, model, actress. trans human & contestant Rupaul's Drag Race S2." Following the assumption that content creators adhere to social media best practices of prioritizing their branding, Sonique puts her artistic accomplishments first, followed by her transness, and last, her time on *RuPaul's Drag Race*.

Season Three: Carmen Carrera

Carmen Carrera competed in season three of *RuPaul's Drag Race*, which aired in 2011. Her aesthetic signature was wearing burlesque-inspired outfits that showcased her physique. In "The Queen Who Mopped Xmas," judge Michelle Visage warns Carmen (from one Jersey Girl to another) about relying on her body to get through the competition. In the work room, Carmen is part of the "Heathers" clique, consisting of Raja, Carmen, Delta, and Manila. The name comes from the 1988 film starring Winona Ryder, in which all the girls in the popular clique are named Heather. Carmen did not come out as transgender until after her time on the show, and it is worth highlighting that she was given a narrative that placed her with the pretty, mean girls and did not portray her as an outsider. However, similar to Sonique, the judges negatively commented that they felt they never got a sense of who Carmen really was.

The final episode of season three aired on May 2, 2011. Carrera later shared in an essay that accompanied a modeling spread she did for *W Magazine* that she decided to transition the day after filming wrapped on season three (Carrera 2013). Carrera came out publicly as transgender one year later, on the ABC news program *What Would You Do?*, a hidden camera show that documents actors in staged situations and the reactions of the people around them. The episode was aired on May 4, 2012, and showed footage of Carrera portraying the role of a transgender waitress who is being harassed by an actor playing the part of a transphobic customer.

The show's premise is ostensibly inspired by Augusto Boal and his work with Theatre of the Oppressed, specifically Invisible Theatre. While Boal was adamant that the actors in his work did not reveal themselves, *What Would You Do?* relies on a format that provides relief in the form of the audience members being told that they are on a television show. The segment shows footage of three different individuals who intervene on Carrera's behalf. Each one stands up to the transphobic remarks of Kevin, the actor hired to play the transphobic customer returning to

his favorite diner after a year of travel. The upstanders address Kevin directly, making remarks such as:

> "That's fine. I don't care what she is ... let her be what he or she is. Mind your business, eat your breakfast and get out. You don't have to stay here. Let her do what she wants to do. All right? It's ok to be whoever you want to be. This is America. MIND YOUR BUSINESS."
>
> "You know what, just leave it alone. Or, take your narrow mind somewhere else."

When Kevin asks this upstander, "How can you be so accepting?" he responds with "How can you not be?"

In the interview that follows the interaction, this upstander is asked, "Where did you learn this?" Without hesitating, he replies, "Good Catholic upbringing. Good Irish mom" (*What Would You Do?*, 2012).

Carrera shares in an interview that she was not totally prepared for how these fabricated interactions would challenge her. Even though people were advocating on her behalf and checking in with her to make sure she was okay, she found herself shaking. When asked what message she wants to share, she replies:

> I would love for the rest of the society to catch up to my mentality. The way I see things is that, I think that transgender people are super brave. If you're a female to male, male to female, if you're that brave to take control of your own body and make it however you want it to be, more power to you. I hear things from people, like oh, religious things, like whatever. But the way I see it is, this body is like my apartment that I'm living in while I'm here on earth. If I want to renovate it or change it and if it's possible to do, why not do it? Why should I be judged for it?
>
> (Garvey 2012)

Since coming out, Carrera has created an international reach for herself as a model and LGBTQIA+ advocate. In 2013, nearly 48,000 fans signed a change.com petition to make her the first transgender Victoria's Secret model (Change.org 2013). In an interview with *The Daily Beast*, Carrera said that she was more than ready to take on a modeling position with Victoria's Secret. She mentioned that Isis King, a transgender contestant on *America's Next Top Model*, had reached out to her when Carrera first started modeling and encouraged her to get in touch whenever needed (Romano 2013).

Carrera was not only confident in her modeling abilities but also acutely aware of the cultural impact of her modeling career:

> Once you get to that point of finally realizing who you are and be strong enough to live it, anything is possible. I want to walk the Victoria's Secret show. I want to walk all the shows all over the world I want to be on Maxim's 100. I want to make People magazine's 50 Most Beautiful People. Those are my goals. Because I feel like trans people need a positive representation and if I have that opportunity now, in my youth, right now, I'm going to take it. I'm going to go for it because who knows who's watching me.
>
> <div align="right">(Sieczkowski 2013)</div>

In 2014, Carrera publicly denounced the "You've Got She-Mail" segment on *Drag Race* in a Facebook post (Molloy 2014). By speaking out against this language, she lent her voice and status as a former contestant to this conversation, which led to the producers renaming the segment entirely. Carrera's activism on this issue was motivated by a response to the notorious "Female or She-male?" mini challenge in which contestants were shown different body parts on a screen and made to guess whether they belonged to a cisgender woman or a drag performer.

Carrera reflected that speaking up about the transphobic segment and language was well worth it as it resulted in tangible changes by the producers of the program. She was candid in revealing that the advocacy was not without a cost. Several contestants and fans criticized her for "biting the hand that feeds her" and even went as far as accusing her of being hypocritical for not coming out against the language while she was a contestant on the show. Carrera has asserted that performance work has been taken away from her because of her speaking up about the transphobic language used on *RuPaul's Drag Race*, which has galvanized her to focus on her modeling and activist work.

Carrera's 2019 appearance on *Hey Qween!* provides a candid and nuanced showcase of her evolution as an entertainer and activist. She starts the interview by highlighting her commitment to work with gender-diverse youth:

> I know a lot of these kids have heard the wishful thinking, like "things get better," "don't worry about it," but they don't have the tools and resources that they need mentally to really set that into motion and have that attitude and be confident in who they are. So that's sort of where my work comes in, because I have questioned myself so many times … you have all these opinions thrown at you and secretly on the inside, my inner child is just screaming for love, too, you know, so that's where we connect, is like, I know the pain that you feel, and I want to take it away from you and I want to get rid of it because it's not yours, it's been projected on to you by society or from people who don't understand you.
>
> <div align="right">(*Hey Qween!* 2019)</div>

She reflects on her time competing on *Drag Race* fondly and says that though she made the decision to transition before going on the show, she wanted her mother to have footage of her pre-transition as a time capsule of sorts. Her intention is to proudly rewatch her season at different stages of her life.

Carrera has nearly 97,000 followers on Twitter and 538,000 followers on Instagram. She lists her pronouns in her Twitter bio and defines herself as an "artivist" and "transgender pioneer" on her Instagram bio. More than any other contestant referenced in this chapter, she has created a prolific international reach in her art and activism. As Carrera said her 2019 appearance on *Hey Qween!*: "Heather has evolved. Heather has transitioned."

Season Four: Jiggly Caliente

Season four of *RuPaul's Drag Race*, which aired in 2012, featured the talents of contestant Jiggly Caliente, who prefers to be credited as Bianca Castro in her acting work. During the season, she performed firmly in the middle of the pack, being eliminated by Willam in the lip sync at the end of the "Dragazines" episode. Her narrative arc on the show focused its attention on a fatphobic narrative, though she consistently presented her runways with confidence.

In 2016, Castro came out as a transgender woman. In an interview on the show *Hey Qween!*, she revealed that she had started to transition before filming season four. However, she was hesitant to come out publicly. She explained that Sonique and Carrera had come out before her, and she did not want to appear to be "riding their coattails." While she perceived other members in the trans community pressuring her to come out publicly, Castro wanted to prioritize privacy around her gender, and she also had trepidations about becoming a public role model and transgender activist.

"I am *the* most flawed individual," she explained, also referencing her experiences as an escort earlier in her life. She finally came out in 2016 to end speculation about her gender. She admits that she feels lighter after coming out but is trying to find a balance between her public and private lives (*Hey Qween!* 2016).

In 2018, Castro originated the character of Veronica Ferocity on the FX series *POSE*. The Ryan Murphy series celebrates the drag performers of underground ball culture in New York in the 1980s and has the distinction of featuring more transgender actors in regularly recurring roles than any other television show in history. She shared the joy she felt when she saw "Bianca Castro" on the credits for the television show, as she feels that her impact as an artist goes beyond her drag persona, and she wants to continue to be recognized for her acting work in addition to the drag character of Jiggly that she has created. Castro has also been

featured multiple times on *Broad City*, including a scene in the final season that showcased a fantasy drag brunch hosted by Alan Cumming.

The year 2018 also saw the release of Castro's first full-length album, *T.H.O.T. Process*, under the name of Jiggly Caliente. She wanted to use the album as a platform to show her pride in her heritage:

> "Purong Pinay" has instruments native to the Philippines used in the actual song. That's one thing I wanted to make sure that people see the culture. I want people to know there is a voice behind this woman. I am proud of my culture, super proud of my culture. I am proud to be Filipina and I wanted my album to represent that, too. My album is hip-hop but it's diversifying the hip-hop world.
> (Youtt 2018)

"All That Body" is an anthem for body positivity and features Isis King, Alaska Thunderfuck, and Ginger Minj. It brings audiences back full circle to the episode of *Drag Race* where she was eliminated for attempting a more serious take on creating a cover for a fitness magazine instead of going the comedic route.

Castro's career since competing on *RuPaul's Drag Race* is impressive, body positive, and intersectional. She has 157,000 followers on Instagram and 2,142 on Twitter and chooses not to include information about her gender in either bio. Her transparency about her fear of being imperfect serves as a reminder that the journey of gender-diverse individuals is deeply personal and unique.

Season Five: Monica Beverly Hillz and Jinkx Monsoon

Season five of *RuPaul's Drag Race*, which aired in 2013, featured both a transgender woman who came out during the course of filming and one of the first contestants to come out as non-binary, after their season had aired. Monica Beverly Hillz has the distinction of being the first contestant to come out as transgender in a season of the program. During her critiques for the "Lip Synch Extravaganza Eleganza" episode, she was placed in the bottom two for her lackluster portrayal of Jiggly during a lip-sync challenge. She started crying when the judges remarked that she appeared to be "disconnected" in her runway presentation. RuPaul asked her what was going on, which led to the following exchange:

> HILLZ: "I've just been holding a secret in, I've been trying so hard—"
> RUPAUL: "What secret?"
> HILLZ: "I'm not just a drag queen. I'm a transgender woman."
> (2013)

Moments later, the episode cuts away to Jinkx Monsoon saying, "Monica has been through everything. Right now, she's my hero. She's the strongest girl in this competition."

It is unclear if RuPaul or the producers had prior knowledge of Hillz's identity, as they did with Sonique. RuPaul offers words of support, saying that the reason Hillz is on the show is because she is fierce and that she needs to believe in herself. Hillz goes on to win the lip-sync challenge on this episode, only to be eliminated at the end of the next.

After her run on the season, Hillz has evolved into a fierce advocate for trans rights, writing a piece for the *Washington Post* in March of 2018 titled "I'm a Trans Woman and a Drag Queen. Despite What RuPaul Says, You Can Be Both" (Hillz 2018). The piece was in direct response to RuPaul's now infamous comments during an interview in the *Guardian* in which he said he probably wouldn't allow a trans woman who had started the process of physically transitioning to compete on the show (Aitkenhead 2018).

Hillz deftly breaks down each aspect of RuPaul's argument in her piece. She starts by stating the importance of her seeing the film *To Wong Foo, Thanks for Everything, Julie Newmar* (1995) as a child. She was unsure whether the character Chi-Chi was a cisgender man doing drag or a transgender woman, but she loved the character because finally she had found representation: a character who looked and acted like she felt.

After foregrounding the importance of representation, Hillz went on to address RuPaul's comments directly, stating that she had known she was a trans woman years before she competed on *Drag Race*. When she tried to share these feelings about her identity with other drag queens, she felt shut down as others would respond by telling her she was just "an effeminate gay guy who made a pretty drag queen" (Hillz 2018).

Her saving grace was ultimately a trans woman who performed in drag, who explained to her how those two things did not have to be mutually exclusive. Through the help of this friend and mentor, Hillz was able to access "street hormones" (those not prescribed by a doctor). She explains:

> By looking more "real," I was safer and received less homophobic harassment while navigating daily life. But it also made me more desirable as a drag queen at clubs. When we appear more feminine, customers consider us more beautiful, bar staff take better care of us and managers book us more. Audiences tip us more frequently and with bigger bills.
>
> (Hillz 2018)

Hillz continues her piece by explaining how the desire to look more "real" dominates drag culture and many performers turn to procedures not covered by insurance:

As a result, there's a lot of pressure on drag queens to turn to street hormones and "pump parties," where non-surgical-grade silicone and other materials are injected to achieve feminine curves. While some male performers realize they identify as women and begin to transition, others continue to identify as cisgender gay men. This issue has divided friends in the drag world. Some gay men may feel betrayed or left behind by their close friends who started off as cisgender but later transitioned.

(Hillz 2018)

This piece is well-worth the read in its entirety. Hillz provides a detailed account not only of her own personal journey, but also of the intersections of race and sexuality that play into these issues and conversations. She is grateful for the opportunity and platform she was given as a result of the show, while still holding RuPaul and the producers accountable to examine their biases and reframe their perception to consider transgender women as "equitable competitors."

Hillz has nearly 53,000 followers on Instagram and almost 49,000 on Twitter, and similar to Castro, she does not reference her transness in her social media bios.

Season five is a landmark season not only because of the cultural contributions of Monica Beverly Hillz, but also for the fact that it was the first season to feature a non-binary contestant, though they came out after the show was released. Jinkx Monsoon won season five of *RuPaul's Drag Race*. Monsoon (who uses they/them pronouns when out of drag) went on to release two full-length albums and book acting and voice-over work, including originating the role of Emerald on the Cartoon Network series *Steven Universe*.

Steven Universe is an inclusive cartoon created by non-binary artist Rebecca Sugar, which premiered on Cartoon Network in 2013. The show focuses on a child named Steven, who presents as a young boy, though he is also half Gem. In the world of the cartoon, the Gems are beings from another realm that protect our universe. Sugar has gone on record stating that all of the Gem characters are non-binary (Necessary 2018). When it was revealed that Monsoon was voicing one of the Gems in 2017, fans perceived Monsoon voicing the role to be a cisgender man giving voice to a non-binary character and expressed their frustration at the casting choice online (Henderson 2018).

Monsoon responded via Twitter, explaining that they had come out as non-binary four years previously and also had "privately identified under the Trans umbrella" since they were a teenager. This online debate was one of the factors that led Monsoon to write a new song for their second album titled "Just Me (The Gender Binary Blues)." The song was also written in response to the national debate about transgender people and bathroom usage. They reflected on the writing process of the song with their frequent collaborator Major Scales:

The biggest misconception I think everyone taking away from it was that a person is defined by their gender or the way that they present and that's just one aspect of our personality. I sat down with Major and went through all the most poignant moments in my life that someone has made some kind of comment either positive or negative about my gender and my gender presentation.

(Goodman 2018)

Memorable lyrics from the song include:

Now in the past I've caused confusion, it's true
But what's the fun of living life pink or blue?
I say just tell 'em all to shut up and just be you.

(Just Me [The Gender Binary Blues] 2018)

Monsoon's priority is to let audiences know that gender is a construct that should be interrogated:

Mainly what I'm trying to do is help everyone see that just because you were born with certain genitalia doesn't mean that anyone gets to tell you to live your life any way prescribed by the genitalia you were born with. Gender is a concept that we created as a society and it's a concept we can recreate and revamp and reform as many times as we need to be inclusive.

(Goodman 2018)

Monsoon has a robust social media following, boasting 1.1 million on Instagram and 422,000 on Twitter. Their Twitter bio includes the differentiation of pronouns in and out of drag: "In Drag: She/Her—out of Drag: They/Them."

Season Six: Gia Gunn

In 2014, season six of *Drag Race* introduced the world to Gia Gunn. Gunn was eliminated during the "Snatch Game" episode on her original season, but returned to the show in 2018 (after coming out as trans in 2017) to compete on season four of *All-Stars*. This marked the first time that a transgender contestant was asked to compete on *All-Stars*, and her casting was seemingly in response to the backlash against RuPaul's comments on trans gatekeeping that appeared in the *Guardian* earlier that year. Gunn had responded earlier in the year to those comments by saying, "I respect that this is RuPaul's decision, but at the end of the day I don't feel that my transness has anything to do with me as an artist. If you're a fierce

queen and you bring it to the runway you should be accepted as one and nothing more and nothing less" (Blackmon 2018).

Gunn was also a guest on the *Race Chaser* podcast, where she opened up about her experience returning to the show. She shared that in the months after filming *All-Stars Four*,

> I realized that I was on there for one reason only, which was really for me to bring not only trans visibility to the show, but in hopes that by me participating—to open doors for, you know, other types of drag queens to come through and hopefully be seen on our television screens, whether that be *Drag Race* or another platform.
>
> (Belli and Thunderfuck 2019)

She revealed that she felt that she was put in a position to clean up the mess/backlash against the show in the wake of RuPaul's comments in the previously referenced interview in the *Guardian*. While she did have an on-camera conversation with RuPaul about his past and current opinions regarding transgender contestants, none of that footage made it to air. Gunn also spoke about her hopes that audience members who watched the show would acknowledge that it is a reality competition. She expressed interest in the audience seeing her as both an instigator/villain reality television character and a transgender activist, as she wants them to know that those two aspects of her persona are not mutually exclusive.

Gunn has 619,000 followers on Instagram and 142,000 on Twitter and does not currently reference her gender in either bio.

Season Nine: Peppermint and Shea Couleé

Season nine of *RuPaul's Drag Race*, which aired in 2017, featured the most gender-diverse cast of any season, though some of the contestants did not come out until after the season aired. Peppermint made history as the first contestant to enter the program as an out trans woman. She came close to winning the season, placing first runner-up to winner Sasha Velour. Peppermint went on to be the first openly transgender woman to originate a role on Broadway as Pythio in the Go-Go's jukebox musical *Head over Heels*, which opened in 2018.

Peppermint understands the importance of representation not only to her community but also to others who might be encountering conversations about gender diversity for the first time:

> To people who might be new to these issues, it's served in a loving way that people can easily understand. On the other hand, it shows people who identify as non-binary, gender non-conforming, or trans: Look at what the possibilities are.
>
> (McPhee 2018)

Peppermint has also achieved success on television. In November of 2018, *Saturday Night Live* produced a commercial parody for a new car navigation system that featured a voice option of "Drag Performer." Both Peppermint and Castro (Jiggly Caliente) were featured in the commercial parody, which has been viewed over eight hundred thousand times on *SNL*'s YouTube channel.

In June 2019, Peppermint was featured in season two, episode two, of *POSE*. She posted on her Instagram feed:

> Art imitates life, for years the only medium that would showcase transgender people was pornography. Hollywood was never interested in displaying transgender artists doing anything. Finally over the last few years we've seen mainstream television take that first step. *Orange is the New Black*, which I believe paved the way for shows like *Transparent*, and now we have *Pose*. One thing I really like about the show is that it not only uses queer and trans talent from the community on and off camera but never before have I seen a mainstream TV show talk about the types of things that would have been life-affirming for me to witness on TV when I was 12.
>
> (Peppermint 2019)

Peppermint has over half a million followers on Instagram and 143,000 on Twitter. Her Twitter bio reads, "New Yorks SWEETEST Diva. activist. trans entertainer. *RuPaul's Drag Race* Season 9."

In May of 2019, season nine contestant Shea Couleé came out publicly as non-binary. Growing up in a very religious family, it was difficult for Couleé to explore their gender. They cited the toxic masculinity within the black community as another impediment to discovering their gender. Drag became a venue for self-discovery:

> Once I started to use drag as gender performance, to study that and understand my identity through that, I feel now that being a gender non-binary person occupying drag spaces is freeing. Everything I'm doing when I'm in those spaces is as authentically me as I can be.
>
> (Lang 2019)

When asked about the future of gender diversity on *Drag Race*, Couleé replied with a call to action to give audiences more credit:

I think they need to stop worrying about whether or not the fans are ready, because I think they are. I understand that the show's viewership has gotten much younger as the franchise has grown. The creators of the show, they have family and young kids and there are things I feel like they think could potentially be confusing, but I don't think it's too hard to explain that there are many different people of different gender identities that perform in drag.

(Lang 2019)

Couleé has 834,000 followers on Instagram and 200,000 on Twitter and chooses not to reference their gender in either bio.

One chapter is hardly long enough to detail all of the cultural contributions provided by the transgender and non-binary contestants of *RuPaul's Drag Race*. The case studies of the contestants contained within this chapter demonstrate the breadth and range of the reach of gender-diverse contestants from the program and the rate at which they are accelerating cultural conversations about gender diversity. They are all transgender theory scholars performing practice-based research in popular culture, gender performance, and LGBTQIA+ activism.

In conclusion: yes, representation in mainstream media is the most visible contribution that trans and non-binary contestants have made. But, arguably, their largest contribution is their practice-based research of being ambassadors in spaces that affect the language of those around them. In season four of *All-Stars*, which aired in 2018, RuPaul changed the famous line "Gentlemen, start your engines, and may the best woman win!" to "Ladies and Gentlemen, start your engines, and may the best All-Star win!" When Peppermint was in the top four in season nine, Ru showed a picture of her as a child, and while he gendered the other contestants in their throwback photos, he did not do so for Peppermint.

The common narrative that continues to resurface between contestants, especially those who are transgender women, is that their culture reflected to them over and over again that they had to choose between their gender and doing drag. And yet each of these contestants pushed through those transphobic messages, embracing their true gender and creating their own career path through the larger platform afforded to them by being on *Drag Race*.

Transgender and non-binary alumni of *Drag Race* provide hope and representation to trans and non-binary youth. For cisgender audiences who might experience transgender representation for the first time by viewing the show, these contestants may start them on the path to tolerance and acceptance of trans identities. As the program evolves, it has the opportunity with its platform to guide modern cultural perceptions of the trans and non-binary community.

Season five contestant and *All-Stars* season two winner Alaska Thunderfuck, though not overtly trans identifying, recently created the Drag Queen of the Year Pageant Competition Award Contest Competition. This competition made its mark not only by its inclusive line up of competitors, but also by a diverse panel of judges, including Gia Gunn, Peppermint, Jiggly Caliente, and drag king and current reigning *Dragula* champion Landon Cider. At the beginning of the competition Alaska addressed the audience by saying, "Drag is for everyone at all times" (Baume 2019).

Even if gatekeepers against transgender and non-binary drag performers continue to exist, the drag community has shown itself to be elastic enough in its inclusivity to continue to expand. Therefore, whether or not to include trans and non-binary drag queens is no longer the pressing question. The question becomes: how can the cultural impact of trans and non-binary drag performers best be honored and celebrated? As the alumni featured in this chapter have shown, the contributions of trans artists are invaluable in galvanizing conversations about gender diversity and performance now and in the future.

REFERENCES

Aitkenhead, Decca. 2018. "RuPaul: 'Drag Is a Big F-You to Male-Dominated Culture.'" *Guardian*, March 3, 2018. https://www.theguardian.com/tv-and-radio/2018/mar/03/rupaul-drag-race-big-f-you-to-male-dominated-culture.

Baume, Matt. 2019. "Alaska's New Drag Competition Proved That Gender-Inclusive Drag Is Better." *Them.us*, May 30, 2019. https://www.them.us/story/alaska-drag-competition.

Belli, Willam, and Alaska Thunderfuck. 2018. "BONUS! Holi-Slay Spectacular." In *Race Chaser with Alaska & Willam* Podcast, December 25, 2018.

———. 2019. "All Stars S4E3 'Snatch Game of Love.'" In *Race Chaser with Alaska & Willam* Podcast, January 1, 2019.

Blackmon, Michael. 2018. "RuPaul Reversed Himself and Is Now Allowing a Trans *Drag Race* Contestant to Compete." BuzzFeed News, November 16, 2018. https://www.buzzfeednews.com/article/michaelblackmon/rupaul-drag-race-all-stars-gia-gunn-trans.

Boal, Augusto. 1985. *Theatre of the Oppressed*. Translated by Charles A. and Maria-Odilla Leal McBride. New York: Theatre Communications Group.

Carrera, Carmen. 2013. "Carmen Carrera: Show Girl." *W Magazine* | Women's Fashion & Celebrity News, August 15, 2013. https://www.wmagazine.com/story/carmen-carrera-transgender-performer-autobiographical-essay.

Fletcher, Carlton. 2014. "Kylie 'Sonique' Love Transitioning into Woman She Was Born to Be." *Albany Herald*, December 18, 2014. https://www.albanyherald.com/news/kylie-sonique-love-transitioning-into-woman-she-was-born-to/article_5b79d763-3a14-5956-b04c-a470984313ac.html.

Garvey, Georgia. 2012. "Carmen Carrera Comes Out—as Transgender." Chicagotribune.com, June 6, 2012. https://www.chicagotribune.com/redeye/ct-red-carmen-carrera-q-and-a-20120606-story.html.

Goodman, Elyssa. 2018. "Jinkx Monsoon Talks New Album, Coming Out as Gender Nonbinary & 'Steven Universe' Role." *Billboard*, January 16, 2018. https://www.billboard.com/articles/news/pride/8094367/jinkx-monsoon-interview-new-album-gender-nonbinary-steven-universe-role.

Hey Qween!. 2016. "Jiggly Caliente UNCUT Part 1 On Hey Qween with Jonny McGovern! | Hey Qween." YouTube video, June 20, 2016. https://www.youtube.com/watch?v=-lJuy38ManY.

———. 2019. "CARMEN CARRERA on Hey Qween!—Part 3." YouTube video, April 22, 2019. https://www.youtube.com/watch?v=iv997hV6Ugk.

Henderson, Taylor. "Jinkx Monsoon Voiced a New Steven Universe Gem, Ignites Heated Debate." Gay Pride—LGBT & Queer Voices, PRIDE.com, January 9, 2018. https://www.pride.com/dragqueens/2018/1/09/jinkx-monsoon-voiced-new-steven-universe-gem-fans-are-obsessed.

Hillz, Monica Beverly. 2018. "Perspective | I'm a Trans Woman and a Drag Queen. Despite What RuPaul Says, You Can Be Both." *Washington Post*, WP Company, April 28, 2018. https://www.washingtonpost.com/news/post-nation/wp/2018/03/09/im-a-trans-woman-and-a-drag-queen-despite-what-rupaul-says-you-can-be-both/?noredirect=on&utm_term=.37e2d983b838.

"Just Me (The Gender Binary Blues)." Jinkx Monsoon. *The Ginger Snapped*. Los Angeles: Producer Entertainment Group, 2018.

Lang, Nico. 2019. "Shea Couleé Opens Up about Embracing Their Non-binary Identity." Them, May 30, 2019. https://www.them.us/story/shea-coulee-interview.

Lovelock, Michael. 2019. *Reality TV and Queer Identities: Sexuality, Authenticity, Celebrity*. Cham, Switzerland: Palgrave Macmillan.

McKinnon, Bob, dir. 2009. *RuPaul's Drag Race*. Season 1, episode 7. "Extra Special Edition." Aired March 16, 2009, on Logo TV.

McPhee, Ryan. 2018. "*RuPaul's Drag Race* Star Peppermint on Making History in New Musical Head Over Heels." Playbill. PLAYBILL INC., June 18, 2018. http://www.playbill.com/article/rupauls-drag-race-star-peppermint-on-making-history-in-new-musical-head-over-heels.

Molloy, Parker Marie. 2014. "Carmen Carrera Slams *Drag Race* Over Transphobic Slur." *Advocate*, April 1, 2014. https://www.advocate.com/politics/transgender/2014/04/01/carmen-carrera-slams-idragracei-over-transphobic-slur.

Murray, Nick, dir. 2011. *RuPaul's Drag Race*. Season 3, episode 2, "The Queen Who Mopped Xmas." Aired January 24, 2011, on Logo TV.

———. 2012. *RuPaul's Drag Race*. Season 4, episode 7, "Dragazines." Aired March 12, 2012, on Logo TV.

———. 2013. *RuPaul's Drag Race*. Season 5, episode 2, "Lip Synch Extravaganza Eleganza." Aired February 4, 2013, on Logo TV.

Necessary, Terra. 2018. "Rebecca Sugar Opens Up about Being Non-binary." Gay Pride—LGBT & Queer Voices. PRIDE.com, July 18, 2018. https://www.pride.com/comingout/2018/7/18/rebecca-sugar-opens-about-being-non-binary.

Peppermint. 2019. Public Instagram story, June 25, 2019.

Romano, Tricia. 2013. "Transgender Model Carmen Carrera Says She Wants to Walk the Victoria's Secret Show." *Daily Beast*, November 12, 2013. https://www.thedailybeast.com/transgender-model-carmen-carrera-says-she-wants-to-walk-the-victorias-secret-show.

Sieczkowski, Cavan. 2013. "Transgender Model Carmen Carrera Responds to Victoria's Secret Petition." *HuffPost US: Queer Voices*, December 11, 2013. https://www.huffingtonpost.ca/entry/carmen-carrera-victorias-secret-transgender_n_4260557.

Youtt, Henry. 2018. "Jiggly Caliente Talks 'Pose' Cameo and New Music: 'I Am Going for It All.'" *Billboard*, July 13, 2018. https://www.billboard.com/articles/news/pride/8465386/jiggly-caliente-interview-pose-new-music-drag-race.

5

How *Drag Race* Created a Monster: The Future of Drag and the Backward Temporality of *The Boulet Brothers' Dragula*

Aaron J. Stone

We have never been queer, yet queerness exists for us as an ideality that can be distilled from the past and used to imagine a future. The future is queerness's domain.
—José Esteban Muñoz, *Cruising Utopia*

Before gays were decorating houses, making wedding cakes and doing celebrities' hair, they were the real fucking artistic terrorists in this world.
—Sharon Needles

Season two of *The Boulet Brothers' Dragula: Search for the World's Next Drag Supermonster* opens with anxious orchestral music and shots of skyscrapers, then cuts to the interior of a white-painted hallway and a door with a gold placard reading "Basic American Network" (Noyes 2017). Behind the door is a group of white male television producers gathered around a conference table. The camera zooms in on a packet of papers held by the man at the head of the table, which reads "*Boulet Brothers' Dragula* Season 2 Pitch." One by one the men in suits begin to voice their concerns about the show being unacceptable for the network. The camera pans down the conference table toward two drag queens, whom viewers will recognize as Dracmorda and Swanthula Boulet, the hosts and creators of *Dragula*. They are done up identically in executive gothic drag: white pantsuits, white fur hats, white contacts, claw-like black stiletto nails, and black rubber

chokers that appear to drip down their white blouses. A savvy viewer will realize that the Boulet Brothers' outfits transform this sketch into a parody of the boardroom scene from the 1981 camp classic *Mommie Dearest*, in which Faye Dunaway, playing Joan Crawford, makes an impassioned and defiant speech against the members of the Pepsi board who are trying to retire her after her husband's death (Perry 1981). In their riff on this scene, the Boulet Brothers stare menacingly at the producer opposite them, who says: "No, no, this won't do. With all due respect, despite the demands of your fans, we feel it would be irresponsible, as a network, to promote and spread the, frankly, disturbing and disgusting message of your show." Another man chips in: "Maybe if it were a little less bloody and a little more heterosexual." The Boulet Brothers respond à la Dunaway—"Don't fuck with us, fellas! This ain't our first time at the rodeo"—before pressing their fingers to their temples and, after a moment of dramatic concentration, telekinetically murdering everyone in the room. The scene concludes with a clawed hand sweeping the placard that reads "Basic American Network" out of its holder on the conference room door and replacing it with one that reads "Boulet Brothers Productions."

This vignette encapsulates much of what *Dragula* stands for. The show, a campy reality drag competition in the style of *RuPaul's Drag Race*, showcases contestants who fit a "drag supermonster" aesthetic. Successful contestants must be able to embody filth, horror, and glamour in their drag performances. As the dramatic sequence that opens season two suggests, mainstream viewers are likely to consider the show, in the words of the fictional producers, "disturbing and disgusting." By thematizing this in its season two premiere, *Dragula* emphasizes its commitment to a perverse drag style that scorns normative values and relishes its own abjection.[1] This scene depicting the Boulet Brothers triumphing over television producers who want to water down their show positions *Dragula* in opposition to mainstream respectability politics and neoliberal LGBTQ+ media representations. Although the scene does not explicitly name *RuPaul's Drag Race*, it alludes rather obviously to fans' concerns that this precursory reality drag competition has lost its edge while cementing its mainstream popularity. First airing on YouTube in 2016, seven years after the first season of *Drag Race*, *Dragula* simultaneously imitates, parodies, and critiques its predecessor. The opening scene of season two posits *Dragula* as the antidote to the polished, respectable, mainstream aesthetic of *Drag Race*. It suggests that the Boulet Brothers constitute a course-correcting force that will shift the future of drag away from respectability politics and back toward its roots in queer oppositionality.

How is it that a show like *Dragula* can claim to represent the future of drag despite its "backward" espousal of abject representations of queerness? Moreover, what can the recent surge of interest in alternative drag styles reveal about the

state of contemporary queer culture in a moment when *Drag Race* has achieved unprecedented mainstream popularity? Is *Dragula* simply a reaction against *Drag Race*'s mainstream success, or do these two projects overlap to a greater degree than the Boulet Brothers might like to admit? What might the conversation that exists between these shows tell us about the future of drag and the impact that *Drag Race* has had on that future?

My goal in this chapter is to examine how *Drag Race* has directly and indirectly primed its viewers to receive favorably a show like *Dragula*. I begin by showing how *Drag Race* promised in its early days to reinvigorate drag by staging a temporal intervention within the art form. Seeking to carve out a place for drag in queer futurity, *Drag Race* performed a backward glance that promised to preserve drag's roots in transgressive modes of social critique. By showcasing queens like Sharon Needles, *Drag Race* has primed fans both to value alternative drag styles that embrace the ethos of the abject queer past and to read these "backward" styles as avant-garde embodiments of futurity. More recently, however, *Drag Race* has become firmly associated with the mainstream and has begun to seem more assimilable to a politics of respectability than committed to a politics of subversion. Consequently, much of its queer viewership has grown discontented with the show's portrayal of drag, which many have criticized as being sanitized and politically defanged. In this way, *Drag Race* has created a passel of viewers eager to champion a show like *Dragula*. By unapologetically embracing an aesthetic of queer abjection and mocking respectability politics, *Dragula* was received by many *Drag Race* fans as delivering on the promises that *Drag Race* had made in its early seasons. By weaponizing abjection, *Dragula*'s embrace of a backward queer temporality has paradoxically been lauded as the future of drag by those who are unsatisfied by contemporary homonormative politics. I contend that one of the most powerful effects that *Drag Race* has had on queer culture has been to create a demand for types of drag that cultivate a backward aesthetic, performing a queer orientation toward futurity that simultaneously glances back at an abject queer past.[2] While many now see *Drag Race* as having adopted a politics of respectability, the show has also paved the way for more transgressive and alternative modes of drag to gain greater popularity, perhaps providing a corrective to the homonormativity for which *Drag Race* has been critiqued.

Drag "Herstory" and Future: *Drag Race's* Early Promises

> I made a pact with myself when I was 15 that if I was going to live this life, I'm only going to do it on my terms, and I'm only going to do it if I'm putting my

middle finger up at society the whole time. So any time I've had yearnings to go, "Aw, gee, I wish I could be invited to the Emmys," I say, *Ru, Ru, remember the pact you made.* You never wanted to be a part of that bullshit. In fact, I'd rather have an enema than have an Emmy.

—RuPaul in 2016

In order to navigate what RuPaul has called the "bullshit" of heteronormative society, queer people have long required survival strategies. José Esteban Muñoz (1999, 4) has coined the term "disidentifications" to describe "the survival strategies the minority subject practices in order to negotiate a phobic majoritarian public sphere that continuously elides or punishes the existence of subjects who do not conform to the phantasm of normative citizenship." Disidentification, Muñoz writes, consists of "read[ing] oneself and one's own life narrative in a moment, object, or subject that is not culturally coded to 'connect' with the disidentifying subject" (12). Embracing a disidentificatory relationship with an unlikely object means "reworking" the "politically dubious or shameful components within an identificatory locus" without eliding these components, "'harmful' or contradictory" though they may be (12). One mode of disidentification that Muñoz describes is the feeling of "backward" connection to seemingly outdated models of queer life. In Muñoz's paradigmatic example, the performance piece *Marga Gomez Is Pretty, Witty, and Gay*, performer Marga Gomez expresses a disidentificatory longing for pre-Stonewall queer life that Muñoz reads as transcending mere nostalgia to enact "a redeployment of the past that is meant to offer a critique of the present" (33) and which "helps us envision the future" (34). In this performance, Gomez recalls her childhood attraction to media depictions of stereotypical queer women, such as those featured on David Susskind's television show *Open End*. As Muñoz describes it:

> Gomez luxuriates in the seemingly homophobic image of the truck-driving closeted diesel dykes. In this parodic rendering of pre-Stonewall stereotypes of lesbians, she performs her disidentificatory desire for this once toxic representation. The phobic object, through a campy over-the-top performance, is reconfigured as sexy and glamorous, and not as the pathetic and abject spectacle that it appears to be in the dominant eyes of heteronormative culture. Gomez's public performance of memory is a powerful disidentification with the history of lesbian stereotyping in the public sphere. The images of these lesbian stereotypes are rendered in all their abjection, yet Gomez rehabilitates these images, calling attention to the mysterious erotic that interpellated her as a lesbian. (3)

The political moment from which Gomez looks back is steeped in the narrative of LGBTQ+ progress that renders nonsensical Gomez's "backward" longing. Gomez disidentifies with stereotypical representations of pre-Stonewall lesbians because she feels the inadequacy of contemporary notions of queer "community" to support the full range of queer experience that falls outside expectations of conformity and respectability. Her disidentificatory romanticization of this queer past thus critiques the constraints of an increasingly homonormative present. The result of this disidentification, according to Muñoz, is that Gomez "helps us imagine an expansive queer *life*-world, one in which the 'pain and hardship' of queer existence within a homophobic public sphere are not elided" (34, emphasis in the original).

Gomez and Muñoz, I contend, help us to understand why the early seasons of *Drag Race* seemed so promising to queer viewers who rejected a politics of respectability (and, as I argue later, why many now see similar potential in *Dragula*). By embodying and celebrating stigma rather than aiming to overcome it, the art of drag has historically rejected the assimilationist expectations of the dominant culture. When *Drag Race* debuted, it promised to glamourize this seemingly backward[3] model of queerness. Many viewers, à la Gomez, would have seen the startling anachronism of a drag reality show on national television as a radical send-up of homonormative respectability politics, a refusal by queer people to abide by hegemonic gender norms or to hide such transgressions. To this audience, the show represented an embrace of queer stigma that refused to elide the painful realities of queer life. In the early years of *Drag Race*, drag's very anachronism was its appeal.

During these early seasons, *Drag Race* promised to use its platform to extend a queer history of cultural critique in order to criticize contemporary homonormativity. When asked in a 2011 interview about slipping subversive content past the show's network, RuPaul said that while Logo TV had rejected plenty of his ideas, he would never stop trying to insert transgressive content into the show: "If I can't make fun of this stupid-ass bullshit world, I don't want to be here, honestly" (Charles 2011). RuPaul goes on to say in the same interview that performing such critique is "a survival technique," emphasizing that *Drag Race* "has the opportunity to pass on a word or a phrase or way of looking at something to a younger generation." This interpretation of drag as a living piece of queer history that is also a mode of self-preservation and cultural critique closely echoes Muñoz's (1999, 4, 33) assertion that disidentification with the queer past constitutes a "survival strategy" by performing "a redeployment of the past that is meant to offer a critique of the present." By characterizing *Drag Race* as an opportunity to model for younger generations this critical relation to the "bullshit world" of the dominant culture, RuPaul here suggests that he meant for the show to perform a disidentificatory redeployment of the past that could disrupt

the status quo and help viewers imagine a queer future. The prospect of modeling this mode of cultural critique for a wide range of viewers was part of what made *Drag Race* so exciting when it first came on the scene.

If *Drag Race*'s early promise of radical potential derived from its ability to glance backward into the queer past and use this to shape a queer future, this impulse peaked with the crowning of Sharon Needles in season four. From her name (punning on risky methods of intravenous drug use) to the incorporation of punk, gothic, and horror elements into her drag aesthetic, Needles invokes the disidentificatory performance mode that Muñoz (1999, 93) calls "terrorist drag."[4] Muñoz theorizes terrorist drag through the Latinx drag performer Vaginal Creme Davis, whose performances he describes as "creating an uneasiness, an uneasiness in desire, which works to confound and subvert the social fabric" (100) and as "performing the nation's internal terrors around race, gender, and sexuality" (108). While Needles doesn't regularly address race in her performances, her drag comes from a similar punk tradition that is meant to evoke both desire and uneasiness in a way that enacts a potent social critique of sexual and gender norms. As with Davis, Needles's drag could be described as employing "humor and parody [...] as disidentificatory strategies whose effect on the dominant public sphere is that of a counterpublic terrorism" (100). Both performers reject normative feminine beauty standards, opting instead to embody abject sexualized personae that combine elements of disgust with desire in order to critique the values and norms of the dominant culture.

As David Halperin (2012) writes, the power that drag retains for contemporary queer culture is bound up in the practice of camp as a theatrical mode of cultural critique levied against conventional notions of beauty, prescriptions for gender presentation and performance, and the tendency to take oneself too seriously. By marrying camp with glamour, drag has long served as a way for gay men to explore "identification with a femininity that is at once glamorous and abject" (211). The importance of the abject here—a central component of the drag of both Vaginal Davis and Sharon Needles—is that, like drag itself, it risks seeming backward today. Embracing an abject drag persona seems anachronistic from the perspective of respectability politics; it embraces, like Gomez, a phobic representation of queerness that refuses to fall in line with normative standards of behavior. If this embrace of the abject constitutes the subversive edge that drag derives from its queer history, then Sharon Needles was *Drag Race*'s promise that the "herstory" and future of drag were closely linked.

RuPaul himself has noted on an episode of his podcast (cohosted by *Drag Race* judge Michelle Visage) that the choice to cast Sharon Needles in season four was an explicit attempt to exploit the popular venue of reality television by gradually introducing viewers to more transgressive forms of drag:

RUPAUL: Sharon Needles is doing what we call "gender f-word" [...] and that's a genre of drag that is as old as Methuselah. But we felt on the show that it wasn't time to introduce the public to it until we eased them into—

MICHELLE: Mainstream drag.

RUPAUL: Exactly.

(Charles and Visage 2014)

Muñoz (1999, 99) posits a somewhat binary distinction between "commercial drag [that] presents a sanitized and desexualized queer subject for mass consumption"[5] and the more militantly queer terrorist drag that is "performed by queer-identified drag artists in spaces of queer consumption." RuPaul, however, suggests here that *Drag Race* was originally meant to occupy a middle ground between these poles, using the platform of mainstream television to familiarize uninitiated audiences with more transgressive drag styles. Furthermore, RuPaul here explicitly connects Needles's genderfuck drag to the long line of "artistic terrorists" that precede her (Raziel 2013; the phrase is Needles's). This suggests that part of his vision for *Drag Race* was to show viewers how drag has been shaped by a queer history of provocative political performance. In these early seasons, *Drag Race* promised that, despite its mainstream venue, it would remain true to drag herstory, shaping a future for drag that was grounded in a disidentificatory commitment to the past.

While RuPaul is right to emphasize that Sharon Needles's style of drag is "as old as Methuselah," Needles's time on *Drag Race* helped to establish the show's orientation toward futurity. This was solidified by one of the most famous moments of season four: her fight with Phi Phi O'Hara, in which Needles utters the now-iconic line—"I'm the fucking future of drag" (Murray 2012). This statement helped to define a set of values that would shape the expectations of *Drag Race* viewers for years to come. In part because of Needles's season four win, these words helped to set the expectation that drag should be evaluated based on its relationship to futurity, that queens should always be pushing the existing boundaries of the form. *Drag Race* has since reinforced this valuation of futurity through various challenges on the show, as with *All Stars* season two, wherein "The Future of Drag" featured as a runway theme meant to challenge contestants to create avant-garde looks (Murray 2016).

For many *Drag Race* fans, Sharon Needles's success on the show made her representative of "the 'future' of drag. Alternative drag. Underdog drag," in the words of one Reddit user (givingyouextra 2018), and her popularity helped to validate alternative drag in the eyes of many viewers. Today, being hailed as the "future of drag" is viewed as one of the best compliments a performer can receive. By branding Needles as "the future of drag," *Drag Race* primed viewers to crave an alternative, edgy, abject drag aesthetic, an aesthetic that Muñoz terms

"terrorist drag" and that RuPaul calls "as old as Methuselah." Needles (2012, 16) herself has been quick to connect her backward-looking drag style to those pioneering queens like Vaginal Davis that came before her: "What I'm doing is nothing new. There's been great transgressive, successful, out-there, art-scene drag queens for decades, and I actually think it's where drag came from." With Needles, *Drag Race* not only propelled a "backward" aesthetic to the top of the drag hierarchy for many viewers; it also promised that the future of drag would be rooted in the transgressive, political ethos that has been sustaining queer culture for decades.

RuPaul, You Are Up for Elimination: Drag Race and Fan Dissatisfaction

RuPaul's Drag Race has fucked up drag.
—Jasmine Masters

If Sharon Needles might be said to mark the highwater point of *Drag Race*'s subversive potential, even she admits that her drag style and persona were compromised to fit the needs of the show. After winning *Drag Race*, Needles (2012, 16) stated in an interview:

> I feel like I have to be more responsible for my actions [now]. I've always just kind of considered myself a punk-rock, downtown clown who was always trying to push barriers, push buttons, take dark issues and put them in the spotlights. But now, every waking moment of my life is completely documented and can be misinterpreted or misunderstood.

She also expresses that, although she never intended to serve as a role model for young people, she was thrust into that position, forcing her to "find a successful compromise between me not budging my artistic intentions and trying not to alienate my broad fan base" (16). As Needles quickly learned, it is nearly impossible to retain a commitment to an antinormative set of values while also maintaining commercial success.

As many viewers and critics have pointed out, the same could be said for *Drag Race* itself. In a 2019 opinion piece for *Vulture*, E. Alex Jung describes the blasé attitude with which many former *Drag Race* devotees now approach the show:

> When the finale of *Drag Race* season 11 aired on May 30, two days before Pride Month, a sense of relief washed over me. It wasn't that the season was bad (it was fine), or that Yvie Oddly, a genuine weirdo, didn't deserve to win (she did),

but the show had begun to feel relentless, like serving gay penance. Many of my friends had either stopped watching or did so only sporadically; the fervor of the early adopters was gone. More than ever, the show has felt like content.

Jung goes on to say that *Drag Race*'s turn toward a mainstream politics of respectability constitutes perhaps the biggest turn-off for these "early adopters":

> Nowhere does the show expose itself more than with its half-baked political statements, which seem telegraphed from the DNC. A potentially insurgent challenge like "Trump: The Rusical" culminated in a call for more female political candidates. The finale's 50th-anniversary tribute to the Stonewall riots could have been an attempt to unearth the intimate histories of drag and trans identity, but instead ended with a limp declaration that "LGBTQ rights are human rights."

A large part of *Drag Race*'s cultural impact has been to make drag queens less of a polarizing presence within both queer and straight communities, and this could perhaps be read as a salubrious effect. But insofar as *Drag Race* has recently sought to distance drag from its association with stigma and the queer past, many queer fans today have ceased to find the show as thrilling as they did during its early seasons. According to Esther Newton ([1972] 1979), drag appealed to antinormative queers in the 1960s precisely because it rejected a respectable assimilation to normative expectations for queer people. If the role of *Drag Race* in the present neoliberal moment is to convince straights and homonormative gays alike that drag queens are not gender traitors, but normal law-abiding citizens who hang up their wigs at the end of the day, then it is only natural that many viewers might experience an anachronistic longing for the "Bad Old Days" when drag was queer.

When asked in a 2016 *Vulture* interview whether drag could ever be mainstream, RuPaul responded: "It will never be mainstream. It's the antithesis of mainstream. And listen, what you're witnessing with drag is the most mainstream it will get. But it will never be mainstream, because it is completely opposed to fitting in."[6] RuPaul's point is that, no matter how successful *Drag Race* might become, drag itself fundamentally stages a critique of social norms and is therefore always-already in opposition to the status quo. Many viewers of the show, however, have begun to take RuPaul to task for what now appears to be a disingenuous assertion, at least as far as *Drag Race* is concerned, especially now that the show has won nine Emmys and counting. On the *RuPaul's Drag Race* page of Reddit, a series of posts have been cropping up in the past few years that have attempted to "memeify" this quotation by pointing out counterexamples. One such post references comments made by Miley Cyrus when she was a guest judge on season eleven of *Drag Race* (see Figure 5.1).

THE CULTURAL IMPACT OF *RUPAUL'S DRAG RACE*

FIGURE 5.1: Reddit post in the style of a meme featuring Miley Cyrus on *Drag Race* celebrating drag's mainstream status. Posted on Reddit by user drwhoster.

The post is composed in a style that is popular among memes, staging a dialogue between two contradictory claims in which the first line of dialogue is provided by text and the second by an image. The title of the post reads: "RuPaul: 'I don't think drag could ever go mainstream.' Miley:" and this is followed by a captioned screenshot in which Miley, speaking backstage with the *Drag Race* contestants, says: "'Cause it gone mainstream. You know?" (drwhoster 2019). Another post entitled "RuPaul Taught Alyssa that Drag is… Mainstream?" (see Figure 5.2) features two captioned screenshots from *Drag Race* alum Alyssa Edwards's Netflix documentary series *Dancing Queen* (busted123abc 2018). Together, the captions read: "but one of the greatest lessons that I've learned from RuPaul is drag, it's mainstream." The most popular comment (posted by lubdisdrink on October 18, 2018) on the post reads: "Alyssa's smart, she knows she's safe because Ru can't figure out how Netflix works." Both posts demonstrate fans' delight in pointing out that people closely associated with *Drag Race* acknowledge the show's status as mainstream, even as RuPaul maintains the opposite. As RuPaul continues to be the butt of such jokes, it is clear that many fans now read him as either delusional or deceptive with regards to the integrity of *Drag Race*.

These posts are but two examples of a trend appearing on the *Drag Race* subreddit in which users identify signs confirming that *Drag Race* has fully entered the mainstream. Some of these are celebratory in tone, making the neoliberal claim that the mainstreaming of drag leads to more visibility and acceptance for LGBTQ+ people.

FIGURE 5.2: Reddit post featuring captioned screenshots from *Drag Race* alum Alyssa Edwards's Netflix special, *Dancing Queen*, in which Alyssa describes a dubious lesson from RuPaul. Posted on Reddit by user busted123abc.

Many are critical, arguing that *Drag Race*'s entry into mainstream culture has watered down the show's subversive potential (afteri86 2019). One especially popular post, entitled "Do you guys agree that because Drag Race is now on VH1 and mainstream, it's a little more censored?" raises the question of *Drag Race*'s decision during *All Stars* season four to prevent contestant Manila Luzon from wearing a dress shaped like a maxi pad (come-to-make-friends 2019). Fans responding to this generally agree that *Drag Race*'s move into the mainstream has meant a more censored, less subversive, and less entertaining show.

Much of the published work on *Drag Race* is also highly critical of the show, especially its relationship to the mainstream. For some critics, reality television

and subversion are inherently contradictory. Niall Brennan (2017) argues that the mainstream genre of reality television has hindered the subversive potential of *Drag Race* by reducing a plethora of authentic drag styles to only a few options, encouraging competitiveness among contestants that leads to self-doubt and prioritizing consumerism by using the show as a platform for the RuPaul brand. Laurie Norris (2014) reminds us that *Drag Race* is a prime example of "gaystreaming," a practice that is employed by networks such as Logo TV and that consists of designing programming that is queer enough to appeal to LGBTQ+ viewers but not so queer as to alienate straight ones. Norris argues that this impulse contributes to *Drag Race*'s gay male-centrism and trans exclusion. The issue of inclusion has long been a point of contention with *Drag Race* fans, who have criticized the show and RuPaul as transphobic and misogynist for not allowing trans women who have undergone gender-confirming surgery, drag kings, or anyone assigned female at birth to compete.

Norris goes on to say that *Drag Race*'s mainstream status has contributed to the show's tendency to favor polished, feminine drag styles:

> A hierarchy exists, if unofficially, within the show that privileges certain types of drag queens over others. [...] The show favors "Glamour Fish" more connected to high fashion and exaggerated runway performances than those who present a less professionally polished character. (33)

This, Norris argues, also reinforces normative beauty standards. Norris here articulates a second critique frequently made of the show: that *Drag Race* offers a limited, "polished" drag aesthetic that is safe and respectable. Kai Kohlsdorf (2014, 67, 69) expands on this idea, arguing that the "inescapable political economy of television" results in the normalization of drag into something that emulates "RuPaul's sanitized and safe fame." Contestants are thus rewarded for "creating a drag image in the best respectable drag just like RuPaul" (70). Describing the show's gender policing, which tends to reward hyperfeminine drag more consistently than androgynous or genderfuck versions, Kohlsdorf argues that "*RuPaul's Drag Race* makes drag safe and confines gender transgressions within heteronormative discourses as well as binary gender codes" (71).

Josh Morrison (2014, 137), reading both *Drag Race* and its spin-off show *Drag U*, importantly points out that *Drag Race*'s citations of queer history are aimed at legitimating drag as a part of a linear progress narrative to show that "drag isn't a freak show." Whereas *Drag Race* seemed to promise that it would stay true to its queer roots, Morrison argues that "queer history is remade to service the contemporary political and economic concerns of this mainstream media show as

it turns the drag that fought off the police into a commodity to be consumed by the mainstream which oppresses it" (138). The result, according to Morrison, is that "RuPaul's TV empire promotes the history of the homophile movements and their call to assimilate rather than agitate as the only queer history worth bringing back" and that "*Drag Race* and *Drag U* actively rewrite the past encouraging the 'draguation' of queer communities in the present to normalcy, rather than to a different and better future" (141). As Morrison and others suggest, *Drag Race*'s early promises to draw from a robust queer history have been thwarted by the limitations of its mainstream platform.

What these responses tell us is that *Drag Race* had initially set up an expectation that, no matter how mainstream its platform, it would remain firmly grounded in honoring the traditions of drag herstory that I have outlined earlier and would use these to forge a future for drag that was tied to queer critique of hegemonic norms. While many have perceived *Drag Race* as failing to live up to these promises, it has succeeded in creating a demand for media representations of drag that seek to preserve a backward, abject aesthetic over a respectable, sanitized one. However, from these critiques by fans and critics, it is clear that viewers have all but decided that *Drag Race* now exists solidly within the mainstream, and many have grown dissatisfied with aspects of the show that they associate with this turn. Fans have grown suspicious of RuPaul for commodifying and profiting from drag while still claiming its inherently subversive nature. They see the show as having made significant compromises that mitigate its subversive potential, such as censoring contestants. Many feel the show has become safe, unexciting, and politically defanged, embodying a homonormative politics of respectability in line with neoliberal values. Others have simply grown bored with the narrow drag aesthetic that the show privileges. My goal is not to confirm or refute any of these claims, but to assess how fans' growing dissatisfaction with *Drag Race* and its shift into the mainstream has affected drag culture. I contend that one major effect of this dissatisfaction is a growing demand to see transgressive styles of drag that might recapture the subversive potential that many fans associate with the early seasons of *Drag Race*. In the following section, I will show how *The Boulet Brothers' Dragula: Search for the World's Next Drag Supermonster* has attempted to make good on those promises from which *Drag Race* has turned away.

Drag, Filth, Horror, Glamour: Dragula's Backward Aesthetic

The drag we grew up around was filthy, political, punk, smart, disturbing and artistic and we refuse to let that style of drag be forgotten.
—Swanthula Boulet

Shortly after the opening sequence of the *Dragula* season two premiere, the Boulet Brothers greet their contestants with something of a mission statement for the show:

> We pride ourselves on celebrating the strange, and the wild, and the sometimes dangerous side of queer culture. And as the rest of the world begins to accept us, they're also trying to squeeze us into a little box and make us conform, and that just won't do. Because to us, drag is a form of radical self-expression; it's an art. And the last thing an artist needs is to be told what to do. So we're gonna do what we want, and what we want is to crown a new drag supermonster—one of you—to join our army and go forward and help spread our message of drag, filth, horror, and glamour.
>
> <div align="right">(Noyes 2017)</div>

These lines serve to define the *Dragula* aesthetic as a direct response to that of *Drag Race*, espousing a queer refusal of the normative respectability standards that fans and critics have accused *Drag Race* of recapitulating. The Boulet Brothers' words express suspicion of mainstream queer acceptance, indicating a distrust of any form of recognition that is contingent on assimilation to hegemonic cultural norms. Rather, by invoking the image of an "army" of drag supermonsters, the Boulet Brothers posit *Dragula* as an oppositional insurrection, an assault on respectability politics, normative beauty standards, and accepted codes of conduct. Drag, for the Boulet Brothers, means radically embracing a disidentificatory embodiment of queer abjection and wielding this as a weapon against normativity and conformity.

Dragula premiered in 2016 as an aggressively low-budget series running on the "Hey Qween TV" YouTube channel. It began, however, as a monthly Los Angeles event hosted by the Boulet Brothers, who have been running alternative queer nightlife in LA for over fifteen years (Leavell 2018). By 2016, *Drag Race* was fending off accusations by viewers that its increasing mainstream popularity came at the expense of its initial promise to usher in a radical future for drag that was built on a foundation of queer oppositionality. Judging by *Dragula* season two's opening scene and the hosts' introductory remarks about conformity, it is clear that many of the norms the Boulet Brothers are resisting are those associated with *Drag Race*. It is no coincidence that season two of *Dragula*, premiering on Halloween of 2017, was preceded in the spring of that year by *Drag Race*'s ninth season, which marked the show's transition from the LGBTQ+ network Logo TV to the more mainstream VH1.

Intent on defining their reality drag competition in contradistinction to *Drag Race*, the Boulet Brothers have infused *Dragula* with forceful assertions of the

show's differences from its predecessor, vowing that they will not compromise their vision to fit the demands of a network and that the contestants will not change their drag styles to fit a mainstream aesthetic. The Boulet Brothers have been clear and unambiguous about this message, explicitly stating in an interview that they would never hold *Dragula* back or make compromises for a network, "as it would go against the whole premise of the show" (Boulet and Boulet 2019). By embracing this no-compromise attitude, *Dragula* promised to fulfill the desires of *Drag Race* fans for a drag competition show that could enact a potent critique of normative culture, desires that early seasons of *Drag Race* sparked in its viewers. In turn, fans have praised the show for its refreshing contrast to *Drag Race*. In this section, I will analyze *Dragula*'s values in order to demonstrate how the show has been actively shaped by the promises and expectations set by early seasons of *Drag Race*. I argue that *Dragula* embraces a backward temporality that rejects the linear narratives that *Drag Race* espouses and instead luxuriates in representations of abjection that hearken back to and disidentify with the "Bad Old Days" of the queer past. However, rather than simply pointing out the differences between the shows, I want to suggest that *Dragula*'s aesthetic is indebted to the ideals that *Drag Race* set out in its early seasons. Insofar as *Drag Race* set up these expectations in its viewers and ultimately failed to deliver, it paved the way for *Dragula* to extend the radical promise that *Drag Race* had initially introduced.

The format of *Dragula* both borrows heavily from *Drag Race* and actively subverts it. As one Amazon review of season one puts it, the show might be described as a "horror spoof on *RPDR* with special effects and a touch of sadism." Like with *Drag Race*, the central premise of *Dragula* is that contestants compete in a series of design and performance challenges with the ultimate goal of snatching the title of "the world's next drag supermonster," a clear parody of the goal of *Drag Race* contestants, who vie to become "America's next Drag Superstar." After each challenge, contestants receive critiques from the judges and are ranked as high-performing, safe, and low-performing. The competitors ranked at the bottom each week must compete in an additional elimination challenge, after which one contestant is sent home. This format repeats each week with minor variations until the top three are selected, at which point the judges choose and crown a winner.

Given their near-identical structures, *Dragula* actively invites comparison to *Drag Race*. Despite the Boulet Brothers' assertion in an interview that they are annoyed by these comparisons, they nonetheless contribute to them:

> *Drag Race* was very trailblazing for the art of drag but it unintentionally suppresses other kinds of drag too. It's making drag what can be shown to the masses so it almost waters down the culture of drag to me. [...] There's a lot

of rebellion and politics and rudeness and punk attitude and performance that come out of drag that you don't see on *Drag Race*.

(Boulet and Boulet 2018b)

What the Boulet Brothers actually seem to mean is that they *do* encourage comparisons with *Drag Race*, so long as these emphasize what is more transgressive about their show. Indeed, the ways in which *Dragula* differs from *Drag Race* read largely as attempts to one-up the show's more mainstream competitor by positing *Dragula* as more transgressive, more authentic, and more inclusive. *Dragula* defines its own backward aesthetic in contradistinction to that of *Drag Race*, critiquing mainstream and normative values by showcasing drag that rejects respectability and embodies queer abjection.

Dragula's alternative drag aesthetic centers on the show's three main tenets: filth, glamour, and horror. Like *Drag Race*, most episodes involve a main challenge in which contestants must design a look and a performance to fit a particular theme. *Dragula*'s themes encourage contestants to embody monstrous and abject personae: witches, zombies, ghouls, aliens, and gothic brides, to name a few. One of the main goals of this alternative drag style is to create performances that will shock and disgust an audience, and *Dragula* rewards contestants who are willing to go to extreme lengths to entertain. This is apparent in both the floor shows and the "extermination" challenges. In the floor show, *Dragula*'s alternative version of the *Drag Race* runway, contestants go all out to embody extreme social transgression through drag performance. Contestants will frequently simulate or induce bodily functions such as defecation, vomiting, bleeding, and menstruation on stage. Many contestants incorporate consumption into their performances, either eating in a repulsive manner or ingesting disgust-inducing items. Partial nudity and sexually explicit performances are common, and unidealized body types are frequently emphasized: large stomachs and unshaved legs and chests are flaunted rather than concealed. A few contestants have even simulated (or at least presumably simulated) drug use on stage.

The Boulet Brothers demonstrated early on in the series that they were primarily interested in concept: their supermonsters should be grotesque, terrifying, punk rock, and extreme. While *Dragula* does want its performers to be able to produce the polish and glamour that *Drag Race* values, it is more invested in ensuring that its contestants embody a punk and monstrous energy, which can sometimes be at odds with polished drag.[7] In season one, contestant Melissa Befierce was critiqued by the Boulets for emphasizing precision over concept. Melissa recounted after her critiques:

I came in that room thinking that because I was very polished my look was going to be like the top one. But in reality, it was not the T. […] Being polished in this competition, it's not enough and it's not gonna cut it.

(Noyes 2016)

Whereas *Drag Race* has been critiqued for privileging a pristine, polished, professional aesthetic that represents drag as safe and respectable, *Dragula* expects its contestants to shock and offend.

Contestants are also expected to demonstrate their resilience and toughness through grotesque or shocking stunts. Their willingness to do so is tested by the extermination challenges: when contestants are ranked in the bottom for a given challenge, they must face a physical trial and risk going home if they fail to perform. In the first three seasons, these have included being buried alive, consuming animal organs and blood, withstanding multiple surface piercings with hypodermic needles, getting a tattoo that is chosen by an opponent, and jumping out of a plane 18,000 feet in the air. When asked in an interview about the extreme nature of these challenges, the Boulet Brothers (2018a) responded: "Keep in mind we threw huge fetish events for many years in our past, and so things like surface piercings or tattoos are fairly standard from our perspective." Invoking the show's connection to fetish communities, the Boulet Brothers emphasize how alternative drag stages a celebration of sexual deviance and queer abjection.

By embracing deviance and performing it alongside monstrosity and stunts meant to induce fear or disgust, the show ironically restages the process of social abjection by which the queer subject is rendered a subhuman Other. In this way, *Dragula* violently rejects normative expectations of respectability by celebrating a temporality that I call "backward" for its turning away from the linear progress narrative that *Drag Race* espouses. Instead, *Dragula* performs a disidentificatory connection to outmoded and phobic notions of queer monstrosity. Rather than provide respectable counterexamples to abject images of queerness, the show's performers embrace perverse stereotypes in order to remake them into sources of powerful dissent against a politics of respectability. What Muñoz (1999, 3) writes about Marga Gomez's disidentification with the "seemingly homophobic image of the truck-driving closeted diesel dykes" could almost be applied to the disidentification with monstrosity that *Dragula* enacts: "The phobic object, through a campy over-the-top performance, is reconfigured as sexy and glamorous, and not as the pathetic and abject spectacle that it appears to be in the dominant eyes of heteronormative culture." *Dragula*'s disidentifications feature one notable difference, however: while they also reconfigure phobic objects into something glamorous, they luxuriate in decidedly unsexy spectacles of pure abjection to show that these, too, can be sources of power. While the dominant culture would surely prefer that drag performers embrace respectability in order to show that what has been labeled deviant is in fact assimilable to normative values, *Dragula*'s backward aesthetic aims to celebrate deviance itself. In this way, *Dragula* endeavors to champion antinormative queer impulses; as the Boulet Brothers put it:

> To us, to be queer is to reject mainstream approval and the idea that anyone has authority over how we live. We are who we are, we don't need anyone else's recognition, and fuck anyone who places themselves above us in the first place.
> (Leavell 2018)

The show thus argues that the politics of drag should not be one of conforming to social expectations of gendered and sexual respectability. Rather, it imagines a future that stubbornly clings to the history of queer marginalization, disidentifying with the phobic stereotypes that adhere to that history in order to critique a politics of homonormativity in the present.

Lip-Sync for Your Legacy: Fans Predict the Future of Drag

> The plague is spreading darling, and you can't escape it—you better get into it.
> —Dracmorda Boulet on *Dragula*

Given that *Dragula* has structured itself both on and in contradistinction to *RuPaul's Drag Race*, it should come as no surprise that drag fans often discuss the two shows in relation to one another. These discussions, often occurring on Reddit, tend to take two forms: the first suggests that *Dragula* is superior to *Drag Race*, and the second expresses a desire for crossover between the shows. These two contradictory impulses illustrate a central paradox surrounding these drag competitions. While many fans of *Dragula* see it as being a more transgressive and exciting show, most see it as supplementing rather than supplanting *Drag Race*. This trend supports my reading that, as much as *Dragula* has marketed itself in contradistinction to *Drag Race*, the relationship between these shows is closer than either might readily admit. If, as I have argued, *Drag Race* felt radical to viewers at its inception because of drag's always-already backward connection to a history of queer abjection, *Dragula*'s more explicit embrace of this abject aesthetic seeks to reignite in viewers the spark of excitement that *Drag Race* had first kindled.

In the first form of comparative discussion of *Dragula* and *Drag Race*, fans take up the project of valorizing the former, often by emphasizing *Dragula*'s comparative freshness. A number of fan reviews of *Dragula* on IMDB and Amazon demonstrate this:

> I'm a huge fan of (the now mainstream) Rupaul's Drag Race—I can literally quote every line, but after 9 seasons of over production I was very ready for something new. Especially because in my hometown drag is way more creative.
> (Posted on IMDB by jolarti on April 25, 2017)

As another drag-based television show moves toward the mainstream, I find myself enamored by Dragula's refusal to be forced into a neat little box of acceptable, mainstream queerness.
(Posted on Amazon by anonymous reviewer, accessed April 1, 2019)

If you like Drag Race, you'll love this. It's better than recent seasons of Drag Race and more inclusive of all styles of drag. Can't wait for season 3.
(Posted on Amazon by anonymous reviewer, accessed April 1, 2019)

These reviewers admit to enjoying *Drag Race* while also positing that *Dragula*'s newness, creativity, inclusivity, and rejection of mainstream values address growing dissatisfaction among fans of *Drag Race*. On Tumblr and Reddit, posts favorably comparing *Dragula* to *Drag Race* also tend to argue for the higher level of artistry, creativity, and performance offered by *Dragula* and emphasize fans' growing boredom with *Drag Race*. One representative meme found on Tumblr dramatizes this sentiment in the style of an object-labeling stock-photo meme series that has come to be known as "Distracted Boyfriend." In this particular iteration, one woman, labeled "*Dragula*," is being ogled by a man, while another, labeled "*RuPaul's Drag Race*," is holding hands with the man and glaring at him in anger and dismay (see Figure 5.3). The meme's caption on Tumblr—simply, "me"—implies the poster's identification with the man: having grown bored in their long-term relationship with *Drag Race*, a glimpse of *Dragula* is enough to make them long for something new and fresh. This meme resonates with a post on the *Dragula* subreddit, entitled "Dragula just passed the threshold," in which the author argues that

after last night's episode, Dragula went beyond Drag Race in terms on [sic] runway costumes and fashion. To be perfectly honest, none, NONE of the outfits I've seen this season so far have been dull or boring. [...] This was a welcomed breath of fresh air. Take note Drag Race producers.
(apparatus86 2017)

As these posts demonstrate, many viewers have turned to *Dragula* to alleviate their discontent with recent seasons of *Drag Race* and have found that the newer show has been delivering more surprising and innovative drag. Another such post, succinctly titled "Dragula > Drag Race," makes this comparison with implicit reference to the idea that *Dragula* constitutes the "future of drag" (see Figure 5.4). The post shows two images superimposed with the text "Category is / Martian Eleganza Extravaganza" (youlooklikeseal 2018).

FIGURE 5.3: "Distracted Boyfriend" meme comparing *Dragula* and *Drag Race*. Posted on Tumblr by user @beazeda.

The top image is a screenshot of Asia O'Hara from *RuPaul's Drag Race* season ten, episode four, wearing a pink Judy Jetson-esque outfit she had sewn for a design challenge and for which she was criticized by the judges. This is juxtaposed with an image of Victoria Elizabeth Black from *Dragula* season two, episode four, done up as an alien monster complete with impeccably detailed makeup, seamless prosthetics, and dripping slime. The images, taken with the curt mathematical title of the post, are arranged so as to posit matter-of-factly not only the superior artistry of the *Dragula* performers but also their status as avant-garde compared to the *Drag Race* contestants. If an ill-fitting Judy Jetson knockoff is *Drag Race*'s idea of the future, the post tacitly argues, then *Dragula* has opened a portal into another dimension entirely.

As I detail earlier, *Drag Race* has instilled the concept of "drag futurity" in the consciousness of its viewers. If these fan comparisons are any indication, *Drag Race* was perhaps too successful in doing so. Although many fans of *Dragula* may rate that show as more future-oriented than *Drag Race*, it is important to remember that the idea of drag having a future at all was uncertain at best when *Drag Race* debuted.

FIGURE 5.4: Side-by-side comparison of Asia O'Hara's Martian drag on *Drag Race* season ten and Victoria Elizabeth Black's alien drag on *Dragula* season two. Posted on Reddit by user youlooklikeseal.

If *Dragula* now promises to deliver the queer future that *Drag Race* promised, it has been able to do so in large part because *Drag Race* defined the parameters by which we can imagine *any* future for drag.

This connection that remains between the shows' respective projects may account for the readiness of many redditors to defend *Drag Race*, even on the *Dragula* subreddit. The top-rated comments[8] on "Dragula > Drag Race" mount a defense of *Drag Race*. One (posted by noey101 on April 15, 2018) reads: "They're two different kinds of queens, its [*sic*] not comparable"; another (posted by Caroz855 on April 15, 2018) reads: "Not to mention this is one of the best looks of the week compared to one of the worst looks." A highly rated comment (posted by acerly on December 7, 2017) on MKA2017's (2017) post reads:

> I do enjoy Dragula more these days. Because it's so young, it doesn't have to fight its way through nine seasons of tropes and cliches to seem fresh, and because it's smaller, it can be so much weirder and wilder. Drag Race is getting old, but so shall we all, if we're lucky. It doesn't erase its legacy. Just because Dragula is fresher, and more extreme and subversive, it doesn't mean Drag Race is blandly mainstream and harmless. We can love Dragula without diminishing RPDR, we really can.

This comment captures how many fans of both shows try to reconcile their abiding respect for *Drag Race* with their newfound excitement for *Dragula*. The post recognizes that *Drag Race* has begun to get stale and that *Dragula* appears to be more radical, but it is also wary about arguing that *Drag Race* has been neutered by its popularity. *Drag Race* is simply showing its age, this commenter argues, and while it may not be the place to go for the most innovative drag, we should still respect its groundbreaking contribution to drag culture.

Another genre of posts to be found on both the *Drag Race* and *Dragula* subreddits are those that fantasize about a crossover between the two shows. On both pages, redditors ask questions like "Which drag race girl would do well on Dragula? And vice versa?" and initiate heated debates about the possibilities (Trinazoe 2019). Many of these speculative discussions take the form of imagining alternative timelines in which contestants on *Dragula* had been on *Drag Race* instead, or vice-versa. While some replies to these threads discuss the fact that many *Dragula* contestants have repeatedly said they would never audition for *Drag Race*, most of the comments on these posts express excitement at the idea of crossover between the two shows.[9] Fans get particularly excited when contestants on one show express any interest in the other. The attention given to Sharon Needles in many such posts also demonstrates that Needles helped to prime *Drag Race* fans to be receptive to a show like *Dragula*; as one redditor writes: "Sharon is so proto-Dragula […]. Like, her opening post-Apocalyptic look is what first brought Dragula-style drag into the 'mainstream' of drag" (jmski822 2017; comment posted by pressuredrop0 on November 9, 2017). Posts on Reddit like "Would Sharon Needles have won Dragula?" reinforce the oft-made connection between this *Drag Race* winner and *Dragula* (jmski822 2017), implying that many viewers see *Dragula* as picking up the baton that *Drag Race* dropped sometime after Needles's crowning.

Posts defending *Drag Race* from critique and those expressing a desire for crossover between the two shows demonstrate that, while much of *Dragula*'s success may be attributed to its attempts to remedy *Drag Race*'s shortcomings, many fans see more continuity than contradiction between the shows. As I have argued, many fans see the shows as complementary because *Drag Race* has primed viewers to read *Dragula* as embodying the notion of "drag future" that *Drag Race*

itself popularized. In a post entitled "Future of Drag" on the *RuPaul's Drag Race* subreddit, redditor Feathers_ (2017) asked *Drag Race* fans to list their predictions for drag's future "now that Drag Race has helped Drag [sic] become more and more mainstream." One of the top comments (posted by satosaison on February 6, 2017) in response to this reads:

> I think drag will become increasingly transgressive and political. A large part of what makes drag exciting is the [provocative] and taboo nature of challenging our conceptions about gender and sexuality. As gay relationships and non-cis gender expressions become more familiar, the art will need to push boundaries in order to stay relevant.

If these are the expectations that many *Drag Race* fans have for drag's future, it becomes clear why a show like *Dragula* holds such appeal for those who were ushered into drag culture by RuPaul. If *Drag Race*, at its peak, helped to instill in viewers an idea of drag culture that is always evolving and always subversive while remaining grounded in a disidentificatory embrace of an abject queer past, it is no surprise that viewers would be quick to critique *Drag Race* when it ceased to meet their expectations. While *Dragula* has moved in to fill this gap for many *Drag Race* fans, it is important to acknowledge, as I have tried to do here, that *Drag Race* itself was instrumental in demonstrating to its viewers the transformative potential of disidentifying with the queer past, with drag as an outmoded form, and with the monstrous stereotypes that have dogged queer people for decades. Even if many viewers today are convinced that *Drag Race* no longer embodies that potential, the queer cultural turn toward alternative drag might still be counted as part of *Drag Race*'s legacy.

NOTES

1. My use of the term "abjection" and its derivatives comes from Julia Kristeva (1982), who defines abjection as the process by which a subject constitutes a sense of self by evacuating from the notion of selfhood anything that is socially coded to cause disgust or horror. Judith Butler ([1990] 2006, 182) neatly summarizes Kristeva's theory of abjection: "In effect, this is the mode by which Others become shit."
2. This notion of a "backward" aesthetic is indebted to Heather Love's (2007, 7) meditations on backwardness as "a key feature of queer culture"; as Love writes, "Queers have embraced backwardness in many forms: in celebrations of perversion, in defiant refusals to grow up, in explorations of haunting and memory, and in stubborn attachments to lost objects."
3. As David Halperin (2012, 116–17) explains, drag has long been an embarrassment to gay men who embrace respectability politics because of the belief that drag, like gay culture

writ large, is "tied to homophobia, to the regime of the closet, to the Bad Old Days of anti-gay oppression," thereby rendering drag "backward" by normative standards.

4. Needles herself refers to drag as terrorism in an interview: "Before gays were decorating houses, making wedding cakes and doing celebrities' hair, they were the real fucking artistic terrorists in this world" (Raziel 2013, 13).

5. Muñoz in fact cites RuPaul's VH1 talk show as an example of mainstream drag representations that fail to challenge the values of the dominant culture.

6. E. Alex Jung, who conducted this 2016 interview, later wrote in 2019:

Nine Emmys later, *Drag Race* can no longer claim outsider status. RuPaul now regularly appears on talk shows (recently with a gushing, teary-eyed Anne Hathaway), and the most successful queens from the series have their own makeup lines, TV shows, and fashion campaigns while shilling everything from Starbucks to vodka to McDonald's breakfast sandwiches. What was once counterculture has simply become the Culture. This has its benefits: Mainstream consumer culture has gotten a little less straight. But in the process, something—maybe the feeling that this was by us and for us, or maybe it was just Alaska saying *anus*—was lost. (Emphasis in the original)

7. Because *Dragula* is more concerned with transgression than the particular form that it takes, the show also rejects *Drag Race*'s practice of identity policing. Whereas RuPaul has made it clear that drag kings, trans women who have had gender-confirming surgery, and people assigned female at birth (AFAB) will not be considered for *Drag Race*, the Boulet Brothers have explicitly stated in interviews that they only care that their contestants identify as monsters:

Our feeling is that anyone can be a drag artist regardless of their gender, and we've maintained that since the first *Dragula* club pageant back in the day. Drag kings, Trans [*sic*] people and afab queens have all competed alongside traditional drag queens on stage at our events (and have won). We are just as open when it comes to contestants on the tv show. (Boulet and Boulet 2019)

The Boulet Brothers made good on this commitment in season three of *Dragula*, which featured the drag king Landon Cider and the self-proclaimed "post-binary drag socialist" Hollow Eve, an AFAB performer (Noyes 2019).

8. On Reddit, users (referred to as "redditors") have the option to denote appreciation or agreement with all posts and comments by upvoting, which adds points to that post; they may also downvote posts to denote disagreement or dislike. This system is helpful for assessing which comments are more representative of consensus within the community of a particular subreddit.

9. Vander Von Odd, winner of *Dragula* season one, has stated on YouTube in response to fan questions that she would never audition for *Drag Race* because "*Drag Race* was not made for someone like me to win" (Von Odd 2017).

REFERENCES

afteri86. 2019. "The Library is OPEN! (Long-form critical analysis REALNESS!)" Reddit, February 19, 2019. https://www.reddit.com/r/rupaulsdragrace/comments/asdp8a/the_library_is_open_longform_critical_analysis/.

apparatus86. 2017. "Dragula just passed the threshold." Reddit, December 7, 2017. https://www.reddit.com/r/Dragula/comments/7i9x4s/dragula_just_passed_the_threshold/.

Boulet, Dracmorda, and Swanthula Boulet [Christos Tsombanidis and Jamie Houchins]. 2018a. "10 Questions with the Boulet Brothers." Interview by Rose Dommu. *Out*, January 27, 2018. https://www.out.com/popnography/2018/1/27/10-questions-boulet-brothers.

———. 2018b. "*Dragula*'s The Boulet Brothers Reveal How They Feel about the Show Being Compared to *RuPaul's Drag Race*." Interview by Catherine Earp. *Digital Spy*, May 9, 2018. https://www.digitalspy.com/tv/ustv/a865528/the-boulet-brothers-dragula-rupauls-drag-race-comparisons-season-amazon-netflix/.

———. 2019. "Drag, Filth, Horror, Glamour: An Interview with the Boulet Brothers." Interview by Nickie Hobbs. *Devolution Magazine*, January 18, 2019. https://devolutionmagazine.co.uk/2019/01/18/interview-drag-filth-horror-glamour-interview-boulet-brothers/.

Brennan, Niall. 2017. "Contradictions between the Subversive and the Mainstream: Drag Cultures and *RuPaul's Drag Race*." In RuPaul's Drag Race *and the Shifting Visibility of Drag Culture*, edited by Niall Brennan and David Gudelunas, 29–43. Cham, Switzerland: Palgrave Macmillan.

busted123abc. 2018. "RuPaul Taught Alyssa that Drag is… Mainstream?" Reddit, October 18, 2018. https://www.reddit.com/r/rupaulsdragrace/comments/9pes1i/rupaul_taught_alyssa_that_drag_is_mainstream/.

Butler, Judith. [1990] 2006. *Gender Trouble: Feminism and the Subversion of Identity*. First Routledge Classics edition. New York: Routledge.

Charles, RuPaul. 2011. "RuPaul on *Drag Race, Hannah Montana*, and 'Those Bitches' Who Stole Annette Bening's Oscar." Interview by Kyle Buchanan. *Vulture*, April 4, 2011. https://www.vulture.com/2011/04/rupaul_on_drag_race_hannah_mon.html.

———. 2016. "Real Talk with RuPaul." Interview by E. Alex Jung. *Vulture*, March 2016. https://www.vulture.com/2016/03/rupaul-drag-race-interview.html#comments.

Charles, RuPaul, and Michelle Visage [Michelle Lynn Shupack]. 2014. "*Drag Race* Auditions, Meditation & Nail Art." April 9, 2014. In *RuPaul: What's the Tee?* Podcast. http://www.rupaulpodcast.com/episodes/2014/4/6/episode-1-drag-race-auditions-meditation-nail-art.

come-to-make-friends. 2019. "Do you guys agree that because Drag Race is now on VH1 and mainstream, it's a little more censored?" Reddit, January 7, 2019. https://www.reddit.com/r/rupaulsdragrace/comments/admj5i/do_you_guys_agree_that_because_drag_race_is_now/.

Distracted Boyfriend: *Dragula* vs. *Drag Race*. Digital image. Tumblr. https://beazeda.tumblr.com/post/171633333784/me.

drwhoster. 2019. "RuPaul: 'I don't think drag could ever go mainstream.' Miley:" Reddit, March 1, 2019. https://www.reddit.com/r/rupaulsdragrace/comments/aw1ktk/rupaul_i_dont_think_drag_could_ever_go_mainstream/.

Feathers_. 2017. "Future of Drag." Reddit, February 6, 2017. https://www.reddit.com/r/rupaulsdragrace/comments/5sfkrw/future_of_drag/.

givingyouextra. 2018. "What does Aquaria represent in the winners' circle?" Reddit, July 4, 2018. https://www.reddit.com/r/rupaulsdragrace/comments/8w1tha/what_does_aquaria_represent_in_the_winners_circle/.

Halperin, David M. 2012. *How to Be Gay*. Cambridge, MA: Harvard University Press.

Hey Qween. 2016. "DRAGULA: Season One Premiere | Hey Qween." YouTube video, October 31, 2016. https://www.youtube.com/watch?v=EK0-nz02P8Y&list=PLba00WWBh2Wh9CDpdqrcvqwWRClhblsX8&index=2&t=0s.

jmski822. 2017. "Would Sharon Needles have won Dragula?" Reddit, November 9, 2017. https://www.reddit.com/r/Dragula/comments/7bx9om/would_sharon_needles_have_won_dragula/.

Jung, E. Alex. 2019. "*Drag Race* Inc.: What's Lost When a Subculture Goes Pop?" *Vulture*, June 11, 2019. https://www.vulture.com/2019/06/drag-race-inc-whats-lost-when-a-subculture-goes-pop.html.

Kohlsdorf, Kai. 2014. "Policing the Proper Queer Subject: *RuPaul's Drag Race* in the Neoliberal 'Post' Moment." In *The Makeup of* RuPaul's Drag Race: *Essays on the Queen of Reality Shows*, edited by Jim Daems, 67–87. Jefferson, NC: McFarland.

Kristeva, Julia. 1982. *Powers of Horror: An Essay on Abjection*. Translated by Leon S. Roudiez. New York: Columbia University Press.

Leavell, Jeff. 2018. "'Dragula' Is Loud, Weird, and Pisses on Heteronormativity." *Vice*, January 17, 2018. https://www.vice.com/en_ca/article/vbyjm3/dragula-is-loud-weird-and-pisses-on-heteronormativity.

Love, Heather. 2007. *Feeling Backward: Loss and the Politics of Queer History*. Cambridge, MA: Harvard University Press.

MKA2017. 2017. "Me thinking about how Dragula has been giving me life each week vs. the tomfoolery that was RPDR Season 9." Reddit, December 6, 2017. https://www.reddit.com/r/Dragula/comments/7i3fvl/me_thinking_about_how_dragula_has_been_giving_me/.

Morrison, Josh. 2014. "'Draguating' to Normal: Camp and Homonormative Politics." In *The Makeup of* RuPaul's Drag Race: *Essays on the Queen of Reality Shows*, edited by Jim Daems, 124–47. Jefferson, NC: McFarland.

Muñoz, José Esteban. 1999. *Disidentifications: Queers of Color and the Performance of Politics*. Minneapolis: University of Minnesota Press.

———. 2009. *Cruising Utopia: The Then and There of Queer Futurity*. New York: New York University Press.

Murray, Nick, dir. 2012. *RuPaul's Drag Race*. Season 4, episode 4, "Queens Behind Bars." Aired February 20, 2012, on Logo TV.

———, dir. 2016. *RuPaul's Drag Race All Stars*. Season 2, episode 4, "Drag Movie Shequels." Aired September 15, 2016, on Logo TV.

Needles, Sharon [Aaron Coady]. 2012. Interview by Raziel. "Spooky yet Beautiful." *Xtra! West: Vancouver's Gay and Lesbian News*, June 28, 2012. Archives of Gender & Sexuality.

Newton, Esther. [1972] 1979. *Mother Camp: Female Impersonators in America*. Chicago: University of Chicago Press.

Norris, Laurie. 2014. "Of Fish and Feminists: Homonormative Misogyny and the Trans*Queen." In *The Makeup of* RuPaul's Drag Race: *Essays on the Queen of Reality Shows*, edited by Jim Daems, 31–48. Jefferson, NC: McFarland.

Noyes, Nathan, dir. 2016. *The Boulet Brothers' Dragula*. Season 1, episode 3, "Zombies in Death Valley." Aired November 18, 2016, on Hey Qween TV.

———, dir. 2017. *The Boulet Brothers' Dragula*. Season 2, episode 1, "Cenobites." Aired October 17, 2017, on OUTtv and WOW Presents.

———, dir. 2019. *The Boulet Brothers' Dragula*. Season 3, episode 1, "The Lesser of Two Evils." Aired August 27, 2019, on OUTtv and Amazon Prime.

Perry, Frank, dir. 1981. *Mommie Dearest*. Hollywood, CA: Paramount Pictures.

Raziel. 2013. "Terrorist Realness." *Xtra! West: Vancouver's Gay and Lesbian News*, February 28–March 13, 2013. Archives of Sexuality & Gender.

Trinazoe. 2019. "Drag Race and Dragula." Reddit, March 4, 2019. https://www.reddit.com/r/rupaulsdragrace/comments/axbtl1/drag_race_and_dragula/.

Von Odd, Vander [Antonio Yee]. 2017. "MASC 4 MASCARA | Vander Von Odd and Samuel Donovan." YouTube video, June 15, 2017. https://www.youtube.com/watch?v=6pQgp5NeLT4.

youlooklikeseal. 2018. "Dragula > Drag Race." Reddit, April 15, 2018. https://www.reddit.com/r/Dragula/comments/8cgo6n/dragula_drag_race/.

6

RuPaul's Drag Race: Between Cultural Branding and Consumer Culture

Mario Campana and Katherine Duffy

Introduction

RuPaul's Drag Race premiered in February 2009 on Viacom's Logo. Pulling on the intertextuality and familiarity of the reality television format (e.g., *America's Next Top Model*, *Project Runway*) it has had success as the first American reality television program focusing exclusively on drag queens (integral to the format is the role of reality television stars, cultural tastemakers, and commercial sponsors). According to the *New York Times*, *Drag Race* leads Logo's strategy to sell "gay culture" to a mixed audience of gay men and heterosexual women (Logo termed this "gaystreaming"). Aslinger (2009, 119) notes that Logo "was born in the digital moment" as the role of social media is key in the creation of a cultural space for the *Drag Race* community to iteratively assemble and overlap entanglements that are at once localized and extended through the social landscape.

In this chapter, we explore *RuPaul's Drag Race* as a cultural brand. Cultural brands are a "conduit for the expression of ideological meanings" (Humphreys and Thompson 2014, 879); they represent icons aimed at addressing societal contradictions and perform specific consumer "identity myths" as they are able to solve cultural contradictions and anxieties of a specific social group by providing consumers with a desired identity (Holt 2004). Similarly, *RuPaul's Drag Race* addresses contradictions about the legitimation of LGBTQ+ subcultures in contemporary society. *Drag Race* promotes a marketplace discourse of self-love, self-acceptance, and acceptance of difference. The brand is very much rooted

within the LGBTQ+ subculture, and it reproduces its language, symbols, myths, discourses, and practices. Starting from a very niche position and broadcast on an LGBTQ+ channel, pulling on the brand cache of RuPaul, the brand was a success among the LGBTQ+ subculture, and it has now reached a wider legitimation within mainstream media. However, although it has now become more mainstream, the brand still reproduces subcultural and political messages. In this chapter, we address the following research question: How do consumers of *RuPaul's Drag Race* create and circulate a cultural brand? The aim is to explore how the cultural brand is created, scaled-up, and mainstreamed, tracing the trajectory from cult hit to mainstream show, or moving from a brand minor to a brand major (Arvidsson and Caliandro 2016). To achieve this, we conduct a "brand image analysis" (Giesler 2012) tracing the evolution of the *RuPaul's Drag Race* brand since it was born in 2009 and its impact on both consumer culture and wider society. We use online newspaper articles (including the *New York Times*, *Huffington Post*, Reddit, Vulture, Dragaholic) and social media data, from *Drag Race*'s pages on Facebook, Reddit, Instagram, and Twitter, generated by the brand and/or by consumers, to gain an initial understanding. Using a hermeneutic analysis, we first identify prominent themes and categories. We then identify four stages of evolution of the *Drag Race* brand around which the chapter is framed: (1) assembling a cultural brand, (2) subcultural legitimation, (3) resignification and mainstream legitimation, and (4) gaystreaming and political branding. We also identify tensions in the brand image that facilitate the evolution of the brand and consumer impact.

Cultural Branding

> I witnessed queens who could school most marketers on how to connect with their best customers. The strategies drag queens use to market themselves hasn't been studied or considered as traditional business marketing, but it should be. These queens had a great approach on how to build their loyal fan base.
> (Huba 2015)

Theoretically, we unpack *Drag Race* in line with a cultural branding perspective to enable us to explore the *Drag Race* brand in a dynamic way, insofar as a brand is not only created by a marketer or the consumer. Instead, a brand is a composition of different material bodies and expressive capacities that interact together. Lury (2004, 1) claims that a brand is "an object"; she asserts that a brand is "the outcome of object-ives and is produced in the tests and trials of object-ivity, and it is sometimes a matter of object-ion." Lury also suggests that

a brand is both an object of information and objectifies information, and this objectivity involves images, processes, products, and relations between products. Why do we commence our discussion by unpacking this definition? Considering a brand as not fixed, but as a platform for the patterning of activity, a mode of activity for organizing activities in time and space, pushes our focus toward a more nuanced perspective as to how the *Drag Race* brand is open, social, and mutates over time.

With this understanding as our starting point, we delve into cultural branding to position our theoretical journey. In line with Lury (2004, 4) we frame our perspective of the *Drag Race* brand as "a specific market modality or market cultural form." Holt's (2004) seminal work on cultural branding contributed a new branding model, which he argues applies to categories in which consumers value products as a mechanism for self-expression and identity work; marketing strategists may refer to these as "lifestyle," however, this is almost reductionist as to the power of these brands. As Humphreys and Thompson (2014) argue, the cultural branding paradigm (Holt 2004) pulls on consumer culture theory understandings of the marketplace as a composite of resources that consumers can utilize in their identity projects (Arnould and Thompson 2005; McCracken 1986), Horkheimer and Adorno's (1944/1972) political philosophy, and arguments of anti-brand activists (such as Klein 1999). It is important for us to acknowledge this political underpinning as we adopt a cultural branding perspective as this allows for us to develop insights into how the *Drag Race* brand functions as a conduit for expressing ideological meanings (Humphreys and Thompson 2014). Holt (2004, 3) proposed that a brand emerges as various "authors" (such as companies, culture industries, intermediaries, and customers) tell stories that involve the brand. Rather than a psychological phenomenon originating from individual consumer perceptions, a brand's power derives from the collective orientation of these perceptions. Holt suggests that consumers are drawn to brands that embody ideals and express who they want to be. He further proposes that the opportunity to build valued myths into the product distinguishes successful cultural branding. Here we come to understand cultural branding as "the set of axioms and strategic principles that guide the building of brands into cultural icons" (11). Cultural branding allows for the brand to function as a mobilizer or as "a cultural activist" encouraging people to think differently about themselves. In the digital landscape of social media, cultural branding facilitates brands to collaborate with communities and subcultures to bolster their ideologies in the marketplace (Holt 2016). Holt argues that within the proliferation of social media ecosystems and digital platforms, brands have shifted focus away from the platforms and to the locus of power, active consumer communities or "crowdcultures" (50). Within this emancipatory framing of digital media, *Drag Race* frequently calls on the audience to

utilize their active and empowered nature through social media to talk about the show and specific queens, for example, in season five, and during the penultimate episode, RuPaul himself asked viewers at home to use social media to support their favorite finalist.

Within a cultural branding perspective, Holt (2004, 2016) argues that brands can help to remedy cultural contradictions and anxieties resonant with a particular sociocultural group, and this has particular therapeutic associations as a cultural resource (Humphreys and Thompson 2014). However, cultural branding also has the power to invert marginal ideologies. Holt (2016) explains that in cultural branding, the brand propagates an innovative ideology that breaks with tradition and conventions within the specific category. To be able to do this successfully, it needs to identify which conventions to challenge and augment; Holt refers to this as "the cultural orthodoxy" and locating "the cultural opportunity" (46). *Drag Race* confronts homophobia, bigotry, and oppression within the cultural opportunity of the show, embedding milestones and political battles from US LGBTQ+ culture into the show (such as *Paris Is Burning*, the Stonewall riots, and marriage for same-sex couples).

Within consumer culture research, we have also seen a shift in attention from brand producers and wider brand management toward a consideration of consumer roles within how branding functions and value is created (Muñiz and O'Guinn 2001; Schau, Muñiz, and Arnould 2009; Schroeder 2009). The brand culture space exists between strategic concepts of brand identity and consumer interpretation of brand image, and an opportunity lies in the ability to ascertain the meaning of the chasm between strategic aims and consumer perceptions (Schroeder 2009; Schroeder and Salzer-Morling 2006). Schroeder (2009) drew attention to the cultural codes of branding, whereby a brand exists as a cultural, ideological, and political object, and advocated that research should examine the cultural processes that affect contemporary brands, such as historical context, ethical concerns, and cultural conventions. A cultural branding perspective of *Drag Race* recognizes the brand's representational and rhetorical power as both a valuable cultural artifact and a meaning repository reflecting wider societal, cultural, and ideological codes (Askegaard 2006; Cayla and Eckhardt 2008; Lury 2004; Schroeder 2009). In considering branding within this view, brands extend beyond mediators of cultural meaning; Schroeder (2009, 124) argues that they have become ideological referents that shape social norms.

To sum up, we look at *RuPaul's Drag Race* as an LGBTQ+ cultural brand. The brand is constituted of multiple brand authors; not only the producers and network of the brand, but also the consumers/audiences, the drag queens, the social media comments (and media more in general), the judges, the brand of RuPaul himself, the associations, partnerships, and more. Drag has always been inherently

subversive and *Drag Race* as a cultural brand subverts even the TV show format with a knowing parody on the conventional reality TV format and is unabashed in its use of promotion as an intrinsic part of the show. Furthermore, the brand has become an icon within the LGBTQ+ culture, and it reproduces several marketplace myths. We therefore look at the different trajectories of the evolution of the brand, keeping in mind the different authors and images that the brand has developed throughout these stages. First, in the next section, we will review the extant literature on LGBTQ+ brands in marketing.

Consumer Culture and Subcultural Perspectives

As the aspiring drag stars take their final sashay down the runway to the closing words "Shante you stay/Sashay away," the slogan evokes a community drawn together through language and subcultural codes (Butler 1997, 2001; Kates 2004; Kates and Belk 2001), where bricolage is commonplace to negotiate and contest the heteronormative structures of the mainstream marketplace. An extensive body of research in marketing and consumer culture has studied the relationship that LGBTQ+ consumers have built with mainstream global brands (e.g., Levi's and Absolut; Kates 2004). LGBTQ+ consumers may consider these brands as either allies or enemies depending on the political battles the brands support (Kates 2004). Examples of LGBTQ+ brands are "the little queer shops" (e.g., Prowler), dating apps (e.g., Grindr, Fem), bars and clubs (e.g., GAY London and Manchester), entertainment products (e.g., *RuPaul's Drag Race*), clothing lines (e.g., Andrew Christian), drag-queen shows (e.g., *Wigstock*), community centers (London LGBTQ+ Community Centre), and others (Coffin, Eichert, and Noelke 2019; Kates 2000, 2002, 2004; Keating and McLoughlin 2005; Rinallo 2007; Visconti 2008). The research in this field describes LGBTQ+ brands as centered around nonheterosexual identities (Coffin, Eichert, and Noelke 2019; Kates 2000). Consumer researchers have explored consumption of nonheterosexual consumers and associated emergent markets (see Kates 2002, 2004; Peñaloza 1996; Rinallo 2007; Visconti 2008). In their systematic review, Ginder and Byun (2015) suggest that advertising and media representations have impacted how LGBTQ+ markets have developed.

While this body of literature in the consumer research domain has focused on market segments and advertising and media representations of LGTBQ+, research has also focused on consumption behaviors and identity work often from a subcultural perspective (Kates 2002; Visconti 2008). Rinallo's (2007) and Visconti's (2008) work identifies that some consumption behaviors that are

labeled as "gay" have become appropriated into mainstream heterosexual culture. Rinallo (2007, 89) found that rather than feeling territorial or protective, gay men welcomed "the diffusion of gay vagueness [...] as a mechanism through which they can gain understanding in society." Further Rinallo highlights that when approached in line with subcultural theory, the filtering of gay aesthetics into the mainstream becomes problematic. He suggests that marketers who co-opt and soften elements of the subculture to retain mainstream appeal have a tendency of "alienating hardcore members, corrupting the subculture and diluting its original appeal" (Schouten and McAlexander 1995, 95). Kates (2002) has shown the oppositional nature of subcultural consumption behaviors with gay consumers, who, through active boundary work, renegotiate the parameters of the subculture and mainstream heterosexual culture. This research also aims at solving specific consumption needs of LGBTQ+ consumers, derived from exclusionary and stigmatization practices within the mainstream marketplace (Visconti 2008). Furthermore, they are usually small and local brands geographically bounded to a neighborhood (Kates 2002). Extant research also shows the importance of these brands especially for white, gay, cisgender, affluent consumers. First, through consuming LGBTQ+ brands, gay consumers are introduced to "mores, history and subcultural meanings" of the local gay culture (397). Hence, LGBTQ+ brands facilitate social processes within and outside the local community. Second, these brands are a "pride wear and battle gear" (Kates 2000, 499) for gay consumers within the local geographical area. They represent a form of "symbolic resistance to perceived social injustice" (499). Third, by consuming these brands, gay consumers show their support to the local community (Kates 2000, 2002, 2004).

Literature in marketing has focused on LGBTQ+ brands that are local and spatially concentrated, usually in urban areas (i.e., gay ghettos). Recently, these brands have become more and more visible in the mainstream marketplace and many of them have scaled-up globally. This is because of the increased social and political legitimation of LGBTQ+ consumers (Coffin, Eichert, and Nolke 2019; Ginder and Buyn 2015). Also, the development of social media has expanded local marketplace cultures worldwide; once locally and spatially concentrated, they are now global and more established (Holt 2016). This has an impact on cultural influence, reach, and power. Consumers within these marketplace cultures are capable of creating "new ideas, products, practices and aesthetics" at a global level, circumventing the "traditional gatekeepers" (43), such as mainstream global brands. Despite its US centrism, we look at RuPaul's *Drag Race* as an LGBTQ+ global cultural brand that targets not only white, gay, cisgender consumers, but also a wider audience within the LGBTQ+ spectrum.

Drag Race, Gaystreaming, and Global Branding

> This is so much more than just a television show to these people. This is bigger than any of us could have imagined.
>
> —Michelle Visage

A large contribution of the success of *RuPaul's Drag Race* as a global brand is due to the broadcaster (Logo) and social media. Specifically, *Drag Race* is part of a bigger phenomenon called gaystreaming, which is a form of entertainment based on "gay content" in terms of meanings of the shows, characters, and storylines. The term "gaystreaming" has been widened to consider the broader LGBTQ+ audience; however, gaystreaming also brings with it connotations of homonormativity and marginalization. We explore the development, discourses, and effects of gaystreaming, whereby the discourses surrounding gaystreaming propagate the construction of homonormativity, which simultaneously marginalizes other queer bodies, behaviors, and practices.

Aslinger (2009) discusses Logo's network growth and ongoing development as indicative of a post-broadcast era that reflects targeting multiple niche audiences and distributing associated content across multiple channels. Within this he highlights emergent tensions between Logo's public announcements of valuing inclusivity on the one hand and how the content of their programming represented and "reinscribed class, race, and national hierarchies in queer cultures" on the other (108). This results in tensions and a problematization of the value of LGBTQ+ cultural spaces when some subjects remain marginalized and others are integrated into the mainstream. Within this we have to question the intersections of sexuality, race, gender, and class but also of the prevailing homonormativity (Duggan 2002; Ng 2014). Ng (2014, 276) further questions whether gaystreaming, rather than being viewed as a predictable outcome of commercial media's focus on LGBTQ+ content, may require framing as an obstacle to queer cultural politics. Ng in her examination of Logo's rebranding strategy, which Logo labeled gaystreaming, asserts that gaystreaming in practice has remarginalized queer subjects through homonormativity, which is pushed forward via discourses of consumerism, progress, and integration. Ng expresses that Logo exalt *Drag Race* as their most highly rated show with an emphasis on sexual and racial diversity; however, while this focus on gaystreaming may extend opportunities of LGBTQ+ interest, it concurrently promotes a narrow set of representations. This is also reflected in the terminology adopted, as gaystreaming omits lesbian, bisexual, transgender, questioning, or queer and, as a result, limits the focus of their intention. With Logo's approach to gaystreaming they abstract this concept from more political undertones (Mulshine 1994), while they utilize it in reference to extending

content and representation in their programming. Ng (2014, 260) further argues that this is representative of the disconnect between their sense of gaystreaming and the discourses that question the dominant commercial culture.

Methodology

We conducted a brand image analysis (Giesler 2012) tracing the evolution of the *RuPaul's Drag Race* brand since it was born in 2009 and its impact on both consumer culture and wider society. We also highlighted a parallel between RuPaul's own branding and the branding of the show. We used online newspaper articles (including the *New York Times, Huffington Post*, Reddit, Vulture, Dragaholic) and social media data, from *Drag Race*'s pages on Facebook, Reddit, Instagram, and Twitter generated by the brand and/or by consumers, to gain an initial understanding. Using a hermeneutic analysis, we first identified prominent themes and categories. There are four stages of evolution of the *Drag Race* brand: (1) assembling a cultural brand, (2) subcultural legitimation, (3) resignification and mainstream legitimation, and (4) gaystreaming and political branding (Table 6.1). We also identified tensions in the brand image that facilitate the evolution of the brand and consumer impact.

Assembling a Cultural Brand—Seasons One–Three, 2009–11

In the first stage, the cultural brand is assembled when all the different bodies and expressive capacities (Parmentier and Fischer 2015) generate a brand that goes against mainstream heteronormative and political discourse. As discussed previously, the brand was launched in 2009 on Logo, an LGBTQ+ channel, with nine contestants, RuPaul as host and as a judge, two other regular judges (Santino Rice and Merle Ginsber), and one or two guest judges. The show pulled on RuPaul's existing brand image and capital, while *Drag Race* established partnerships with brands that have been historically supportive of the LGBTQ+ community such as Absolut Vodka, Anastasia Beverly Hills Cosmetics, and Marco Marco Underwear.

In season one, widely regarded as "the lost season," the focus was on the creativity and resourcefulness of competitors while showcasing the drag world. As Jade Sotomayor, season one competitor, comments to *Paper* magazine: "At that time there were still a lot of people that were blind, that didn't understand drag. And so we were really excited to be pioneers in this movement to try and educate" (Katz 2019). The first season reflected the early brand image of RuPaul—an underground drag queen with a low budget to perform the art of drag. However, the show has changed dramatically since that first season with practicalities

Brand evolution	Main components of the cultural brand	Events	Tensions
Assembling a cultural brand (seasons 1, 2, 3) 2009–11	The brand cache of RuPaul, LogoTV, 12 drag queens, 3 judges + guest judges, LGBTQ+ subculture	Educating the audience to drag Person behind the personality, used to highlight struggles such as Ongina and HIV Alternative political discourse: message of love and acceptance LGBTQ+ brands (i.e., Absolut) Spin-offs: *DragU*	Resignification of practices: RuPaul's is the "right way of doing drag" Inclusivity issues emerge—Sonique example
Subcultural legitimation (season 4, 5, 6, All Stars 1) 2012–14	Michelle Visage (MV) becomes one of the judges, 12–14 drag queens, professionalization of the production, prize money increases	Show becomes a pillar for LGBTQ+ Multiplicity of events and LGBTQ+ brands: LGBTQ+ shows, DragCon, movies, etc. The show format becomes more stable from season 4 onward	Commercial logic Hate toward drag queens on social media
Transition to legitimation (season 7 and 8) 2015–16	New generation of drag queens: they grew up watching the show 100th queen on the show	Show appears with mainstream fashion (Marc Jacobs), music (Miley Cyrus), and brands 1st Emmy won	Mainstreamization and backlash for the drag queens Cultural appropriation Impact on wider drag practices outside the show Successful drag queens are only the ones on the show

Brand evolution	Main components of the cultural brand	Events	Tensions
Gaystreaming and political branding (season 9, 10, 11, All Stars 2, 3, and 4) 2016–19	Show moves to VH1 Famous guest judges opening the season (e.g., Lady Gaga, Christina Aguilera, Miley Cyrus)	9 Emmys RuPaul queen of hearts of the *Pirelli* Calendar Openly political: pushing the agenda against the Trump administration *Trump the Rusical*	Controversies about the legitimation of the show RuPaul's transgender contestants' controversy

TABLE 6.1: Brand evolution of *Drag Race*.

such as the number of queens competing per season increasing, the length of the show increasing, and the cash prize growing from $20K in season one to $100K by season four. The first season was seen as raw and experimental, as there was nothing similar to benchmark the show against. While there was some rivalry between the queens in this first season, the show focused more on the aesthetics and scrappiness of the contestants and key to the narrative were personal stories and journeys of the queens (Katz 2019).

In this early stage the *Drag Race* brand was promoting a message of love, acceptance, and inclusion of individuals who had been living on the fringes of society. Not only did the brand promote these discourses, but it put perceived "outcasts" such drag queens at the center of the stage, exposing them to the general audience. The show put under the spotlight a subculture that had been up until that time mostly limited to the LGBTQ+ clubs and venues. The show also educated the general public on the drag scene and underground ballroom scene by providing explanations of slang used in this underground culture. For example, the show often uses references from *Paris Is Burning*, the famous documentary about NYC ballroom culture and the life of African American, Latinx, gay, lower-status, and the transgender communities involved.

The cultural impact of *Drag Race* on LGBTQ+ consumers has been strong since the beginning. For example, Aquaria, the winner of season ten, states during the finale:

> I remember catching season 1 and I was like, especially Nina Flowers [season 1 contestant], I don't know what it is, but I see something about me in her. Let me be a fan of this as long as I can. (Aquaria, DragRage S10E14)

Aquaria says that she became a drag queen because she was initially a big fan of the show, and especially of Nina Flowers. Through the message of love and acceptance the brand has helped many LGBTQ+ consumers to come out of the closet, embrace their identity, and find their voice within the mainstream culture. The brand also disseminated educational messages about subcultures that have been traditionally stigmatized. For example, one of the contestants of season two, Sonique, came out as transgender, and she discussed that she was transitioning during the moment the show was filmed. A comment of a user on Reddit shows how her coming out helped *Drag Race*'s consumers to better understand transgenderism:

> So proud of Sonique though and she's so right. I'm an old b***h by this subs standards and I can remember totally not understanding what trans was at all. I saw nothing wrong when NPB and Shangie accused girls of being "trannies" and freely threw that word around myself. It's amazing how far trans acceptance has come in this past decade. Also, Sonique is totally stunning and talented!
> (Reddit)

Other contestants have come out as transgender in the following seasons, but the show has also touched upon other stigmatized topics for the LGBTQ+ community such as HIV/AIDS. For example, Ongina, in season one, was among the few people who openly acknowledged her being HIV positive on TV. She says that this revelation inspired a lot of people to accept their HIV-positive status as well (Valdez 2017).

We observe two major tensions in the cultural brand at this stage. First, the contestants started receiving backlash on social media, which affected them personally. At this stage, the brand also started resignifying drag queen practices by providing a new/right "way of doing drag." *Drag Race* became the benchmark against which all new drag queens emerging into the scene started measuring themselves. In fact, as Aquaria pointed out in the quotation earlier, people started doing drag because of *Drag Race* and they started reproducing the same practices in their drag performance. We see the show shift from introducing drag and embracing a role as a cult hit show, to adopting the role as the main purveyor of drag culture (Katz 2019). Tensions also started to emerge here with regards to inclusivity, such as the issues around trans contestants within the show and the show's response as seen within the wider development of the brand. This highlighted tensions both within and outside of the LGBTQ+ community.

Subcultural Legitimation—Seasons Four–Six, All Stars 1, 2012–14

In this second phase we see the brand assemblage start to solidify, whereby the format became more formalized and the brand more stable. The audience of the

show grew significantly in this period thanks to the professionalization of the production, the addition of a new judge, Michelle Visage (first appeared in season three), who became key for the success of the show, the development of narratives that facilitated the reproduction of marketplace myths, the development of a constellation of brands, and the elevation of RuPaul's brand to the benchmark of drag. It was at this stage that the show started being legitimized within the LGBTQ+ culture. As news about the show spread by word of mouth, people started watching seasons four, five, and six, and after that they engaged in watching the previous seasons as well. Together with RuPaul, other drag queens such as Sharon Needles, Willam, Alaska, Bianca Del Rio, Roxxxy Andrews, Detox, Latrice Royale, and Jinkx Monsoon gained success and start building their own brand as well linked to the success of the cultural brand of *Drag Race*. The brand assemblage also expanded in a constellation of different brands not only promoted by drag queens, who effectively became marketing experts, but also several spin-off brands such as *DragU* (which was not a big success and terminated in 2012).

However, what made the brand really successful were the narratives developed on the show, which facilitated the construction of marketplace myths (Holt 2004). These myths facilitate the work of sensemaking of consumers around a brand, and they are tools that consumers use to construct their identity (Thompson 2004). It was in these seasons that *Drag Race* defined its main narratives as a brand, which was then replicated in seasons seven, eight, nine, ten, and eleven. For example, during "lip synch for your life," Roxxxy Andrews revealed her personal struggle as a child being abandoned by her mother at the bus stop. That moment was "gagging" for the audience and strengthened the identification that the consumer had with the show.

> Roxxy Andrews. No matter how it came out, that's the saddest, most f***d up thing I've ever heard. My Dad abandoned us when I was little, and it still impacts my life- and I still had a parent! It's no excuse for some of her romper room bullshit, but it's still sad as f**k.
>
> (Reddit Comment 2014)

Roxxxy Andrews' narrative was not the only one that the show promoted and with which the users identified. For example, Jinkx Monsoon won season five because she reproduced the classic narrative of "rags to riches," where the outcast is ostracized by other forces (e.g., Roxxxy Andrews), but in the end manages to achieve their goal. Propagating these types of stereotypes facilitated consumer identification with the brand. Furthermore, it also helped to build cultural-cognitive legitimacy (Humphreys 2010) within the LGBTQ+ cultures. In fact, LGBTQ+ consumers better understand the brand, what it stands for, and how it can fit into their life.

Also at this stage backlash emerged from the consumer perspective, especially on social media. The narratives produced by the brand polarized consumers online against the drag queens. Consumers became very vocal, insulting drag queens online based on what happened on the show. For example:

> I like to see @RoxxxyAndrews use some of her copious amounts of duct tape to try and patch together an actual personality.
>
> (#DragRace from Twitter)

> If @RoxxxyAndrews wins, I will stop watching #RPDR. The way she acted on the last episode was DISGUSTING!
>
> (From Twitter)

This hate toward Roxxxy Andrews, in their attempt to sabotage Jinkx Monsoon, went even further. In fact, consumers online suggested that she could even be hurt or kill herself. She was not the only one who generated vociferous hate from fans; every season queens received hate online. This can be considered as a further narrative of the show that is an integral and problematic part of the brand assemblage.

Transitioning to Mainstream Legitimation—Seasons Seven and Eight, 2015 and 2016

Starting from season seven, we see a transition of the brand to mainstream legitimation as it caught the attention of consumers beyond the LGBTQ+ culture. This happened for several reasons. First, the narratives developed in the previous stage generated even further word-of-mouth around the brand reaching non-LGBTQ+ consumers. Second, for the first time in season seven the show invited drag queens who were *Drag Race* kids. They were (and are) consumers of *Drag Race*, who were still in their teenage years when they started watching the show. They became drag queens because of the show, and they have learnt to be drag queens through the show. In addition, given the success of the previous editions, mainstream brands start legitimizing the brand assemblage overall. For example, the show won an Emmy, RuPaul and the drag queens were recognized by the fashion system and mainstream media and by the music industry, and *Drag Race* received endorsements by mainstream brands such as Fiat and Lush.

From the start, *Drag Race* embraced the digital moment and enhanced the brand experience across social media platforms, including social media sites that extended and amplified the reach of the show beyond the parameters of the television show format. The show developed and propelled a "brand language," which is a series of sentences or words that are generated by the brand and enter

the everyday life of consumers. Since the beginning of his career, RuPaul has propagated several catchphrases and idioms belonging to black ballroom culture as part of his own branding, which have now become a mainstream way of speaking within the LGBTQ+ culture. Through an analysis of the social media data, we found that consumers routinely use words such as "shade," "gagging," and "realness." (See the word cloud for an overview of the social media language associated with *Drag Race* as a cultural brand in Figure 6.1.) We also see that the show promotes linguistic expressions of the niche drag queen community as hashtags, which in turn become mainstream for use in the gay community first and then for a wider audience, moving *Drag Race* from a brand minor to a brand major (Arvidsson and Caliandro 2016).

Similarly to stage 2, at this stage there was an emergent tension with the angry narratives directed toward the drag queens. Furthermore, there was a tangible problem of cultural appropriation of the brand language by the mainstream audience. Although this brand language makes *Drag Race* even more successful, it is now devoid of the cultural meanings it had when it was used in the ballroom scenes or underground LGBTQ+ environments.

FIGURE 6.1: An overview of the most used social media language regarding RuPaul as a cultural brand.

Finally, because of the emergence of the "Drag Race kids," the brand created a specific type of drag performed by the new queens. Shannel, a season one contestant, commented:

> Now it's become a social media phenomenon and so many of the girls that have these huge social media followings are the ones that are getting on. In many ways it's become a very bankable, profitable asset to both parties, and I get that because business is business, however I miss the mindset of just being an amazing queen, going in and going 110% of who you are what you are and competing.
>
> (Katz 2019)

This more mainstream and commercialized approach to drag sparks a lot of discussion within the drag community as *Drag Race* is seen as becoming the only way of performing drag, and consumers are not interested anymore in the local drag queens or other forms of drag, unless they have appeared on the show.

Gaystreaming and Political Branding

A fundamental life event of the brand was when *Drag Race* moved to a mainstream TV channel (VH1), which broadcasts to 92 million homes, compared to Logo, which is predominantly a niche TV channel. This allowed the brand to become more mainstream and more widely accepted outside of the LGBTQ+ subculture. For example, an iconic moment was when *Drag Race*, and specifically Trinity The Tuck Taylor (season nine), was mentioned in a sketch on *Saturday Night Live* with Chris Pine. At this stage, *Drag Race* was more easily accessible to the mainstream audience and also receives mainstream acknowledgment, which were precluded earlier. RuPaul famously said that "drag will never be mainstream" as it challenges the most core convictions within society. Furthermore, he said that for this reason *Drag Race* will never win prizes such as the Emmy. As of 2019 the show has won nine Emmys in total, where RuPaul has won as best reality host. Furthermore, *Drag Race* has become a real franchise that has expanded significantly beyond the spin-off shows by adding brands such as *Drag Con, Drag Race Thailand, Drag Race UK*, and *Drag Race Canada*. This has extended the audience of the brand online and offline and has made *Drag Race* a real LGBTQ+ global brand. Finally, especially in season eleven, the *Drag Race* queens have become endorsers of global brands, for example, Monet Exchange endorsing Pepsi and Shangela endorsing McDonalds.

As of season nine, the brand has become more mainstream and it has also strengthened its political components. While drag could be seen as inherently political, this focus of the show has been spearheaded for two reasons. First of all, *Drag Race* has been strongly standing against the Trump administration for policies such

as segregation strategies for LGBTQ+ individuals. For example, in season eleven, one of the main challenges, "Trump the Rusical," was focused on the women of Trump's administration and the scandals around the president. This challenge also promoted a message of female empowerment, as the drag queens were lip-synching about standing against these powerful men and that the "future is female."

Second, by becoming mainstream, *Drag Race* took on the role of educating non-LBGTQ+ consumers about the subculture. For example, during the finale of season ten, the brand broadcasted a video on the impact of drag queens on mainstream culture and the impact of *Drag Race* on consumers during Trump's administration.

Overall, the show continues to reproduce the archetypal narratives developed during the "subcultural legitimation" stage (stage 2) by showcasing the struggles of drag queens and LGBTQ+ consumers within society. For example, in season ten, Dusty-Ray Bottoms recounted that when his parents found out he was gay, they sent him to conversion therapy. His story was very emotional as he was talking about the long-lasting struggles of being a gay person within a religious community. Overall, *Drag Race* showcases struggles of LGBTQ+ individuals with race, gender, class, family, and religion. *Drag Race* is a true cultural brand as it propagates narratives and myths that go against mainstream societal discourses and helps consumers to construct their identity in the face of societal struggles. This comment from Reddit gives an example of how *Drag Race* provides a sense of meaning for consumers:

> Rupaul drag race is one of things that keeps me alive. I'm 21 years old closeted gay guy from jakarta, indonesia, living with anxious and dont really have friend that i can rely to talk about it. I've been knowing rpdr since season 8, then i watch the previous seasons and allstar. I found out about this show when i was in my lowest point of my life and this show has been helping me through all that. I'm in my 2nd year in college now (4th semester) majoring in computer science and recently things are getting harder which make my anxious worse. The fear of failing in classes and organizatons also facing the next semester leads my mind to afraid of not getting job in the future which make it even more difficult to come out and live the life i want (Indonesia isn't a progressive country who can accept the lgbtq+ community, so to meet people who can accept me in the future I think i need to live at least in middle class society). I don't really make friend irl because i just want to be friend with open minded person who can accept my sexuality and i have none so far, i tried grindr and jackd recently but most of the user in my area are still in the closet, only looking for hook up and the worst thing is racist (there's a lot of people who put no sissy, no fat, masc4masc, etc in their profile). I just want to share with you guys how it feels like being rpdr fan in Indonesia, i always jealous with people from twitter or tumblr when they share their inner queer and have people irl who support them.
> (From Reddit)

In these lines, this LGBTQ+ consumer from Jakarta said that *Drag Race* saved his life. He is still in the closet because of the lack of acceptance of LGBTQ+ people in Indonesia, but can be his true self by watching *Drag Race*.

While at this stage *Drag Race* is established as a very strong cultural brand, we see the emergent tensions between the different parties in the brand assemblage have become even more exacerbated, and as a result we start to see competing discourses surrounding the cultural brand. First, *Drag Race* has been considered divisive within the LGBTQ+ community. For example, it has been accused of promoting a specific style of drag, which is US-centered and focused on cisgender gay men who dress like women, discounting the other types of drag performances (such as cisfemale and trans and non-binary performers). A recent interview by *Guardian* (Aitkenhead 2018) with RuPaul also supported this divisive vision. In fact, RuPaul said that only transgender women who did not fully transition could compete on the show as a matter of fairness. In a following tweet he said: "You can take performance enhancing drugs and still be an athlete, just not in the Olympics" (RuPaul in interview with Aitkenhead 2018). This referred to the enhancement that transitioning women have (e.g., breast implants). While he later admitted regret over the comments, there was already a big backlash for the brand, as it was alienating one of the main audiences of the show that identify with the brand, such as transgender people. It also sparked a wave of disappointed anger within several of the surrounding brand communities, including *Drag Race* fans, the show's former contestants (trans and otherwise), trans performers, and social commentators in the wider media. Peppermint (the runner-up of season nine), who had been heralded as the first openly trans contestant, expressed her dismay that she may no longer belong with the *Drag Race* brand as a now fully transitioned woman, but seemed to come around to thinking that it was a "non-issue." This example shows the complexities of the show's positioning as a cultural brand, and RuPaul's comments and reticence to adapt the brand highlight the contestations of the cultural brand when it no longer aligns fully with the brand community's sociocultural perspectives. RuPaul's influence over drag culture and the impact on the LGBTQ+ community has further been questioned "in light of what have been called transphobic comments by the television star" (Blackmon 2018). Essentially, we see here that the *Drag Race* brand becomes problematic as it is seen to ostracize and marginalize key community members who had previously sought solace and acceptance within the brand, but also that the brand has failed to keep itself up to date with current sociocultural temperatures within the trans community and wider LGBTQ+ consumers and missed the opportunity to further gender identity conversations through the lens of the *Drag Race* brand. From a cultural branding perspective it demonstrates a disconnect between the brand image communicated by the brand through *Drag Race*, and the actions communicated by

the brand, especially regarding the comments by RuPaul. It highlights an uneasy discord between the drag community regarding acceptance and the "right way of doing drag" as is represented in the show.

Overall, *Drag Race* is a strong cultural brand that tries to navigate these different tensions and contestations in order to bring change within society.

Discussion

Overall, we identified four stages of evolution of *Drag Race* as a cultural brand. We also identified tensions in the brand image that facilitate the evolution of the brand and create consumer impact. Throughout these four stages, we observed how *Drag Race* was initially charged with an ideological and political discourse promoting love and acceptance. A cultural brand was created as it promoted a political message that went against the mainstream heteronormative market discourse. The political messages propagated by the brand also inspired many LGBTQ+ people to proudly come out of the closet. As *Drag Race* developed, the brand took a stronger political stance against the Trump administration, reinforcing its political message and becoming one of the symbols of the resistance against isolating political discourses. Furthermore, *Drag Race* diffused a specific brand language (Arsel and Thompson 2011) among consumers, which mobilized underground drag queen parlance. Terms such as "shade," "condragulations," and "lipsynchs" are diffused through social media and have become a form of identification and signification of the LGBTQ+ subculture.

However, the gaystreamization of the brand also resignified practices of "doing drag" for drag queens, which sparked several controversies in the LGBTQ+ world. Further contestations emerged as the wider drag culture suffered from consumers' interest in *Drag Race* queens, rather than drag queen practice more generally. Critics have claimed that *Drag Race* does not depict the complexity of drag culture or allows for progression of the culture through its mainstreamization. Finally, one of the most significant contestations emerged regarding participation of transgender contestants. There had already been the "female or she-male" controversy and then RuPaul expressed views of being against transgender women as *Drag Race* competitors. This sparked outrage in the LGBTQ+ subculture because of the contradictory messages that the show was promoting by creating exclusions within the community.

We observed social media assuming a central role in the diffusion of the show and in the creation of the community around it. The brand community assembled by use of the hashtag #DragRace, and consumers engaged in discussions about the different elements of the show. These conversations also continued offline,

redefining the boundaries of the community that engaged with the show. In fact, not being informed about these conversations meant not being part of the specific niche community. By nature of its social media presence and actively pulling on the power of digital media, *Drag Race* openly invites and inspires dialogue and debate among fans, critics, and former contestants; bringing people from a multitude of backgrounds, lived experiences, and political motivations into potentially fruitful encounters centered around the brand.

Conclusions

In defining *Drag Race* as a cultural brand, we suggest that the show extends beyond being a pillar for LGBTQ+ consumers; it acts as a "conduit for the expression of ideological meanings" (Humphreys and Thompson 2014). *Drag Race* is iconic insofar as it allows consumers to address societal contradictions and perform specific "identity myths" to explore these contradictions and anxieties (Holt 2004). By taking a cultural branding (Holt 2004, 2016) approach to *RuPaul's Drag Race* we have shown how the *Drag Race* brand is created together with the audience, and thus it is active and ongoing, scaling from brand minor to brand major (Arvidsson and Caliandro 2016). With the *Drag Race* television show as the foci, products, services, and audience are made meaningful and valuable, while in tandem the brand continues to scale up. Seminal to this is understanding that the *Drag Race* brand happens in a cultural context that is continuously evolving and tensions continually emerge, as it does not happen in a vacuum. The macro-discourses, such as political discourses as we have shown, are very much part of the brand assemblage. We also highlighted the challenges, tensions, and contestations that occurred to the *Drag Race* brand as it was integrated into the mainstream.

The *Drag Race* brand narratives are defined in conjunction with the consumers, and the social nature of the *Drag Race* brand changes the locus of control. Parmentier and Fischer (2015, 1248) argue that brands cannot be understood without viewing them as comprising both the narratives that the brand harnesses and the myriad of components with important material capacities that make up the product itself, as well as the consumers who contribute at times to stabilizing and at other times to destabilizing. In an assemblage and cultural product such as the *Drag Race* brand, these components include both people and things, such as the consumers of the brand, the amplification of the reach of the brand through social media, and the technologies of distribution that allow the consumer to access the brand. In exploring the different components of the brand, and how they stabilize and destabilize the brand, we showed how the community uses language to create a

shared brand reality and how getting to know the contestants' personal stories of displacement and marginalization highlights the ongoing struggles with the LGBTQ+ community, while drawing attention to a lack of cohesion within the community.

Against a backdrop of political and societal unrest in the United States, the *Drag Race* brand demarcates a cultural space that addresses social contradictions and is constituted of overlapping entanglements of the brand that are at once localized and extended through the social landscape. We draw attention to the political dimensions of the show, which have always been present but in the current environment have become more acute and explicit. Within this US-centric depiction of drag culture, the undercurrent of race, gender, and class struggles becomes more visible. Our consideration of gaystreaming highlights unresolved questions about the value of LGBTQ+ specific cultural spaces, and the extent to which the resignification of such spaces marginalizes some LGBTQ+ subjects even as others then become legitimized and mainstreamed.

REFERENCES

Aitkenhead, Decca. 2018. "RuPaul: 'Drag is a big f-you to male-dominated culture'". *Guardian*, March 3, 2018. https://www.theguardian.com/tv-and-radio/2018/mar/03/rupaul-drag-race-big-f-you-to-male-dominated-culture.

Arnould, Eric J., and Craig J. Thompson. 2005. "Consumer Culture Theory (CCT): Twenty Years of Research." *Journal of Consumer Research* 31 (4): 868–82. https://doi.org/10.1086/426626.

Arsel, Zeynep, and Craig J. Thompson. 2011. "Demythologizing Consumption Practices: How Consumers Protect Their Field-Dependent Capital from Devaluing Marketplace Myths." *Journal of Consumer Research* 37 (5): 791–806. https://doi.org/10.1086/656389.

Arvidsson, Adam, and Alessandro Caliandro. 2016. "Brand Public." *Journal of Consumer Research* 42 (5): 727–48. https://doi.org/10.1093/jcr/ucv053.

Askegaard, Soren. 2006. "Brands as a Global Ideoscape." In *Brand Culture*, edited by Jonathan E. Schroeder and Miriam Salzer-Mörling, 91–102. London: Routledge.

Aslinger, Ben. 2009. "Creating a Network for Queer Audiences at Logo TV." *Popular Communication* 7 (2): 107–21. https://doi.org/10.1080/15405700902776495.

Baym, Nancy K. 2002. "Interpersonal Life Online." In *Handbook of New Media: Social Shaping and Consequences of ICTs*, edited by Leah A. Lievrouw and Sonia Livingstone, 62–76. London: SAGE.

Blackmon, Michael. 2018. "Queens Are Questioning RuPaul's Grip on Drag Culture after His Controversial Trans Comments." *BuzzFeed News*, March 9, 2018. https://www.buzzfeednews.com/article/michaelblackmon/rupaul-drag-race-queen-trans-transphobic.

Butler, Judith. 1997. *The Psychic Life of Power: Theories in Subjection*. Stanford, CA: Stanford University Press.

———. 2001. "Doing Justice to Someone: Sex Reassignment and Allegories of Transsexuality." *GLQ: A Journal of Lesbian and Gay Studies* 7 (4): 621–36.

Cayla, Julien, and Giana Eckhardt. 2008. "Asian Brands and the Shaping of a Transnational Imagined Community." *Journal of Consumer Research* 35: 216–30. https://doi.org/10.1086/587629.

Coffin, Jack, Christian A. Eichert, and Ana-Isabel Nolke. 2019. "Towards (and beyond) LGBTQ+ Studies in Marketing and Consumer Research." In *Handbook of Research on Gender and Marketing*, edited by Susan Dobscha, 273–93. London: Edward Elgar.

Duggan, Lisa. 2002. "The New Homonormativity: The Sexual Politics of Neoliberalism." In *Materializing Democracy: Toward a Revitalized Cultural Politics*, edited by Russ Castronovo and Dana D. Nelson, 175–94. Durham, NC: Duke University Press.

Giesler, Markus. 2012. "How Doppelgänger Brand Images Influence the Market Creation Process: Longitudinal Insights from the Rise of Botox Cosmetic." *Journal of Marketing* 76 (6): 55–68. https://doi.org/10.1509/jm.10.0406.

Ginder, Whitney, and Sang-Eun Byun. 2015. "Past, Present, and Future of Gay and Lesbian Consumer Research: Critical Review of the Quest for the Queer Dollar." *Psychology & Marketing* 32 (8): 821–41. https://doi.org/10.1002/mar.20821.

Green, Erica L., Katie Benner, and Robert Pear. 2018. "Transgender: Could Be Defined Out of Existence under Trump Administration." *New York Times*, October 8, 2018. https://www.nytimes.com/2018/10/21/us/politics/transgender-trump-administration-sex-definition.html.

Holt, Douglas B. 2004. *How Brands Become Icons: The Principles of Cultural Branding*. Brighton, MA: Harvard Business.

———. 2016. "Branding in the Age of Social Media." *Harvard Business Review* 94 (3): 13.

Horkheimer, Max, and Theodor W. Adorno. 1944/1972. *Dialectic of Enlightenment*. New York: Continuum.

Huba, J. 2015. "Build Fan Loyalty Like RuPaul and America's Top Drag Queens." June 29, 2015. https://www.forbes.com/sites/jackiehuba/2015/06/01/build-fan-loyalty-like-rupaul-and-americas-top-drag-queens/#3106bde2577d.

Humphreys, Ashlee. 2010. "Megamarketing: The Creation of Markets as a Social Process." *Journal of Marketing* 74 (2): 1–19. https://doi.org/10.1509/jm.74.2.1.

Humphreys, Ashlee, and Craig J. Thompson. 2014. "Branding Disaster: Re-establishing Trust through the Ideological Containment of Systemic Risk Anxieties." *Journal of Consumer Research* 41 (4): 877–910. https://doi.org/10.1086/677905.

Kates, Steven M. 2000. "Out of the Closet and Out on the Street! Gay Men and Their Brand Relationships." *Psychology & Marketing* 17 (6): 493–513. https://doi.org/10.1002/(SICI)1520–6793(200006)17:6<493::AID-MAR4>3.0.CO;2-F.

———. 2002. "The Protean Quality of Subcultural Consumption: An Ethnographic Account of Gay Consumers." *Journal of Consumer Research* 29 (3): 383–99. https://doi.org/10.1086/344427.

———. 2004. "The Dynamics of Brand Legitimacy: An Interpretive Study in the Gay Men's Community." *Journal of Consumer Research* 31 (2): 455–64. https://doi.org/10.1086/422122.

Kates, Steven M., and Russell Belk. 2001. "The Meanings of Lesbian and Gay Pride Day: Resistance through Consumption and Resistance to Consumption." *Journal of Contemporary Ethnography* 30 (4): 392–429. https://doi.org/10.1177/089124101030004003.

Katz, Evan Ross. 2019. "Revisiting *RuPaul's Drag Race* Season 1, The 'Lost Season.'" *Paper Magazine*, August 14, 2019. https://www.papermag.com/rupaul-drag-race-season-1-2639822060.html.

Keating, Andrew, and Damien McLoughlin. 2005. "Understanding the Emergence of Markets: A Social Constructionist Perspective on Gay Economy." *Consumption Markets & Culture* 8 (2): 131–52. https://doi.org/10.1080/10253860500112842.

Klein, Naomi. 1999. *No Logo: Money, Marketing, and the Growing Anti-corporate Movement*. New York: Picador.

Lury, Celia. 2004. *Brands: The Logos of the Global Economy*. London: Routledge.

McCracken, Grant. 1986. "Culture and Consumption: A Theoretical Account of the Structure and Movement of the Cultural Meaning of Consumer Goods." *Journal of Consumer Research* 13 (1): 71–84. https://doi.org/10.1086/209048.

Mulshine, Paul. 1994. "Man-Boy Love." *Heterodoxy* 2 (10): 10–11.

Muñiz, Albert M., and Thomas C. O'Guinn. 2001 "Brand Community." *Journal of Consumer Research* 27: 412–32. https://doi.org/10.1086/319618.

Ng, Eve. 2014. "Post-Gay Era? Media Gaystreaming, Homonormativity, and the Politics of LGBT Integration." *Communication, Culture & Critique* 6 (2): 258–83. https://doi.org/10.1111/cccr.12013/.

Parmentier, Marie-Agnes, and Eileen Fischer. 2015. "Things Fall Apart: The Dynamics of Brand Audience Dissipation." *Journal of Consumer Research* 41 (5): 1228–51. https://doi.org/10.1086/678907.

Peñaloza, Lisa. 1996 "We're Here, We're Queer, and We're Going Shopping! A Critical Perspective on the Accommodation of Gays and Lesbians in the US Marketplace." *Journal of Homosexuality* 31 (1–2): 9–41. https://doi.org/10.1300/J082v31n01_02.

Rinallo, Diego. 2007. "Metro/Fashion/Tribes of Men: Negotiating the Boundaries of Men's Legitimate Consumption." In *Consumer Tribes*, edited by Bernard Cova, Avi Shankar, and Robert Kozinets, 76–92. London: Elsevier.

Schau, Hope J., Albert M. Muñiz, and Eric J. Arnould. 2009. "How Brand Community Practices Create Value." *Journal of Marketing* 73 (5): 30–51. https://doi.org/10.1509/jmkg.73.5.30.

Schouten, John W., and Jim H. McAlexander. 1995. "Subcultures of Consumption: An Ethnography of the New Bikers." *Journal of Consumer Research* 22 (1): 43–61. https://doi.org/10.1086/209434.

Schroeder, Jonathan E. 2009. "The Cultural Codes of Branding." *Marketing Theory* 9 (1): 123–26. https://doi.org/10.1177/1470593108100067.

Schroeder, Jonathan E., and Miriam Salzer-Morling. 2006. *Brand Culture*. London: Routledge.

Thompson, Craig J. 2004. "Marketplace Mythology and Discourses of Power." *Journal of Consumer Research* 31 (1): 162–80. https://doi.org/10.1086/383432.

Valdez, Matt. 2017. "Ongina on Coming Out as HIV+ on National TV, and Why Raja Is to Thank for Her Drag Career." *Queerty*, July 12, 2017. https://www.queerty.com/ongina-coming-hiv-national-tv-raja-thank-drag-career-20170712.

Visconti, Luca M. 2008. "Gays' Market and Social Behaviors in (De)constructing Symbolic Boundaries." *Consumption, Markets and Culture* 11 (2): 113–35. https://doi.org/10.1080/10253860802033647.

7

RuPaul's Franchise: Moving Toward a Political Economy of Drag Queening

Ray LeBlanc

In 2017, DragCon Los Angeles produced $9 million in merchandise sales and almost $2 million in entry tickets, with over 40,000 attendees and over 300 exhibitors (Rudi 2018). A transatlantic series of multiday conventions devoted to "art, pop culture and all things drag," DragCon features fan merchandise, wigs and other drag supplies, children's areas, corporate sponsors, panel discussions, live recordings for web shows, VIP luxury experiences, and meet-and-greets with *RuPaul's Drag Race* celebrities and dozens of other drag icons, legends, and social media influencers (DragCon 2019). Even Elizabeth Warren's presidential campaign booked a booth at DragCon NYC (Fitzsimons 2019). The convention has grown from a two-day event in Los Angeles in 2015 to three weekends across the globe. DragCon expanded to New York City in 2017 and London in 2020. As one journalist marvels, DragCon is a "multi-million-dollar extravaganza" and "there's money in it, honey" (Im 2018). Another concludes with awe, "RuPaul is the queen of DragCon, so naturally his subjects bow down. But he's also launched the careers of basically every queen who's appeared on his shows, thrusting drag deep into the mainstream" (Klein 2019). While RuPaul frames the convention as a "place to find your tribe," World of Wonder cofounder Fenton Bailey says "the fans demand for more, more, more!" (DragCon 2016). Indeed, customer demand for all things *Drag Race* seems insatiable, especially since DragCon is only one small component of RuPaul's franchise and the global drag industry it has seemingly produced.

Although RuPaul is widely recognized as the "Supermodel of the World" who created an iconic career by way of globalization (Balzer 2005), I believe the depth

and intensity of his investments are overlooked. I recognize a proliferation of "RuPaul's franchise," a cultural and economic powerhouse at the forefront of this new market for drag enthusiasts and claims of drag entering the mainstream. Eleven seasons of *RuPaul's Drag Race* are the franchise's foundation, alongside six spin-off cable television series in the United States (*Untucked!*, *Drag U*, *All Stars*, *Gay for Play*, *The Trixie & Katya Show*, and *RuPaul's Celebrity Drag Race*), two Christmas cable television specials, five localized television series outside the United States (Chile's *The Switch*, *Drag Race Thailand*, *Drag Race U.K.*, *Drag Race Canada*, and *Drag Race Australia*), two Netflix series (*Dancing Queen* and *AJ & the Queen*), the *Drag Race LIVE!* Las Vegas residency, dozens of web series and studio albums, repeated attempts at a *RuPaul* daytime talk show, a podcast, three self-help memoirs, premium events, global tours, merchandising, sponsorships, pop-up retail shops, conventions, and the subsequent careers of nearly two hundred drag queen contestants and judges. Unlike the conventional drag audience of gay men's nightlife, RuPaul's franchise finds commercial success across a wider demographic of sexualities and genders, primarily young women, children, and families (Im 2018). The franchise caters to a global consumer base and massive online fandom that reproduces and engages with the RuPaul brand through blogging, web shows, art, crafted goods, and innumerous *Drag Race*–inspired competitions across the world.

Over the past decade, performers, enthusiasts, and scholars have witnessed the many tendrils of RuPaul's franchise influence significant cultural, political, and financial transformations. In some ways, it seems RuPaul's success has changed everything for drag queens, but to me the economic effects are especially clear: millions of dollars are now at stake for drag queens. Many *Drag Race* contestants, colloquially known as "Ru Girls," seem to be the first queens in the United States to profitably rely on drag as their primary source of income on this scale (Harrison 2017; Schottmiller 2017). In turn, drag performers unassociated with RuPaul's franchise are also finding increased economic opportunities through the rising popularity for all things drag, such as drag brunches with local performers (Saxena 2019) and local *Drag Race* viewing events (A.X.S. 2018). As Varla Jean Merman recently told the *New York Times*, "This has never been seen before […] Drag is a viable career" (Oliver 2018). Drag performance is no longer limited to local gay nightlife, but rather an emerging global network of increasing capital flows between corporations, promoters, venues, performers, and fans. Appearing on *Drag Race*, whether as a contestant or guest, is a gateway to participate in the franchise's conventions, festivals, global concert tours, corporate sponsorships, and special guest appearances, not to mention the boundless commodity opportunities for merch: makeup, apparel and a vast variety of memorabilia ranging from air fresheners to used and autographed makeup wipes. In turn, performers

spend thousands of dollars on a network of corporate cosmetic brands and mostly independent wig makers, jewelers, and clothiers to sustain their drag. These transformations signal the need for a serious consideration of how drag has become the foundation for a new global market and industry.

I rely on my own experiences as a consumer, casual performer, and scholar in the drag industry alongside various forms of media to inform this analysis. I have researched drag queening for over five years, attending nearly two hundred drag shows across six states, the District of Columbia, and Canada. Through this time, I followed drag performers on all social media platforms and regularly consumed countless hours of drag queening media on YouTube, including recordings of pageants and performances, drag queen vloggers and tutorials, fan-made media and memes, and the several web series by World of Wonder. Due to confidentiality agreements with nightlife promoters and Viacom, many performers are unable to discuss the financial details of their career. However, social media posts and occasional media interviews provide valuable yet brief insights. I reference various forms of media, cultural events, and the commentary that surrounds them to move toward a political economy of RuPaul's franchise and drag queening at large.

Before the recent boom of RuPaul's franchise, scholars widely referred to drag performance as an unreliable source of income (Berkowitz and Belgrave 2010; Rupp and Taylor 2003). While drag queens were considered socially and financially marginalized, most research highlighted tremendous political potential to reimagine gender, sexuality, and identity. Drag queens were seen as subversive entertainment confined to LGBTQ+ nightlife, a token metaphor for "doing" gender in a hyper-visible way (Basenberg 2008; Butler 1990; Moreman and McIntosh 2010; Rupp and Taylor 2003; Schacht and Underwood 2004). In this way, more research needs to consider a political-economic approach to describe how the economic potential for drag queens has transformed in the contemporary landscape. I utilize a framework of "drag queening" to emphasize it as a set of labor practices accessible to all bodies. Drag queening includes not only performance on the stage but also unseen backstage practices of training, self-promotion, and production. These shifts in language allow for a more nuanced discussion of drag queening men, women, and others while also emphasizing how doing drag, especially in the context of RuPaul's franchise as I argue, is a form of labor and practices situated within the global political economy.

Situating the drag industry within the global political economy requires a queer approach to consider how gender, sexuality, and capitalism engage with one another and other structures. Queer theory is often critiqued for ignoring materiality (McLaughlin 2006) and political economy may assume heteronormativity and erase gender and sexual differences (Danby 2007), but both overlap in their investigation of desire and power (Cornwall 1997). A queer political economy

framework "allows identity to be understood not only as a social construction but also as being fluid—that is, constructed and reconstructed depending upon social location and political economic context" (Cantú 2001, 116). Most of this scholarship explores contradictions of agency and dominance amid the rise of LGBTQ+ marketing and consumerism. As Amy Gluckman and Betsy Reed (1997, xi) note, "It was just a century ago that medical textbooks, rather than glossy magazines, detailed the nature of gay life." John D'Emilio (1983) and Dennis Altman (1996) argue how capitalism globally reproduces dominant, neoliberal understandings of a Western gay identity, while more recent scholarship seeks to recognize complexity and agency between the global and the local while questioning the idea of Western dominance (La Fountain-Stokes 2009; Manalansan 2003). The queer performance of capitalist success, such as the strive for opulence in the ballroom documentary *Paris Is Burning*, may be read as an empowered practice of "disidentification" (Muñoz 1999), but I argue when this attitude is enacted by a global franchise on a million-dollar scale it must be scrutinized more closely. RuPaul's franchise does not hold an unyielding global domination of all things drag queening, but it is undoubtedly the most visible and holds the most capital, thereby acting as a powerful foundation for how drag queening is globally understood. Ultimately, a queer political-economic approach guides me to consider postmodern understandings of subjectivity and recognize materialist concerns of economic, racial, and imperialist inequalities.

First, I begin by reviewing the economic and political structures of RuPaul's franchise to extrapolate an underlying reproduction of neoliberal, late capitalist ideology and pop psychology. Then, I describe the exploitative relationship between Ru Girls and the franchise to question the supposed shared rewards of RuPaul's success. Last, I illustrate how the economic boom of drag queening also results in emphasized inequalities and risks. The ideology and economic structure of RuPaul's franchise conceals and reproduces these inequalities and risks for all involved in the drag business. By reviewing the shifting economic realities for drag queens against this proliferation of RuPaul's franchise, I demonstrate how drag performers must be recognized as laborers within a rapidly burgeoning global industry.

"Freaky money do make the money"

On February 24, 2014, RuPaul released his seventh studio album, *Born Naked*, including the electronic bounce track "Freaky Money." The song features emcee-style commentary by the infamous blackfaced drag queen Shirley Q. Liquor and New Orleans bounce legend Big Freedia. "Checkin' out my Nasdaq while you

lick my snack pack," RuPaul raps, "I'm an ATM machine." The same day of the album's release, RuPaul rang the closing bell for the New York City stock exchange. Representing Logo, the MTV family of channels, and their parent company Viacom, RuPaul's appearance promoted the upcoming season six premiere of *Drag Race* and the successful two-year relationship between Nasdaq and Viacom. As Nasdaq Vice President David Wicks boasted, companies with "a combined market capitalization of over $250 billion have actually followed Viacom's lead and transferred their listing" (Judy 2014). RuPaul, looking exceptionally flamboyant in an oversized orange suit and black fedora, yelled the popular drag queen greeting as he walked on stage: "Hiiiiieeeeeeee!" After thanking Logo, the gay-owned production company World of Wonder, and the global fan base, he turned his attention to the stockbrokers in the room. "To all of you wolves of Wall Street," RuPaul quipped, "I have one thing to say." Quickly pulling out a stack of money, he tossed the bills and shouted: "Make it rain! Make it *rain*! Yeah! Halleloo! Halleloo!" (Judy 2014). The crowd erupted and Wicks returned to the stage blushing, as he remarked that no one had ever thrown money at the ceremony before.

This moment in time was a new height of success for RuPaul's franchise in a few ways. The powerhouse contestants and gripping plot of *Drag Race* season five were more popular than ever, as evidenced when five of the queens were later brought back for *All Stars 2*, the most from a single season to ever return at once. The underdog rise of Jinkx Monsoon against the "Rolaskatox" clique, in addition to the iconic feud over the Miss Gay America 2010 title between Coco Montrese and Alyssa Edwards, gave season five an unprecedented level of drama ripe for memes. Later in 2013, Logo re-premiered season one as "The Lost Season Ru-Vealed." In November, RuPaul made a very rare appearance in drag singing with Lady Gaga and the Muppets for her Thanksgiving television special on ABC. This was the last time RuPaul ever appeared in drag outside of his own franchise. At the start of 2014, *Drag Race* expanded its *Battle of the Seasons* tour to the franchise's first international stops in Canada. With this context in mind, the small eight-minute Wall Street ceremony solidifies the relationship between Viacom and the drag market as a serious capitalist venture while also legitimizing RuPaul as a successful entrepreneur.

Further, RuPaul undoubtedly sticks out among the corporate crowd with his *Drag Race* catchphrases and over-the-top money toss. This campy, self-aware attitude toward capitalist success is a strong component of RuPaul's brand. Shameless overpromotion is a running gag on *Drag Race*. Everything is "now available on iTunes," or as Trixie Mattel frequently jokes in her impersonation of RuPaul: "I was updating my Squarespace on my Boll & Branch sheets on my Casper mattress waiting for my delivery from BlueApron.com listening to my audiobook

from Audible.com about to take a shit on my Squatty Potty" (WOWPresents 2017). This was especially exemplified by the *RuPaul's Drag Race* "Holi-Slay Spectacular," a Christmas-themed special advertised as a serious standalone competition but in actuality an extended commercial for RuPaul's newest album. The special began like any new season of *Drag Race* with surprise contestants entering the work room. However, RuPaul then tells viewers that the special is a musical and the queens campily sing RuPaul's growing portfolio of original Christmas songs for the remainder. Midway, one of the contestants is clearly replaced by a body double with fabric over their face. Then, at the final runway, the competition implodes as RuPaul crowns everyone "Christmas Queen." Celebrating their victories, the contestants pretend to gasp and cheer as obvious stunt doubles of the judges dance. The "Holi-Slay Spectacular" was widely criticized as a "bait and switch" and "the biggest test of [the fan base's] undying faith yet" (Framke 2018b). From one angle, I acknowledge how the overpromotion could be perceived as campy meta-commentary on capitalism and consumerism (Schottmiller 2017). On the other hand, it is a very real commercial for real products, and, as I argue, there are very real amounts of money involved. For me, then, regardless of whether RuPaul's franchise uses satire to promote sponsors and its products, possibilities for anti-capitalist resistance are overshadowed by the looming political economy and material conditions of drag queening laborers.

Other scholars have taken issue with RuPaul's capitalist tendencies as well. Carsten Balzer (2005) takes a critical look at how drag queens entered the global mainstream media in the 1990s through music videos and film. By "becoming 'nice' drag queens," Balzer writes, "the New York queens obtained rewards and commercial success in the mainstream of a reward-based society, which resulted in a media hype" (127). For Balzer, RuPaul reproduces dominant conventions and found success only when drag could be digested by a heterosexual, mainstream audience. When RuPaul planted himself within traditional notions of femininity and capitalism, drag queening was easier to market. Similarly, Kai Kohlsdorf (2014) asserts RuPaul's success to his seemingly universal, all-American brand. Kohlsdorf writes, "She is limited in what she is able to express and must continuously make claims to appease readers and viewers that she is 'just like them,' even if it means erasing race, gender, and sexuality differences" (73). In his recap of the *All Stars 2* finale, Spencer Kornhaber (2016) calls the show's "soul" into question with similar concerns. He writes, "*Drag Race* presents itself as creating a family for misfits and outcasts, but it's become such an institution that it's creating insider/outsider dynamics of its own." Kornhaber wonders if the reality show is excluding fringe aesthetics of drag, which fall outside many conventional notions and are far less marketable.

It can be extremely difficult to tell when RuPaul is serious, but there is no question that his self-help memoirs, *What's the Tee?* podcast, and "wake up" rants to contestants on *Drag Race* are sincere. The "guRu" element of RuPaul's franchise is an amalgamation of self-help pop psychology that negotiates between a neoliberal, self-made narrative against its simultaneous assertion to live against the mainstream. For example, during a challenge on *All Stars* 2 to create and market a product, RuPaul abruptly confronts the contestants and the audience to legitimize his status as the ultimate queen of drag: "I marketed subversive drag to a million motherfuckers in the world. I'm a marketing motherfucking genius over here" (*RuPaul's Drag Race All Stars* 2016). While RuPaul is criticized for upholding institutions rather than challenging them, he positions himself as a sort of double agent working to sneak protest into mainstream structures.

RuPaul's mission has certainly succeeded in increasing the visibility of drag queens and growing drag performance to an unprecedented production standard, but as the "guRu" aspect of the franchise grows, queer fans grow skeptical. As Carl Schottmiller (2017, 238) poignantly concludes, "*White women* will invest time and money into consuming this self-help advice" (emphasis added). These sentiments can be traced to the spin-off series *Drag U*, which featured Ru Girls teaching cisgender women how to improve themselves and was canceled after three seasons. Josh Morrison (2014, 126) gives a vivid description of the show as he writes,

> In the bizarre *Victor/Victoria* meets *Dr. Phil* universe of *Drag U*, men who act like women tell women how to act like men who act like women to become better women through embracing "the miracle of drag," all the while chastising women for not embodying "proper" femininity.

Thus, the "camp capitalism" (Schottmiller 2017) of RuPaul's franchise is informed by a sincere ideology of self-improvement that is largely accepted by more mainstream viewers.

This tension is best represented by the controversy surrounding a 2015 interview with *Buzzfeed* in which RuPaul seems to tell a story about watching a man drown. Discussing how gay men's concerns over disappearing gay bars are superfluous, RuPaul gives an anecdote the interviewer frames as confusing:

> I remember once I had this place that overlooked the Hudson River, and I saw this guy on a sailboat and it had capsized and I went to the phone thinking, "I've got to call someone." But then I thought, "What's the best thing I can do? You know what? I'm gonna pray for this person. I'm gonna send them loving energy."
>
> <div align="right">(Strudwick 2015)</div>

The interviewer notes that the fate of the drowning man is unknown. This small part of the interview became viral as many headlines claimed RuPaul was responsible for the death of a stranger. Within the larger context of the piece, it could be argued that RuPaul is telling a facetious story to show the ridiculousness of sending love and energy and criticizing gay men for only caring about LGBTQ+ nightlife once it begins to disappear. However, fans memed the story to criticize RuPaul's pop psychology as neoliberal bootstraps ideology and pointed out his frequent tweets criticizing millennials' desires for participation trophies.

The story became a popular meme again in 2018 when RuPaul argued with black contestants The Vixen and Asia O'Hara at the season ten reunion. Throughout the season, many fans and critics noticed heightened racial tensions in the show's editing and continued promotion of racial stereotypes in challenges. As many scholars have noted, *Drag Race* has post-racial problems as it encourages queens of color to rely on stereotypes for humor, and there is a large disparity of success between white contestants and contestants of color (Goldmark 2015; Hargraves 2011; Hernandez 2014; Herold 2012; Jenkins 2013). At the reunion, RuPaul prompts The Vixen and white contestant Eureka O'Hara to discuss their disagreement from an earlier episode in which Eureka had tested The Vixen's temper. While The Vixen expresses that she wants Eureka to apologize and claim ownership for purposefully angering her and manipulating their on-screen relationship, RuPaul redirects the conversation to argue that The Vixen should have practiced better self-control and was an instigator herself.

Visibly upset, The Vixen responds,

> I came here to thank my fans for the love and support that they gave me, for all the wonderful people who relate to me, understand me, appreciate me, and now that I've done that, y'all can have a good night.

She walks off the stage as other contestants ask her to stay. After a commercial break, the contestants give their opinions on The Vixen's exit and RuPaul tells them, "At one point, you gotta say, there is nothing else I can do." Asia disagrees, as she cries:

> It's ridiculous that our thought process about people is so self-centered that if it's hard to help somebody, well, just let them struggle. We're not just drag queens, we're people. And now we've got one of our people outside. Here we are filming during Pride season, and we let one of our sisters walk out the fucking room 'cause nobody wants to fucking help her.

As they continue to argue back and forth, the veins on RuPaul's neck tighten as he uncharacteristically yells over Asia:

> What am I gonna go back and follow her and go say, "Come here, let me tell you something." Can you explain to someone who cannot be spoken to? But look at me, look at me god damnit! I come from the same god damn place where she comes from and here I am. Do you see me walking out? No, I'm not walking out. I fucking learned how to act around people and how to deal with shit. I'm not fucking walking out and saying "Fuck all y'all," you know? That's disrespectful to each of you. And I know you feel for her because you see yourself in her. Because we all have that same frustration. Let me tell you something, I have been discriminated against by white people for being black, by black people for being gay, by gay people for being too femme. Did I let that stop me from getting to this chair? No. I had to separate what I feel or what my impression of the situation is to put my focus on the goal.

The contestants, mouths agape, sit in perplexed silence while RuPaul's seamlessly transitions to a clip about how *Drag Race* fights religious discrimination against the LGBTQ+ community.

The incident prompted a flood of online commentary and think-pieces as fans debated who was correct. For some, RuPaul's comments were a direct reflection of his "guRu" brand. *Drag Race* recapper John Paul Brammer (2018) writes,

> Ru's American "by your bootstraps" ethic paired with his Buddhist passivity to earthly affairs kept him from fully engaging with The Vixen's argument, which included a vital analysis of race. It's an identity-based element Ru probably identified as "ego," as he is wont to do.

Brammer's harsh criticism of RuPaul's pop psychology echoes widely shared concerns of how the franchise's neoliberal undercurrents erase important analyses of inequality and oppression. As Alyxandra Vesey (2016, 12) explains, "If *Drag Race* is meant to teach contestants how to commodify themselves, it does not uniformly value their efforts or grant them equal access to harness the means of production." This unique interaction between RuPaul, Eureka, The Vixen, and Asia tests the limits of the "guRu" approach and shows how the fundamental ideology of RuPaul's franchise may posit itself as subversive and radical yet inevitably returns to rather conservative ideals of respectability.

The relationship between RuPaul's franchise and its neoliberal capitalist framework is highly complex yet increasingly apparent. While *Drag Race* has brought drag queens and LGBTQ+ people into the mainstream media and started important discussions on inequality, this visibility comes with the cost of heteronormative politics and a campy yet still sincere embrace of the capitalist mentality that anyone can overcome adversity if they work hard enough. While the earlier example

focuses on race, the franchise has also faced wide criticism for its attitudes toward drag queening women, both transgender and cisgender (Cuby 2018; Framke 2018a; Norris 2014; Verman 2018). Further, RuPaul's pop psychology claims to erase ego, but it propagates neoliberal assumptions of the individual that have deterred many fans and scholars. In this way, the ideological branding of RuPaul's franchise is a form of "queer liberalism" (Eng 2007), the reproduction of oppressions and erasure of differences through the appearance of LGBTQ+ inclusion and diversity. Although it is important to acknowledge how RuPaul's franchise both challenges and reifies conventional societal structures, I emphasize how the franchise's queer appearance is ultimately a capitalist institution that reproduces the mainstream more than it redefines it. Now that I have outlined the political and economic ideology of RuPaul's franchise, I demonstrate how these attitudes shape the material conditions of Ru Girls and other drag queens.

"I make more money than you, girl"

Joining RuPaul's franchise has become a critical and necessary step for most drag queens seeking a full-time career. As Alaska sings in her first single, "I'm a Ru Girl … and I make more money than you, girl" (Thunderfuck 2013). Simply by competing on *Drag Race*, regardless of when they are eliminated or whether they win, performers receive international exposure and are thrust into the franchise's whirlwind of media appearances, sponsorships, special events, and tours. "The *Drag Race* formula—get on the show, release a single, go on tour," Brian O'Flynn (2019) notes, "is an unfailing one-way ticket to gay stardom." While race and gender heavily shape the potential for success, the gap between *Drag Race* contestants and local performers is substantial. Raven (2016), past contestant and RuPaul's current makeup artist, comments that Ru Girls are "lucky enough to get checks with commas in them" and should remember their beginnings in local nightlife. This comma, then, becomes an important symbol for the wealth gap between drag queens supported by RuPaul's franchise and local performers. As I explain, RuPaul's franchise acts as a gatekeeper of all drag performers' mainstream success and establishes a standard for how to market drag queening.

Traditionally, audience members hold out dollar bills between their fingers to tip performers during their number. These are often minimal and sporadic. Further, drag queens often perform for free at charity and community events. Nightlife venues may offer a small stipend, around $100, if the performer successfully attracts customers (Kravitz 2018). As drag queen Hellvetika (2019) tweets, "Lots of gigs are framed as 'opportunities' and expect you to perform for free." During

my fieldwork in Baton Rouge (Siebenkittel 2016), queens usually performed for the publicity and received little to no financial compensation. I observed an increasing animosity toward RuPaul and *Drag Race*. Some performers felt that the show unfairly portrayed them as bitchy entertainment, while others said the show promoted misconceptions about what drag is and can be. Most expressed feeling reduced to silly catchphrases, even suggesting their language was appropriated into mainstream culture. Above all, the local queens told me they were unfairly judged against Ru Girls since they did not have access to enough financial and social resources to produce their performances at the same caliber as what audiences saw on television or at *Drag Race* tours.

Contestant Thorgy Thor elaborates on this idea as she explains, "The goal now is to get on TV so more people see you, and it just so happens to be *RuPaul's Drag Race* has sort of killed drag for queens who are not on the show" (Allen 2016). Jasmine Masters (2016), another contestant, famously vlogs about how *Drag Race* has "fucked up" drag, explaining, "You'll be watching YouTube and drag queens from *RuPaul's Drag Race* and you think that's the only drag that there is." This is echoed in Thorgy's interview cited earlier as she raises similar concerns of homogeneity. She says,

> Drag Race has killed the excitement of being a little sloppy because now the expectations are so much higher. It seems to be really saturated with everyone looking like Miss Fame, and everyone wants to get paid [...] It's over-saturated, it's too much.
>
> (Allen 2016)

Miss Fame is another contestant who is known for "flawless," high fashion beauty, an example of the aesthetic that has become dominant by way of RuPaul's franchise. Contestants who succeed on *Drag Race* tend to fit this mold, and winners are celebrated for their "polished" looks.

These sentiments are elaborated by Washington, D.C., local performer Summer Camp. She publishes her concerns on Facebook:

> Huge fan of RuPaul's Drag Race. HUGE. But I think it's caused a homogenization of drag looks. It celebrates and rewards specific aesthetics. Blocked brows. Clinched waists. Shaved faces, pits, and legs. Nails. Lace-front wigs. Padded hips. Not saying that any of these elements of drag style aren't beautiful (and I use many of them), but I feel like they're becoming mandatory expectations of a quality queen. When I see comments from RPDR fans that clock non-conforming queens, I can't help but think their opinions have been cemented by RPDR.
>
> (2016)

Summer pinpoints RuPaul's franchise as a powerful and problematic influence on how drag performance is conceived by performers and perceived by audiences. These arguments suggest *Drag Race* viewers come to associate proper or successful drag queening with characteristics celebrated on the show and become harsh critics of their local performers.

The Austin International Drag Festival, which began one year before DragCon, attempts to counter this homogenization and raise awareness of independent performers. They also publish a stance on Facebook:

> For every Queen that appears on *RuPaul's Drag Race* there are hundreds of talented artists out there that are just as deserving of your love, generosity and gratitude. They struggle every day to make ends meet while bringing their best to the stage to entertain you. They are Queens, Kings, LadyQueens, BioKings, and everything in between. And they are all performing somewhere near you, from the grandest of opera houses to your local dive bars. Even when they are struggling they are always willing to lend their talents to help raise money for charities in your area. They are our brothers and sisters and deserve our respect. Even after the "race" has ended, the wigs will march on. Support your local Drag artists.
> (Austin International Drag Festival 2017)

The call to "support your local drag artists" becomes an important rallying cry at the end of each *Drag Race* season, as attendance at local gay bars and drag shows drops until the next season's premiere. New *Drag Race* episodes and visits from Ru Girls have become crucial to the economic survival of local gay nightlife. Still, I notice many local queens frequently post on social media to express their disappointment and anger at audience members who skip out on the performances by local queens either before or after the episodes air at bars. Even worse, *Drag Race* "super fans" are heavily criticized on social media for attending local events to see a headlining Ru Girl and either leave for the other performances or only tip the Ru Girl. An increasing amount of local performers post on social media that they are losing pay and gigs to Ru Girls, an effect Sam Chapman (2018a) describes as "a kind of plutocratic system in which substantial wealth and influence are wielded by those who have agreed to anchor their careers to RuPaul's institutions." Clearly, RuPaul's franchise is a capitalist force that may homogenize perceptions of drag queening and solidify a class hierarchy. Performers with RuPaul's corporate endorsement are more likely to reach financial success and "good drag" is heavily coded as white and upper class by the franchise and its fans.

The commercial success for Ru Girls is complicated, however, when considering what RuPaul's franchise requires from its contestants. In fact, if Ru Girls stand any chance of making it to the top, they must go into substantial debt to

prepare for the reality show. As Trinity the Tuck (2019) tweets, "I paid off one of two credit cards that I maxed out for [*All Stars 4*]." Likewise, Honey Davenport (2019) tweets,

> Everyone has dollar signs in their eyes when they look at me right now ... like yes I am on the next season of *Drag Race* also I invested over $20k to compete and I have been doing shitty $150 gigs for 10 years. So I'm still broke sis.

Most contestants refuse to discuss the depth of their investments in preparing for *Drag Race*, but these social media posts confirm speculation that it takes a considerable amount of cash and credit. On season ten of *Untucked*, episode seven, contestants Kameron Michaels and Miz Cracker briefly joke backstage about their financial debt. Kameron says, "I spent more coming into this competition than I did as the down payment on my house." Cracker responds, "I spent more on this competition than I did on college." Meanwhile, on the main stage Monique Heart defends her subpar runway look explaining she had to sew her outfit instead of buying it like the other contestants. Relying on the "guRu" celebration of hard work, the judges assure the contestants and viewers that it does not take money to win *Drag Race*, but Monique is eliminated. With expectations for contestants to showcase dozens of custom-made garments, styled wigs, heels, accessories, and cosmetics, the hopeful queens really do take out loans and max out credit cards for their chance not just to win *Drag Race*'s $100,000 prize but a sustainable career promised by the franchise.

These investments, however, are not always rewarded as RuPaul's franchise suggests. Many of the companies that offer prizes for *Drag Race* challenges and the overall winner fail to follow through. Season one winner Bebe Zahara Benet was awarded a "lifetime supply" of MAC products she never received (Desta 2017) and only $10,000 rather than the publicized $20,000 (Lovekin 2009). SNL Designs promised couture gowns for Alaska, Detox, Alyssa, and Tatianna, yet the company seems to have gone out of business. Jinkx was awarded a luxury trip from Al and Chuck yet never received it, calling it a "sore subject" (Sarah O'Connell Show 2019). Phi Phi O'Hara has tweeted about not receiving any prizes (O'Hara 2018). Detox has posted on social media about not receiving any of her prizes from season five or *All Stars 2* (Sanderson 2017). Max (2017) never received the promised "fierce drag jewels." Kim Chi (2016) has also publicly complained about not receiving a Fabric Planet gift card. Dozens of other contestants have slipped casual comments in interviews and livestreams that they hope to someday receive their prizes. The often promised $100,000 to the season's winner also takes considerable time to receive. Then, if the prizes are ever awarded, like other substantially valuable gifts, they are susceptible to taxes. It is fair to say that the "prizes" offered

on *Drag Race* are mostly a novelty for entertainment and the hopeful contestants must gamble with how much they are capable of investing against how long they can wait to see financial gains from the franchise.

The actual details of *Drag Race* contracts are mysterious and confidential, but by chance the season eight contract was found on the World of Wonder website and shared by the blog *Reality Blurred* (Dehnart 2018). Reportedly, the contestants are paid $400 per episode, with returning queens receiving a 5 percent raise each season. Notably, contestants must assume responsibility for any emotional or physical harm that occurs during filming, and all catchphrases, characters, and creative content captured by the cameras become the intellectual property of *Drag Race*. This intellectual property clause prevents Ru Girls from copyrighting or trademarking the popular catchphrases that are often used to promote future seasons and appropriated into RuPaul's daily language (e.g., Alaska's "Hiiieeee" and Shangela's "Halleloo" at the Nasdaq ceremony). Further, the franchise also subsumes ownership of any existing YouTube channels and contestants must receive permission before signing to a talent agency. Contestants are not paid for promotional work, but are entitled to a $75 per diem if the location is over 50 miles from their home. Most importantly, the contract reads that

> I acknowledge and understand that my appearance on the Project does not fall under the jurisdiction of SAG, AFTRA or any other guild or union agreements. My appearance and participation in any aspect of the Project is not a performance, and I am not portraying any role or part in taking direction as a performer, but am appearing as myself.
>
> (World of Wonder 2015, 21)

Thus, it is evident that like other reality television programs, the labor of the contestants is legally restricted and reclassified in order to keep down costs and risks for the franchise.

Therefore, while RuPaul's franchise seems to boost Ru Girls to unprecedented levels of financial success, the labor and personal debt invested by the contestants are concealed and the benefits are not equally shared to performers among or outside the franchise. Ru Girls are able to perform in drag as a full-time job, but it is a highly selective process that only rewards the most marketable contestants. Last, the legal aspects of reality television discredit the labor of all the contestants and calls into question the apparent financial prosperity propagated by RuPaul's franchise. Ultimately, RuPaul's "guRu" ideology cooperates with the exploitative economic relationships set forth by the reality television industry to establish a dominant understanding of drag queening as a low-cost, individualistic practice that just requires hard work and perseverance but yields high profits in an emerging market. Now that I have outlined how RuPaul's franchise also

exploits the performers it celebrates and uplifts, I next continue to consider the risks experienced by drag queening laborers.

"M is for money!"

For the last section of my analysis, I draw attention to the ways all drag queens face particular consequences under the expanded drag industry framed by RuPaul's franchise. Money and access to capital has always dominated drag queening, as Divine (1982) growls over synth beats, "M is for money!" While many of these risks existed for drag queens before the *Drag Race* boom, the move to drag queening full-time amid a million-dollar industry emphasizes dangers. I argue there is an unequal relationship between not just drag queens and RuPaul's franchise, but also the satellite industry of nightlife promoters, management companies, and independent artisans. In my experience, it is not hard to assume the freelance nature of drag performance and nightlife allows some of these transactions to occur through cash, off the official books. As drag queen entrepreneur BibleGirl666 comments on the industry, "I would like it to be not so under the table" (Dommu 2018). This means drag queens are susceptible to workplace mistreatment and have no guarantees of sustainability, further concealing the political economy of drag queening.

Drag performers seeking to perform full-time, including Ru Girls, must negotiate the potential exposure to a global consumer base of millions of drag fans brought about by RuPaul's franchise. Popular performers must build and unveil websites and merch stores. Content must be regularly produced on all social media platforms. For DragCon and other mass events, they must invest in decorations, workers, and merch for their booths, in addition to scheduling and performing at offsite events. The labor of a drag performer is many jobs in one. Peppermint explains,

> You're doing your clothing, makeup, and hair; you're writing your material, choosing your music, mixing it, creating the act, doing costumes for backup dancers if you have them, figuring out scenery. Often you have to be your own businessperson, too, and book your own events and schedule flights.
> (Goodman 2019)

Ru Girls are pushed into the multimillion-dollar industry of RuPaul's franchise overnight, but even local performers must be entrepreneurial jacks of all trades. Many drag queens, not only Ru Girls, now rely on talent management companies to maintain websites and merch stores while negotiating gigs and employment benefits.

According to Jacob Slane from Producer Entertainment Group (PEG), one of the two biggest firms representing Ru Girls, "top queens are earning in the low to mid-six figures annually" (Harrison 2017). This statement is questionable, however, given that PEG has been sued by Adore Delano and Detox for embezzlement, fraud, and unpaid royalties. Both queens allege that PEG forced them to invest their own funds into their music careers upfront and never paid their full cut after the songs and music videos were successful, in addition to taking unagreed amounts out of their booking fees. Detox sued for $75,000, while Adore sued for $3.5 million. Adore's suit was dismissed and PEG has filed a countersuit of $180,000 for unnecessary legal fees (Beresford 2018). Murray and Peter Presents, the second firm that represents the majority of Ru Girls, fell under fire when they canceled all of Monét X Change's appearances on the *Haters Roast* tour because she accepted a role in an upcoming Madonna music video. When Monét asked for a night off, they refused, and so she took the opportunity anyways. Murray and Peter took to Instagram to publicly shame her and faced strong backlash from fans, with Trinity withdrawing from the tour in solidarity.

At the start of summer in 2019, multiple performers took to social media to express their frustrations with the Chicago-based management company Neverland. The company previously faced criticism earlier in the year after multiple Ru Girls purchased their "DragCon booth services." Neverland cited unfortunate circumstances, but customers like Kim Chi, Monique Heart, and Miz Cracker arrived to DragCon to find no booth decorations, workers, or merchandise. Shea Coulée (2019) reposted these events to explain a new development—Neverland owed her $12,000 from past gigs. Kim Chi (2019) confirmed the story and explained that when she and Naomi Smalls ended their contracts the company refused to release their respective website domains without an additional $20,000. Later in the week, The Vixen posts screenshots of her conversation with the owner of Neverland after she discovered her insurance was canceled while filling a prescription. "I have not paid myself anything in 4 months," the owner pleads. The Vixen (2019) responds, "The bigger issue is that you are making decisions with my money and my insurance without telling me. Decided when and how to pay me as if I don't have bills, responsibilities of my own." Only a couple weeks later, drag queen Lucy Stoole posts her disappointment that Neverland, through their merchandise fulfillment company Elite Queens, has sold the rights to her merch designs to another company without her knowledge. Again, conversations with the owner of Neverland are published. "I'm so terribly sorry for not consulting you on a decision that made you money and gained you retail exposure," he remarks to Lucy in the screenshotted email (Stoole 2019).

Similarly, in August 2018, contestant BenDeLaCreme announced she would not be performing in a tour out of solidarity with unpaid colleagues. BenDeLaCreme (2018) explains:

> At this point in time, queens have no unions to protect us, and we have to stick together as advocates for each other. It is important for all performers to stand up for the fair treatment and pay of everyone working in drag, burlesque, cabaret, and all of the many designers and artists that support us. I cannot in good faith continue to tour with a promoter who is not treating performers without my platform with the same consideration as those who have been on TV.

Thus, these social media posts reveal that the legal and financial relationships between performers, venues, and promoters are highly contested and ripe for fraud. As Chapman (2018b) outlines, most drag performances do not include contracts, communication is typically informal in social media messages, payment is largely unreliable, and there are no standards or qualifications to be a nightlife promoter or producer. By considering these public disagreements between drag queens, managers, and promoters, it is apparent that many performers find themselves within tumultuous and heightened legal situations brought about by the recent economic boom.

Drag queening full-time also introduces new risks involved with travel and long hours. Ru Girls, especially, become susceptible to the isolation and fatigue of an on-the-go rock star lifestyle. With hardly any time to get in drag on busy days, Ru Girls will travel in a full face of makeup or even stay in full drag for easily twelve hours or more. Contestant Blair St. Clair (2019a) tweets, "I work 6 days a week from 9–5 just on creating content, brand building, and media strategy. I travel full time, and I'm constantly auditioning for new TV shows, films, and theatre." In another tweet, Blair (2019b) comments "I've been in drag for 18 hours working and I just got to another gig. Never stop hustling." While I argue drag labor includes these extended periods of "hustle" off the stage, they are not considered payable labor time by promoters and venues. Traveling while drag queening also means higher visibility and risk of harassment like stalking. In February 2019, *Dragula* season one winner Vander Von Odd livetweeted from her hotel room as an unknown man repeatedly commented on her gender presentation and demanded she open the door for sex. Now deleted, Vander continuously updated the Twitter thread as the man continued to knock on the door while hotel staff told her on the phone it seemed to be a "misunderstanding," not sexual harassment. With the surge of publicity, the hotel apologized. Still, the next day Vander Von Odd (2019) tweeted "This is the 3rd time I've had someone follow me to my hotel room and it's by far been the scariest." Thus, the disregard of drag queening off the stage is not only an issue of accurately considering the time and amount of labor power but also conceals the off-stage risks. Trixie tellingly jokes, "If drag queens were calling [Occupational Safety and Health Administration], every drag show would be shut down" (WOWPresents 2019). The reality, however, is that most drag queens are more than likely ineligible for these kinds of government protections for laborers.

Although full-time drag queens seem to be successful, this is not a long-term solution. As Peppermint quips, "Drag doesn't necessarily offer a pension and health insurance, so it may not be what mommy and daddy are happy about" (Goodman 2019). The need for drag queening to be recognized as labor sometimes becomes a matter of life and death, especially concerning health insurance. Most drag queens rely on crowdfunding to support themselves when they fall sick. Kendra Onixxx, a contestant on *Dragula*, had a traumatic experience performing with fire and severely burned her face. She relied on GoFundMe to cover medical expenses. Similarly, a tweet raising funds for another performer reads, "Being a drag legend doesn't come with a 401k" (trashqueen 2019). Sasha Velour frequently speaks out on this issue, explaining how drag queening offers opportunities and risks:

> There are more opportunities for gender non-conforming people in media now than ever before. It's complicated, though, because we're still fighting for people in our community to survive. Sometimes people don't recognize how much work goes into drag. In public or online, interactions can be very disrespectful when it feels like people take for granted how hard we work, how much we sacrifice. We don't have a lot of legal protections. There's no union. People feel entitled to pictures, time, and physical touching that isn't appropriate with someone at work, creating a show. Sometimes showing up to a job in a bar or a theatrical situation, it feels little attention is given to performers, their costumes, their space, their need for cleanliness, proper lighting, like we're not seen as serious artists or people who care when we care so deeply.
>
> (Goodman 2019)

Of course, these concerns for employment benefits are not unique to drag queens and are common in the bolstering gig economy of freelance work. However, as Sasha stresses, it is first essential to acknowledge drag queening as part of this larger gig economy and legitimate form of labor.

To review, drag performers in the contemporary industry catalyzed by RuPaul's franchise enter newly developing economic relationships that often result in confusion and exploitation between performers and management companies. As drag queening becomes more visible and popular, the financial stakes quickly rise and performers often find themselves in exploitative situations. With the neoliberal ideology of RuPaul's franchise as the larger context, drag queens are pushed to "hustle" without long-term assurances and other employment benefits. The risks of drag queening that existed long before *Drag Race*, such as sexual harassment and the toll on health, continue and may even be concealed by the pay structures of nightlife entertainment and RuPaul's franchise.

Conclusion

As I have demonstrated in this chapter, scholars must consider how drag queens are now part of a multimillion-dollar global industry. While some argue we are in a new era of drag performance where queens can find unprecedented success, I show how access to this success is complex and comes with repercussions. A corporate behemoth of media, merchandise, and events, RuPaul's franchise influences political, economic, and social transformations that set a global tone for how drag queening is understood by most fans and consumers. The franchise's neoliberal pop psychology erases important inequalities and establishes a dominant understanding of drag queening as an entrepreneurial opportunity in which anyone can financially succeed. Finally, I look to drag queen media and commentary to reveal the political-economic relationships between all drag performers, consumers, companies, and many other actors now involved in the industry.

A political economy of drag queening reveals the material conditions of performers and exposes how the glamorous lifestyle of full-time queening promised by RuPaul's franchise may be an exaggerated fantasy. All drag queens face the erasure of their labor among a global flow of capital, dangerous working conditions, and virtually no protections against fraudulent promoters or clothiers. Keeping in mind a queer political-economic approach suggests that discourses of sexuality and gender are intertwined with capitalism but that individuals also have the ability to express agency and change dominant structures. On a global scale, this framework implies RuPaul's franchise is met with localized understandings that reproduce it while also holding potential to create new meaning. I contend that while the ideology and economic relationships standardized by RuPaul's franchise are not wholly dominating, they do in fact have a considerable amount of unrecognized influence over the lives of drag performers and their fans. Drag queens can achieve tremendous global visibility through RuPaul's franchise but the consequences must be acknowledged.

In order to imagine how these issues might be resolved, I look to Shangela's founding of her own management company, Say What Entertainment. Although the group is small, it is run by drag queens, for drag queens. Similarly, outside RuPaul's franchise New York drag queen BibleGirl666 operates a million-dollar web store, *DragQueenMerch*, which allows performers to independently upload designs for t-shirts and other items. Over the past few years, *DragQueenMerch* has developed a partnership with Hot Topic, allowing a new level of visibility to drag queen products. To me, these collaborations are the important beginning of drag queens unionizing to gain control against Viacom and RuPaul's franchise. It is important for drag queens to retain ownership of their image, products, and performance. As with any other occupation, pay structures must be transparent

and drag queens must work together to assert their power as laborers and seize the means of production against the exploitative capitalist system.

Still, I remain concerned about the relationship between capitalism and drag queening. The dollar bill is a holy symbol of appreciation and visibility between fans and performers, yet at the same time it creates a stratification of performers based solely on market value. Drag queens' campy embrace of capitalism and entrepreneurship reflects larger conversations about the corporatization of Pride celebrations and what it means for the LGBTQ+ community to emerge as a global consumer market (Greer 2019; Sipe 2018; Ward 2003). At DragCon LA in May 2019, a global "direct to consumer" loan app announced a partnership with RuPaul's franchise. "Shop like a queen," their press release reads, stressing how Ru Girls "create their looks with Klarna" (Klarna 2019). The app offers enticing late capitalist perks like being able to purchase anything from any store without any interest, with terms and conditions that are widely recognized as predatory lending. As I have demonstrated, RuPaul's franchise is a motor removing drag queening from queer politics of resistance and visibility and toward capitalist embrace. The ethical and political implications that drag queens are now peddling predatory loans to fans is profound. Drag performers, fans, and scholars must seriously consider the political economy of drag queening and ask how drag can exist either outside or against capitalism.

REFERENCES

Allen, Timothy. 2016. "*RuPaul's Drag Race* Has Sort of Killed Drag for Queens Who Are Not on the Show." *Queerty*, April 25, 2016.

Altman, Dennis. 1996. "On Global Queering." *Australian Humanities Review* 2.

Austin International Drag Festival. 2017. Public Facebook post, March 8, 2017 [no longer available].

A.X.S. 2018. "Step inside a Gay Bar for *a RuPaul's Drag Race* Viewing Party." *Economist*, May 17, 2018. https://www.economist.com/prospero/2018/05/17/step-inside-a-gay-bar-for-a-rupauls-drag-race-viewing-party.

Balzer, Carsten. 2005. "The Great Drag Queen Hype: Thoughts on Cultural Globalisation and Autochthony." *Paideuma* 51: 111–31.

BenDeLaCreme. 2018. Public Facebook post, August 14, 2018, 3:30 p.m. https://www.facebook.com/bendelacreme/posts/931473113706557.

Beresford, Meka. 2018. "*RuPaul's Drag Race* Star Adore Delano Slapped with Lawsuit in Ongoing Legal Battle." *PinkNews*, January 11, 2018. https://www.pinknews.co.uk/2018/01/11/rupauls-drag-race-star-adore-delano-slapped-with-lawsuit-in-ongoing-legal-battle/.

Basenberg, Lanier. 2008. "Doing Emphasized Femininity for Pay: How Sex Workers and Drag Queens use Femininity for Profit." Paper presented at annual meeting for the American Sociological Association, Boston, Massachusetts, July 31–August 4.

Berkowitz, Dana, and Linda Belgrave. 2010. "She Works Hard for the Money: Drag Queens and the Management of their Contradictory Status of Celebrity and Marginality." *Journal of Contemporary Ethnography* 39: 159–86.

Brammer, John Paul. 2018. "How The Vixen Exposed the Racism of *RuPaul's Drag Race*." *Them*, June 22, 2018. https://www.them.us/story/the-vixen-racism-drag-race.

Butler, Judith. 1990. *Gender Trouble*. New York: Routledge.

Cantú, Lionel. 2001. "A Place Called Home: A Queer Political Economy of Mexican Immigrant Men's Family Experiences." In *Queer Families, Queer Politics*, edited by Mary Bernstein and Renate Reimann, 112–36. New York: Columbia University Press.

Camp, Summer. 2016. Facebook status, September 12, 2016, 12:48 p.m. https://www.facebook.com/MissSummerCamp/posts/10154597477342755.

Chapman, Sam. 2018a. "Local Drag Performers Often Don't Get Paid Enough to Even Cover the Cost of Their Outfit." *Stranger*, September 21, 2018. https://www.thestranger.com/slog/2018/09/21/32646576/tip-your-local-drag-queens-they-need-it.

———. 2018b. "The Economics of Drag: No Contracts, Unresponsive Bookers, and Unreliable Payments." *Stranger*, October 9, 2018. https://www.thestranger.com/slog/2018/10/09/33568853/the-economics-of-drag-no-contracts-unresponsive-bookers-and-unreliable-payment/comments/8.

Chi, Kim. 2016. Public Twitter post, September 17, 2016 [no longer available].

———. 2019. Public Instagram story, May 20, 2019 [no longer available].

Cornwall, Richard. 1997. "Deconstructing Silence: The Queer Political Economy of the Social Articulation of Desire." *Review of Radical Political Economics* 29 (1): 1–130.

Coulée, Shea. 2019. Public Instagram story, May 20, 2019 [no longer available].

Cuby, Michael. 2018. "These Trans and Cis Female Drag Queens Have Some WORDS for RuPaul." *Them*, March 6, 2018.

Danby, Colin. 2007. "Political Economy and the Closet: Heteronormativity in Feminist Economics." *Feminist Economics* 13 (2): 29–53.

Davenport, Honey. 2019. Public Twitter post, February 2, 2019, 2:31 p.m. https://twitter.com/Honey_Davenport/status/1091826550184525824.

Dehnart, Andy. 2018. "The *RuPaul's Drag Race* Contract." *RealityBlurred*, May 10, 2018. https://www.realityblurred.com/realitytv/2018/05/rupauls-drag-race-contestant-contract/

D'Emilio, John. 1983. "Capitalism and Gay Identity." In *Powers of Desire: The Politics of Sexuality*, edited by Ann Snitow, Christine Stansell, and Sharan Thompson, 100–13. New York: Monthly Review.

Desta, Yohana. 2017. "Catching Up with BeBe Zahara Benet, the Very First Winner of *RuPaul's Drag Race*." *Vanity Fair*, March 23, 2017.

Divine. 1982. "Alphabet Rap." *Jungle Jezebel*. New York City: O Records.

Dommu, Rose. 2018. "BibleGirl666 on Memes, Teens & the Business of Drag." *Out*, July 5, 2018. https://www.out.com/out-exclusives/2018/7/05/biblegirl666-memes-teens-business-drag.

Eng, David. 2007. "Freedom and the Racialization of Intimacy: Lawrence v. Texas and the Emergence of Queer Liberalism." In *A Companion to Lesbian, Gay, Bisexual, Transgender and Queer Studies*, edited by George Haggerty and Molly McGarry, 38–59. Malden, MA: Blackwell.

Fitzsimons, Tim. 2019. "Elizabeth Warren Goes after LGBTQ Vote with Booth at DragCon." *NBC News*, September 9, 2019. https://www.nbcnews.com/feature/nbc-out/elizabeth-warren-goes-after-lgbtq-vote-booth-dragcon-n1051561.

Framke, Caroline. 2018a. "How RuPaul's Comments on Trans Women Led to a *Drag Race* Revolt—and a Rare Apology." *Vox*, March 7, 2018. https://www.vox.com/culture/2018/3/6/17085244/rupaul-trans-women-drag-queens-interview-controversy.

———. 2018b. "TV Review: '*RuPaul's Drag Race* Holi-Slay Spectacular.'" *Variety*, December 7, 2018. https://variety.com/2018/tv/news/rupauls-drag-race-holi-slay-spectacular-christmas-episode-review-recap-1203084815/.

Gluckman, Amy, and Betsy Reed. 1997. *Homo Economics: Capitalism, Community and Lesbian and Gay Life*. New York: Routledge.

Goldmark, Matthew. 2015. "National Drag: The Language of Inclusion in *RuPaul's Drag Race*." *GLQ: A Journal of Lesbian and Gay Studies* 21 (4): 501–20.

Goodman, Elyssa. 2019. "Drag Is a Hustle: Top Queens Explain the Sacrifice, Struggles and Impact of Their Careers." *Them*, April 25, 2019. https://www.them.us/story/trixie-mattel-peppermint-sasha-velour-merrie-cherry-drag-hustle.

Greer, Evan. 2019. "Corporations Love to Profit off Pride: But They Can't Protect LGBTQ People." *Washington Post*, June 20, 2019. Video op-ed. https://www.washingtonpost.com/video/editorial/opinion--corporations-love-to-profit-off-pride-but-they-cant-protect-lgbtq-people/2019/06/20/d7fda939-95ff-4289-8038-5fd28986006b_video.html.

Hargraves, Hunter. 2011. "You Better Work: The Commodification of HIV in *RuPaul's Drag Race*." *Spectator* 31 (2): 24–34.

Harrison, Mitchell. 2017. "Life after *RuPaul's Drag Race*: How Music, Merch & More Can Add Up to Six Figures." *Billboard*, August 14, 2017. https://www.billboard.com/articles/news/7898226/rupaul-drag-race-music-merch-six-figures.

Hellvetika, 2019. Public Twitter post, February 19, 2019, 4:27 p.m. https://twitter.com/PanderShirts/status/1097968507747221504.

Hernandez, John. 2014. "Giving Face, Shade, and Realness: A Queer Analysis of Gender Performance and Sexuality in *RuPaul's Drag Race*." Master's thesis, University of Hartford.

Herold, Lauren. 2012. "*RuPaul's Drag Race* Is Burning: Performances of Femininity and Neoliberalism in 'Post-racial' America." Senior thesis, Columbia University.

Im, Jimmy. 2019. "How *RuPaul's Drag Race* Helped Mainstream Drag Culture—and Spawned a Brand Bringing in Millions." *CNBC*, May 30, 2019. https://www.cnbc.com/2018/09/28/rupauls-drag-race-inspired-multimillion-dollar-conference-dragcon.html.

Jenkins, Sarah Tucker. 2013. "Hegemonic 'Realness'? An Intersectional Feminist Analysis of *RuPaul's Drag Race*." Master's thesis, Florida Atlantic University.

Judy. 2014. "RuPaul Rings NASDAQ Closing Bell; Celebrates 6th Season of *RuPaul's Drag Race*." YouTube video, 8:04, February 25, 2014. https://www.youtube.com/watch?v=0AI QXU09dX8&lc=UggJeKoi20ca-ngCoAEC.

Klarna. 2019. "Shop Like a Queen Everywhere with the New Klarna App." *Klarna*, May 28, 2019. https://www.prnewswire.com/news-releases/shop-like-a-queen-everywhere-with-the-new-klarna-app-300857531.html.

Klein, Jessica. 2019. "As *RuPaul's Drag Race* Expands to the U.K., DragCon Shines Light on Its Mainstream Success." *Fortune*, September 24, 2019. https://fortune.com/2019/09/24/rupaul-drag-race-uk-dragcon/.

Kohlsdorf, Kai. 2014. "Policing the Proper Queer Subject: *RuPaul's Drag Race* in the Neoliberal 'Post' Moment." In *The Makeup of RuPaul's Drag Race*, edited by Jim Daems, 49–66. Jefferson, NC: McFarland.

Kornhaber, Spencer. 2016. "The Battle for the Soul of *RuPaul's Drag Race*." *Atlantic*, October 14, 2016. https://www.theatlantic.com/entertainment/archive/2016/10/rupauls-drag-race-all-stars-finale-alaska-katya-review-soul/504125/.

Kravitz, Melissa. 2018. "What It Takes to Make a Living as a Drag Queen." *Vice*, July 27, 2018. https://www.vice.com/en_us/article/ne53qw/drag-queens-costs-earnings-tips.

La Fountain-Stokes, Lawrence. 2009. *Queer Ricans: Cultures and Sexualities in the Diaspora*. Minneapolis: University of Minnesota Press.

Lovekin, Stephen. 2009. "Winner Bebe Zahara Benet Attends at *RuPaul's Drag Race* Winner Event at Therapy Bar on March 23, 2009 in New York City." Photo image. *Getty Images North America*. https://www.gettyimages.ca/detail/news-photo/winner-bebe-zahara-benet-attends-at-rupauls-drag-race-news-photo/85572490.

Manalansan, Martin F. 2003. *Global Divas: Filipino Gay Men in the Diaspora*. Durham, NC: Duke University Press.

Masters, Jasmine. 2016. "Jasmine Masters RuPaul Dragrace Fucked Up Drag." YouTube video, 5:35, January 28, 2016. https://www.youtube.com/watch?v=gf25Xzhpz_k.

Max. 2017. Public Twitter post, October 27, 2017, 3:52 a.m. https://twitter.com/MAXcollective/status/923819558867296256.

McLaughlin, Janice. 2006. "The Return of the Material." In *Intersections between Feminist and Queer Theory*, edited by D. Richardson, J. McLaughlin, and M. E. Casey, 59–77. London: Palgrave Macmillan.

Moreman, Shane, and Dawn McIntosh. 2010. "Brown Scriptings and Rescriptings: A Critical Performance Ethnography of Latina Drag Queens." *Communication and Critical/Cultural Studies* 7: 115–35.

Morrison, Josh. 2014. "'Draguating' to Normal: Camp and Homonormative Politics." In *The Makeup of RuPaul's Drag Race: Essays on the Queen of Reality Shows*, edited by Jim Daems, 124–47. Jefferson, NC: McFarland.

Murray, Nick. 2016. *RuPaul's Drag Race All Stars*. Season 2, episode 6, "Drag Fish Tank." Aired September 9, 2016, on Logo TV.

Norris, Laurie. 2014. "Of Fish and Feminists: Homonormative Misogyny and the Trans*Queen." In *The Makeup of* RuPaul's Drag Race: *Essays on the Queen of Reality Shows*, edited by Jim Daems, 31–48. Jefferson, NC: McFarland.

Muñoz, José Esteban. 1999. *Disidentifications*. Minneapolis: University of Minnesota Press.

O'Flynn, Brian. 2019. "Can Drag Queens Become Pop Stars?" *Guardian*, March 6, 2019. https://www.theguardian.com/music/2019/mar/06/can-drag-queens-become-pop-stars.

O'Hara, Phi Phi. 2018. Public Twitter post, July 18, 2018, 6:49 p.m. https://twitter.com/JustJaremi/status/1019715885597151232.

Oliver, Isaac. 2018. "Is This the Golden Age of Drag? Yes. And No." *New York Times*, January 17, 2018. https://www.nytimes.com/2018/01/17/arts/drag-queens-rupaul-drag-race.html.

Raven. 2016. Public Facebook post, March 10, 2016, 5:29 p.m. [https://www.facebook.com/permalink.php?story_fbid=10154096375844274&id=350860534273].

Rudi, Mariella. 2018. "Here's What to Expect When RuPaul's DragCon Returns This Weekend." *Time Out*, May 9, 2018. https://www.timeout.com/los-angeles/news/heres-what-to-expect-when-rupauls-dragcon-returns-this-weekend-050918.

RuPaul. 2014. "Freaky Money." *Born Naked*. New York City: RuCo Inc.

Rupp, Leila, and Verta Taylor. 2003. *Drag Queens at the 801 Cabaret*. Chicago: University of Chicago Press.

Sanderson, Matthew. 2017. Facebook post, July 18, 2017, 8:33 p.m. [no longer available].

Sarah O'Connell Show. 2019. "Jinkx Monsoon Interview—*RuPaul's Drag Race* Winner, Ginger Snapped, Drag Becomes Her." YouTube video, 47:03, March 22, 2019. https://www.youtube.com/watch?v=hrmsBRaTyAY.

Saxena, Jaya. 2019. "When Did Drag Brunch Get So Normic?" *Eater*, June 20, 2019. https://www.eater.com/2019/6/20/18677572/drag-brunch-queer-food-mainstream-prohibition-history.

Schottmiller, Carl. 2017. "Reading *RuPaul's Drag Race*: Queer Memory, Camp Capitalism, and RuPaul's Drag Empire." PhD diss., University of California, Los Angeles.

Schacht, Steven, and Lisa Underwood. 2004. "The Absolutely Fabulous but Flawlessly Customary World of Female Impersonation." *Journal of Homosexuality* 46: 1–17.

Siebenkittel, Ray. 2016. *Glue Sticks and Gaffs: Disassembling the Drag Queening Body*. Master's thesis, Louisiana State University.

Sipe, William Joseph. 2018. *Reclaiming Resistance: Neoliberalism, No Justice No Pride and the Pursuit of Queer Liberation*. Master's thesis, Ball State University.

St. Clair, Blair. 2019a. Public Twitter post, February 28, 2019, 10:40 a.m. https://twitter.com/BlairStClair/status/1101145009045336066.

———. 2019b. Public Twitter post, January 30, 2019, 12:58 a.m. https://twitter.com/BlairStClair/status/1090851810384973824.

Stoole, Lucy. 2019. Public Twitter post, June 9, 2019, 6:15 a.m. https://twitter.com/LucyStoole/status/1137664486956044289.

Strudwick, Patrick. 2015. "This Is What Happens When You Interview RuPaul and He Throws Some Serious Shade." *BuzzFeedNews*, June 2, 2015. https://www.buzzfeednews.com/article/patrickstrudwick/this-is-what-happens-when-you-interview-rupaul-and-he-throws.

Trashqueen. 2019. Public Twitter post, May 1, 2019, 2:10 p.m. https://twitter.com/trashqueen/status/1123650798028718087.

The Tuck, Trinity. 2019. Public Twitter post, April 5, 2019, 9:03 a.m.

Thunderfuck, Alaska. 2013. "Ru Girl." Single. December 17, 2013.

Verman, Alex. 2018. "RuPaul's Comments About Women in Drag Show a Misunderstanding of Gender." *Teen Vogue*, March 8, 2018. https://www.teenvogue.com/story/rupauls-comments-about-women-in-drag-show-a-misunderstanding-of-gender.

The Vixen. 2019. Public Twitter post, May 20, 2019. https://twitter.com/TheVixensworld/status/1130641569382576130.

Vesey, Alyxandra. 2017. "A Way to Sell Your Records: Pop Stardom and the Politics of Drag Professionalization on *RuPaul's Drag Race*." *Television & New Media* 18 (7): 589–604.

Von Odd, Vander. 2019. Public Twitter post, February 19, 2019. https://twitter.com/VanderVonOdd/status/1097832157777661952.

Ward, Jane. 2003. "Producing 'Pride' in West Hollywood: A Queer Cultural Capital for Queers with Cultural Capital." *Sexualities* 6 (1): 65–94.

World of Wonder. 2015. "Participant Agreement Form." Shared on *RealityBlurred*, May 10, 2018. https://www.realityblurred.com/realitytv/2018/05/rupauls-drag-race-contestant-contract/.

WOWPresents. 2017. "UNHhhh Ep 50: 'Random AF' w/Trixie Mattel & Katya Zamolodchikova." YouTube video, 9:05, June 19, 2017. https://www.youtube.com/watch?v=O1TiSy1ZWsE&list=PLCoMbb_Y5WJH0GyOgy6qMQ2tKTPrHRSym&index=56.

———. 2019. "UNHhhh Ep 92: 'Crime Part 2' with Trixie Mattel and Katya Zamolodchikova." YouTube video, 11:22, April 17, 2019. https://www.youtube.com/watch?v=m1xxNlY6TuU.

8

Legend, Icon, Star: Cultural Production and Commodification in *RuPaul's Drag Race*

Laura Friesen

> *People are always like, "why do you do your makeup so differently?" and I'm like, well, in a subversive art form, ask yourself why so many drag queens do their makeup exactly the same. If you can do anything, why does everyone do the same thing?*
> —Trixie Mattel in an interview with Jeffrey Masters for Afterbuzz TV

> *That's what we do here. We sell and endorse products.*
> —RuPaul in an interview with Cathy Horyn for the *New York Times*

> *Queerness is not yet here.*
> —José E. Muñoz in *Cruising Utopia: The Then and There of Queer Futurity*

Introduction: Trixie Mattel—from Mediocrity to Superstardom

I saw Trixie Mattel perform in Winnipeg on her *Now With Moving Parts* Tour in summer 2018, in the wake of her *RuPaul's Drag Race: All Stars* season three win. She was pink, she was blonde, she was glittery, she was larger-than-life, she was almost perfectly plastic. She sang earnest country songs and told dick jokes.

It was simultaneously one of the most memorable nights of my life and a strange, sparkly disappointment.

Trixie Mattel is the stage name and drag persona of performer Brian Firkus, who first found fame as one of fourteen contestants on *RuPaul's Drag Race* (*RPDR*) season seven in 2015. Like many *RPDR* viewers, I first fell in love with her dark sense of humor, her "life in plastic" aesthetic, and her struggle for confidence. She had a consciously fake, doll-like look ("drag queens are like an exaggeration of women; I'm like an exaggeration of drag queens" [Afterbuzz TV]) and a sense of humor about the competition and her place in it.

Trixie's time on the show was characterized less by a series of highs and lows and more by a mediocre sense of trying to get by and fly under the judges' radar. After four episodes of competition, she was initially eliminated in a comedic music video challenge (she has since wryly commented on this failure as she's found much of her success as a comedian and singer/songwriter since the season aired). Trixie was brought back to the competition in episode eight, when she and teammate Pearl won the Conjoined Queens challenge (the show's complicated and frequently disrespectful portrayals of disability is another essay), staying for an additional two episodes, and then was eliminated again and ultimately ended up slightly ahead of the pack in sixth place.

Trixie herself has made light of her less-than-impressive first *RPDR* appearance, notably during her *RPDR All Stars* entrance, during which individual contestants reintroduce themselves and fill viewers in on how their lives and careers have changed since their initial *RPDR* appearance: "I need to make amends for the fact that I came in here and just hit the cement, and got dragged out like a dead body … twice" (S3, E1). Trixie, approaching her *All Stars* season three debut with a more practiced sense of humor and a stronger point of view than on *RPDR* season seven, immediately appears more confident as her voiceover plays and we see her rollerblading around the set's workroom. In that moment we realize she has become a brand, a recognizable image, and a point of view, all facets of what the show encourages and enables its participants to create with their work and their platform on the show. In short, she has become the transformed subject that Julia Yudelman (2017, 16) argues the show creates with its competitive challenges, narrative trajectories, and shaping of what "America's next drag superstar" looks like. In the case of Trixie Mattel, the bulk of the transformation happened not on *RPDR* but rather as a response to it. But, importantly, that transformation undeniably took place. When she arrived on *RPDR* season seven, Trixie was not winner material. When she arrived on *All Stars* season three, she was the definition of it.

While a popular, fan-favorite contestant on season seven despite her performance, Trixie's return to *RPDR* on *All Stars* signaled a kind of redemption for her, as it does for many *All Stars* contestants. In the two and a half years between her

RPDR appearances, she became a drag superstar. In her words, she "leeched off my famous friend Katya" (Zamolodchikova, stage name of Brian McCook, also an *RPDR* season seven alum) (VH1 2018), with the two of them launching a World of Wonder–produced web series called *UNHhhh*, itself a pivot borne from their stint guest-hosting WOW's *Fashion Photo RuView* web series, which became the most-viewed episode of the series (WOWPresents 2015).

After *UNHhhh*'s success, Trixie and Katya were offered a slot on Viceland to make a slightly tweaked and extended version of essentially the same format for a half-hour TV time slot, this time titled *The Trixie and Katya Show*. The format differed just enough from the established and wildly successful *UNHhhh* template in that it had a slightly clunky feel, but by this time there was no stopping the Trixie-and-Katya train—both had achieved a level of fame and popularity, particularly among young, straight, white audiences, not seen by even the most successful queens from previous *RPDR* seasons.

Sitting near the front of the theatre that night at the Trixie Mattel show in Winnipeg, I realized the full extent of her transformation as an entertainer and subject, as formed by the commodifying impetus of *RPDR*. During the show, a child approached the stage and held out money in her grasped hand toward Trixie, who, in mild surprise, asked what this was, to which the child responded that it was a tip. Trixie very kindly and good-naturedly declined, saying this wasn't an occasion where tipping was expected, but the young fan persisted. I'm not sure if I was the only person who detected an awkwardness in the theater, but after a few seemingly awkward moments Trixie accepted, cracked a joke about not being too good to take money from a child, and continued on with the show. The moment bothered me, and its implications continued to weigh on me after the show; my sense that the moment represented a cultural slippage—from drag as cultural clapback to mere financial transaction—and in some way signaled a dilution of drag's political potency was the inspiration for this chapter.

Trixie Mattel's rise within the *RPDR* world and beyond points to a cluster of interconnected phenomena in the way capitalist and neoliberal notions of success and redemption, race, and drag culture's rich history are narrativized and presented to viewers on *RPDR*. The timing of her first appearance on *RPDR* and the ways in which season seven was different from previous seasons of the show, in combination with the ability of *RPDR* producers to quickly produce a seemingly endless stream of marketing/advertising opportunities and content (including Trixie's additional, more successful, appearances on *All Stars* season three and *UNHhhh* as well as World of Wonder's series of DragCon events), drag's explosion in popularity, and the resulting homogeneity of drag expression that has occurred in response to this mainstream success, make Trixie an ideal lens with which to view the cultural impact of *RPDR*. My analysis of this impact includes a review

of RuPaul's work and *RPDR*'s origins, a look at *RPDR*'s early versus later formats and narratives, and a study of why Trixie's appearance on season seven—a season that framed young, white, and white-presenting queens, including Trixie, as the more versatile, viable contestants—established, prompted, and invented the terms of her post–season seven success. In the latter half of my chapter, I look at the profusion of drag-related marketing opportunities that sprang up in the wake of season seven, including DragCon and social media—just two of the markers of success that are unequally accessible to *RPDR* alumni based on their ability to improve themselves and their marketability in response to the show's neoliberal critiques of their drag, complicated by intersectional factors such as race and age. Finally, I'll track the specific ways in which Trixie has addressed and intensified the terms of drag success based on how RuPaul has defined it through the narratives of *RPDR* and his own career.

Writer and "*RuPaul's Drag Race* herstorian" Kevin O'Keeffe (2018) has addressed the shift in *RPDR*'s casting, editing, marketing, and reach that occurred in season seven and that has continued (with a few exceptions) since then. With this shift in mind, I argue the show has moved from *reflecting* LGBTQ+ audiences through its casting and editing to *producing* a bastardized and heavily commodified version of drag culture (Yudelman 2017) that furthers the neoliberal project. In becoming the commercialized, post-political stars that RuPaul and the show grooms its queens to be, success as a drag queen in the age of Trixie Mattel is signaled by a flattening of the collaborative, familial, nonwhite, genderqueer history of drag and queer performance to make way for a distinctly twenty-first century, capitalist copy of drag culture, created in the images of RuPaul, reality television, and neoliberalism.

From Cultural Reflection to Cultural Production

If, in the words of José E. Muñoz (2009, 1), queerness is "the rejection of a here and now and an insistence on potentiality or concrete possibility for another world," what future world is being shaped by the ever-surging popularity of *RPDR*? Is it one that explores queer subjectivities and pluralities by giving a showcase to alternative identities and modes of queer cultural production? Or has the sheer popularity of the kinds of LGBTQ+* performance that are showcased on *RPDR* indicative of another kind of cultural production? Using Julia Yudelman's (2017) distinction between representational/reflective analyses and productive/transformational analyses of *RPDR*, I argue that the show's reality TV genre constraints have been complicated by an audience-responsive shift in the terms through which a queen is expected to succeed, from giving a platform to what was at one time

a small, more diverse segment of drag culture in the United States, to a commercialized platform through which drag culture is made legible and legitimate. I contend that RuPaul's vision for *RPDR* is not primarily to celebrate the multiplicities of drag and queer cultural performance and identity, but to commodify drag and shape it into a solidly outlined, less amorphous entity that's identifiable and consumable by the largest number of fans possible.

It is generally acknowledged that *RPDR* began with two primary inspirations for its format and content: Jennie Livingston's 1991 documentary *Paris Is Burning*, about ball culture in 1980s New York City (Brennan and Gudelunas 2017, 2; Edgar 2011, 136), and the reality TV competition *America's Next Top Model* (*ANTM*) (Marcel 2014, 16–17). In 2009, with its first season, RuPaul intended for *RPDR* to be a fully camp, tongue-in-cheek parody of *ANTM*, which is apparent in many of the conventions constructed by the show and held to be intrinsic to its format, including the emphasis on each episode's runway presentation (and seemingly required model-like walk) and its corresponding panel of judges (conspicuously always devoid of any drag queen additional to RuPaul) (Into More 2018, E4; Marcel 2014, 16). The show's dual cultural inheritance of *Paris Is Burning* and *ANTM* are not as oddly matched as they might at first seem: bell hooks (1992, 148) notably critiqued *Paris Is Burning* and the racist and patriarchal power structures replicated in some of its narratives—what many (white) viewers saw as an empowering look into an LGBTQ+ subculture—when she saw "black men [...] [and] their obsession with an idealized fetishized vision of femininity that is white." This is to say that *RPDR* referencing the language, styles, and influence of *Paris Is Burning* does not represent the show being inspired by an earlier, "purer" form of drag culture that it has since departed from, but rather that the influence of both *ANTM* and *Paris Is Burning* represents highly mediated, digestible narratives that are built for mainstream audiences.

Both because of and in spite of these influences, *RPDR* is a curious amalgam of the history of drag culture and its ever more profoundly co-optable, commodified present. Serving as cocreator, role model, host, judge, mentor, and titular persona, RuPaul's place at the show's center signals his drag bona fides, first established as a performer who cut his teeth in the New York drag scene of the 1980s and who then brought drag to the mainstream masses in the 1990s—albeit frequently as a gimmick (Edgar 2011, 135–36; Into More 2018, E12). He is uniquely positioned to package up parts of his own history and knowledge and sell them as a reality TV competition. Crucially, it is only *certain parts* of his own history that get wrapped up in the now-familiar candy-pink, TV-ready packaging of *RPDR*, which also happens to preach individual empowerment for all. RuPaul appears to selectively repackage and sell LGBTQ+ history with an adeptness and ease that belie its diversity and complexity, glossing over earlier parts of his career that are

less commodifiable and trading only on the aspects that made him a mainstream star (Brumfitt 2015; Garel 2018). On the *RPDR* mainstage, whenever a queen gets read; that is, critiqued, for not being passably fishy, or feminine, enough, I'm reminded of RuPaul's own youthful, punky, genderfuck, low-budget drag experimentation and, again, the kinds of drag that are being shaped as acceptable by the show.

Despite its reality TV competition trappings and RuPaul's selective refashioning of queer and LGBTQ+ history, the first three seasons of *RPDR* had the peculiar effect of largely *reflecting* many different identities and viewpoints within the LGBTQ+ community. These seasons had the undeniable draw of representation—seeing queer performance being celebrated on TV meant powerful identification for LGBTQ+ audiences across the United States and beyond. The show's participants were often able to transcend its commercial format, but this was also before its success and its audience were foregone conclusions. While this does not mean that representation, particularly of racial diversity, on the show was faultless (Strings and Bui 2014), there was a variety of narratives being shaped and a variety of experiences that were highlighted, such as that of Ongina (S1), the first queen on *RPDR* to declare her HIV-positive status; Sonique (S2), the first *RPDR* queen to come out as transgender; and the fact that there were only six white queens cast *in total* on seasons one and two. (Hunter Hargraves [2011, 27] has attributed *RPDR*'s early diversity directly to its reality television format, "with [...] each program's cast generating interpersonal conflicts and moments of education about the experiences of people of color.") This format enabled more nuance in storyline and, more importantly, employed a framework through which the cast could share their own experiences and identities and have them play to viewers as genuine moments, rather than RuPaul-sanctioned instances of forced story or political correctness. The shape and feel of more contemporary *RPDR* narratives, which I'll explore shortly, have instead been informed to a much higher degree by marketability and appeal to the largest audience possible.

This disjunction within the canon of *RPDR* is what Julia Yudelman (2017, 18) refers to when she writes about traditional approaches to *RPDR*-as-LGBTQ+*-representation analyses falling short; she notes that "when we deploy this traditional approach to representation, we overlook one of the key ways that representation functions: as a productive force." Further to this, she incorporates Jack Bratich's work on the power structure dynamics in reality television and Michel Foucault's, Stuart Hall's, and Judith Butler's work on theories of representation and production to posit that *RPDR*, as a cultural production about subjects who have been historically marginalized and oppressed, is a performative phenomenon that, "rather than representing the real, is actually a changing force that both *produces* and *is produced by* the real" (19; emphases added). This last point

is particularly relevant to my argument here, as I identify a shift within *RPDR* itself: the first three seasons of the show exemplify reality TV being produced by the real (the real being the diversity, community, and political potency of drag culture), while later seasons, particularly those from season seven onward, have the effect of producing the real, or forming drag culture into a shallow version of itself, informed by reality TV and obsessed with image, status, individuality, financial affluence, and cultural influence.

Additionally, RuPaul's role in shaping and exemplifying these representational shifts through his career before *RPDR* and on *RPDR* is of particular importance here, as Trixie Mattel has, in large part, based her own career upon many of the goalposts of RuPaul's success. As with many queens when they start out, Trixie's early work was unpolished and only somewhat successful within the confines of *RPDR*, an example of the show reflecting the reality of queer culture. When Trixie returned to the show for *All Stars* season three, her performance improved in the ways that *RPDR* specifically values, showing that she began reflecting *RPDR*'s highly commodifiable, marketable version of queer culture.

The Season Seven Shift and the Means of Success

When Trixie Mattel made her return to *RPDR* and rollerbladed into the workroom for *All Stars* season three, the redemption viewers expected that she would show the *All Stars* season three audience that "in the real world I've been a real all star" (S3, E1). But her performance stalled. *All Stars* season three played to viewers as a muddle of storylines and would-be frontrunners who either quit the competition (BenDeLaCreme) or got ousted by the results of a gimmicky last-minute vote (Shangela). Trixie won *All Stars* season three less because her performance on the season outshone those of the other competitors and more because of a failure in the show's storyline and editing, and because of her status as a pop culture icon (… legend, star), proven not during her seasons of *RPDR* but between them (Kheraj 2018) and, more importantly, because of them.

The circumstances and effects of Trixie Mattel's *RPDR*-prompted rise serves as a nexus of related phenomena all pointing to the irrevocable change in *RPDR* and its equally irrevocable influence on drag and queer culture. Kevin O'Keeffe's (2018) assertion that the *RPDR* fans now accept as normal was formed in season seven is of particular interest here; he writes that, starting with season seven, the cast included a remarkable number of young, white, quirky queens who were each afforded the nuance that enabled them to pull away from the competition and be viewed as unique, viable contestants while many of their counterparts, whether older competitors or queens of color, were not edited and hence viewed with the

same potential. Through casting, narrative, and editing, the capacity for certain *RPDR* queens to experience the growth of their brand and fan base while others are seen to somehow lag behind for lacking a certain market-ready "it girl" sensibility is made clear. Indeed, on season seven, young white queens with similar makeup- and fashion-based skills—Violet Chachki, Miss Fame, Max, Pearl, and at times Katya and Trixie—were all framed as serious competitors, even as they struggled through acting, comedy, and improvisation-centered challenges. This was played against the performances of queens of color, age, and size: when performers like Jaidynn Diore Fierce or Jasmine Masters struggled in the same challenges, they were understood to be embarrassing themselves or putting themselves at serious risk for elimination (S7, E3, E5, and E6; Schlichte 2018).

This narrativized clash between young/white and older/nonwhite queens is illustrated with stark clarity in a confrontational moment from *All Stars* season three, when competitor Milk is comparing the performances of fellow queens Kennedy Davenport and Thorgy Thor, the latter of whom was just sent home after they were both up for elimination. As Milk tries to explain that she responds more to Thorgy's work and that she thinks Kennedy deserved to be sent home for her less exciting work in comparison, a clip of Kennedy's rejoinder to the confessional camera is cut in. "Fuck my drag, right?" she both asks and states—her tone is equally offended and annoyed (S3, E3). I see the barely veiled subtext of this scene as a direct confrontation between what *RPDR*—and Milk—see as the viable, exciting "future of drag," and the work of path-paving queens like Kennedy, whose more traditional style of performance serves as the drag foundation upon which Thorgy Thor and Milk's more "modern" work is built. Adding weight to the moment is the fact that Kennedy is one of the queens who first appeared on season seven and despite making it to the top four of the season, remarked on *All Stars* season three about feeling far less popular than other queens while doing meet-and-greets as a group on tour (S3, E7; Schlichte 2018).

RPDR frames participants' success as directly contingent on their individual ability to see the larger picture of drag and pop cultural trends, to respond to the judges' critiques and implement changes into their work so they can succeed within the format of the show, and to be aware of their individual strengths, weaknesses, personas, and brands. It does not acknowledge its own part in mediating how participants are edited and presented to audiences, how some challenges are built for entertainers with certain skills that may be unequally distributed based on race, culture, class, size, or age divides (Vesey 2017), or how discussion around the winner, who is meant to represent the so-called future of drag, is often white (Into More 2018, E3) and is only able to present a "forward-thinking" or "edgy" body of work because of the decades of foundational work done by queens of color. While the rise of season eight's top four competitors, all queens of color, is

a notable exception to this trend, many of the show's narratives in season nine, season ten, and *All Stars* season three continued to elevate the performances of white and white-presenting queens at the expense of their counterparts of color, making evident that the kind of work *RPDR* expects its top competitors to do is that which primarily young, white queens have the resources to master and perform.

Even queens who don't see themselves as subjects formed by the productive power of *RPDR* benefit from it: Sasha Velour, who won season nine of *RPDR*, has characterized her drag as highly political and intellectual, engaging with drag culture's historical traditions of community and activism (Damshenas 2019), but through the lens of *RPDR* her more serious, academic moments are tempered by the show's framing of her looks and persona as unique and worthy of winning regardless of how seriously she takes herself. While it would be an unfair and incorrect stretch to describe her work as mediocre, Sasha, like Trixie on *All Stars* season three, had a relatively under-the-radar run on the show leading up to her win. Conversely, The Vixen, another serious and political performer who appeared on season ten, is thought to have received what viewers and TV critics refer to as the "villain edit"—that she was framed as the season's antagonist through unfavorable postproduction that took her behavior out of context and made it seem irrational and overblown—and was thus seen by *RPDR* fans as contentious, mean, and overly serious (Garel 2018; Into More 2018, E1). Even though many of their views on drag's political gravity overlap, Sasha was spared this portrayal on season nine and, indeed, won the title. Sasha is an example of the way a white queen who is perceived as young, quirky, and unique is able to leverage political seriousness to her advantage without being seen as a killjoy or as someone who can't appreciate the fun, camp, over-the-top qualities of drag.

The idea of a villain edit was first brought into public discourse around *RPDR* when Phi Phi O'Hara spoke to *Vulture* about her negative, one-dimensional portrayal on *All Stars* season two (AS2), bringing to light the idea that the show's editing and postproduction furthers a drama-maximized, viewer-baiting narrative without regard for the queens' actual, contextualized behavior during filming or their well-being after the show airs, when fans may turn on queens in response to how they've been presented to audiences (Into More 2018, E1; Jung 2016). Since then, the concept of the villain edit has been a popular way for fans and TV critics to explain the narrative conflict and momentum that drives episodes and seasons of *RPDR*. These edits have also been criticized for elevating the trajectories and motives of white queens over their counterparts of color (Garel 2018)—indeed, most of the infamous *RPDR* queens who have come to be known as villains of their respective seasons, including Phi Phi O'Hara (*RPDR* S4, AS2), Roxxxy Andrews (*RPDR* S5, AS2), The Vixen (*RPDR* S10), and Gia Gunn (*RPDR* S6,

AS4), are all performers of color. At its core, the way the show frames its (s)heroes, villains, winners, and losers, along with their narrative journeys, is a product of the interweaving of racist, classist, commodification-driven inequalities built into the competition's values and structures, alongside postproduction that works to intensify and complicate the meanings generated by the queens and their interactions during production. This means that marked differences in the discourses of race, marketability, audience appeal, and versatility underscore which *RPDR* alumni are embraced by the fandom and become stars, with the means to then further elevate their brands through DragCon and social media.

Commodification, DragCon, and Audience Demographics

The way race is framed and presented on *RPDR* and, consequently, after queens' appearances on the show, widens this disparity in image. While on earlier seasons racialized queens were relegated to performing race even as they subverted gender (Strings and Bui 2014), further dimensions have been added in more recent seasons as *RPDR* alumni navigate post-show capitalization of their personas and brands. Shea Couleé (*RPDR* S9), Jasmine Masters (*RDPR* S7, AS4), and Tyra Sanchez (*RPDR* S2) are just three queens who have been outspoken in identifying and calling out racist double standards that queens of color are subjected to by *RPDR* fans (Garel 2018; Schlichte 2018). Additionally, as the show's audience grows and changes in demographic (Patten and Haring 2018), the disparity between *RPDR*'s top queens and their earning potential widens in comparison with queens who haven't appeared on the show or are less popular with young, white fans. As a result of fan racism and biases, the terms of success for drag queens has shifted and influenced the show itself in a kind of self-perpetuating echo chamber of mainstream, individual financial success, not political strength as a group or community. As Alim Kheraj (2018) puts it:

> What seems to be happening to *RuPaul's Drag Race* is the inevitable entropic eroding that occurs when all reality TV shows get to a certain size: producers feel a need to tinker with the special formula that constitutes a show's DNA, in a bid to grow demographics and keep audiences coming back for more. Likewise, the show's growth and ultimate unravelling feeds into a wider trend of the commodification, and therefore banalisation, of queer culture, making things more palatable to a wider (read: cisgender, white, straight) audience.

What is it that *RPDR*'s most popular queens are doing off-screen that causes some of them to eclipse their cohorts, both on and off the show? The short answer,

commodification, is largely made up of two parts: (1) social media brand-building, and (2) RuPaul's DragCon. But social media and DragCon-prompted growth took off, in turn, because of the enormous growth in audience and change in audience demographics since season seven. In addition to the queer audiences who made up the viewership of *RPDR* from seasons one to six, when the viewership began exponentially growing with season seven it added a large number of young, white, social media-savvy women to its regular audience, and then, with its move to mainstream channel VH1 in 2017, almost everyone, including families and young children (Into More 2018, E8; Metzger 2016, 59–60).

Starting in 2015 (and almost-perfectly coinciding with the last few episodes of season seven's broadcast on Logo TV), RuPaul's DragCon was introduced in LA to *RPDR* fans who wanted to meet their favorite queens in person and engage with drag culture in a more participatory way. Two years later, a second version of the convention was added in New York, making the event biannual. As with most fan conventions, while attendees undeniably do get the thrill of meeting their (s)heroes, the cost of this engagement for fans seems to rise every year and, indeed, often corresponds to the relative popularity of the queens they're hoping to meet. For the price of entry, fans are unleashed in a sea of merch booths so they can spend more money on T-shirts, pins, dolls, and more. For a further fee, they can queue to meet and greet their favorite queens and get a picture together. The introduction of "Fast Passes" is another perk that comes with a cost (Betancourt 2019). DragCon is a marketing event that separates drag culture from its rightful home, gay bars, and transplants it into a space and mode that privileges the consumption of commodities as tokens of drag culture, not the consumption of diverse drag culture in and for itself (Davies 2018). Consequently, DragCon separates mega-popular *RPDR* alumni from the merely liked, often along racial and class lines, while nurturing a shallow, commodified understanding of drag culture held by *RPDR*'s youngest fans.

Social media, however, is arguably where these inequalities in commodification potential are made most publicly visible. Twitter and Instagram are the sites where follower counts illustrate, in the plainest terms, which queens succeed as *RPDR* alumni. *RPDR* analysis web series The Kiki notes that of the eleven *RPDR* alumni Instagram accounts with over a million followers, eight are of white queens, three are queens of color, and none are black (Into More 2018, E3). Meanwhile, social media also gives young fans a means to engage with the queens and storylines of *RPDR*, in both positive and negative ways. The immediate and public quality of the social media backlash and harassment that queens of color face seems symptomatic of a more general internet racism in the age of social media, but also takes on different nuances when leveled at queens of size, or at queens of color by fans of other queens of color (Rodriguez 2019). Regardless of the show's

representation of queens of diversity, *RPDR*'s courting of larger young, white, straight audiences has been shown to intensify the online bullying that queens of color disproportionately face.

The potential for commodification trickles down from brand establishment based on sales at DragCon and popularity on social media. The complexity that white and white-presenting *RPDR* queens are allowed, from a marketing perspective, is significantly broader than that available to queens of color. Consider Trixie Mattel's music career: she has released two albums of introspective country/folk music, representing a sharp turn from the music typically released by *RPDR* alumni. Most queens interested in a music career beyond *RPDR* take the well-trod RuPaul route and make slick, glossy club music with a built-in audience of queer bar-goers and *RPDR* fans. Trixie's popularity grew with the release of her music both *despite* and *because of* her ascent in the *RPDR* fandom—the flexibility to launch a music career outside of the *RPDR*-sanctioned dance music template is a privilege not afforded to queens who don't read as white (Firkus has spoken about his Ojibwe heritage and his white-passing privilege [Brooke 2015]). Even when queens of color make club music in a more obvious dance/pop mold, they are not guaranteed success on the scale of their white peers. Alyxandra Vesey (2017, 600) has researched the double standards queens of color face when launching post-*RPDR* music careers next to their white and light-skinned peers, contending that "if *Drag Race* is meant to teach contestants how to commodify themselves, it does not uniformly value their efforts or grant them equal access to harness the means of production." Further, she shows that "the show's engagement with pop music reinforces both the recording industry's and reality programming's neoliberal impulses to represent queer subjects as vehicles for capitalist accumulation that neutralize the potential for diversity and systemic change within queer communities" (601). While most of her peers of color aren't able to transcend their racialized identities to achieve mass popularity while producing work outside of the established drag template, Trixie's image and popularity aren't compromised by her earnest music; they're buoyed by her perceived authenticity.

Discussions of popularity and commercialization in the world of drag culture also raise questions of causation and origin: does *RPDR*'s emphasis on commodification prompt participants to shape their work in response to the show's critiques and the market it has created, or does *RPDR*'s impact on mainstream culture create participants who arrive to compete on the show increasingly equipped with the commercial tools to succeed within its parameters? While much of my chapter gives examples of the former direction, season ten winner Aquaria is a notable example of how the latter can work. As the youngest winner of *RPDR* to date, her knowledge of drag was directly informed by her consumption of the show, as well as by her existing connections within New York City's drag and club kid

nightlife scenes prior to even entering the workroom (Dommu 2018). While she came across as young and awkward to the confessional camera and in interactions with RuPaul and her fellow queens, she also was able to anticipate her challenges in a way viewers hadn't seen on the show before. Given her tendency to stumble over her words, Aquaria realized in advance that the perennial Snatch Game challenge would be a struggle for her unless she prepared for it. In response, she presented a studied caricature of Melania Trump that hit all its (scripted) marks and earned her the challenge win (S10, E7). Considering Aquaria's success and the likelihood that these kinds of responses to *RPDR* will become more commonplace as the series progresses, it appears that *RPDR* has and will continue to produce drag culture on a number of levels: namely, by shaping queens who appear on the show into their marketable, "idealized" selves, as well as by shaping the larger drag culture into a source of savvy potential *RPDR* contestants.

RuPaul, Trixie Mattel, and the Neoliberal Redemption of Drag

As I've tried to suggest throughout this chapter, related and overlapping phenomena, specifically RuPaul's narrowing and commodifying certain "acceptable" forms of drag, *RPDR*'s narrative and structural shifts from season seven onward, and the ways in which social media and DragCon have grown audiences and changed popular responses to drag have had the combined effect of making drag success something that has become very narrowly defined, particularly when contrasted with the art form's expansive, creative roots. Again, Trixie Mattel's career emerges as characteristic of these constraints and this new kind of success.

On the surface, Trixie and RuPaul perform very different kinds of drag. Trixie's humor is snarky and self-deprecating while RuPaul conveys a more old-school, winking knowingness that only hints at some of the bawdy themes Trixie has covered with her comedy. While RuPaul laid much of the groundwork for drag queens wanting to cross over as dance music recording artists to make music echoing drag's perceived shiny artifice, Trixie's songs bridge a gap between Trixie the drag queen and Brian Firkus the performer and songwriter, humanizing the drag queen pop music trajectory in a way that initially seems antithetical to what pop music as performed by drag queens is meant to be. RuPaul tends to appreciate and reward passably feminine fishiness on the show, preferences Trixie has shaken off and twisted for her own clownish, comedic use. Despite these differences in approach, the example that RuPaul and *RPDR* set for drag success has, for Trixie, been taken earnestly to heart and has made her the drag queen she is today.

While not a success within the competition of season seven, Trixie's very participation in that particular season of *RPDR* helped invent the terms of her current

explosive popularity. Season seven rewrote the rules for what *RPDR*'s top drag queens are expected to possess: self-awareness and an established brand identity, broad appeal and marketability (usually translated as whiteness, youth, and quirky individuality), and a wide-ranging skill set that can be applied across audiences and markets. Trixie's success in the post-*RPDR* drag landscape is directly tied to her narratives—both failures and successes—from the show itself.

Between and after her seasons on *RPDR*, she has responded to precisely the challenges that *RPDR* presents and corrected or improved upon them. On season seven Trixie was eliminated from the competition for the second time after a challenge in which she and fellow participant Ginger Minj rehearsed and performed a dance routine incorporating country and robot styles. This was the first time audiences saw Trixie in country-inspired drag: cowboy hat and square dancing dress, vertically split in half with a corresponding stereotypically masculine country look (S7, E10). Fifteen minutes after she walked the runway in this dual look, she was eliminated and not seen on the *RPDR* stage again until the first episode of *All Stars* season three, when she performed in the main challenge in unmistakably Dolly Parton-esque country drag while singing and accompanying herself on autoharp. Even the sleeve design of her debut album *Two Birds* seemed to reference and correct that failed opportunity on season seven, with her two country selves, man and drag queen, looking wistfully into the distance (Büscher 2017).

In the regularly featured *RPDR All Stars* personal branding and product challenge, competitors are tasked with encapsulating and distilling their personas to create and pitch marketable products based on distinct and identifiable aspects of their drag identities. Trixie's Andy Warhol–inspired soup can (AS3, E5), while praised on the show, was supplanted in spring 2019 with her actually-for-sale makeup line Trixie Cosmetics, complete with a brightly colored, pun-filled promo campaign as seen on the brand's website. It speaks to all of RuPaul's preferred branding and marketing devices as shown through the soup can challenge: tongue-in-cheek references to drag while promoting a product to mainstream audiences, cute and cartoony imagery, a sense of camp and goofiness, and plenty of references to how the product is sure to make the customer more fabulous.

The minor stumble that was *The Trixie and Katya Show* even worked out in Trixie's favor in the end. After showing that she—and guest cohost, *RPDR* season eight winner Bob the Drag Queen—could pinch hit in Katya's absence (Ifeanyi 2019), Trixie's emergency save didn't seem to expand her opportunities and success at first. But Katya and original web series *UNHhhh* both returned later in 2018, with a comeback episode themed around reunions. Trixie and Katya looked fresher than ever, and returned right to their regularly scheduled programming of surreal and frequently disgusting off-the-cuff banter, which now gives off the curious sense that they're letting off steam between more lucrative and profile-boosting gigs.

Just three years ago, Trixie and Katya's World of Wonder web series appearances *were* the profile boost; now those episodes are the little "extra" they seem to do as a gesture of affection for *RPDR* and the fans.

While Trixie's disastrous *All Stars* season three Snatch Game caricaturization of RuPaul almost got her eliminated from the competition, Trixie played and ultimately won a longer RuPaul impersonation game—she has seized upon and intensified RuPaul's precise conception of success as a drag queen. She says that "I just saw RuPaul recently and he was like, 'You're doing things no one has ever done—not even me'" (Ifeanyi 2019). As Jonathan Buck (2019, 4) puts it, "In the world of *Drag Race*, American life is postulated as being past oppression, and what remains is for individuals to prove their self-worth." Trixie pulled up her bootstraps, made herself into something out of nothing, and became *RPDR*'s idealized subject in an individualized, neoliberal marketplace of mainstream competition and popularity. As another quotation in her *Fast Company* profile has it,

> This [watching the documentary *Trixie Mattel: Moving Parts*] makes me feel like I did something with my life. In drag, sometimes you're sitting there in a chicken suit like, what are we doing right now? This movie makes me feel like I could die and I did something.
>
> (Ifeanyi 2019)

With her full-circle redemption complete and her legendary status confirmed, Trixie emerges as *RPDR*'s definitive, exemplary success story, having spun banal reality TV straw into gold.

Conclusion: Drag as Mainstream Entertainment

I first watched a YouTube interview with Trixie Mattel for Afterbuzz TV's *LGBTQ&A* series after I had seen her perform live and was feeling let down by some of her lowest-common-denominator humor. Her tactics to have gained the kind of audiences she commands—enormous, screaming ones, from queers and longtime *RPDR* fans to newer, younger fans, including the particularly young one from my anecdote—were clearly more powerful and wide-reaching than I was even aware of. I felt a little alienated in the audience when I didn't find her jokes about school shooters funny yet was surrounded by waves of practically hysterical laughter.

So, I watched the interview to see what else Trixie had to say about her success. I knew she was smart, but the amount of insight she had to share about drag and how she's found her place in it suddenly made me remember why I fell in love with her during season seven. In the interview, she acknowledged that "my bank

account's very happy that [drag] has gone mainstream" but also talked about the subversive, destabilizing potential of what she does. While making the shape of an exaggerated hourglass figure with her hands, she asks, "Why does this silhouette—which is psychotic!—and this much makeup make you think 'woman'? It should make you reflect on appreciating women for whoever they are" (Afterbuzz TV 2017). After watching the interview, I realized that there is a gap in Trixie knowing and revering the subversive potential of drag performance, yet writing and performing a show that deliberately appeals to her large audience's baser tastes. She is able to write and perform depoliticized comedy, make herself into a brand and sell products, and grow her career because of her privilege as a white-presenting performer and *RPDR* alum who, like RuPaul, can strategically deploy when and how she chooses to be political.

The interview reminded me of what drag performance was meant to do, and how it might open up, not close, possibilities for subversion, self-expression, and transformation, as queer cultural production has always done. As Benny LeMaster (2015, 171) writes, "The point of queer criticism is to encourage and/or protect difference rather than to foreclose its emergence," and with that in mind I contribute my critique of a show (and its queens) that I continue to love despite its descent into mere entertainment. As many others have noted, *RPDR* is one of the very few shows on mainstream TV—and is far and away the most popular one—that centers LGBTQ+ subjects of color and their experiences. It pushes "genderqueer norms into mainstream televisual media and create[s] a new base of knowledge that helps to legitimize genderqueerness and drag in a dominantly heteronormative society" (González and Cavazos 2016, 661), but it also produces specific kinds of drag that it accepts and promotes as legitimate, namely, those that are widely marketable.

While I hope that drag culture's current popularity will prompt new, young fans to look outside of *RPDR* for inspiration and diversity, I also realize that RuPaul's vastly expanding empire and influence means that queer cultural production is at risk of becoming more commodified than we can even anticipate. But at the same time, *RPDR* won't go on forever, and while I have little hope for a new vision of drag transformation under RuPaul's banner, the radical potential of the many queens who have strutted *RPDR*'s mainstage—as well as the queens who never have and never will—inspires me and gives me hope for a future of engaged drag culture that negotiates with, not tramples over, its own complex history.

REFERENCES

Afterbuzz TV. 2017. "Interview with Trixie Mattel: Aging, Dating, and Wanting to Look Like a Wind-Up Toy." January 24, 2017, YouTube video, 34:19. https://www.youtube.com/watch?v=-2OnPCYMcNk&.

Betancourt, Manuel. 2019. "*RuPaul's Drag Race* Helps Turn Queens into Stars—and Savvy Marketers." *Vox*, March 14, 2019. https://www.vox.com/the-goods/2019/3/14/18262325/rupaul-drag-race-season-season-11-merch-shangela-dragcon.

Brennan, Niall, and David Gudelunas. 2017. "Drag Culture, Global Participation and *RuPaul's Drag Race*." In RuPaul's Drag Race *and the Shifting Visibility of Drag Culture*, edited by Niall Brennan and David Gudelunas, 1–11. Cham, Switzerland: Palgrave Macmillan.

Brooke, Zach. 2015. "Q&A: Trixie Mattel." *Milwaukee Magazine*, September 8, 2015. https://www.milwaukeemag.com/qa-trixie-mattel/.

Brumfitt, Stuart. 2015 "RuPaul Talks Gender Fuck and Drag Genre." *I-D*, May 29, 2015. https://i-d.vice.com/en_uk/article/zmxyy4/rupaul-talks-gender-fuck-and-drag-genre.

Buck, Jonathan. 2019. "Et Tu Ru? Entrepreneurship and the Commodification of Drag in *RuPaul's Drag Race*." *for(e)dialogue* 3 (1): 1–19. https://journals.le.ac.uk/ojs1/index.php/4edialog/article/view/3144.

Büscher, Christoph. 2017. "Q&A: Trixie Mattel on Her Debut Album 'Two Birds.'" *ArtMagazine*, May 11, 2017. https://medium.com/artmagazine/q-a-trixie-mattel-on-her-debut-album-two-birds-c1ae15b1f84c.

Damshenas, Sam. 2019. "Sasha Velour on Deconstructing Gender and What It Would Mean for Drag." *Gay Times*, February 14, 2019. https://www.gaytimes.co.uk/culture/118580/sasha-velour-on-deconstructing-gender-and-what-it-would-mean-for-drag/.

Davies, Wilder. 2018. "*RuPaul's Drag Race* and What People Get Wrong about the History of Drag." *Time*, March 9, 2018. http://time.com/5188791/rupauls-drag-race-history/.

Dommu, Rose. 2018. "Aquaria: The Unreal Housewife of New York." *Paper*, April 5, 2018. https://www.papermag.com/aquaria-transformation-2556492149.html.

Edgar, Eir-Anne. 2011. "Xtravaganza!: Drag Representation and Articulation in *RuPaul's Drag Race*." *Studies in Popular Culture* 34 (1): 133–46.

Garel, Connor. 2018. "RuPaul Perpetuates the Myth That Black Progress Is Tied to White Acceptance." *Buzzfeed News*, July 5, 2018. https://www.buzzfeednews.com/article/connorgarel/rupauls-drag-race-the-vixen-eureka-respectability-politics.

González, Jorge C., and Kameron C. Cavazos. 2016. "Serving Fishy Realness: Representations of Gender Equity on *RuPaul's Drag Race*." *Continuum: Journal of Media & Cultural Studies* 30 (6): 659–69. http://dx.doi.org/10.1080/10304312.2016.1231781.

Hargraves, Hunter. 2011. "You Better Work: The Commodification of HIV in *RuPaul's Drag Race*." *Spectator* 31 (2): 24–34.

hooks, bell. 1992. *Black Looks: Race and Representation*. Boston: South End.

Horyn, Cathy. 2011. "RuPaul: Still Strutting, on Stage and Off." *New York Times*, August 5, 2011. https://www.nytimes.com/2011/08/07/fashion/at-lunch-with-rupaul-main-course.html.

Ifeanyi, KC. 2019. "Trixie Mattel Is Doing Things No Drag Queen Has Ever Done ... including RuPaul." *Fast Company*, May 4, 2019. https://www.fastcompany.com/90343693/trixie-mattel-is-doing-things-no-drag-queen-has-ever-done-including-rupaul.

Into More. 2018. "The Kiki." YouTube web series, 12 episodes. https://www.youtube.com/playlist?list=PL8TrohViKpyKLYqeOtdHmw_avtOr-Gnau.

Jung, E. Alex. 2016. "*RuPaul's Drag Race*'s Phi Phi O'Hara on RuPaul: 'We're Just Game Pieces for Her Show.'" *Vulture*, September 22, 2016. https://www.vulture.com/2016/09/phi-phi-rupauls-drag-races-edit-and-rupaul.html.

Kheraj, Alim. 2018. "After Ten Fab Years, *Drag Race* Is Becoming the Reality Show It Satirised." *Dazed*, March 20, 2018. http://www.dazeddigital.com/film-tv/article/39436/1/rupaul-drag-race-all-stars-season-3-review-shangela.

LeMaster, Benny. 2015. "Discontents of Being and Becoming Fabulous on *RuPaul's Drag U*: Queer Criticism in Neoliberal Times." *Women's Studies in Communication* 38 (2): 167–86.

Marcel, Mary. 2014. "Representing Gender, Race and Realness: The Television World of America's Next Drag Superstars." In *The Makeup of* RuPaul's Drag Race: *Essays on the Queen of Reality Shows*, edited by Jim Daems, 13–30. Jefferson, NC: McFarland.

Metzger, Megan M. 2016. "That's Ru-volting! How Reality TV Reimagines Perceptions of American Success." Thesis, DePaul University. https://via.library.depaul.edu/etd/209.

Muñoz, José E. 2009. *Cruising Utopia: The Then and There of Queer Futurity*. New York: New York University Press.

O'Keeffe, Kevin. 2018. "Why Season 7 Is the Most Important *RuPaul's Drag Race* Season Ever." *Into More*, April 6, 2018. https://www.intomore.com/culture/why-season-7-is-the-most-important-rupauls-drag-race-season-ever.

Patten, Dominic, and Bruce Haring. 2018. "*RuPaul's Drag Race* Hits All-Time Highs with Season 10 Ratings." *Deadline*, June 29, 2018. https://deadline.com/2018/06/rupauls-drag-race-hits-all-time-highs-with-season-10-ratings-1202419952/.

Rodriguez, Mathew. 2019. "9 Times the *Drag Race* Fandom Was Actually Terrible." *Out*, February 4, 2019. https://www.out.com/entertainment/2019/2/04/8-times-drag-race-fandom-was-actually-terrible.

Schlichte, Garrett. 2018. "*RuPaul's Drag Race* Has a Race Problem." *Slate*, February 15, 2018. https://slate.com/human-interest/2018/02/rupauls-drag-race-queens-see-racism-in-show-treatment-and-fan-love.html.

Strings, Sabrina, and Long T. Bui. 2014. "'She Is Not Acting, She Is': The Conflict Between Gender and Racial Realness on *RuPaul's Drag Race*." *Feminist Media Studies* 14 (5): 822–36.

Vesey, Alyxandra. 2017. "'A Way to Sell Your Records': Pop Stardom and the Politics of Drag Professionalization on *RuPaul's Drag Race*." *Television & New Media* 18 (7): 589–604. https://journals.sagepub.com/doi/10.1177/1527476416680889.

VH1. 2018. "Meet Trixie Mattel: 'The Folk Drag Musician' | *RuPaul's Drag Race All Stars* 3." January 24, 2018, YouTube video, 2:32. https://www.youtube.com/watch?v=nRNDvFqjc0o.

WOWPresents. 2015. "Trixie & Katya's Fashion Photo RuView, RuView of Raja & Raven." December 31, 2015, YouTube video, 12:35. https://www.youtube.com/watch?v=xUtKgqq4epM&t.

Yudelman, Julia. 2017. "The 'RuPaulitics' of Subjectification in *RuPaul's Drag Race*." In RuPaul's Drag Race *and the Shifting Visibility of Drag Culture*, edited by Niall Brennan and David Gudelunas, 15–28. Cham, Switzerland: Palgrave Macmillan.

9

Repetition, Recitation, and Vanessa Vanjie Mateo: Miss Vanjie and the Culture-Producing Power of Performative Speech in *RuPaul's Drag Race*

Allan S. Taylor

Can I get an amen? Not today, Satan. Because I have had it—officially! Having been seen on screen for over a decade, *RuPaul's Drag Race* (*RPDR*) has amassed an encyclopedia of catchphrases that have become adapted and appropriated by fellow drag queens and *RPDR* fans alike. The culture-producing power of these phrases was most recently illustrated when Vanessa Vanjie Mateo, the first queen to sashay away in season ten, spoke her own name three times on her departure. As soon as the performative announcement of "Miss Vanjie" echoed on the runway, the phrase foreshadowed the eponymous queen's inevitable return, while simultaneously sparking the repetition of a phrase that entered cultural consciousness as a multipurpose statement of queer celebration and identification.

But the question I will address is not necessarily around whether it is possible for *RPDR* to "create" language: clearly it can as it has produced an inexhaustible list of words and catchphrases that fans can recite and reference. *RPDR* relies on this seeping of speech from show to online to offline for fans to feel as though they are a part of its community. In this chapter, I suggest that *RPDR*'s success is due, in part, to its dialogue with its fans through participatory culture and that the ambiguity of the phrase "Miss Vanjie" lends itself to the remixing and reappropriation inherent in meme creation. Particularly, what made the Miss Vanjie phrase so

remarkable in season ten is its performative power, transforming it from a mere form of self-identification into a rebellion of populist rhetoric upon its utterance. Miss Vanjie was placed as a "disidentifcatory non-citizen" (from Muñoz 1999) because she broke the tension of the localized hegemony of the show, thereby illustrating how resistance can be asserted through self-identification. This resonated with fans who wanted to resist their own disappearance or erasure from popular consciousness. Consequently, the ostensive act of speaking Miss Vanjie's name in public is to announce one's own alliance with queer culture and, in particular, as a reaction against that which threatens to consign queer behaviors to the closet. From engaging in the sharing of memes to speaking her name aloud at bars and clubs, reciting the phrase "Miss Vanjie" allows fans to identify each other as participants in the drag culture of *RPDR* while simultaneously celebrating their own sense of queerness in the face of the cultural anxiety the rise of the Trump-era politics is creating in minority communities. Repeating the statement becomes a force that defies the expectations of the context, thereby queering the situation in which it is uttered, and offers a celebratory assertion of queer identity.

What Does "Miss Vanjie" Mean Anyway?

Vanessa Vanjie Mateo at first admitted in a magazine interview immediately after elimination that when she first uttered her name on the runway, it "meant nothing" apart from a way to remember her (Crowley 2018). But in the penultimate season ten reunion episode, fellow contestant Miz Cracker remarks on the phenomenon by joking that using the phrase "Miss Vanjie" has become "the new gay aloha—hello, goodbye and thank you." Vanessa then acknowledges later on the same episode that it has become a "multi-purpose thing" and people had sent many messages to her on social media, including one instance of someone having intercourse, with their various interpretations of what it might mean to be or do "Vanjie."

The conferral of meaning onto ambiguous, meaningless, or nonsensical words on *RPDR* is not a new phenomenon. Performative speech has become a somewhat characteristic feature of the show, surpassing its own self-referential nature to create statements that enact social and cultural action. The statements in themselves do not have to have previous meaning, but instead accrue meaning through their repetition to become a celebration of diversity and a method of promoting cohesion. The phrases have in themselves become performative in the most traditional sense of Austin's (1975) speech-act theory:[1] when spoken aloud and repeated, they have the power to set in motion cultural action, as the statements both create drag and/or queer culture, announcing the possibility of producing

reality through their citation. The transformation of Miss Vanjie's name into a culturally significant statement marked a dramatic shift in which these catchphrases are more than just enactments of drag phraseology that fans and contestants repeat. Language on *RPDR* has, in fact, become a way of unifying fans and queens across cultural and linguistic barriers. In some instances, language can illustrate universal themes of both celebration and victimization in queer and drag culture.

Anthony (2014, 61) discusses *RPDR*'s propensity to do this when she details an exchange between Jessica Wild and Jujubee in the season two episode "Once Upon A Queen." They both discuss their experiences of bullying, where they exchange slurs in other languages ("*malo*" and "*kathoey*," respectively). Anthony writes that "the inclusion of this scene suggests that it does not matter which language(s) the contestants speak because they have all been bullied on the basis of their homosexuality" (61). Going one step further, she says the catchphrases that permeate the show celebrate linguistic diversity no matter their origin, and so when RuPaul says "*escandalo*" or "*echa'palanté*," it is the jubilant, kitsch undertones the audience appreciates rather than its direct meaning per se. The tone and pronunciation of both statements takes precedence over the actual meaning, bringing together the Latinx and English-speaking drag communities under such a phrase.

Similarly, their enunciation forms community because the umbrella of such speech acts is used as a form of identification, akin to the identity-producing effect of other performative actions. In repeating these phrases, *RPDR* can waver between the parodic and the performative to produce what Moore (2013, 24) calls "linguistic drag," thereby creating a hybrid discourse between the performance of drag identity and the identification and parody of cultures inherent in referencing the linguistic traditions of the genre, writing,

> Through the technologies of drag, physical and ineffable, the "drag racers" exhibit the possibilities of radical agencies that highlight flexibility, movement, transgression, and transformations [...] [Parody] highlights the use of language to create successful disruptions of hegemonic gender discourse and praxis.[2]

Therefore it might be surmised that a combination of linguistic ambiguity, elatory tone, parody, and possibility of the disruption of hegemonic discourse is what makes statements from *RPDR* so contagious. There are other near-words or nonsensical words that have made it into the *RPDR* lexicon—Roxxxy Andrews's "sequence dress," Pearl's "flazéda," Jasmine Master's "jush," or even Shangela's "halleloo" could all be seen as aspects or iterations of this. It seems that drag performance and incidental speech acts on *RPDR* have a dual effect of both creating and critiquing language, thereby creating and critiquing culture using both parody and performativity.

However, by announcing her own name three times, Vanessa Vanjie Mateo left the show with what one might call a "verbal signature": a form of self-identification that, in Derrida's (1988, 9) terms, was a simultaneous marker of her own presence on and absence from the show. In fact, in this line of thought, Derrida's description of "writing" could be evoked. First, it subsists without the subject who inscribed it. Second, the meaning of the text is never constrained by its context. "The sign," Derrida explains, "possesses the characteristic of being readable even if the moment of its production is irrevocably lost and even if I do not know what its alleged author-scriptor intended to say at the moment he wrote it."

When "Miss Vanjie" was first uttered at the end of the first episode of season ten, Vanessa Vanjie Mateo repeats it three times and invokes the citation, but it is Michelle Visage who first starts to give it meaning through repetition:

RUPAUL:	What was her name again?
MICHELLE VISAGE:	Miss Vanjie
	(Michelle leans over)
	Miss Vaaanjie.
	Miss Vaaanjie.
	(RuPaul's stern face breaks out into laughter)
RUPAUL:	*(through laughter)* You better stop.

In the next episode, Monét X Change states that Vanessa is "vanjie-ing somewhere else," and in response the rest of the queens reply in a cacophony of Vanjies. Subsequently, in episode five, "The Bossy Rossy Show," Monique Heart and Blair St. Clair decided to use it as a "safe word," but as soon Blair conjures up the phrase, the improvised scenario descends into a call and response of "Miss Vanjies" to one another.

When viewed in the Derridean sense, the statement of "Miss Vanjie" can freely hop about from context to context but always contains within it a trace or mark of Vanessa's presence. By speaking her name, she left the audience and contestants a "signature" of her presence in the form of a citation. Simmons (2014) states that by repeating and speaking these phrases, the performance of drag speech codes upholds a code of conduct akin to a "sisterhood," portrayed as everyday behavior in the course of the show. He writes that they are "qualities and characteristics of communication that a drag queen must perform, uphold, and repeat in order to uphold drag family values, thus fulfilling the code of love, respect, and dignity" (645). In repeating Miss Vanjie's name, the code goes even further. It becomes a way of calling into presence their absent sister, so that she was not forgotten by themselves or the public. If the speaker says "Miss Vanjie," the recipient mimics

the phrase thereby identifying themselves as familiar with the precedent of the term, being that it was in itself a repetitive phrase when first uttered.

And so the queens enact the remark in situations that are not similar in context or nature. However, a kind of "code of conduct" is enacted when Miss Vanjie's name is mentioned, and this establishes a precedent throughout season ten in which it feels as though Miss Vanjie never really left because a trace of her presence was always available during the series' run.

But as soon as the repetition of the name was broadcast, the iterability of the Miss Vanjie name was mapped back into what Derrida (1988, 26) calls the "structural unconsciousness": something that simultaneously compares itself to and distances itself from other frames of reference. The ever-elusive ghost of Miss Vanjie that was simultaneously present and absent throughout season ten started to take on a more significant shift as she wavered between appearance and disappearance with speech as the only tool to reinvoke her existence.

But what, if anything, is the operation of uttering "Miss Vanjie" aloud or using the phrase in other media? This may be best explained through one of the memes generated by the event, in which a teenage girl looking into a mirror sees an apparition of Vanessa Vanjie Mateo behind her, with a caption reading, "Legend has it if you look into the mirror and say Miss Vanjie three times, she will appear behind you [sic]" (Figure 9.1).

This is a direct reference to the conjuration of Bloody Mary—a folklore legend that describes the spirit of a blood-soaked woman conjured to reveal the future, said to appear in a mirror when her name is chanted repeatedly. Dundes (2002, 74) talks about this in the context of international resonance of the Bloody Mary myth as a way of representing a cultural anxiety regarding the coming of age of women. First mentioned as a Halloween superstition, in which a young woman could brush her hair backward and repeat "Bloody Mary" until the specter showed the invocator an image of their future husband, Dundes provides a psychoanalytic reading to say that Bloody Mary is an embodiment of the cultural anxiety teenage girls feel about menstruation. In this context, menstruation is linked to sexual maturity and her readiness to find a life partner.

If Bloody Mary represents the anxieties of coming into womanhood, then Miss Vanjie becomes representative of the anxiety of leaving the show first, the threat of vanishing into obscurity in the show's canon. Her elimination is symbolic of a real threat of repression and seeking to deny that which is present. In both cases, it is the name that becomes representative of the underlying anxiety and so speech and the act of speaking one's name becomes key in exposing the power systems at play. The idea of speech as an act of resistance against oppression is echoed in Kosofosky-Sedgwick's (1990, 4) *The Epistemology of the Closet*, which details that silence is a kind of "speech act" in itself, writing: "The fact that silence is rendered as pointed

and performative as speech [...] [and] highlights more broadly the fact that ignorance is as potent and as multiple a thing as is knowledge." Speaking Bloody Mary's name serves as a reminder of the repression of sexual maturity. When Miss Vanjie repeated her own name, she illustrated a rejection of the flippancy of decision and elimination in reality show television—and the refusal to succumb to its eradicative power. Repeating her name causes RuPaul's governmental and matriarchal façade to slip as he descends into laughter while Michelle Visage imitates the phrase.

FIGURE 9.1: Miss Vanjie as the monster in the mirror meme posted by Twitter user @easterbrookrj.

At once it becomes both ridiculous and rebellious, representative of that which cannot be silenced and challenges the status quo. The werkroom stands in for the metaphorical closet to which all queer peoples have been confined at some point of their lives and Miss Vanjie rejects having to be shoehorned back in. Even by walking backward, she refuses to move inward toward that closet, staring firmly face-first at the mechanisms that seek to banish her.

Repression, therefore, is the force the invocator seeks to overturn when they announce the name "Miss Vanjie." It is the repetition of the absent force's name that pushes against the power that seeks to repress what it represents. In the case of Vanessa Vanjie Mateo, she refused to go quietly, challenging the repressive nature of being humbly and silently consigned to the closet by Mama Ru. Drawing on Foucault (1990), this could be a deliberate attempt to overturn the dominant discourse around the first queen to leave being so easily forgotten. In his repressive hypothesis he supposes systems are governed by repression: that the taboo cannot be talked about and, moreover, that the governing of sexuality provides a key linchpin through which dominant power and law can assert itself. However, he also reveals that discourse, while producing and transmitting power, can also undermine and expose it, that "silence and secrecy are a shelter for power, anchoring its prohibitions; but they also loosen its holds and provide for relatively obscure areas of tolerance" (101). Therefore Miss Vanjie serves to remind us that even when a queen is eliminated from the show, they exist in a context removed from it as well.

But more than rallying against the inherent and inevitable nature of the reality show's elimination order, the cry of "Miss Vanjie" could be seen as a clarion call in an era of populist rhetoric and Trumpian politics. Timing is clearly a factor in the significance of the statement as Miss Vanjie appeared at a time when a very real threat of repression in mainstream politics has resurfaced. Therefore the threat of her disappearance mirrored the potential disappearance of minority voices across the United States. If Trump represents the typical modernist male through which privilege is magnified, Vanessa Vanjie Mateo is his counterpart—a "queer loser" primed to be pushed out of the running to be America's next Drag Superstar.

Vanessa Vanjie Mateo's refusal to go quietly struck a nerve in the popular imagination, and this could be because of what Greenhalgh (2018) terms as drag as a form of resistance in such an era of right-wing rhetoric. She finds resistance through direct action, social media presence, and straight-up mockery. While highlighting that drag is antithetical to the conservative worldview that considers binaries fundamental, Greenhalgh notes the inherent limitations within drag's rise to the mainstream, concluding that if drag is "darkness turned into power," drag artists must use this power to fight inclusively against the common enemy.

Further credence is given to this through Muñoz's (1999, 25) idea of disidentification, with particular relation to Miss Vanjie's Latinx identity. Muñoz describes this process as "shuffling between production and reception [...] The hermeneutical performance of decoding mass, high or any other cultural field from the perspective of a minority subject in such a representational hierarchy" (25). Earlier in the chapter, I mention examples of non-English or nonsensical words becoming iconic and some of these examples could be seen to highlight a representational hierarchy within the show itself. Both as a drag queen and as a queer person of color, Miss Vanjie is able to use a marker of her own self-identification (her name and racial identity) as a form of disidentification with a bigger cultural power (the problematic racial tensions of the Trump administration), using the show as the hegemonic framework. Miss Vanjie, the individual, resists the governmentality of Mother Ru simultaneously through self-identification and disidentification.

By rejecting the circumstances of her disappearance, Vanessa Vanjie Mateo cites a dissatisfaction of the hegemonic state of affairs and refuses to disappear. And so on a broader scale the statement of "Miss Vanjie" was a way of refuting the silence of queer voices everywhere, announced in the playful and parodic way that drag utilizes to subvert and unify against that which seeks to repress. In making her protest celebratory rather than sorrowful, Vanessa Vanjie Mateo manages to make the political personal, and to call upon participants of *RPDR* culture to refuse to "leave quietly" and speak against the populist uprising.

While Vanessa Vanjie Mateo's exclamation was relatively small in the scale of social and political protest, it clearly hit a relatable nerve with a broader audience. Her resistance to convention drew parallels with a world that swings ever more to the right and its jubilant tone counteracts the angry rhetoric associated with the alt-right. In summary, if Miss Vanjie could "mean" anything, it would be a statement that celebrates the individual by disrupting the existing state of affairs and calling attention to the individual's role in the dominant context in which it is spoken. The citation of Miss Vanjie grates against convention, and using the phrase is a tactic to defy expectations of an anticipated or rehearsed response in order to confuse, baffle, and delight the recipient of the phrase.

Convergence Culture and Queering Context

Nowhere was this more evident than when *RPDR* fans started to create memeable moments featuring "Miss Vanjie," and because of its ambiguity, seemingly disruptive nature, and unexpected utterance on the runway, fans took to social media with a variety of memes, clips, and edited videos that featured the phrase. Wiggins and Bowers (2014, 1903) detail that some of the aspects inherent in such

a speech act have the essential qualities required for meme proliferation stating that "as artifacts of participatory digital culture illustrate the duality of structure in that they possess the instructions on how to remix and reproduce themselves while they simultaneously evince the agential activity needed for their reproduction". In short, in order for Miss Vanjie to be successful as a meme, the enunciation of such a statement had to be inherently inconclusive and yet full of performative power. "Miss Vanjie" has both ambiguity and agency, which contributed to its popularity. In iterating and reappropriating the statement, the invocation of Miss Vanjie accrued meaning through its comparison with such contexts, lending further insight into why it had such resonance with the audience. By considering the application of the phrase on social media it starts to become clear what "Miss Vanjie" meant to *RPDR* audiences in their own personal identities.

What marks the utterance out from previous catchphrases generated by the show was a factor of contagion, and when the *RPDR* community responded to the Miss Vanjie event by creating these spreadable memes, they were engaging with the idea of participatory digital culture (Jenkins 2009, 3), where low barriers to artistic expression and civic engagement and strong support for creating and sharing one's creations lead to the proliferation and creation of such spreadable media (usually through social media).[3] But *RPDR* in particular couples the use of such technologies with the desire for a direct link to the queens in the audience's daily lives. It is this desire to feel a direct connection to the queens coupled with embrace of new media that contributed to the evolution of the speech act of "Miss Vanjie" from a passing catchphrase into a cultural statement.

While social media has evolved since *RPDR* first aired in 2009, the need for fans to feel directly engaged with the contestants is what has elevated the show from cult hit to mainstream success. *RPDR* may appear to enjoy widespread notability, but Gudelunas (2017, 547) points out that technically *RPDR* could not be considered a "hit" show in the traditional sense: ratings in 2015 averaged 300,000 viewers and, even by season ten, weekly ratings of a given episode were still only around 700,000. This is a fraction of the audience enjoyed by other so-called hit shows that regularly pull in millions of viewers on a weekly basis. Gudelunas, therefore, emphasizes that the online-offline relationship has been key to *RPDR*'s success, explaining that "for all of the new media innovations and social media savvy bundled into the *RPDR* experience, the core audience still clamors for off-line interactions" (547). This, for many fans, is bundled into the multitude of touchpoints *RPDR* offers—from YouTube previews through to DragCon or even a guest appearance from your favorite queen at your local drag venue in Pittsburgh, Pennsylvania. Therefore for *RPDR* fans online interactions are very closely associated with the potential liveness of seeing and engaging with the queens. Online statements are meant to be enacted as a way to engage with the show outside of

its own televisual boundaries and, while the memes are an online interaction, it is important to reflect on what this might mean to fans in terms of offline ostension. While social media is important in the proliferation of the phrase, it is also equally important to analyze the contexts and content in which it was used and why this gave "Miss Vanjie" so much resonance. In the creation and subsequent sharing of such memes, fans were able to queer a variety of cultural references and take *RPDR*'s queering practices and performative potential outside of the framework of the show itself.

Shetina (2018) describes *RPDR* as having this unique ability to use queer oppositional modes of relating to culture—in his example, illustrated by the show's popular maxi-challenge "The Snatch Game." He argues that Snatch Game is a way of "queering" the archive of cultural reference and documents not only a canon of gay icons but also the networks of pleasure and belonging fabricated through their queer circulation. This, he says, "provides insight into how contemporary queers deploy [citations] to make their own affective networks around shared feelings about popular culture" (156). If *RPDR* demonstrates the ability to queer cultural reference within its own framework, then it stands to reason that the queens who feature in the show can use their performative power to queer existing cultural references outside of the boundaries of the show itself. As a disruptive force, the evocation of "Miss Vanjie" makes these familiar references strange once again and acts as a kind of break between what the viewer thinks they know and how they reassess the citation in light of the intervention that the utterance of "Miss Vanjie" brings to the situation.

For example, a series of comparisons with horror films were made, notably *The Shining*. In a parody of the most iconic scene from the film, Jack Nicholson's crazed face poking through a freshly cut-down door is replaced with Miss Vanjie's face (Figure 9.2). As she says her name, Shelley Duval convulses to the floor in terrifying shock. The effect is furthered in another meme when young Danny's stock phrase "Redrum" is replaced by "Miss Vanjie" (Figure 9.3).

In this, the threat of saying, doing, or being Vanjie is ever-present and breaks out in a momentary micro-aggressive meme. The child with the gift of the shining has a prophetic ability and his compulsion to write "Miss Vanjie" on the walls shows that there is a hidden force continually trying to break through. A similar theme is explored in a more comedic way through *The Simpsons*. Bart stacks a multitude of megaphones to amplify the volume, ultimately saying "Miss Vanjie" at a ground-shaking, window-breaking volume (Figure 9.4).

But the referentiality extends beyond this. For example, a pictorial sequence from the 2017 film *Call Me By Your Name* positions the Miss Vanjie invocation in the frame of queer coming of age. In the original scene from the 2017 film, 17-year-old Elio starts a relationship with his father's 24-year-old protégé Oliver.

FIGURE 9.2: Screen shot of video: Miss Vanjie peeks through the door in the style of Jack in *The Shining*. Posted on YouTube by Stambini.

FIGURE 9.3: Boy from *The Shining* writing "Miss Vanjie" backwards in red. @brittanyvisage.

One night after making love, Oliver commands Elio, "Call me by your name and I'll call you by mine" (Figure 9.5).

The meme disrupts the expected invocation by replying "Miss Vanjie," cutting through the intimate gesture and making the recipient reassess the intention of reversing their names. Rather than romantically suggesting that they are somehow intertwined, the invocation breaks the tension and highlights the ridiculousness of the statement.

FIGURE 9.4: A screen cap from a video in which Bart Simpsons says "Vanjie" through a dozen megaphones, within a tweet posted by Twitter user@ jHo1987.

It forces the recipient to revisit the credibility of the proposed name reversal and also Oliver's intentions for making such a statement.

There are an overwhelming number of examples to draw on: Dorothy from *The Wizard of Oz* trying to reason with Miss Vanjie through the witch's crystal ball, Vanjie making an appearance in *Chicago*'s Cell Block Tango and stealing the spotlight as the name on everyone's lips in "Roxie" as well as making an appearance in name only in a scene from *The Fault In Our Stars*. In all of these examples, Miss Vanjie stands in for "that which must not be spoken." But in the true nature of repression, uttering her name becomes the disruptive force that breaks through this secretive atmosphere, and it is exactly this defiance of the expectation of what *should* happen that gives the statement such performative power. Davis (2013) identifies this when she explains that the power of performativity lies not in its ability to usher forth what she terms an "all-speaking present," but that it has the capacity to breach temporality while, simultaneously, presenting the spectator with an unexpected sense of event.

FIGURE 9.5: Miss Vanjie meme in a scene from *Call Me By Your Name*. Posted by Twitter user @daniellismore.

Davis writes, "The hope is not that its power might be mastered [...] But that its rupturing force might throw time and its normative limits [...] leaving us open to the gift of futuricity, a to-come for which I cannot prepare" (82). Therefore there is an element of Miss Vanjie's statement that speaks in the "future possible" tense. It is not just a reaction against a situation, but speaking her name is also a promise to return in order to disrupt the status quo.

The ultimate endorsement of Vanessa Vanjie's rebellion came when RuPaul herself could not stop tweeting about her, including comments such as "Always be yourself. Unless you can be Miss Vanjie" as well as appropriating a famous Stephen Hawking quotation, "Life would be so tragic if it weren't so Vanjie" (Figures 9.6 and 9.7). In doing this, RuPaul, first, gives his blessing to the original rebellious act of speaking out and, second, reinforces that Vanjie as a term is a whimsical defiance of intention, meaning anything, everything, or nothing to its recipient.

FIGURE 9.6: A tweet featuring an image of Vanjie with text that replaces "always be yourself" with Vanjie. Posted by Twitter user @RuPaul.

In looking at its usage, Miss Vanjie then becomes a queering practice in order to confuse, question, or disrupt. Its vagueness is its strength as it allows a freedom of interpretation and yet still manages to disturb and bemuse. For fans, memes became a way through which to call upon the spirit of Miss Vanjie and to vocalize a queer experience and also to recode a series of cultural references in a new light. Saying, writing, or invoking Miss Vanjie thereby appeals to those who identify as queer or as participants of drag culture due to its intentionally ambiguous and befuddling meaning while still being conveyed in a jubilant tone. Eventually bleeding into daily conversation, ostension and acting out the statement in everyday life were the final part of the puzzle. As the memes spread, so did the cries of "Miss Vanjie" in day-to-day situations.

Speaking Aloud and Back with a Vanjeance: Repetition and Return

There is a quality about the continuation of Miss Vanjie's invocation that spoke to queerness and queer culture, but Miss Vanjie's social media fame became cemented when the statement crossed the boundaries of digital culture into day-to-day life. It is still not uncommon to hear cries of "Miss Vanjie" in queer hangouts.

FIGURE 9.7: Image of Vanjie, featuring quotation parodically credited to Stephen Hawking. Posted by Twitter user @RuPual.

In this example, if a queer individual shouts "Miss Vanjie" in public expecting a response of the same nature, both caller and respondent proudly announce and acknowledge their own respective presence and queerness regardless of how widely it is understood by those who do not participate in queer culture or acknowledge the origin of the reference. Henn et al. (2017, 660) summarize this when they say, "Performativities enacted through social network appropriations of *RPDR* evoke cultural snapshots of different times and different experiences, which coalesce in the context of an event that both encourages processes of meaning making and remains disputed in contemporary society." Moreover, participatory culture in the context of *RPDR* has allowed very real cultural or political expression to be

declared in the form of such ostensive actions and it is not just that Miss Vanjie became a spreadable moment or an amusing utterance: it seemed to transcend its own meaning, the barriers of the show and social media networks to be understood within everyday queer interactions. This is where the culture-producing power of performative speech in the show takes on its optimum effect. Henn et al. identified this when they discuss how the show's narratives can seem as though they are really happening to the fans and audiences, stating that "besides giving new forms to drag culture in media complexes, the spreadable quality of *RPDR*'s narratives has the potential to implicate larger changes within cultural systems" (643). Speaking Miss Vanjie's name has become a healing power of expression and the ostensive act of saying the phrase allows the invocator to freely assert their own power to counter the elements of society that may seek to restrain such behaviors. But rather than being aggressive or forceful, it becomes a playful way of calling one's attention to the individual and the scenario in which it is spoken.

The seeping between show and social media, social media and spoken word, and queen and audience illustrated on a monumental scale that *RPDR* is not solely capable of producing language, but of creating shifts in culture. Using the politic, parodic, and performative force of drag, queer identification and celebration can be encapsulated in a short phrase. Its disruptive force seems to break the context of a given situation, offering speakers the chance to identify themselves and others as participants in drag culture in an unashamed way. Moreover, the pause for thought that speaking Miss Vanjie's name offers allows its invocator an opportunity to reverse expectations of an anticipated response in a playfully rebellious way. Calling her name is a way of relieving the tension of the repression of a circumstance in a momentary burst of comic relief, but in many ways the spirit of Miss Vanjie's defiance is always present—and ready to return at any moment.

The idea of performative speech marking such a return of an ever-elusive individual is ingrained in our cultural consciousness. Examples of this include the 1992 Bernard Rose film *Candyman*. In a similar idea of resisting repression, the Candyman legend claims he can be summoned by saying his name five times while facing a mirror, whereupon he will kill the summoner with a hook jammed on the bloody stump of his right arm. Similarly, Jennifer Kent's 2014 film *The Babadook* mimics the idea of the monster being consigned to the closet. In the film, a single mother is plagued by the violent death of her husband and battles with her son's fear of a monster lurking in the house. The mother and son become aware of the Babadook when he repeats his name—"Babadook-dook-dook."

In rooting herself so firmly in contemporaneous traditions of the boogeyman who returns to enact their vengeance, Vanessa Vanjie Mateo's departure on season ten was actually a way of performing her own future in the way that Muñoz (2009, 1) describes as existing "for us as an ideality that can be distilled from

the past and used to imagine a future." Perhaps, then, it seemed a foregone conclusion that she would make her return in season eleven as the enunciation and repetition of "Miss Vanjie" was a "not quite yet" for fans. In the season eleven trailer "RuVeal," Miss Vanjie says she is "back with a Vanjeance," announcing her own avenging intentions—perhaps to prove that she is not so easily dismissed. While the returning queen is not unheard of on the show—Shangela, Cynthia Lee Fontaine, and Eureka O'Hara have all been given second chances on a subsequent season of the show—the open-ended and repetitive nature of "Miss Vanjie" sets up her "eternal return" to the show. Perhaps it has become part of *RPDR*'s metareferentiality that leads fans to this eventuality. As the show continues it sets up its own dramatic narratives, fictions, and folklores, and Miss Vanjie fits a convenient storyline that any young queen with enough charisma, uniqueness, nerve, and talent can pave a runway to their own redemption.

Whatever the case, it seemed inevitable that she would return to the Werk Room on the first episode of season eleven, subsequently managing to charm her way to the top five and cementing her reputation as having enduring star quality. Had she not initiated the process of performativity by saying her name three times, *RPDR* fans may never have seen her again or experienced her raucous humor and distinctive voice (or her wardrobe of many corsets and leotards for that matter). But even upon leaving the show for the second time, she proved to be the queen of goodbyes, coming back to the stage three times and even threatening to perform at the finale upon her elimination the second time round. And, despite not winning a single challenge, she still unsuccessfully petitioned the public to allow her to lip sync for the crown at the grand finale.

While we can accept that some queens are consigned to *RPDR* obscurity, there is something about Vanessa Vanjie Mateo that has left open the expectation of her return. This is due, in part, to the persistence of her repetitious and eponymous statement that is now ingrained into cultural memory. But more than this, the repetition of Miss Vanjie has come to signify a moment that will resonate throughout *RPDR*'s history. In so doing, Vanessa Vanjie Mateo has managed to embed herself both in the narrative of the show and in a certain moment that encapsulates the rejection of the anxieties of the twenty-first century. The invocation of "Miss Vanjie" in gay bars, clubs, and pubs across the world has now come to represent a moment of collective joy and playful resistance—a statement that may retain its meaning for years to come.

NOTES

1. Austin (1975, 6) describes a performative statement as follows:

 A) though they may take the form of a typical indicative sentence, performative sentences are not used to describe (or "constate") and are thus not true or false; they have no truth-value. B) Second, to utter one of these sentences in appropriate circumstances is not just to "say" something, but rather to perform a certain kind of action.

2. Moore (2013) also cites Butler's (1999 [1990]) idea of performativity and how the gender play of drag is also a linguistic technology. I mention this because I want to recognize, but not fully explore, gender performativity as having a role here. However, the main focus is the idea of linguistic performativity and citation as "speech act."
3. This term is detailed in Jenkins, Ford, and Green (2013, 3): "'Spreadability' refers to the potential—both technical and cultural—for audiences to share content for their own purposes, sometimes with the permission of rights holders, sometimes against their wishes."

REFERENCES

Anthony, Libby. 2014. "Dragging with an Accent: Linguistic Stereotypes, Language Barriers and Translingualism." In *The Makeup of RuPaul's Drag Race: Essays on the Queen of Reality Shows*, edited by J. Daems, 49–66. Jefferson, NC: McFarland.

Austin, John L. 1975. *How to Do Things with Words*. Oxford: Oxford University Press.

Butler, Judith. [1990] 1999. *Gender Trouble: Feminism and the Subversion of Identity*. New York: Routledge.

Crowley, Patrick. 2018. "Vanessa Vanjie Mateo Explains What Was Going through Her Head During Insanely Viral 'Miss Vanjie' Moment." *Billboard*. https://www.billboard.com/articles/news/pride/8283885/vanessa-vanjie-mateo-viral-meme-interview-explanation (last modified April 3, 2018).

Davis, Diane. 2013. "Performative Perfume." In *Performatives after Deconstruction*, edited by M. Senatore, 70–86. London: Bloomsbury.

Derrida, Jacques. 1988. *Limited Inc.* Evanston, IL: Northwestern University Press.

Dundes, Alan. 2002. *Bloody Mary in the Mirror: Essays in Psychoanalytic Folkloristics*. Jackson: University of Mississippi Press.

Foucault, Michel. 1990. *The History of Sexuality: Volume 1: An Introduction*. London: Allen Lane.

Greenhalgh, Ella. 2018. "'Darkness Turned into Power': Drag as Resistance in the Era of Trumpian Reversal." *Queer Studies in Media and Popular Culture* 3 (3): 299–319.

Gudelunas, David. 2017. "Digital Extensions, Experiential Extensions and Hair Extensions: *RuPaul's Drag Race* and the New Media Environment." In RuPaul's Drag Race and

the *Shifting Visibility of Drag Culture*, edited by N. Brennan and D. Gudelunas, 529–51. New York: Palgrave Macmillan.

Henn, Ronaldo, Kolinski Machado, Felipe V., and Christian Gonzatti. 2017. "'We're all born naked and the rest is drag': The Performativity of Bodies Constructed in Digital Networks." In RuPaul's Drag Race *and the Shifting Visibility of Drag Culture*, edited by N. Brennan and D. Gudelunas, 632–60. New York: Palgrave Macmillan.

Jenkins, H. 2009. *Confronting the Challenges of Participatory Culture: Media Education for the 21st Century*. Cambridge, MA: MIT Press.

Jenkins, Henry, Sam Ford, and Joshua Green. 2013. *Spreadable Media: Creating Value and Meaning in a Networked Culture*. New York: New York University Press.

Kosofosky-Sedgwick, Eve. 1990. *Epistemology of the Closet*. Durham, NC: Duke University Press.

Moore, Ramey. 2013. "Everything Else Is Drag: Linguistic Drag and Gender Parody on *RuPaul's Drag Race*." *Journal of Research in Gender Studies* 3 (2): 15–26.

Muñoz, José Esteban. 1999. *Disidentifications: Queers of Color and the Performance of Politics*. Minneapolis: University of Minnesota Press.

———. 2009 *Cruising Utopia: The Then and There of Queer Futurity*. New York: New York University Press.

Shetina, Michael. 2018. "Snatching an Archive: Gay Citation, Queer Belonging and the Production of Pleasure in *RuPaul's Drag Race*." *Queer Studies in Media and Popular Culture* 3 (2): 143–58.

Simmons, N. 2014. "Speaking Like a Queen in *RuPaul's Drag Race*: Towards a Speech Code of American Drag Queens." *Sexuality & Culture* 18: 630–48.

Wiggins, B. E., and G. B. Bowers. 2014. "Memes as Genre: A Structurational Analysis of the Memescape." *New Media and Society* 17 (11): 1886–906.

10

It's Too Late to RuPaulogize: The Lackluster Defense of an Occasional Unlistener

Timothy Oleksiak

I remember watching the first episode of *RuPaul's Drag Race* in 2009 with my then-partner. Two white, cisgender, gay men sit in a Minnesota apartment with snacks and wine. We love drag. Its queerness and artistic values move us. When we find out the "supermodel of the world" is behind it all: Well, honey, that's all we need to watch. Since its inception, *Drag Race* has advanced messages of love, sisterhood, self-acceptance, and empowerment. As Decca Aitkenhead (2018) describes it, on *Drag Race* "RuPaul performs the role of grand matriarch, and it's his unexpected humanity which both defines and elevates the show." RuPaul tells Aitkenhead his one condition when creating the show: "I don't want to do anything mean-spirited." Lest viewers forget the message, RuPaul's sign-off each episode further solidifies this humanity: "If you can't love yourself how in the hell are you gonna love somebody else? Can I get an amen!" These messages of love and kindness in the face of real trauma and adversity in the contestants' lives resonate with fans and critics alike. Rafi D'Angelo (2014) explains, "*Drag Race* is the kind of program that has the potential to do a lot of good in the world" with a message that gay and straight audiences should welcome. However, the messages so central to *Drag Race* are not as universal as RuPaul and his fans might think.

Three moments between 2012 and 2018 reveal cracks in RuPaul's loving brand for some trans activists and their co-conspirators (Patterson 2018, 147).[1] Analyzing RuPaul's rhetoric during interviews and on social media helps fans and critics alike understand not just the offense but why the offense causes harm and how trans women and their co-conspirators respond. Ultimately, we cannot assess

the effectiveness of RuPaul's language without first understanding why some trans activists are upset with him. The first incident illustrates RuPaul's comfort with derogatory language directed at trans people. During an interview with Michelangelo Signorile (2012), RuPaul was asked to weigh in on the singer Lance Bass apologizing for using the word "tranny." RuPaul responds, "It's ridiculous! It's ridiculous! ... I love the word tranny ... and I hate the fact that he apologized. I wish he would have said, 'F-you, you tranny jerk.'" Trans journalist Parker Marie Molloy's (2014a) "It's Time to Stop with the *T* Word" illustrates the continued frustration many trans women feel at living in spaces where derogatory language aimed specifically at their communities is used with such ease.

The second and perhaps more incendiary incident occurred during the sixth season of *Drag Race*. During a mini-challenge, contestants were to determine if close-up pictures of bodies belonged to either "biological" or "psychological" women using the answers "she-male" or "female." In addition to using an offensive slur, the mini-game advances an erroneous belief that gender expression and presentation are determined by the viewer rather than by an individual. The right to self-determination, crucial to many trans people and their co-conspirators, is challenged by the ocular-centric game that suggests gender differences can be determined by the way a person looks and appears to others.

Responses to the mini-challenge were largely critical. What is important to note about these criticisms of the mini-challenge is not simply the hurt expressed in them but the calls for better ways of being and doing. Gregory Rosebrugh (2014) called the episode "as vile and flagrantly trans-phobic as you can imagine." Parker Marie Molloy (2014b) detailed RuPaul's historic and frequent uses of "tranny" and jokes about the differences between trans women and drag queens. Rosebrugh and Molloy offer to RuPaul hurt and a context of repeated offense, respectively. Former *Drag Race* contestant and trans model Carmen Carrera posted her dismay about the episode on her Facebook page:

> "Shemale" is an incredibly offensive term, and this whole business about if you can tell whether a woman is biological or not is getting kind of old. We live in a new world where understanding and acceptance are on the rise. *Drag Race should be a little smarter about the terms they use and comprehend the fight for respect trans people are facing every minute of today.* They should use their platform to educate their viewers truthfully on all facets of drag performance art. #SheHasSpoken.
>
> (Carrera 2014, emphasis added)

Carrera calls *Drag Race* into a different way of being, one that is clearly aligned with trans women. Trans drag queen and former *Drag Race* contestant Monica

Beverly Hillz expressed slightly different sentiments when asked about the mini-challenge and RuPaul's use of "tranny":

> After my experience of being on the show, I would say that, to me, the use of the words "she-male," "ladyboy" and "tranny" are not cute at all.
>
> *I have fought, and still am fighting, for respect from society*—to be accepted as a woman and not referred to as a "tranny" or "she-male."
>
> *People don't understand the daily struggle it is to be a transgender woman.* Some days are great and some days I can't be around anyone because I have so much anxiety, so much on my mind and just feel alone in this world.
>
> After being on TV and coming out, it is very difficult to live a normal life. So when you see a show that you look up to and have been a part of, it kind of sucks hearing them use those words.
>
> (Nichols 2014, emphasis added)

Monica Beverly Hillz offers her lived experiences; she is giving an account of her life *for* RuPaul and those who think like him. This accounting offers a space of contemplation for RuPaul rather than a simple claim of offense and condemnation. Amplifying these voices creates not only a space that allows for trans women's stories to circulate but also a text to which RuPaul might hear different ways of engaging trans women. Monica Beverly Hillz and Carmen Carrera's responses name the hurt *and* offer alternative courses of action and contemplation. They represent rhetorically sophisticated responses worthy of emulation.

The network airing *Drag Race*, Logo TV, promptly responded to the incident with the following statement:

> We wanted to thank the community for sharing their concerns around a recent segment and the use of the term "she-mail" on Drag Race.[2] Logo has pulled the episode from all of our platforms and that challenge will not appear again. Furthermore, we are removing the "You've got she-mail" intro from new episodes of the series. We did not intend to cause any offense, but in retrospect we realize that it was insensitive. We sincerely apologize.
>
> (Nichols 2016)

When asked about Logo's decision to remove "she-mail" from past, current, and future episodes, RuPaul replied, "I don't know. You know, I didn't do that. The network did that, and you'd have to ask them why they did it, but I had nothing to do with that" (Jung 2016). Whether or not Logo's response is sufficient is irrelevant. Their response does, however, contrast markedly with RuPaul's and reveals that though RuPaul does have a lot of creative input into *Drag Race*'s creative direction, he does not act with impunity.

The third and final incident that can help contextualize and situate RuPaul's tensions with trans activists occurred during a 2018 interview with Decca Aitkenhead. Aitkenhead asked RuPaul if he would allow trans women to be contestants on *Drag Race*. RuPaul put it plainly, "Probably not." As *Drag Race* is widely understood as a career-launch platform for all of its contestants, RuPaul's response is discriminatory. It wasn't the qualified denial of trans women that provoked an onslaught of criticism; it was RuPaul's rationale. He explains,

> Drag loses its sense of danger and its sense of irony once it's not men doing it, because at its core it's a social statement and a big f-you to male-dominated culture. So for men to do it, it's really punk rock, because it's a real rejection of masculinity.
>
> You can identify as a woman and say you're transitioning, but it changes once you start changing your body. It takes on a different thing; it changes the whole concept of what we're doing. We've had some girls who've had some injections in the face and maybe a little bit in the butt here and there, but they haven't transitioned.

In her response to RuPaul's interview with Aitkenhead, Precious Brady-Davis (2018) notes that his words function to erase those *Drag Race* contestants "who transitioned after the show: Carmen Carrera, Sonique, Kenya Michaels, Monica Beverly Hillz, Gia Gunn, Stacy Layne Matthews, and Jiggly Caliente." These erasures deny the role these women played in the construction of what *Drag Race* has become. While substantively different from the erasures caused by disproportionate levels of violence toward trans folks, Brady-Davis's insights into trans erasure encourage reflection on the multiple ways trans folks are forced to contend with a world that imagines their destruction.

These three moments reveal a wider concern in contemporary United States over language use and its effects. With full disclosure, I side with those trans people who express great frustration and hurt when a popular figure with a large public platform uses derogatory language. As a rhetorical theorist and critic, I believe that language is a form of action to the extent that it changes values, beliefs, and attitudes, which then may lead to modifications in behaviors or reinforce entrenched prejudices (Burke 1969, 24–25). What this chapter explores is not whether RuPaul has the right to say offensive things. He does. Rather, I explore how a popular and influential queer, black drag queen who is undoubtedly *the* voice of American drag queen culture actively disrespects trans women. RuPaul's continued use of trans exclusionary language and his denial of coveted spots on *Drag Race* to trans women contestants leave many to see RuPaul as hypocritical at best and harmful to trans equity at worst. In the face of this tarnished image, understanding rhetorical

strategies RuPaul uses to repair his image offers insights into cross-cultural negotiation and how people with seemingly incompatible worldviews might come to see each other in more forgiving ways. At the risk of spoiling the surprise, it is important to say at the beginning that this chapter ends on a note of cautious hope. That is to say, RuPaul offers a gesture of hope for those who wish to hold him more accountable for his harmful language. This gesture of hope does more to restore his image as a champion of love than the strategies he uses to defend himself against legitimate accusations.

In what follows, I assess the rhetorical strategies RuPaul uses to defend himself against claims of transphobia[3] and trans exclusionary action. The goal throughout is to understand the way RuPaul uses language to maintain his image of champion of love and strength in the face of those claims that tarnish this image. To do this, I use theories of *apologia* or defense/face-saving strategies that individuals use to maintain a particular image of themselves. This chapter, therefore, provides answers to the following questions: First, how do rhetorical critics describe RuPaul's defense of himself? Second, how can we understand the (in)effectiveness of these self-defense strategies?

RuPaulogizing: All T, All Shade, No Pink Lemonade

Rhetorical theorists interested in the way individuals defend themselves turn to a body of scholarship known as *apologia*.[4] Apologia differs from mere apology to the extent that it allows critics to understand the ways in which those accused of harmful acts or misdeeds use language to save face or restore their perceptions with those who claim offense. Further, rhetors engage in apologia to "refashion identity in the face of public moral indictment," which fashions an "act, context, audience, or any combination therefore in an effort to repair or reinforce certain aspects of their character" (Milford 2019, 328). Apology, on the other hand, is a form of apologia whereby the individual accepts blame for committing the offense and corrects future action. Logo's statement and subsequent actions regarding "she-mail" is best understood as an apology in this sense. RuPaul, as I show, offers a combination of various forms of apologia.

Rhetorical scholars have long-explored the way public figures defend themselves in the face of accusations of word and deed that run contrary to the moral codes of particular audiences. In the case of RuPaul, claims of transphobia and trans exclusionary practices run contrary to the image of love RuPaul seeks to project and protect. Before such analysis begins, two things must be clear. First, something bad must have occurred. As Benoit (2015, 20) notes, "If nothing bad happened—or if the person believes that what happened is not considered to be offensive by the

salient audience—then the persuader's face is not threatened." For Benoit, then, *perception* is a crucial aspect of apologia. For if the accused does not recognize the accuser or if the accused does not believe the accusation is damaging, there would be no need to engage in defensive rhetoric. Second, Benoit suggests that the "accused must be held responsible for the occurrence of that reprehensible act by the relevant audience" (20). Regarding RuPaul's use of "tranny" and other derogatory terms for some trans communities, the offense cannot be clearer. "Tranny" is derogatory (GLAAD n.d.). Rupaul uses derogatory terms. Further, during his defense trans women could not compete on the show *if* they had transitioned prior to the producers inviting them on the show.[5] While several trans women have competed on the show, as of this writing, their disclosures came *after* admittance.

Though specific journalists and bloggers have claimed outrage at RuPaul's relationship with trans communities, it would be a mistake to suggest that RuPaul's defense is in *response* to a single accuser. That is, RuPaul never mentions Precious Brady-Davis or Carmen Carrera, for example, by name. What is clear is that there is a network of people who exist that are responding to RuPaul's words and behaviors and collectively this network of individuals coalesces into the various accusations against which RuPaul contends.

Scholars of apologia identify several strategies individuals deploy when responding to perceived and actual harms. In a classic and frequently cited piece titled "They Spoke in Defense of Themselves," Ware and Linkugel (1973, 275) describe four forms apologia takes: denial, bolster, differentiation, and transcendence. An individual denies charges when they insist that their actions either did not take place or were not offensive. Rather than focus on the specific action, an individual bolsters attempts to focus on themselves as a good person. Bolstering takes an audience's focus away from the act that causes harm (275). When individuals differentiate, they shift the act in question into a category of similar things in order to illustrate that the offense is *less* damaging than other acts within that category. Finally, transcendence occurs when individuals "[place] the act in a broader, often moral, context so that the ends justifies the means" (Len-Ríos and Benoit 2004, 97). Further, when individuals attempt transcendence, they engage strategies that "cognitively joins some fact, sentiment, object, or relationship with some larger context within which the audience does not presently view that attribute" (Benoit 2005, 3). While still useful and applicable, scholars expanded it to include strategies such as evasion of responsibility, reducing offensiveness, and even attacking the accuser directly (23–29).

In addition to these strategies, there are particular aims individuals seek to accomplish through their apologetic rhetoric. Ware and Linkugel (1973, 277) describe these aims as reformative or transformative. For example, with a reformative aim, an individual does not attempt to shift the values or beliefs of

the audience. Rather, she is asking audiences to understand her differently. As McClearey (1983, 12) notes, "Neither denial nor bolstering attempts to modify the auditors' conceptual or emotional 'sets' toward the situation." When individuals seek to change values and moral perceptions, they engage in transformative strategies such as differentiation and transcendence.

Over the course of this four-year controversy, RuPaul uses all of the strategies previously described in rather complex ways. Before showing how RuPaul does so, it is important to place his rhetoric within the context of his worldview and his perception of what drag is.

For RuPaul, drag's power is located in a biological male mocking gender identity (Aitkenhead 2018). Drag is powerful and eternal. RuPaul says, drag's function is to

> remind you that you are not your shirt or your religious affiliation. You are an extension of the power that created the whole universe. You are God in drag. You are dressed up in this outfit of a body, which is temporary. You are eternal. You are forever, You are unchanged.
>
> (Jung 2016)

Drag "breaks the fourth wall" to illustrate that "you're not who you appear to be on your driver's license or your birth certificate. You're actually—you're a God in drag" (Signorile 2012). This notion of being a god in drag is a recurring theme for RuPaul when asked to discuss its power[6] and is closely connected to RuPaul's Buddhist worldview.

RuPaul's worldview and philosophy emerges in his repeated aphorism "We're all born naked and the rest is drag" and during interviews. Recognizing this illusion[7] is important for RuPaul; it animates his willingness to mock and encourage everyone to not take life so seriously. For RuPaul, the ego is a significant threat to the illusory nature of the world. It is the ego that clings to identity. In a Facebook post (August 29, 2015) RuPaul writes, "Ego loves identity—Drag mocks identity—Ego hates drag." For him, clinging to fixed identities betrays the farce of reality. This worldview and conception of drag allows RuPaul to position drag and trans community at opposite ends, saying "We [drag queens] mock identity. They [trans folks] take identity very seriously. So it's the complete opposite ends of the scale" (Jung 2016).

It is no surprise that RuPaul makes frequent attempts to bolster his image when asked to comment on trans women and his use of "tranny." With Aitkenhead (2018) RuPaul suggest that at one point he was offended by new uses of words only to "accept it because I understand where it comes from." The implication here is that RuPaul learns to hear the intention behind language use rather than act brashly against any use of words that offend. Implicitly RuPaul is relying on strategies of transcendence here. He is now in a higher moral position to understand language differently.

At one level, a question of whether or not RuPaul has the right to use the word "tranny" must be resolved. Perhaps as a response to this charge, RuPaul tweeted:

> Transitioning since day mother%king one #SitDownAmateures #KaBoom #CatchIt #LearnItpic.twitter.com/YKZtQQRvf.
>
> (RuPaul 2014b)

> I've been a "tranny" for 32 years. The word "tranny" has never just meant transsexual. #TransvestiteHerstoryLesson.
>
> (RuPaul 2014d)

These are also attempts to *bolster* his image and reclaim the language as a member of the in-group. The use of #Transvestite Herstory Lesson functions to *bolster* RuPaul's image as a person who understands histories of trans communities. What is also the case is that the first tweet also has an embedded *differentiation*: "The word 'tranny' has never just meant transsexual." Here RuPaul suggests the word is not always offensive. With such a suggestion, RuPaul invites his audience to consider the multiple meanings of "tranny" and consider that his use of it is not offensive. This perspective is reinforced by RuPaul's comparing his use of "tranny" to calling a girlfriend a "bitch"—it is not offensive if it is communicated with love. The rhetorically sophisticated move is to suggest that the word is not offensive because it is similar to a situation that many would accept as inoffensive. By drawing a comparison to similar contexts of use, RuPaul can minimize the offensiveness of his use of "tranny."

In his interview with Michelangelo Signorile (2012), RuPaul *attacks his accusers* unapologetically, "But if you're offended by someone calling you a 'tranny,' it was only because you believe you are a 'tranny!' [Laughter] So then, the solution is: Change your mind about yourself being a 'tranny.'" This strategy is consistent with his critique of ego and fixed identity. If the world is bothering you it is your responsibility to be and think differently about it. That everything is part of the Matrix means it is a matter of will to bend it to how you want.

Months after the episode with the infamous "She-male" mini-challenge aired, RuPaul sent out a tweet stream that attacks his accusers:

> Never argue with an idiot.
>
> (RuPaul 2014a)

> Why would U wanna be around anyone who takes themselves so f%king seriously? Pic.twitter.com/opPHlZRnPo.
>
> (RuPaul 2014e)

In another tweet in the stream that includes the previously mentioned tweets, RuPaul attempts to transcend the accusations tweeting,

> It's not the word itself, but the intention behind the word.
> (RuPaul 2014c)

In each of the major interviews referenced here, RuPaul consistently invites people to see beyond the offense and to the intentions behind the words.

During his interview with Marc Maron (2014), RuPaul attacks and mischaracterizes his accusers by saying,

> It's not the transsexual community who's saying that. These are fringe people who are looking for storylines to strengthen their identity as victims. That's what we are dealing with. It's not the trans community. 'Cause most people who are trans have been through hell and highwater. They've looked behind the curtain of Oz and went "oh, this is all a fucking joke." But some people haven't and they've used their victimhood to create a situation where, "No! You look at me! I want you to see me the way you're supposed to see Me!"

Here RuPaul is attacking his accusers by creating two categories of people: victims and trans people whose values align with his. The creation of a two-tiered community of trans victims and trans folks who see the cosmic joke allows RuPaul to reject having to answer accusations of offense.

When Maron (2014) asks RuPaul about the word "tranny," he says,

> Four people with an internet connection sit behind a computer and deliberately misinterpret our verbiage and decide, "you hurt me …" We are not doing anything to you. That's how you interpreted it. That is your prob … that is you.. You have the freedom to do that. But, you know, we're coming from a place of love. And in fact, the ego cannot discern the intention. You know, I can call myself a "nigger, faggot tranny" all I want because I've fuckin' earned the right to do it. I've lived the life. I've been on the front line. And my intention … if I call my other girlfriend "bitch," you know, she knows I'm talking' about it from a place of love. She knows that. And so … people out of school can take the same information and try to use it against me because the ego cannot pick up the intention behind it

It's worth quoting this passage at length because there are many apologetic strategies happening. First, he is *attacking his accusers'* motives. He then *denies* doing anything wrong at all. He *transcends* by suggesting that his intentions are loving and that his use of "tranny" is part of in-group language used to express affection

for others. Again, there is another attempt to differentiate "tranny" offensive slur or term of endearment. RuPaul's reference to "people out of school" is a direct address to millennials who are part of a generation, to RuPaul's mind, that are imbricated with victimization.

These examples of RuPaul's apologetic rhetoric reveal two things that are important to consider. First, as is obvious to those who pay attention to RuPaul, he is thoughtful and consistent in his worldview. Second, RuPaul is largely concerned with how others understand and receive his messages. It appears that RuPaul generally does not care to repair his image with those trans women who are hurt by his seemingly willful misunderstanding of their hurt and frustration.

As Emil B. Towner (2010, 294) notes, "Scholars have recently demonstrated that critical analysis of apologia can benefit from the use of additional rhetorical theories to uncover the rhetorical and social implications of a rhetor's words and actions." To make sense of RuPaul's defense of himself and its social consequences, I turn to a theory of rhetorical listening. Rhetorical listening offers a lens through which to see how individuals engage in cross-cultural communication regarding meaningful, unresolvable differences.

Good God Get a Grip Girl: The (In)effectiveness of RuPaulogy

RuPaul is wrong on many points about trans women's roles in drag history and trans gender communities generally. Alex E. Jung (2018) points out that Marsha P. Johnson, the cofounder with Sylvia Rivera of S.T.A.R. House, performed as a drag queen. Sasha Velour, winner of *Drag Race* season nine, tweeted,

> My drag was born in a community full of trans women, trans men, and gender non-conforming folks doing drag. That's the real world of drag, like it or not. I think it's fabulous and I will fight my entire life to protect and uplift it.
> (Velour 2018)

Peppermint's response to the issue similarly acknowledges the history of trans women in drag communities. She writes, "Women have always been directly and indirectly contributing to the art form of drag [...] Gay men do not own the idea of gender performance" (2018). Trans drag queen Gia Gunn also schooled RuPaul tweeting,

> Trans women were the first entertainers I ever saw in drag & have always been a big part of the industry. To now hear such words of segregation from an icon

who has created a world wide community of unity, makes me sad. Is [*sic*] never been LGB so let's not forget about the T!

(Gunn 2018)

RuPaul also has an untenable position about identity in trans communities. In interviews, RuPaul consistently creates a binary between drag queens and trans women arguing that drag mocks identity and embraces fluidity whereas trans women embrace identity and fixity. Alex E. Jung (2018) puts the matter well saying, "In [RuPaul's] mind, trans people are essentialist, whereas drag queens are not. But this is also where there's a contradiction, because if it's *all* drag, then why does it matter whether someone is cisgender male or a transgender woman?" (emphasis in the original). By insisting that drag is most powerful when cisgender men are in the position is to have an essentializing perspective of drag, "it requires believing there is an origin point of maleness with which to fuck" (Jung 2018). His essentialist views on drag and transgender people are limiting and betray an ignorance on the subject that makes his defenses weak and ill-considered.

Finally, as should be abundantly clear, people do use the word "tranny" to hurt and cause damage. When RuPaul says, "And no one has ever said the word 'tranny' in a derogatory sense" (Signorile 2012), he is wrong.

Pointing to the times where RuPaul gets this issue wrong is only part of the story. People can be factually wrong and yet still wage successful defenses of themselves. RuPaul's apologia is likely to resonate with many of those who share similar worldviews and perspectives. Identifying errors does not paint a full picture of RuPaul's ineffective defenses and is unlikely to move us toward better approaches to cross-cultural negotiations. To aid in the creation of this fuller pictures, I turn to theories of rhetorical listening.

For Ratcliffe (2005, 17), rhetorical listening is a stance of "openness that a person may choose to assume in relation to *any* person, text, or culture." As indicated by those with an active stake in the resolution to the use of "tranny," it is clear that the clash is between transgender individuals and drag queens. The meaningful differences between them rest at the center of language use. One side uses the term in exactly the ways that RuPaul has demonstrated during his interview with Marc Maron (2014): the term is an in-group expression of love and community. This is perfectly in keeping with RuPaul's image as a champion of love. However, trans women who claim harm hear the word primarily as a violent, life-negating expression. If drag and trans communities are to work with these meaningful differences at the fore, then we need better tools to make sense of this incompatibility than apologia.

Rhetorical listening is a method for rhetorical invention (for how to create words and meaningful connections between and among different cultures). This method asks individuals to first engage in cross-cultural negotiation to seek to

stand under the discourses of others (Ratcliffe 2005, 28). RuPaul consistently reduces the concerns of trans women to a single complaint: you hurt me, apologize. When we listen to Carmen Carrera's response to RuPaul, we should hear *more than just* offense. Monica Beverly Hillz and Peppermint also speak with a capacious understanding of the harm that RuPaul's language inflicts. RuPaul resists standing under *all* the discourses contributing to the tensions between drag queens' uses of "tranny" and trans women's receptions of the term. To only hear offense is to ignore the weariness that comes from having derogatory language used with such ease by those who claim to uplift all members of the LGTBQIA+ communities. By saying these trans women are weary, I do not mean to suggest that they do not experience joy or vitality. Rather, it is to recognize the weight of having to consistently defend yourself while fighting for a more just world.

This is not to suggest that we process every response before we engage in cross-cultural negotiations. That would be an impossible task. To listen rhetorically means that before we speak, we should first understand the complexity of the issue and the multiple discourses that those who claim hurt are using.

The second component in rhetorical listening is to proceed with a sense of accountability. Accountability recognizes that "we are indeed all members of the same village, and if for no other reason than that [...] all people necessarily have a stake in each other's quality of life" (Ratcliffe 2005, 31). RuPaul believes those who are offended should recognize their ego and get over the hurt they feel. In order to make such a suggestion, RuPaul must deny his role in creating offense. He did not wound or cause hurt; trans women and their co-conspirators allowed themselves to be upset by RuPaul. Here is where a major irreconcilable difference is located: RuPaul refuses to account for the way his language creates and contributes to the feelings of weariness and discomfort of trans women who have invested their energy to resolve the issue. By refusing to account for his position, RuPaul's apologetic rhetoric may gain adherents who already believe in the "life is hard, get over yourselves" rhetoric used to resist account, but it will do little to silence the voices of those are not already open to his message.

Third, RuPaul fails to see the cultural logics animating the claims of those who accuse him of harm. For Ratcliffe, listening moves beyond understanding the argument an individual offers us. We must also see how the individual reasons through the argument. With respect to the word "tranny," at least two cultural logics make this term differently meaningful for those who have an honest stake in the issue's resolution. For RuPaul, tranny is an in-group term of endearment. For those trans women who speak back to RuPaul, the word is derogatory; its use is hurtful. Until RuPaul demonstrates his understanding that the term can mean different things to different people and then *act* on the recognition of those differences, his defenses are likely to fail to repair his reputation with this group. When viewed through the lens

of rhetorical listening, it is clear that RuPaul is not concerned with speaking cross-culturally and toward negotiation of meaningful difference. RuPaul cannot hear beyond hurt and offense. This inability creates a tension between RuPaul and those trans men and women and their conspirators who respond to his transphobic language. Until he demonstrates the alternative meanings circulating around "tranny," he is likely to remain stuck speaking to those who already agree with him and further alienate those who are disposed to disagree.

Listening works both ways. As such, who deserves the force of rhetorical analysis and criticism must be determined with care. I choose to focus on RuPaul's location within this conversation about trans women in drag history and *Drag Race* history because he is in the position of power but also because I do not think he has been good at listening to calls into better ways of being. More robust analysis on the topic of trans people, *Drag Race*, and apologia might pay different attention to RuPaul's language or even to how responses to RuPaul fail to recognize important and powerful differences he invites all of us to consider. But differently, we can ask if critiques of RuPaul's use of language during these moments fail to listen on RuPaul's terms.

Trans people in contemporary gay rights politics are still upsettingly marginalized. Trans people are similarly marginalized in academic scholarship. I have my own work to do as I learn and respond as a better co-conspirator with trans people. This chapter is part of that commitment. I hope that this analysis not only helps us understand RuPaul better, but also how to think differently about the way we speak and approach our trans siblings as cisgender co-conspirators and critics.

Coda: Mary, Mary, Quite Contrary

Two days after his interview with Decca Aitkenhead (2018), RuPaul tweeted the following message, with a picture of a rainbow flag:

> Each morning I pray to set aside everything I THINK I know, so I may have an open mind and a new experience. I understand and regret the hurt I have caused. The trans community are heroes of our shared LGBTQ movement. You are my teachers.

There are multiple ways to read RuPaul's tweet. A cynical view suggests RuPaul's words are similar to "thoughts and prayers" politicians from the United States offer after the latest incident of gun violence. Literally, RuPaul's tweet offers his own thoughts and his own prayers for learning. The inversion of the "thoughts and prayers" commonplace here is striking in its ineffectiveness at responding to

the requests of those who seek repair and its inward-facing focus. Though it is difficult to articulate *how* you understand something within the bounds of a single tweet, RuPaul offers a vague gesture toward acknowledging his role in offense.

And yet, the cynical view is an unfair reading of RuPaul's tweet and can be done only by either ignoring RuPaul's worldview or unfairly dismissing it. From RuPaul's perspective, the inward focus of the tweet, his articulation of praying for strength and guidance for himself is perfectly in step with his belief that self-love and self-empowerment are the pathways to better worlds.

The tweet also creates a space of hope. There is hope that RuPaul learns from these experiences with trans community's hurt and anger at his words and behavior. RuPaul's spiritual self takes learning rather seriously. His life stories are connected and animated by moments of influential people helping him to see the world differently.[8] As such, when RuPaul frames trans communities as "teachers," there is reason and hope to believe that these communities now have a special spot in his thinking. Without specific action, however, it remains difficult to trust that RuPaul will change. But that is the tricky thing about hope: it is a delayed promise of something better. Second, there is hope in the effectiveness of placing pressure on those we believe have done wrong and doing so consistently over time. RuPaul's tweet does not happen automatically and no one should consider it a given. The tweet is a direct response to trans women, trans drag queens, and their co-conspirators putting *pressure* on RuPaul to be different. These messages have gotten to RuPaul and they work. When language is dismissed as the ineffectual assertions of a snowflake generation or "slacktivism," it is possible to turn to this tweet as a guarded success. When it comes to cultural transformation, successes, even guarded ones, are precious and rare. Their occurrences should be sustaining.

What this cautiously successful campaign also illustrates is that there is power in vulnerability and sensitivity. Fans of *Drag Race* love the show and what it does for LGBTQIA+ visibility. In their love for the show, they ask for it to be better, to serve better, to reduce harm and hurt: a core message to RuPaul's own personal and branded philosophy. Stories of wounds and calls to be better work together as a powerful form of activism that leads to the potential for change.

There is yet another reason for hope. Without fanfare or special announcements, RuPaul selected Gia Gunn as a contestant on the fourth season of *RuPaul's Drag Race: All Stars*. *All Stars* is a popular spin-off of *Drag Race* where former contestants return to compete for a place in the *Drag Race* hall of fame. What made Gia's return important was that she now identifies as a proud trans woman. This marks the first trans woman to identify as such prior to appearing on a *Drag Race* show.

Perhaps the producers of the show forced RuPaul to include a trans woman as a response to the public relations mess they noticed RuPaul getting deeper into.

All Stars season four is the most immediate season following the infamous interview with Aitkenhead, after all. Having Gia on the show would do much to repair RuPaul's trans exclusionary practices. He would just need to keep his mouth shut. But there is also a less cynical perspective to take on Gia's return. It might be that RuPaul's thoughts and prayers take him to a path of realization and correction.

There is hope.[9]

NOTES

1. While speaking of scholars, specifically, G. Patterson notes that cisgender people tend to "stake their authority to speak on trans topics by deploying their identity as a trans ally" without really understanding those communities and their needs (146). Rather than use ally, Patterson, following McKenzi (2014) suggests the term "co-conspirator," who (1) discloses positionalities, (2) foregrounds reciprocity, (3) demonstrates competency, and (4) amplifies trans voices. My use of "some" to describe those trans folks who have a stake in this issue's resolution is to indicate that trans communities are not monolithic and that not all trans women take issue with RuPaul's use of the word "tranny" or his policies on who can participate on *Drag Race*.
2. As a regularly occurring feature of *Drag Race*, RuPaul's prerecorded voice saying "You've got she-mail" brought contestants to attention before each mini-challenge. A generous queer reading of the message is that RuPaul is playing with and giving honor to Tyra Bank's show *America's Next Top Model* where the use of "Tyra Mail" serves a similar function.
3. There is some movement away from the term "transphobia/transphobic" and toward the word "cissexism." I acknowledge this movement in some activist communities but retain "transphobia/transphobic" in order to align with the language used by authors who criticize RuPaul. For more, see Monroe (2016).
4. "Rupologize" is a term coined by *Drag Race* contestant Willem Belli. Willem insisted that he would not "rupologize" for breaking the rules that led to his elimination from season four. Its formal definition is: "an apology with some shade thrown in; an apology which is presented as sincere, but is insincere and everyone knows it." The secondary definition is more fitting for the analysis undertaken in this chapter: "To make excuse for or regretful acknowledge of a fault or offense in a dramatic way." My spelling—rupaulogize—plays on these meanings but draws specific attention to RuPaul's apologetic rhetoric.
5. I discuss Gia Gunn's appearance on *RuPaul's Drag Race: All Stars* season four later.
6. RuPaul uses the same phrase—"You are a God in drag"— during his interview with Marc Marion on *WTF with Marc Maron* (2014) and with Michelangelo Signorile (2012), and a variation of it with Aitkenhead (2018): "[drag is] about recognizing that you are God dressing up in humanity, and you could do whatever you want."

7. RuPaul at times references the illusion of reality as Oz, the Matrix, breaking the fourth wall, a joke, and so on.
8. In nearly every interview referenced in this chapter, RuPaul mentions his tenth-grade teacher telling RuPaul not to take life so seriously.
9. I am thankful for Dave Kube, Kevin Wozniak, the reviewers of this chapter, and Cameron Crookston for their feedback and guidance on this chapter.

REFERENCES

Aitkenhead, Decca. 2018. "RuPaul: 'Drag Is a Big F-you to Male Dominated Culture.'" *Guardian*, March 3, 2018. https://www.theguardian.com/tv-and-radio/2018/mar/03/rupaul-drag-race-big-f-you-to-male-dominated-culture.

Benoit, William L. 2015. *Accounts, Excuses and Apologies: Image Repair Theory and Research*. New York: SUNY Press.

Brady-Davis, Precious. 2018. "Even the Gods Can Err: RuPaul's Lips Are out of Sync." *Into*, March 5, 2018. https://www.intomore.com/you/Even-The-Gods-Can-Err-RuPauls-Lips-Are-Out-of-Sync/31fb7b195c3f4fb5.

Burke, Kenneth. 1969. *Rhetoric of Motives*. Berkeley: University of California Press.

Carrera, Carmen. 2014. "Some of you guys asked me to make a comment so here it goes … Although I am certain RuPaul's Drag Race didn't mean to be offensive, let this be a learning experience." Facebook, March 31, 2014. https://www.facebook.com/carmencarrerafans/posts/some-of-you-guys-asked-me-to-make-a-comment-so-here-it-goes-although-i-am-certai/679959392050537/.

Charles, RuPaul. 2014. "498: RuPaul Charles." Interview by Marc Maron. *WTF with Marc Maron*, podcast, May 19, 2014, MP3 Audio, 1:19:55. https://www.stitcher.com/podcast/stitcher-premium/wtf-marc-maron-premium/e/46813254.

D'Angelo, Rafi. 2014. "Enjoyed This Week's *RuPaul's Drag Race*? Then You're a Little Transphobic." *Slate Magazine*. March 19, 2014. https://slate.com/human-interest/2014/03/rupauls-drag-race-and-transphobia-why-the-shemale-game-was-offensive.html.

GLAAD. n.d. "GLAAD Media Reference Guide—Transgender." GLAAD.com. https://www.glaad.org/reference/transgender.

Gunn, Gia (@GiaGunn). 2018. "Trans women were the first entertainers I ever saw in drag & have always been a big part of the industry. To now hear such words of segregation from an icon …" Twitter, March 5, 2018, 11:13 a.m. https://twitter.com/GiaGunn/status/970739148469411840.

Jung, Alex E. 2016. "Real Talk with RuPaul." *Vulture*, March 23, 2016. https://www.vulture.com/2016/03/rupaul-drag-race-interview.html.

Len-Ríos, María, and William L. Benoit. 2004. "Gary Condit's Image Repair Strategies: Determined Denial and Differentiation." *Public Relations Review* 30: 95–106. https://doi.org/10.1016/j.pubrev.2003.11.009.

McClearey, Kevin E. 1983. "Audience Effects of Apologia." *Communication Quarterly* 31 (1): 12–20. https://doi.org/10.1080/01463378309369480.

McKenzi, Mia. 2014. *Black Girl Dangerous: On Race, Queerness, Class and Gender*. Oakland, CA: BGD Press.

Milford, Mike. 2019. "Rhetorical Emancipation: Apologia and Transcendence on Death Row." *Western Journal of Communication* 83 (3): 326–44.

Molloy, Parker Marie. 2014a. "Op-ed: It's Time to Stop with the *T* Word." *Advocate*, February 20, 2014. https://www.advocate.com/commentary/2014/02/20/op-ed-its-time-stop-t-word.

———. 2014b. "RuPaul Stokes Anger with Use of Transphobic Slur." *Advocate*, March 18, 2014. https://www.advocate.com/politics/transgender/2014/03/18/rupaul-stokes-anger-use-transphobic-slur.

Monroe, Denarii. 2016. "3 Reasons to Find a Better Term Than '-Phobia' to Describe Oppression." October 9, 2016. https://everydayfeminism.com/2016/10/find-a-better-term-than-phobia/.

Nichols, James. 2016. "*RuPaul's Drag Race* to Refrain from Using 'Transphobic Slur' in Wake of Controversy." *Huffpost*. https://www.huffingtonpost.com/2014/04/14/rupauls-drag-race-transphobic-slur_n_5142855.html?1397483032 (last modified on February 2, 2016).

Nichols, James Michael. 2014. "Carmen Carrera and Monica Beverly Hillz Address *Drag Race* Transphobia Allegations." *Huffpost*, April 1, 2014. https://www.huffingtonpost.com/2014/04/01/drag-race-transphobia_n_5072399.html.

Patterson, G. 2018. "Entertaining a Healthy Cispicion of the Ally Industrial Complex in Transgender Studies." *Women & Language* 41 (1): 146–51. https://www.academia.edu/37627041/Entertaining_a_Healthy_Cispicion_of_the_Ally_Industrial_Complex_in_Transgender_Studies_G_Patterson_pdf.

Peppermint. 2018. "Peppermint Responds to RuPaul's Apology over Controversial Interview: Exclusive." Billboard.com, March 6, 2018. https://www.billboard.com/articles/news/pride/8233000/peppermint-rupaul-apology.

Ratcliffe, Krista. 2005. *Rhetorical Listening: Identification, Gender, Whiteness*. Carbondale: Southern Illinois University Press.

Rosebrugh, Gregory. 2014. "It's Never Too Late to Rupologize: Transphobia and *Rupaul's Drag Race* Recap #3." March 21, 2014. https://www.indiewire.com/2014/03/its-never-too-late-to-rupologize-transphobia-and-rupauls-drag-race-recap-3-214511/.

RuPaul (@RuPaul). 2014a. "Never argue with an idiot." Twitter, May 23, 2014, 10:09 a.m. https://twitter.com/rupaul/status/469887772098957312.

———. 2014b. "Transitioning since day mother%king one #SitDownAmateurs #KaBoom #CatchIt #LearnIt." Twitter, May 23, 2014, 10:28 a.m. https://twitter.com/rupaul/status/469892682840420352.

———. 2014c. "It's not the word itself, but the intention behind the word." Twitter, May 24, 2014, 10:03 a.m. https://twitter.com/rupaul/status/470248645745733632.

———. 2014d. "I've been a 'tranny' for 32 years. The word 'tranny' has never just meant transsexual. #TransvestiteHerstoryLesson." Twitter, May 24, 2014, 10:16 a.m. https://twitter.com/rupaul/status/470252018523979776.

———. 2014e. "Why would U wanna be around anyone who takes themselves so f%king seriously?" Twitter, May 24, 2014, 10:17 a.m. https://twitter.com/rupaul/status/469889749549723649.

———. 2018. "Each morning I pray to set aside everything I THINK I know, so I may have an open mind and a new experience. I understand and regret the hurt I have caused ..." Twitter, March 5, 2018, 3:57 p.m. https://twitter.com/RuPaul/status/970810665685299201.

Signorile, Michelango. 2012. "RuPaul Sounds off on New Season of *RuPaul's Drag Race*,' Obama, the Word 'Tranny,' and More." https://www.huffingtonpost.com/2012/01/13/rupaul-on-rupauls-drag-race-obama-tranny_n_1205203.html (last modified December 6, 2017).

Towner, Emil B. 2010. "A<Patriotic> Apoloiga: The Transcendence of the Dixie Chicks." *Rhetoric Review* 29 (3): 293–309.

Urban Dictionary, s.v. "rupologize." https://www.urbandictionary.com/define.php?term=Rupologize.

Velour, Sasha (@sasha_velour). 2018. "My drag was born in a community full of trans women, trans men, and gender non-conforming folks doing drag." Twitter, March 5, 2018, 12:55 p.m. https://twitter.com/sasha_velour/status/970764764950429696.

Ware, B. L., and A. Linkugel. 1973. "They Spoke in Defense of Themselves: On the Generic Criticism of Apologia." *Quarterly Journal of Speech* 59 (3): 237–83. https://doi.org/10.1080/00335637309383176.

11

"This is a movement!": How RuPaul Markets Drag through DragCon Keynote Addresses

Carl Schottmiller

With their hit television series *RuPaul's Drag Race*, drag artist RuPaul and the production team at World of Wonder created a queer cultural phenomenon.[1] The massive commercial success of this program has undeniably impacted the twenty-first-century drag landscape in innumerable ways, which the show's multiple audiences will dissect and discuss for years to come. A recurring question about these impacts revolves around the issue of mainstreaming drag. Fans and critics of this show alike ponder the implications for drag performance, as *RuPaul's Drag Race* continuously and successfully markets RuPaul's commercial drag brand to expanding demographics. The annual RuPaul's DragCon events provide unique opportunities to analyze RuPaul's growing commercial drag economy. RuPaul's DragCon is a weekend-long event that originated in Los Angeles on May 15, 2015.[2] Billed as a space to "celebrate the art of drag, queer culture, and self-expression for all," RuPaul's DragCon provides fans with ample opportunities to meet drag artists, purchase products from vendors and exhibitors, observe panel discussions on different topics, and witness RuPaul's culminating keynote speech (St. James 2015). Since the first 2015 Los Angeles convention, RuPaul's DragCon events have expanded to add conventions in New York City and London. These massive events have garnered significant increases in attendees, from 13,718 at the 2015 LA convention to over 100,000 between the 2019 LA and NYC conventions.[3] These conventions play an integral role in mainstreaming RuPaul's commercial drag economy because they attract so many attendees and generate millions of dollars in sales.[4] In this chapter, I situate an analysis of RuPaul's three keynotes from the Los Angeles DragCon events within the growing body of scholarship on

RuPaul's Drag Race in order to analyze some key features and impacts of RuPaul's commercial drag economy.

Thus far, scholars have produced a rich and growing multidisciplinary discourse on *RuPaul's Drag Race* and its social, cultural, political, and economic impacts.[5] This field of "*RuPaul's Drag Race* studies" includes brilliant considerations of the reality television phenomenon, which tackle important topics, including drag's history and politics, questions of identity and representation, and issues of cultural appropriation and drag's commodification, among others. One thread within this field analyzes the show's marketing strategies and considers their political potentials and pitfalls. Jessica Hicks, Chelsea Daggett, and Lori Hall-Araujo provide invaluable insights into RuPaul's brand of consumerism and its impacts on the show's multiple audiences. Analyzing episodes of the television series, Jessica Hicks argues that *RuPaul's Drag Race* successfully uses the discourse of "self-love" to draw in outsider (non-drag, non-LGBTQ+) audiences. These cultural outsider audiences form an emotional connection to *Drag Race* and its drag performers through the show's messages of self-love, disseminated by RuPaul and the drag queen contestants through often universalizing appeals to a shared human condition/struggle. As Hicks (2013, 155) suggests, this sense of community and self-love discourse can have positive benefits for LGBTQ+ people, as non-LGBTQ+ audiences connect to the show and want to become supportive allies. Chelsea Daggett extends this conversation to consider how the show's "self-love" discourse relates to consumerism. Through an ethnographic media analysis, she analyzes how *RuPaul's Drag Race* and drag artists deploy these narratives of universally held emotions along with parodic mimicry to embrace different forms of consumerism. For Daggett (2017, 271–74), this element of parody allows *RuPaul's Drag Race* and drag artists to embrace empowering forms of consumerism, using discourses of self-love to expand their brands and build alliances with non-LGBTQ+ audiences.

This parodic element of drag distinguishes RuPaul's brand of consumerism from more traditional forms of neoliberal capitalism. Chelsea Daggett suggests that because the show embraces drag parody, the resulting appeals to universal emotionality blur a strict binary between regressive manipulative consumption and potentially subversive forms of commodity activism (272). In other words, because RuPaul and drag queens are "in on the joke" of their shameless consumerism, they can mimic, mock, and subvert capitalism while also encouraging consumption. Lori Hall-Araujo builds on this point further as she analyzes RuPaul's specific brand of consumerism evident at RuPaul's DragCon. Like Daggett, Hall-Araujo asserts that RuPaul uses parody to both participate in and subvert capitalism. RuPaul turns his shameless self-promotion into a parody of blatant consumerism, which he distinguishes from "vulgar consumerism." Vulgar consumerism, or "neoliberal manipulative consumption," to use Daggett's phrasing, encourages

consumers to spend money by identifying a lack within themselves or their lives that must be filled by purchasing products. By contrast, RuPaul's "products are designed to reinforce a sense of perfect imperfection and self-acceptance among anyone who feels marginalized" (Hall-Araujo 2016, 239). As Hicks, Daggett, and Hall-Araujo all persuasively argue, RuPaul's brand of consumerism has subversive political potential because *Drag Race* combines drag parody with a self-love discourse. This appeal to self-love can effectively build political and cultural alliances with non-LGBTQ+ audiences, as evidenced by the increasing popularity of the show among non-LGBTQ+ viewers and, by extension, the increasing presence of mainstream audiences at live *Drag Race*–sponsored drag tours and the RuPaul's DragCon events. At the same time, the parodic element of RuPaul's consumerism builds this sense of community by encouraging audiences to embrace (and purchase) drag as a way to practice self-acceptance.

While this combination of self-love and (specifically camp) parody are key elements for the massive success of RuPaul's commercial drag brand, the subversive political potentials of this consumerism are not guaranteed. Indeed, as I propose in this chapter, RuPaul's consumerism loses its campy political edge and becomes more similar to neoliberal capitalism as the *Drag Race* brand gains mainstream popularity. In my previous study of the *RuPaul's Drag Race* phenomenon, I demonstrate how RuPaul effectively builds his commercial drag empire by embracing what I call camp capitalism: a marketing strategy imbued with camp that Ru uses to shamelessly and safely sell the *Drag Race* brand to mainstream audiences (Schottmiller 2017). In this formulation, I understand camp as a (sub)cultural phenomenon that develops directly from the lived experience of homophobic oppression (Babuscio 1980; Bergman 1993; Bérubé 1990; Britton 1999; Bronski 1984; Case 1999; Chauncey 1994; LaValley 1995; Long 1989; Medhurst 1997; Melly 1970; Meyer 1994; Muñoz 1999; Newton 1972; Sedgwick 1990). Historically, LGBTQ+ people use the key elements of camp (irony, parody, humor, and aestheticism) to navigate, challenge, and respond to their social marginalization.[6] For example, drag artists often use camp parody to mimic, deconstruct, and mock oppressive gender norms, while also empowering and validating their own gender identities. In my previous study of the *RuPaul's Drag Race* television series, I demonstrate how RuPaul camps capitalism by imbuing this parodic mimicry into his shameless, over-the-top marketing, thereby encouraging audiences to both laugh at capitalism and purchase RuPaul's products.[7] As Jessica Hicks, Chelsea Daggett, and Lori Hall-Araujo suggest, this element of camp parody creates connections among non-LGBTQ+ audiences and allows Ru to contrast his camp capitalism with neoliberal consumerism.

However, in practice, the subversive political potentials of camp capitalism become more akin to manipulative neoliberal capitalism as Ru's commercial drag

economy expands. As Judith Butler and camp scholars have suggested, camp's political potential is not always guaranteed: often, camp ends up reifying the very material it also seeks to parody. While Ru's camp capitalism starts off as a subversive commentary on consumerism, his marketing strategy loses this campy edge as the brand attracts a wider mainstream audience and Ru gains more corporate branding opportunities. In my larger study of *RuPaul's Drag Race*, I trace this shift through a study of the television show's aired episodes. With this chapter, I make this point salient by analyzing changes in RuPaul's keynote addresses at three Los Angeles DragCon events. I have chosen to focus on the DragCon keynotes because they provide an invaluable opportunity to analyze Ru's shifting discourse at a live event, and they also provide interesting opportunities for documenting tangible practices among the audience of consumers. Through my study of these keynotes, I demonstrate how RuPaul's marketing strategies become less specifically LGBTQ+, less parodic, and less politically subversive over the three keynotes. Rather than subverting capitalism, RuPaul uses his self-love consumerism to build his "guRu" brand: an Oprah-esque figurehead who inspires audiences to love themselves.

As Ru transforms into the guRu, his DragCon keynotes lose their distinctly LGBTQ+ campy elements in favor of more maudlin self-love discourse. As a result, heterosexual audience members at these events increasingly internalize and reproduce elements of manipulative neoliberal consumerism that RuPaul's capitalism originally parodied. To build this argument, I analyze three of RuPaul's keynote addresses and the accompanying audience "Q&A" sessions from the 2015, 2016, and 2017 RuPaul's DragCon events. I have selected these three specific keynotes for two reasons. First, RuPaul gave keynote addresses only at the 2015–18 Los Angeles DragCon events.[8] Second, these three keynotes best demonstrate Ru's shift away from camp capitalism toward guRu preaching. During my ethnographic fieldwork, I attended these DragCon events, observed, recorded, and analyzed RuPaul's keynote speeches and the accompanying audience "Q&A" sessions. I present this material written in an ethnographic participant observation voice, as a way to convey the experience of attending these speeches while also providing critical commentary throughout.[9]

"Go down there, and get the stuff!": The Inaugural RuPaul's DragCon, 2015

The culminating event of RuPaul's first DragCon event in 2015 is RuPaul's keynote address. When RuPaul enters, the crowd erupts into applause. Dressed in a red suit, RuPaul effortlessly commands attention with his aura. He walks back and forth

across the stage waving to us, as we devoted fans give him a standing ovation. For the next 30 minutes, RuPaul gives a seemingly effortless, thoughtful, and campy keynote. Ru starts by welcoming us to the first DragCon and, after name dropping audience members Big Freedia and Sheryl Lee Ralph, lays out DragCon's goal:

> RUPAUL: That's what this whole thing is all about, it is about bringing people together from all over the world. And that's what the show *RuPaul's Drag Race* is about. We are showing people that it's important to not take life so seriously. Yes, life is serious, but you have to have fun with it. You have to enjoy the colors and the music and the beauty and the joy. And that's the job of the drag queen throughout history. Know what you're here for, which is, you are the physical reality of god.
> (Some audience members laugh, while others applaud. Someone close to me says, "Amen honey," and another person in the room shouts, "Preach!")
> RU: You are the physical realization of the power that created the entire universe. That's you. I'm not talking about Jiggly Caliente alone.
> (Audience laughs)
> RU: It's not just Jiggly. It's *you*. And you, and you [Ru points at different audience members]. Everyone within the sound of my voice. That's what we're here for. That's why this thing is so important.
> (RuPaul 2015)

Although he does not use the word "camp" in his keynote, RuPaul essentially preaches a camp ideology: the need to not take life too seriously. LGBTQ+ people historically use camp as a survival strategy when confronting oppression, as a way to laugh so that you do not cry. Ru communicates this similar sentiment to the DragCon audience. While his invocation of a nondenominational god, which recurs throughout the 30 minutes, could easily devolve into overly serious proselytizing, RuPaul peppers the speech with campy jokes to avoid such a situation. His mentioning of Jiggly Caliente, a contestant from season four of *Drag Race*, injects humor into the seriousness. Jiggly's name becomes a running joke, a way to lighten the mood and elicit raucous laughter from the crowd, and at certain times throughout the speech, audience members shout out "Jiggly Caliente!" in response to some of Ru's more serious questions. Ru's use of camp to subvert the maudlin is a key part of the 2015 keynote, which changes in the latter two speeches.

While the majority of this year's keynote focuses of gay identity and experience, Ru affirms the straight audience's presence through a strategic rhetoric of "being an outsider." Ru frames DragCon as both "a convention of people who

understand how important it is to be yourself" and an opportunity for superfans to connect. He says:

> The big news here is that you see each other on Twitter, but this time you get to meet each other in person like this. You get to put a face to the name and connect, and I'm just excited for the sort of ripple effect this is going to have in pop culture for *years* to come. This convergence of people who love color and beauty and everything.
>
> <div align="right">(RuPaul 2015)</div>

Having studied Ru's interviews over the years, I recognize these familiar tropes. Ru tends to discuss the *Drag Race* audience as people who love color, beauty, music, and dancing—a sort of Bohemian cultural identity defines the group in its totality rather than a specific marginalized identity. This language of embracing outsider status through artistry, creativity, and irreverence brings together diverse consumers who love the show. At the same time, however, this inclusive strategy does not necessarily foreground actual LGBTQ+ experiences with oppression. To me, these bon mots seem directed more toward straight members of the audience: a way for RuPaul to affirm their participation in and consumption of a culture to which they do not necessarily belong. Interestingly, however, Ru situates this rhetoric within a type of camp ideology. Love for artifice, humor, and glamour, key elements of camp, become the defining quality of DragCon's community. In a sense, then, the audience's ability to embrace and love camp becomes their unifying quality. Through this strategy, Ru marks the audience as distinctly "queer," not in their experiences with marginalization or their radical politics, but in their appreciation for and consumption of a queer television show.

To my delight, the topic of Ru's 2015 keynote is gay experience and "educating the children." Ru makes times to honor the legacy of queer forebears, address the importance of *Drag Race* as an educational tool, and articulate the need for younger viewers to understand LGBTQ+ history. In making these arguments, Ru addresses the younger fan base and their toxic social media behavior directly:

RUPAUL: We decided that we would go a lot younger for season seven, and you see them. We have twenty-ones, several twenty-one year-olds on the show. And because of that, we've gotten a lot of younger fans on the show. And through social media, we've noticed that younger fans who don't know the history of the gay experience where there are certain double entendres, certain speech if spoken out of school can be perceived as misunderstood. But they've taken that part of the language without understanding the backstory behind it. There is a certain hurtfulness that young people will display on social

RU: media that doesn't have the backstory that some of the older queens would have. There's a certain meanness that has been happening that is not in line with the gay experience, you know what I mean? (I and many audience members respond, "Yes!")

RU: I wanted to talk about this in this event right now because where we come from, we know the pain. We have lived through it. You know, a lot of the language that we talk about in the gay experience was a secret language. We had to have a secret language because we didn't want to be killed, we didn't want to be hurt by other people, so we had to create a secret language, and some of it if heard out-of-school, so to speak, could be misperceived and misunderstood. So, we're still trying to work this dialogue out with young people and educating them. And again that's why this event is so important. Because we come from a long line of people whose blood was spilled to make sure and ensure that we could have this convention here tonight. (Audience cheers)

RU: We would do them a disservice if we didn't acknowledge them and if we didn't educate young people about this. There was a void in-between the generations where they didn't get the message, unfortunately. And I think you know why that void happened, but we can make up for that right now. We can do that through this event and through the show and everything we do, actually. We can tell them the story. (Someone from the audience shouts, "How's your head?")

RU: I haven't had any complaints! (The audience cheers wildly)

RU: But, you know, that's a perfect example honestly. That kind of humor, the fact that they have to understand that sort of off-center twisted sense of humor.

(RuPaul 2015)

During this segment of the speech, Ru speaks directly to LGBTQ+ communities and experiences. He contextualizes *Drag Race*'s representation within a larger queer subcultural history, and he discusses LGBTQ+ peoples' experiences with violent forms of oppression. As I hear his keynote, I feel a specific queer subcultural connection to Ru. Because we are both gay men who know this history, we connect on the details. Ru is directly referencing the use of camp's coded language for LGBTQ+ survival here, as well as HIV/AIDS. He does not directly name camp or HIV/AIDS, but the cultural references are present and identifiable for audience members who know this history. I connect more directly to these moments of Ru's keynote because they speak to our shared experiences as members of the LGBTQ+

community. In this moment, DragCon feels like an extension of our shared history and not just a commercial enterprise.

An approximately 24-minute Q&A session follows RuPaul's prepared remarks, during which audience members ask a mixture of thoughtful and humorous questions. The majority of questions come from attendees dressed in drag, one of whom identifies themselves as a former member of The Cockettes (the San Francisco–based drag performance troupe). For the final question, the speaker asks Ru how to love yourself on a daily basis. In response, Ru shares his daily morning routine of stretching, praying, and meditating. He goes on to situate the need for self-care within our capitalist society:

RUPAUL: We live in a consumer culture. When you live in a consumer culture, the way the culture thrives is you have to buy stuff. You got to buy a lot of stuff, and you got to buy stuff you don't need. So how are they gonna get you to buy things that you don't need? They have to tell you that you're not whole, that you're not really clean unless you're zestfully clean.
(Audience laughs)
RU: That's how they do it. So you feel really, really bad about yourself. You feel awful about yourself. You think you've got to buy this; you've got to buy that. So how do you offset that? You have to take care of yourself.

(RuPaul 2015)

In this moment, RuPaul differentiates his form of self-love-based camp capitalism from toxic, neoliberal "consumer culture." For Ru, toxic consumer culture identifies a lack within individuals, who then must spend money on products to "fix" themselves. Ru does not want the audience to feel this lack or need to fix themselves. Indeed, he tells us that we need to love ourselves instead of spending money to change ourselves. With this public performance, RuPaul aligns his live marketing strategies and ideology with those he displays on *RuPaul's Drag Race*. The Q&A session ends when Mathu Andersen, RuPaul's longtime collaborator, joins Ru on stage. Mathu is scheduled to present in room 515AB after RuPaul's keynote, which by this point is running long. After praising Andersen's genius and talent, RuPaul says with seemingly no hint of irony, "I want you all to head to the RuPaul Realness experience downstairs and get some of the gorgeous products that we are slashing the prices! Slashing the prices on things! Yes! So go down there, and get the stuff." RuPaul ends his keynote with a performance of his call-and-response catchphrase, "Now everybody say love! [Audience: love!]. Everybody say love! [love!]" (RuPaul 2015).

To me, this ending perfectly encapsulates the contradictions and complexities of Ru's self-love consumerism. Ru suggests that dominant "consumer culture" sustains

itself by forcing us to buy stuff, and he wants to differentiate his own economy and brand of camp capitalism. Instead of identifying a lack within the audience, RuPaul encourages us to purchase items that display our individuality and creativity. Ru's message here is not "consume to fix yourself" but rather "consume to enjoy a Bohemian creed and assert your creative individuality." While these marketing strategies differ, both forms of consumerism ultimately share a central feature: the audience must consume. RuPaul wants us to love ourselves, but he also needs us to invest our time and money into his empire. DragCon cannot exist, and this commercial drag enterprise cannot thrive, unless we attendees invest our time and money. While Ru can camp capitalism by shamelessly selling himself and bringing us "in on the joke," his consumerism still maintains a foundational feature of capitalism: we must consume.

"This is a movement!": RuPaul's DragCon, 2016

Before introducing RuPaul at the 2016 Los Angeles keynote, World of Wonder creators Fenton Bailey and Randy Barbato announce DragCon, 2017. They encourage us to purchase weekend tickets now, before the price increases. When RuPaul enters, the crowd goes wild and gives him a cheer-filled standing ovation. For the next 30 minutes, RuPaul gives a decidedly different keynote from the previous year. Whereas the 2015 keynote focuses on gay experience and speaks directly to the LGBTQ+ audience, this year's speech instead emphasizes a theme of "self-care" couched in the rhetoric of mothering oneself (apropos since the day happens to be Mother's Day):

RUPAUL: It couldn't have happened on a better day. Mother's Day, it's perfect. Cause who am I? I'm Mama Ru!
(Audience shouts, "Mama Ru!")

RU: I sort of inherited that slogan, "Mama Ru." Just happened to be Mama Ru. You know, the kids dubbed me, "Mama Ru." You know, everybody's looking for a mama, I guess.
(Audience laughs)

RU: You know, it's true. Everybody wants that warmth, that comfort from a mother. That's what the name "mother" invokes, that comforting thing. That sweet, loving, comforting thing. Of course, very few people have that, you know?
(Audience laughs)

RU: Some people do. My mother was *not* that.

(RuPaul 2016)

Ru describes his mother as "a sweet, sensitive soul whose heart was broken by the world." Because Ms. Charles could not handle the weight of the world, she

transformed into a sad, world-weary person filled with bitterness and darkness. This anecdotal beginning introduces the keynote's theme: how to overcome a broken heart. Ru frames the issue as a battle between lightness and darkness. Those individuals "stuck in the bitterness that life hasn't given them what they deserve," versus those who embrace irreverence and laughter. In performing this ideology, Ru does not ground the keynote in LGBTQ+ history or experience. Instead, this year, he performs a type of "self-help guRu" role who gives the audience life advice. As a marketing strategy, this approach veers away from last year's campy approach. RuPaul now identifies a lack within the audience (our need/desire to feel mothered), and he wants to give us life advice to fill this need.

When addressing the audience, Ru emphasizes our connection as queer consumers. The 2015 keynote included some of these elements (e.g., suggesting that a Bohemian creed brings the audience together), but this year's keynote amps up the message. Ru emphasizes the audience's shared identity as lovers of art and participants in a cultural movement:

RUPAUL: The fact that you are here today in this gorgeous, gorgeous event means that you know that you have the potential to create beauty and magic. You can see magic. That's why you're here. You want to align yourself with the magic people because this world needs you. And talk about movements. This is a *movement*!
(Some audience members cheer)

RU: This is what this is all about. We are God experiencing life on this planet. You—we're not separate from one another, by the way. We are one organism, one thing experiencing humanity, experiencing life on this planet together. And we get to decide where we want to land with this, whether it's the darkness or light. And, by the way, darkness, light, it's all good. You get to choose. And I'm a living witness up here. I was a little boy from San Diego with dreams to go and become an international star. I didn't know how I was gonna do it, but I was open to the possibility. And each of you here, the fact that you're here right now means you have it. You're the ones with the ability to go out and be the mother to all of these children out here. The mother of invention, the mother of the house of extravaganza!

(RuPaul 2016)

The focus of Ru's keynote shifts from "educating the children" in 2015 to teaching the straight and gay audience how to "feel good" in 2016. When I sit in the audience and hear RuPaul speak, I do not feel the same connection with him that I did in 2015. I still admire his skill as a performer, but the speech's substance does not

connect with me. In this moment, I feel like a cultural outsider, or at least not the speech's target audience. When I listen to Ru's speech, I want to hear his perspective on gay culture, history, or politics because I view him as a significant queer cultural icon. This speech's emphasis on life advice falls flat to me because I do not view Ru as a "guRu" figure, and I do not look to drag queens as Oprah-esque figures. Compared to the 2015 keynote, this speech lacks the same presence of irreverent campy humor. Last year, Ru disrupts moments of maudlin oversentimentality with camp, but this year, his performance strategy is built upon connecting to the audience through emotions. While I do not necessarily disagree with Ru's advice, I wish that this self-help overcoming narrative would directly address institutionalized forms of oppression that LGBTQ+ people face. This speech feels both more inclusive of the diverse consumer audience and less specifically LGBTQ+.

As with last year's keynote, this year features another Q&A session following Ru's prepared remarks. Whereas last year's Q&A features a mix of thoughtful and humorous questions about drag history, this year's Q&A focuses more on self-help. One person asks Ru how not to "get into your own head," and Ru talks about meditating and breaking down the ego. A perfectly campy "How's your head?" joke goes unsaid. Ru ends her keynote by telling us,

> Be the mother to yourself. Treat yourself the way you feel you deserve to be treated, and also be the mother to all these children out here who are looking for guidance. I love you and thank you so much for coming.
>
> (RuPaul 2016)

When I leave this year's keynote, I am struck by the changes in Ru's performance strategies. Ru now markets himself as the guRu to connect with this year's audience, which contrasts greatly with his focus on LGBTQ+ history from 2015. Through this speech, Ru markets himself as a guRu who can provide consumers with life advice. When hearing the speech in 2016, I think about how this performance could herald a new addition to Ru's marketing personae: the self-help guRu. Based on the audience's receptiveness to this rhetoric, I can envision RuPaul effectively giving this presentation at seminars for consumers who invest time and money into life advice. I interpret Ru's performance strategy this year as a way to build his future career options—and sure enough, Ru later releases a self-help book entitled *guRu* in 2018. To a room full of *Drag Race* consumers, RuPaul has set the stage for his future business opportunities rooted in self-love consumerism. Ru uses this change in rhetoric to open the door for more money-making ventures, and in so doing, he stops embracing elements of parodic camp subversion. Ru is not parodying an Oprah-esque figure here; rather, he is trying to become drag Oprah for these expanding markets. This shift toward over-the-top, shameless self-love consumerism leaves camp and LGBTQ+ history by the wayside.

"This is the best of times and the worst of times!": RuPaul's DragCon, 2017

For the 2017 keynote address, Michelle Visage introduces RuPaul as "our beautiful leader" to the room packed with DragCon attendees. Ru once again walks out to wild applause and a standing ovation. He begins with his call-and-response catchphrase, "Everybody say love," before previewing his keynote topic: the 1-2-3s of how to love yourself. RuPaul moves further in the direction of the guRu figure and away from a specifically LGBTQ+ focus. This year, Ru instructs the crowd to think of themselves as "human machines" who need to "clear out the blockage" in their lives. Similar to the 2016 keynote, RuPaul references his childhood as a way to personalize the self-help rhetoric. As children, Ru and his sisters (who once again sit in the audience) would wait on their mother's porch to be picked up by their alcoholic father. Their father never came. According to Ru, this experience of neglect created a "victim mentality," wherein Ru would chase unattainable men because he saw himself as that little boy always waiting for somebody who never arrives. Years of therapy allows Ru to "clear out the blockage" from this experience. With this keynote, RuPaul once again performs his guRu persona, speaking to the audience and giving us self-help advice. As with last year's keynote, I do not directly relate to this performance because I do not seek self-help advice from RuPaul.

Instead, I want RuPaul to speak directly about Donald Trump's toxic campaign and its potential impacts on the US political climate. This speech seems like a perfect opportunity to address the potential danger of a reality show host who embraces racism, xenophobia, misogyny, heterosexism, and transphobia. To me, having the opportunity to publicly confront Trump's bigotry at a drag convention would be both an invaluable contribution to Ru's legacy and an important way for us all to acknowledge the history of queer politics. A point made particularly resonant, given Ru's emphasis of LGBTQ+ history and culture in the 2015 keynote address. While Ru chooses not to make politics the focus of his keynote, he does address Trump later in the keynote:

RUPAUL: Every person who's ever lived on this planet for a long time who is successful, who is doing what you want to do, somehow they have learned how to circumvent those booby-traps that we create for ourselves. And we all have them. We have friends who don't want to move from where they were. In fact, this whole election—I mean, this is the best of times and the worst of times, right now. This election, when you look under the hood of it and see what it's really about, what happened, it's like the TV show *Downton Abbey* where it's the changeover from the 20th century to the 21st century. And the people who don't

|RU:|want to move into the future and move on uptown like my World of Wonder friends, they took on this used car salesman who promised them that they could turn back the hands of time and bring it back to what it was. We ain't going back, baby.|

(Audience cheers wildly)

RU: That is the key for you young people who've come to *Drag Race*, you feel the color and the love, know that that same creativity can work against you if your saboteur gets ahold of it. It's very insidious, it's smarter than you are. That's why the meditation is important because you have to—a problem cannot be solved on the same conscious level it was created on.

(The white woman sitting in front of me, who appears to be in her late teens/early 20s, says, "Mmm," indicating that she finds this part of Ru's speech moving)

RU: Let me say it one more time. A problem cannot be solved on the same conscious level that it was created on.

(The same white woman says, "Amen." I watch as she takes out her phone, opens up her Twitter account, and posts to her page, "A problem cannot be solved on the same conscious level that it was created on-RuPaul")

RU: So, you need some intervention. And, again, I'm not religious, but any time—because you have free will, any time you say the words, "Please help me," your angels will hear it, and they will come and they will intervene because they can't do it unless you say it because you have free will.

(RuPaul 2017)

In this section of Ru's keynote, he addresses the election briefly by relating the situation back to his self-help theme. Unlike the other DragCon panels this year that directly call out Donald Trump for his litany of offensive qualities, Ru walks a fine line here. Ru does not directly name or mention Trump, and he explains the current political climate through a *Downtown Abbey* reference. This rhetoric presents a very digestible narrative: a few people want to turn the country backward, but we will not go back. Ru then immediately connects this brief invocation of Trump back to his topic's overall self-help theme, and in so doing, he guides the conversation away from fiery politics to emotional guidance. Ru affirms the audience's shared identity as people who "feel the color and the love," presumably in contrast to the individuals wanting to move the country backward. When Ru delivers this portion of the keynote, he assumes that everyone in the DragCon audience voted against Trump. Love of *RuPaul's Drag Race* and attendance at RuPaul's DragCon do not inherently translate into a certain liberal or progressive political affiliation. As a gay

man witnessing this speech, I want RuPaul to directly tell the audience that if they consume queer culture, they have an obligation to vote for queer rights. Ru does not, perhaps because such a directive could harm the mainstream expansion of his commercial drag empire. The political, subversive power of camp is now absent.

Although I do not relate to this speech, I am struck by the young white woman in front of me who hangs on Ru's words and even retweets a bon mot in real-time. She relishes Ru's self-help advice so much that she shares to her Twitter account a direct quotation about "clearing out the blockage" from Ru's speech. In witnessing her reaction to Ru's keynote, I am struck by how differently this diverse DragCon audience consumes his performance. Ru has successfully marketed himself as a guRu, such that now younger female followers share his self-help advice via social media. The Q&A session further reveals the tangible effects of Ru's marketing strategies. The first question comes from a female attendee who asks Ru for advice on how to deal with family struggles. Next, an individual who visually reads as a middle-aged white woman walks with her cane to the microphone. She shares with Ru (and the audience) that she is currently celebrating seven years being cancer-free. The woman chokes up as she continues, saying that she lives with chronic pain and feels like she cannot catch a break in life. She asks for RuPaul's advice on dealing with chronic pain. As with the previous question, this woman also wants self-help advice from the guRu. Now, however, she seeks advice that Ru cannot provide: how could a drag queen, who has not publicly disclosed living with chronic pain, provide coping advice to someone living with chronic pain?[10] In his response, Ru makes this very point:

> I'm so sorry. Honestly, I don't know the answer to that question, but right now, everyone in this room, if you can accept it, is sending you loving energy at this very moment. (The audience claps). I hope that can somehow alleviate some of it, but I honestly don't know. The fact that you brought it out there into the world, and the fact that you want it to end is the beginning.
> (RuPaul 2017)

A professional drag queen who does not experience chronic pain cannot tell someone how to live with chronic pain. That these women seek Ru's self-help advice reveals the effectiveness of Ru's guRu persona.

At the same time, these questions reveal fissures in Ru's self-love discourse. RuPaul on *Drag Race* and in his 2015 keynote frames his brand of self-love consumerism as antithetical to corporate consumerism, in large part because Ru's brand does not seek to fix individuals. Ru does not suggest that his audience is flawed and must consume his products in order to become whole. Now, however, these DragCon attendees seek Ru's advice to fix a part of themselves. They want the guRu to instruct them how to fix family issues or how to cope with physical pain. Ru's guRu persona in practice

capitalizes on a lack in consumers: they connect with and personalize his discussions of hardship, and they want Ru's self-help to fix this distress. As these questions demonstrate, Ru has effectively marketed himself as a guRu, and increasingly more consumers will invest time and money into consuming this self-help advice.

Conclusion: The Complexities and Contradictions of RuPaul's Camp Consumerism

I leave DragCon, 2017, filled with a mixture of awe from a weekend full of powerful queer political discourse, as well as unease from the Q&A portion of Ru's keynote. This dichotomy perfectly encapsulates the commercial drag economy on display at RuPaul's DragCon. As *RuPaul's Drag Race* grows in popularity, the fan base increasingly becomes more "queer" but less specifically LGBTQ+. The attendees at RuPaul's DragCon are all queer in the sense that they all share a love of consuming this queer television show. They invest in DragCon to celebrate the show, to consume drag cultures/histories, to meet their favorite *Drag Race* contestants, to shop, and to mingle. This shared queer identity is ultimately rooted in consuming the *Drag Race* franchise (and investing time and money into RuPaul's commercial drag enterprise). As *RuPaul's Drag Race* grows in mainstream popularity, straight audiences (particularly white women) invest and participate in the economy. At the same time, aspects of the event are becoming less specifically LGBTQ+. RuPaul's keynote shifts from 2015 to 2016/2017 indicate a change in marketing strategies. The first year, Ru performed the role of queer knowledge keeper and spoke primarily to the LGBTQ+ audience. The next two years, Ru defined the audience as queer by virtue of their shared love for Bohemian culture (e.g., color, music, etc.). When I hear these keynote speeches, I get the sense that I have become a cultural outsider during Ru's talk. Because I do not consume Ru for his guRu persona, I do not connect with his rhetoric.

As RuPaul's brand becomes increasingly mainstream, his marketing strategies change in focus from campy consumerism rooted in self-love discourse to more overt attempts to brand himself as a guRu. This guRu, who performs the role of an Oprah-esque life-advice figure, impacts his audiences differently than the previous queer knowledge keeper. As I observe during these DragCon Q&A sessions, more and more audience members treat RuPaul like a spiritual guide whose knowledge can help fill voids in their lives. As a result, the effects of RuPaul's campy consumerism more and more tend to mirror the results of what Ru calls "toxic consumerism." These audiences identify a lack within themselves, and now that RuPaul has become their guRu, they want him to fill this void. This relationship to RuPaul raises significant questions about the impacts of Ru's commercial drag enterprise, specifically when we think about how these fans bring similar relationships to other

drag performers. The drag artist has historically been an important cultural and political figure in LGBTQ+ communities, one not confined by the bounds of neoliberal capitalism. As more mainstream audiences embrace RuPaul's evolving brand of consumerism, they may conceptualize all drag artists as "guRus," when many of these performers would not wish to take on such an identity. While *RuPaul's Drag Race* undoubtedly impacts the twenty-first-century drag landscape, the show's marketing strategies may create opportunities for harm among audiences as much as they create opportunities for campy, queer subversion.

NOTES

1. Founded in 1991, World of Wonder produces reality and documentary television programs, feature films, and online/digital media for multiple networks in the United States and United Kingdom. WOW almost always produces content related to LGBTQ+ people/cultures or camp figures, such as a documentary about Christian televangelist Tammy Faye Bakker (narrated by RuPaul). As of 2015, WOW started producing conventions, with the advent of RuPaul's DragCon, a now annual drag-related convention held in Los Angeles, New York City, and London.
2. As of this writing, the Los Angeles Convention Center has hosted five RuPaul's DragCon events in 2015, 2016, 2017, 2018, and 2019. In September 2017, the Jacob K. Javits Convention Center in New York City hosted the first NYC-based DragCon, and the event has continued in 2018 and 2019. In January 2020, the Olympia London hosted the first RuPaul's DragCon UK.
3. In 2015, DragCon garnered an attendance of 13,718 fans. This number increased to 22,575 attendees in 2016, over 40,000 in 2017, over 50,000 in 2018, and 100,000 in 2019 (Ifeanyi 2019). As these numbers indicate, RuPaul's DragCon is a huge event that brings together large numbers of drag performers, queer artists, vendors, and *Drag Race* superfans—all of whom invest time and money into RuPaul's commercial drag economy.
4. The 2017 RuPaul's DragCon events in Los Angeles and New York City combined generated an estimated $8 million in merchandise sales on the convention floor alone. This total excludes the money raised through ticket sales (Im 2019).
5. For a fuller picture of this discourse, see: Brennan and Gudelunas (2017), Collins (2017), Crookston (2018), Daems (2014), Daggett (2017), de Villiers (2012), Edgar (2011), Gamson (2013), Goldmark (2015), González and Cavazos (2016), Greenhalgh (2018), Gudelunas (2016), Hall-Araujo (2016), Hargraves (2011), Heller (2018), Hernandez (2014), Herold (2012), Hicks (2013), McKinnon (2018), Metzger (2016), Moore (2013), Rodriguez y Gibson (2014), Sandoval (2018), Schottmiller (2017), Shetina (2018), Simmons (2014), Strings and Bui (2014), Tucker Jenkins (2013), Vesey (2017), and Zhang (2016).
6. Through irony/incongruity, theatricality/parody, humor, and aestheticism, camp turns an identity laden with shame (homosexuality) into a positive subjectivity, thereby helping

to relieve the stigma associated with gayness (Bérubé 1990; Halperin 2012; Newton 1972). Camp takes as its subject matter incongruity/irony in response to heteronormative society's defining queers by a stigmatized position of social and moral deviancy (Babuscio 1980; Newton 1972). Homosexuals often utilize camp as an ironic commentary on their Othered positions in society. Theatricality is camp's style, with camp reveling in exaggeration and the notion of life-as-theater (Babuscio 1980; Newton 1972). Camp's theatricality develops in part from the need for queers to "pass" as heterosexual. Because masquerading as straight often functions as a form of survival in homophobic societies, queers learn to hide their identities through calculated self-presentation. As a form of role-playing, camp frequently parodies heteronormative gender and sex roles (Babuscio 1980; Bérubé 1990; Case 1999; Flinn 1999; Newton 1972). For example, female impersonation and butch/femme aesthetics display the performativity of gender such that masculinity, femininity, and identity itself become signifiers that anybody may perform through role-playing (Butler 1990; Case 1999; Newton 1972). Camp's theatricality thus transforms the "natural" into the performative, thereby disrupting essentialized identity categories. Humor is camp's strategy, with the aim of making a queer audience laugh at their incongruous position instead of crying (Babuscio 1980; Bérubé 1990; Halperin 2012; Newton 1972). Often ironic, sarcastic, and even hostile, camp's bitter wit neutralizes the sting of homophobia by embracing and mocking homosexuals' stigmatized identities, thereby undercutting rage through derision (Babuscio 1980; Chauncey 1994; Newton 1972).

7. For a more thorough analysis of camp capitalism, see the chapter "'Available on iTunes': Camp Capitalism and RuPaul's Commercial Drag Economy" from my 2017 dissertation. In this chapter, I conduct a content analysis of the *RuPaul's Drag Race* television series, tracing the development of camp capitalism from the show's first season through season nine.
8. RuPaul did not deliver keynote addresses at the New York City or London DragCon events, and he did not give a keynote at the 2019 Los Angeles DragCon.
9. For the sake of space, I have truncated some excerpts from RuPaul's keynote addresses. The overall content is unchanged, as I predominantly removed moments of repetition.
10. As of this writing, RuPaul has not publicly disclosed that he lives with chronic pain or illness. I do not want to assume his experience with chronic pain but base this assertion on his public statements.

REFERENCES

Babuscio, Jack. 1980. "Camp and the Gay Sensibility." In *Gays & Film*, edited by Richard Dyer, 40–57. London: BFI.

Bergman, David. 1993. "Strategic Camp: The Art of Gay Rhetoric." In *Camp Grounds: Style and Homosexuality*, edited by David Bergman, 92–112. Amherst: University of Massachusetts Press.

Bérubé, Allan. 1990. *Coming Out Under Fire: The History of Gay Men and Women in World War II*. 20th anniversary ed. Chapel Hill: University of North Carolina Press.

Brennan, Niall, and David Gudelunas, eds. 2017. RuPaul's Drag Race *and the Shifting Visibility of Drag Culture: The Boundaries of Reality TV*. New York: Palgrave Macmillan.

Britton, Andrew. 1999. "For Interpretation: Notes against Camp." In *Camp: Queer Aesthetics and the Performing Subject*, edited by Fabio Cleto, 136–43. Ann Arbor: University of Michigan Press.

Bronski, Michael. 1984. *Culture Clash: The Making of Gay Sensibility*. Boston: South End.

Butler, Judith. 1990. *Gender Trouble: Feminism and the Subversion of Identity*. New York: Routledge.

Case, Sue-Ellen. 1999. "Toward a Butch-Femme Aesthetic." In *Camp: Queer Aesthetics and the Performing Subject*, edited by Fabio Cleto, 185–99. Ann Arbor: University of Michigan Press.

Chauncey, George. 1994. *Gay New York: Gender, Urban Culture, and the Making of the Gay Male World, 1890–1940*. New York: Basic Books.

Collins, Cory G. 2017. "Drag Race to the Bottom? Updated Notes on the Aesthetic and Political Economy of *RuPaul's Drag Race*." *Transgender Studies Quarterly* 4 (1) (February): 128–34. https://doi.org/10.1215/23289252-3711589.

Crookston, Cameron. 2018. "Off the Clock: Is Drag 'Just a Job'?" *Queer Studies in Media & Popular Culture* 3 (1): 101–15. https://doi.org/10.1386/qsmpc.3.1.101_1.

Daems, Jim, ed. 2014. *The Makeup of* RuPaul's Drag Race: *Essays on the Queen of Reality Shows*. Jefferson, NC: McFarland.

Daggett, Chelsea. 2017. "'If you can't love yourself, how in the hell you gonna love somebody else?' Drag TV and Self-Love Discourse." In RuPaul's Drag Race *and the Shifting Visibility of Drag Culture: The Boundaries of Reality TV*, edited by Niall Brennan and David Gudelunas, 271–85. New York: Palgrave Macmillan.

de Villiers, Nicholas. 2012. "*RuPaul's Drag Race* as Meta-reality Television." *Jump Cut: A Review of Contemporary Media* 54 (Fall): unpaginated.

Edgar, Eir-Anne. 2011. "'Xtravaganza!': Drag Representation and Articulation in *RuPaul's Drag Race*." *Studies in Popular Culture* 34 (1) (Fall): 133–46.

Flinn, Caryl. 1999. "The Deaths of Camp." In *Camp: Queer Aesthetics and the Performing Subject*, edited by Fabio Cleto, 433–57. Ann Arbor: University of Michigan Press.

Gamson, Joshua. 2013. "Reality Queens." *Contexts* 12 (2) (Spring): 52–54. https://doi.org/10.1177/1536504213487699.

Goldmark, Matthew. 2015. "National Drag: The Language of Inclusion in *RuPaul's Drag Race*." *GLQ: A Journal of Lesbian and Gay Studies* 21 (4) (October): 501–20.

González, Jorge C., and Kameron C. Cavazos. 2016. "Serving Fishy Realness: Representations of Gender Equity on *RuPaul's Drag Race*." *Continuum: Journal of Media & Cultural Studies* 30 (6): 659–69. https://doi.org/10.1080/10304312.2016.1231781.

Greenhalgh, Ella. 2018. "'Darkness Turned into Power': Drag as Resistance in the Era of Trumpian Reversal." *Queer Studies in Media & Popular Culture* 3 (3) (September): 299–319. https://doi.org/10.1386/qsmpc.3.3.299_1.

Gudelunas, David. 2016. "Culture Jamming (and Tucking): *RuPaul's Drag Race* and Unconventional Reality." *Queer Studies in Media & Popular Culture* 1 (2) (June): 231–49. https://doi.org/10.1386/qsmpc.1.2.231_1.

Hall-Araujo, Lori. 2016. "Ambivalence and the 'American Dream' on *RuPaul's Drag Race*." *Film, Fashion & Consumption* 5 (2) (December): 233–41. https://doi.org/10.1386/ffc.5.2.233_1.

Halperin, David. 2012. *How to Be Gay*. Cambridge: Belknap Press of Harvard University Press.

Hargraves, Hunter. 2011. "'You better work': The Commodification of HIV in *RuPaul's Drag Race*." *Spectator* 31 (2) (Fall): 24–34.

Heller, Meredith. 2018. "RuPaul Realness: The Neoliberal Resignification of Ballroom Discourse." *Social Semiotics* (November): 1–15. https://doi.org/10.1080/10350330.2018.1547490.

Hernandez, John. 2014. "Giving Face, Shade, and Realness: A Queer Analysis of Gender Performance and Sexuality in *RuPaul's Drag Race*." Master's thesis, University of Hartford.

Herold, Lauren. 2012. "*RuPaul's Drag Race* Is Burning: Performances of Femininity and Neoliberalism in 'Post-Racial' America." Senior thesis, Columbia University.

Hicks, Jessica. 2013. "'Can I get an amen'?: Marginalized Communities and Self-Love on *RuPaul's Drag Race*." In *Queer Love in Film and Television*, edited by Pamela Demorey and Christopher Pullen, 153–60. New York: Palgrave Macmillan.

Ifeanyi, KC. 2019. "How *RuPaul's Drag Race* Is Doubling Down on the Experience Economy." *Fast Company*, September 23, 2019. https://www.fastcompany.com/90407204/how-rupauls-drag-race-is-doubling-down-on-the-experience-economy.

Im, Jimmy. 2019. "How *RuPaul's Drag Race* Helped Mainstream Drag Culture—and Spawned a Brand Bringing in Millions." *CNBC*, May 30, 2019. https://www.cnbc.com/2018/09/28/rupauls-drag-race-inspired-multimillion-dollar-conference-dragcon.html.

LaValley, Al. 1995. "The Great Escape." In *Out in Culture: Gay, Lesbian, and Queer Essays on Popular Culture*, edited by Corey K. Creekmur and Alexander Doty, 60–70. Durham, NC: Duke University Press.

Long, Scott. 1989. "Useful Laughter: Camp and Seriousness." *Southwest Review* 74 (1): 53–70.

McKinnon, Scott. 2018. "*RuPaul's Drag Race* Is Still Figuring out How to Handle Gender and Race." *The Conversation*, June 27, 2018. http://theconversation.com/rupauls-drag-race-is-still-figuring-out-how-to-handle-gender-and-race-96711.

Medhurst, Andy. 1997. "Camp." In *Lesbian and Gay Studies: A Critical Introduction*, edited by Andy Medhurst and Sally R. Munt, 274–93. London: Cassell.

Melly, George. 1970. *Revolt into Style: The Pop Arts in Britain*. London: Allen Lane The Penguin Press.

Metzger, Megan M. 2016. "That's Ru-volting! How Reality TV Reimagines Perceptions of American Success." Thesis, DePaul University.

Meyer, Moe. 1994. "Introduction: Reclaiming the discourse of Camp." In *The Politics and Poetics of Camp*, edited by Moe Meyer, 1–22. New York: Routledge.

Moore, Ramey. 2013. "Everything Else Is Drag: Linguistic Drag and Gender Parody on *RuPaul's Drag Race*." *Journal of Research in Gender Studies* 3 (2): 15–26.

Muñoz, José Esteban. 1999. *Disidentifications: Queers of Color and the Performance of Politics*. Minneapolis: University of Minnesota Press.

Newton, Esther. 1972. *Mother Camp: Female Impersonators in America*. Chicago: University of Chicago Press.

Rodriguez y Gibson, Eliza. 2014. "Drag Racing the Neoliberal Circuit: Latina/o Camp and the Contingencies of Resistance." In *The Un/Making of Latina/o Citizenship: Culture, Politics, and Aesthetics*, edited by Ellie D. Hernández and Eliza Rodriguez y Gibson, 39–62. New York: Palgrave Macmillan.

RuPaul. 2015. "RuPaul's DragCon Keynote Address." Speech, Los Angeles, CA, May 17, 2015.

———. 2016. "RuPaul's DragCon Keynote Address." Speech, Los Angeles, CA, May 8, 2016.

———. 2017. "RuPaul's DragCon Keynote Address." Speech, Los Angeles, CA, April 30, 2017.

Sandoval, Jorge. 2018. "The RuPaul Effect: The Exploration of the Costuming Rituals of Drag Culture in Social Media and the Theatrical Performativity of the Male Body in the Ambit of the Everyday." *Theatre Symposium* 26: 110–17. https://doi.org/10.1353/tsy.2018.0007.

Schottmiller, Carl. 2017. *Reading RuPaul's Drag Race: Queer Memory, Camp Capitalism, and RuPaul's Drag Empire*. PhD diss., University of California, Los Angeles.

Sedgwick, Eve Kosofsky. 1990. *Epistemology of the Closet*. Berkeley: University of California Press.

Shetina, Michael. 2018. "Snatching an Archive: Gay Citation, Queer Belonging and the Production of Pleasure in *RuPaul's Drag Race*." *Queer Studies in Media & Popular Culture* 3 (2) (June): 143–58. https://doi.org/10.1386/qsmpc.3.2.143_1.

Simmons, Nathaniel. 2014. "Speaking Like a Queen in *RuPaul's Drag Race*: Towards a Speech Code of American Drag Queens." *Sexuality and Culture* 18 (3): 630–48. https://doi.org/10.1007/s12119-013-9213-2.

St. James, James. 2015. "Get Your Tickets Now for RuPaul's DragCon." *World of Wonder*, March 13, 2015. http://worldofwonder.net/world-wonder-announces-rupauls-drag-con-coming-may-16-17/.

Strings, Sabrina, and Long T. Bui. 2014. "'She Is Not Acting, She Is': The Conflict between Gender and Racial Realness on *RuPaul's Drag Race*." *Feminist Media Studies* 14 (5): 822–36. https://doi.org/10.1080/14680777.2013.829861.

Tucker Jenkins, Sarah. 2013. "Hegemonic 'Realness'? An Intersectional Feminist Analysis of *RuPaul's Drag Race*." Master's thesis, Florida Atlantic University.

Vesey, Alyxandra. 2017. "'A Way to Sell Your Records': Pop Stardom and the Politics of Drag Professionalization on *RuPaul's Drag Race*." *Television & New Media* 18 (7) (December): 589–604. https://doi.org/10.1177/1527476416680889.

Zhang, Eric. 2016. "Memoirs of a GAY! Sha: Race and Gender Performance on *RuPaul's Drag Race*." *Studies in Costume & Performance* 1 (1): 59–75. https://doi.org/10.1386/scp.1.1.59_1.

Contributors

Mario Campana is a lecturer in marketing and consumer behavior at the Institute of Management Studies at Goldsmiths, University of London, United Kingdom. He completed his PhD in consumer research at Cass Business School, London, UK. His research interests lie in the fields of consumer entrepreneurship, consumption of money, consumer collectives, and materiality. His approach is rooted in consumer culture with a critical twist and macro-perspective that is also reflected in his teaching practice and interests.

Cameron Crookston currently teaches at the University of Toronto's Mark S. Bonham Centre for Sexual Diversity Studies. His research focuses on drag, LGBTQ2+ history, queer cultural memory, and queer pop culture. Cameron received his doctorate from the Centre of Drama, Theatre and Performance Studies, in collaboration with the Centre for Sexual Diversity Studies at the University of Toronto. His work appears in *Queer Studies in Media & Popular Culture* and *New Essays on Canadian Theatre*. He is also coediting an upcoming issue of *Canadian Theatre Review* on Canadian drag performance.

Ash Kinney d'Harcourt completed their PhD in cognitive psychology at the University of Texas at Austin and is currently pursuing a doctorate in the department of Radio-Television-Film. Their writing has appeared in *Flow*, the university's online media and culture journal, and their research interests include queer and feminist media studies, television genre, media representation of identity, and celebrity culture.

Katherine Duffy is a lecturer in marketing at the Adam Smith Business School, University of Glasgow. She holds a PhD in marketing from the University of Strathclyde, United Kingdom. Her current research interests include sociocultural dimensions of value, sustainable clothing consumption, and the digitalization of consumption. Her research has been published in *Gender, Work and Organisation, Consumption, Markets and Culture, Journal of Marketing Management*, and *Journal of Retailing and Consumer Services*.

Laura Friesen is a writer and arts administrator from Winnipeg, Manitoba. Her interests and writing coalesce around the intersections of gender, queerness,

feminism, pop culture, music, and media. Her work has appeared in the Repeater Books anthology *Under My Thumb: Songs That Hate Women and the Women Who Love Them* (2017).

Ray LeBlanc is a PhD candidate in the cultural studies program at George Mason University in Fairfax, Virginia. Trained as a queer ethnographer, their research primarily investigates the cultural practices of drag queens from a variety of approaches, ranging from autoethnographic narratives to analyses of social media usage. LeBlanc is currently working on an ethnography of drag queening in New York City.

Timothy Oleksiak (he/him/his) is a low-femme assistant professor of English and director of the Professional & New Media Writing program at the University of Massachusetts Boston. There he teaches courses in rhetoric and composition. His primary research interests focus on developing theories and pedagogies based on queer listening as a worldmaking practice. He is currently working on queering peer review in the writing classroom.

Joshua W. Rivers is a PhD candidate in the Department of Anthropology at the University of Wisconsin-Milwaukee. His research resides at the nexus of queer theory, institutions, and video games with past projects focusing on queer community making in massively multiplayer online games. Alongside his work in digital anthropology, Josh is committed to synthesizing queer theory and anthropological methodologies so as to better inform current understandings of ethics, institutions, and community. Growing up queer in the Deep South, Josh was drawn to anthropology because of its celebration of diversity and exploration.

Carl Schottmiller researches and teaches courses in the areas of LGBTQ studies, disability studies, and culture and performance studies. His dissertation work analyzed the *RuPaul's Drag Race* phenomenon using interdisciplinary research methods and studying the show's uses of camp. Carl earned his PhD in culture and performance studies from UCLA's Department of World Arts and Cultures/Dance. He currently teaches courses at UCLA and Cal State LA in disability studies, LGBTQ studies, and gender and women's studies.

Lwando Scott is an Andrew W. Mellon Postdoctoral Fellow at the Centre for Humanities Research at the University of the Western Cape in Cape Town, South Africa. Lwando earned his doctorate from the University of Cape Town with a thesis on same-sex marriage in South Africa titled " 'The more you stretch them, the more they grow': Same-Sex Marriage and the Wrestle with Heteronormativity."

He was an Innovation in Science Pursuit for Inspired Research Fellow at Ghent University in 2016–17. He was awarded the Yale Fox Fellowship at Yale University in 2013–14. Lwando's work, academic and otherwise, is centered on advancing queer politics in South Africa. His work interrogates narrow definitions of "Africanness" that position African LGBTI people as outside the definitions.

Aaron J. Stone is a PhD candidate in English language and literature at the University of Michigan. Their primary research interests span queer and trans studies, modernist literature, and narrative theory. Aaron's dissertation project explores the social crisis of form that nascent queer communities faced in early-twentieth-century America as queer people tried to imagine what shapes their lives might take. The project investigates how these subjects turned to narrative to work out their desires for form, focusing especially on how queer yearnings for structure and stability conflicted with the modernist eschewal of "conventional" forms.

Allan S. Taylor is an academic and practitioner working across media, performance, and photography. His work focuses on what images "do" and how performativity underpins or informs our idea of cultural reference in popular culture. Particularly, he looks at acts of queer and gender performativity and their subsequent representation in visual culture. He lectures in media and cultural theory at De Montfort University.

K. Woodzick is an activist, educator, theater artist, and the founder of The Non-Binary Monologues Project. Currently, they are a PhD student in theatre and performance studies at the University of Colorado, Boulder. Woodzick holds a BA in theatre/dance from Luther College in Decorah, Iowa, and an MFA in contemporary performance from Naropa University in Boulder, Colorado. They are fascinated by exploring how the theatre industry can become more inclusive of gender and neurodiversity. They would love for you to listen to their album "Hoops of Steel: The Musical" on Spotify and also want you to know they are a *Drag Race* super fan.